Taking to the Field

Taking to the Field

A History of Australian Women in Science

Jane Carey

Published by Monash University Publishing
Matheson Library Annexe
40 Exhibition Walk
Monash University
Clayton, Victoria 3800, Australia
publishing.monash.edu/

Monash University Publishing: the discussion starts here

© Copyright 2023 Jane Carey

Jane Carey asserts her right to be known as the author of this work.

All rights reserved. Apart from any uses permitted by Australia's *Copyright Act 1968*, no part of this book may be reproduced by any process without prior written permission from the copyright owners. Enquiries should be directed to the publisher.

Taking to the Field: A History of Australian Women in Science
9781925835410 (paperback)
9781922633682 (pdf)
9781922633699 (epub)

A catalogue record for this book is available from the National Library of Australia

Design: Les Thomas
Typesetting: Jo Mullins

Cover photograph: Corporal Patricia Anne Ladyman, Australian Army Medical Women's Service at work in the pathology laboratory in the 110th Australian General Hospital, Perth, 1943, P01641.042, Australian War Memorial, Canberra.

Printed in Australia by Griffin Press

Contents

Acknowledgements . vii

Introduction: Women, Science and History 1

1 'Of Great Use to Science':
Women and Colonial Scientific Discovery 12

2 'Pioneers':
Studying Science, 1880–1920 47

3 Taking on the Profession:
Women Working in Science, 1900–1920s 76

4 Making a Better World?
Women and the (Racial) Science of Social Reform, 1890–1940 . . 118

5 Neither Rebels nor Radicals:
Studying and Working in Science, 1930s–1950s 154

6 A Profession for Men:
The Transformation of Australian Science, 1940–1960 188

Conclusion: Where Did All the Women Go? 222

Appendix 1:
 Women Studying Science at Australian Universities, 1885–2020 . . . 233

Appendix 2:
 Women Staff of Australian Universities, 1929–1955 239

Notes . 245

Index . 299

About the Author 311

Acknowledgements

This book has been a long time in the making and I have incurred many debts along this journey. Firstly, to Pat Grimshaw, the unparalleled mentor and towering scholar who shaped this book, and indeed my whole career, in so many ways. Sincere thanks to Camille Nurka, editor extraordinaire, whose skill and sharp mind made this book better in more ways than I can express and whose enthusiasm got me through more than one period of self-doubt. I have been fortunate to have had outstanding research assistants at various stages of this project, most of whom are now established in their own academic or other careers – Belinda Ensor, Andrew Junor, Georgia Shiells, Ben Silverstein, Jordy Silverstein and most recently Lauren Samuelsson, who I am sure will go on to great things. Research for this book was supported at various stages by Australian Postgraduate Award, an Australian Research Council Postdoctoral Fellowship, a Monash University Fellowship and small grants from the University of Wollongong. To Julia Carlomagno and Joanne Mullins at Monash University Publishing, thank you for all your work and your enthusiasm for this book. For reading chapters and invaluable feedback at various stages, I am hugely grateful to Zora Simic, Sarah Pinto, Justine McGill, and members of CASS at the University of Wollongong.

There are many who have shaped this book, or made it possible, through conversations, guidance and practical assistance. Thank

you to the many supportive mentors, colleagues and inspirational scholars of the feminist history, colonial history and Indigenous studies communities in Australia and beyond: Ann Curthoys, Zoë Laidlaw, Jane Lydon, Vera Mackie, Lynette Russell, Penny Russell, Shurlee Swain, Angela Wanhalla and Kehaulani Kauanui. I have learned so much from all of you. Thank you to friends and colleagues at the University of Wollongong, particularly Jen Roberts, who is always there for a good gossip and a laugh and took over my teaching during the final stages of writing. My oldest and dearest friends, Gareth Weston and Lisa Ewenson, you keep me sane, and thanks for putting up with me while I got this done (or, more precisely, being understanding about my absence). And thank you to my brilliant and cherished academic friends and colleagues, some of whom I've known since honours (or earlier!), and others through the heady PhD and postdoc days at the University of Melbourne: Zora Simic, Timothy Jones, Penny Edmonds, Kat Ellinghaus, Ellen Warne, Crystal McKinnon, Ann Standish, Liz Conor, Kalissa Alexeyeff and the much-missed Tracey Banivanua Mar. Your integrity, compassion, activism and scholarship exemplify the best of what the academy should be.

Introduction

Women, Science and History

On 5 October 2009 molecular biologist Elizabeth Blackburn received a phone call from Geneva with the news that she, along with her American colleagues Carol Greider and Jack Szostak, had been awarded the Nobel Prize for Physiology or Medicine.[1] As the news became official, the Australian media swiftly celebrated the Tasmanian-born scientist as the nation's eleventh Nobel Laureate. Of particular interest was the fact that Blackburn was the first Australian woman to win a Nobel Prize, the highest scientific accolade in her field.

Blackburn's award confirmed her position as a global scientific leader. It recognised the ground-breaking research she had conducted in the US since the late 1970s, which led to, as the Nobel citation described it, 'the discovery of how chromosomes are protected by telomeres and the enzyme telomerase'.[2] This muted description did little justice to the significance of these discoveries. The telomere is a cap-like structure at the end of chromosomes which stops them from disintegrating during cell division. Telomerase is the enzyme that builds telomeres. We literally could not live without them. Blackburn's research uncovered a fundamental biological process and she founded an entirely new scientific field.

Unsurprisingly, the media celebration of Blackburn's achievement focused not on her scientific work but on her gender, and especially her place as a pioneer for women in the field. She was represented as a 'crusader for women in science … [who] pushed the cause of women in science as strongly as she did her own endeavours'.[3] The *Sydney Morning Herald* (erroneously) reported, 'Dr Blackburn's career path wasn't easy.'[4] In fact, her career trajectory had been remarkable. Blackburn herself expressed the hope that her success would send 'a signal that says women can participate [in science] as much as men'.[5] Completely absent from the media coverage was any sense of the long and significant history of Australian women's scientific endeavours.

Nearly 125 years before Elizabeth Blackburn received her Nobel Prize, Edith Emily Dornwell had become Australia's first female science graduate and the first woman to graduate from the University of Adelaide. There was relatively little fanfare in the press. While her achievement might seem momentous to modern eyes as a radical departure for women of this period, this was not how it was represented at the time. The editorial in Adelaide's leading newspaper for that day – 16 December 1885 – devoted several paragraphs to describing the annual graduation ceremony and reflected with satisfaction on the general state of the university. Only then did it finally observe:

> One noteworthy feature of the celebration today will be the conferring of the first B.Sc. degree on one of the students of this University, and this is rendered all the more remarkable because the candidate who has won this unique position is a young lady … It is to be hoped that Miss Dornwell may be the precursor of a long line of graduate girl bachelors.[6]

Despite the apparent novelty of the event, it was not singled out for any further comment. There was no suggestion that Dornwell's entry into science was inappropriate, or in any way undesirable, for a member of her sex. In line with South Australia's self-image as an enlightened colony, her graduation was rather a matter of pride for the university – proof of its modern, progressive status.

Edith Dornwell's graduation was not an isolated occurrence. As this book reveals, women have had a far greater presence in Australian science than is commonly realised.[7] From the 1880s (when science degrees were first offered in Australian universities), women enthusiastically took to the field. Up to the end of the Second World War, women in fact made up 30 to 40 per cent of science students in most universities. At the University of Sydney, women graduating in science reached a peak of 55 per cent in 1943.[8] Large numbers of women also worked as scientists in many universities over this period. Despite common assumptions that women have always been more prominent and accepted within the humanities, in Australia it was in science that women were first appointed to academic positions. Women's contributions were essential to the very foundation of Australian science.

This is a truly extraordinary history, but one that remains largely hidden. In 1885 another Adelaide newspaper confidently predicted that 'so long as genuine hard work and real ability are worthy of praise, Miss Dornwell B.Sc. need not fear that she will be forgotten'.[9] This confidence was misplaced. Today Edith Dornwell remains largely unknown, as do the thousands of women scientists whose lives and important contributions to the development of Australian science are recovered in this book. If asked to name a woman scientist from the past, most people would be able to identify Marie Curie, but few could go further than this. Very few would be able to name a significant

woman scientist from Australia's history. This is unsurprising given that existing histories of Australian science largely overlook women. Their absence from these histories gives the impression that, until recently, there were no Australian women scientists.[10]

Most of the women recorded here were (and remain) obscure. Few were well known in their own lifetimes, and even those who enjoyed a measure of fame, or infamy, were usually quickly forgotten. Both 'mainstream' and women's histories have, paradoxically, worked together to disguise the extent and variety of women's past scientific endeavours. When I began working on this book, informed by the best feminist scholarship, I assumed that writing a historical account of Australian women scientists would encompass only a very small number of individuals. Reading books and articles with titles like 'A World Without Women' had given me to understand that, until very recent times, women were almost entirely absent from science.[11] The astounding wealth of Australian women's scientific activities that I quickly uncovered took me totally by surprise. When, after hours spent poring over lists of graduating classes, I discovered that 40 per cent of Sydney University's science graduates up to 1930 were women, I realised I would have to entirely revise my thinking. Clearly, there was a more complex story to be told.

Most accounts of women's experiences in science in the Western world have emphasised their marginality and exclusion, the barriers they faced and their struggles to gain entry into a male domain. Alongside military service, science is generally presented as an area which has been particularly hostile to women.[12] It is widely assumed that women have always, and inevitably, been discouraged from all scientific pursuits, that they have never had significant access to scientific education or employment, and that a radical rebellion against the norms of feminine

Introduction

socialisation was required for a woman to pursue a scientific career. Women were, after all, almost entirely barred from higher education until the late nineteenth century. They were also excluded from most of the prestigious scientific academies, many of which did not elect their first woman member until well into the twentieth century. Few women feature in the highest honour roles of science – for example, as Nobel Prize winners. The explicit exclusion of women, and qualities viewed as 'feminine', has been traced right back to the birth of modern science in the sixteenth century – which Francis Bacon (pioneering figure of the scientific method in England) actually called 'The Masculine Birth of Time'.[13]

What is less well known is that some areas of science have, in certain times and places, been very closely associated with women. Thus, in 1887 an essay in the highly influential journal *Science* asked the question, 'Is Botany a Suitable Study for Young Men?' The essay opened by observing that 'an idea seems to exist in the minds of some young men that botany is not a manly study; that it is merely one of the ornamental branches, suitable enough for young ladies and effeminate youths'.[14] These observations simultaneously affirmed botany as a womanly activity, but also show how this meant the field had a comparatively low status. This paradox runs throughout the history of women and science.

This book recovers the strong and vibrant culture of Australian women in science, particularly in the years up to the end of the Second World War. It is focused on the academy, as this was the major site of scientific research in this period, but also follows women's scientific interests and activities into many other areas. It is a history that presents significant challenges to prevailing assumptions about women's enduring absence from science. By the early twentieth century, Australian women were

highly visible in many scientific occupations – as academics, researchers, laboratory workers and teachers. They were in the overwhelming majority in some areas. Some made careers for themselves in fields that were accepted as women's domains, such as domestic science and dietetics. But most were part of the 'mainstream' of science. While their achievements were certainly limited by institutional barriers and discriminatory attitudes, women were by no means completely excluded from science, and there were significant forces which supported and encouraged their participation.

What follows is a wide-ranging exploration of the richness and diversity of women's contributions to Australian science since British invasion. Indigenous women and men were, and continue to be, the holders of vast knowledge of the Australian continent. But until recently, Indigenous and Western science have remained distinctly separate – not least because Western science produced the racial theories that provided 'justification' for colonialism at large. Indigenous peoples were viewed as 'objects' for scientific study. We are only now coming to understand how vital Indigenous Knowledge was to early colonial endeavours, including scientific 'discoveries', and indeed to colonists' very survival.[15] This knowledge was either dismissed or else simply appropriated without proper acknowledgement of its source. It was within this context of colonial dispossession and authority that white women first gained a foothold as participants in the making of scientific knowledge.

The book primarily deals with the period from the 1880s when the introduction of science degrees into Australian universities gave women (and men) the opportunity to engage in the emerging world of modern, professional science and undertake advanced research. The first chapter begins in the earlier nineteenth century, the period of amateur

science, when women from the colonial elite were drawn into a range of natural-history endeavours through their cultural backgrounds, families and social connections to emerging scientific networks, and their proximity to 'unexplored' landscapes. Women engaged in a range of amateur scientific pursuits from the early years of colonial invasion. As such, they enthusiastically contributed to collecting and claiming the contents of the 'new' land.

The book also encompasses the period when the modern scientific age that we all now inhabit emerged and then rose to dominance. The influence of science has extended well beyond the secluded ivory tower of the laboratory to touch almost every aspect of our daily lives, and it has offered a range of avenues for women's engagement well beyond the academy. Science has also provided the impetus for mass social movements – around global warming, to name just one prominent current example. People in the past were also inspired by the promise science seemed to hold to solve critical problems and create a better, even ideal, world. Women were strongly involved in, and leaders of, a range of scientific social-reform movements. Recovering these activities provides a fuller picture of their engagements with science.

The following pages trace both broad trends and individual women who were either prominent in their field or obscure but exemplary of typical experiences, activities and contributions. Most came from the upper echelons of society. Access to tertiary education was extremely limited in Australia prior to the Second World War. Women of privileged class, race and educational backgrounds enjoyed advantages that significantly expanded their horizons. The women who entered science were typically those who escaped the barriers that restricted other women so completely. It was not until 1966 that Margaret Valadian became Australia's first (identified) Indigenous university graduate

when she gained her bachelor of social studies from the University of Queensland.[16] In 1976 the Australian census recorded just seventy-eight Aboriginal people with a university degree.[17] By this point, thousands of non-Indigenous women had obtained science degrees.

Australian women's early prominence in science is in some ways exceptional, but by no means unique. Women certainly formed a far larger proportion of the Australian scientific community from the early 1900s to the 1940s than was the case, for example, in Britain or the US. But internationally (outside the most elite centres of research) women's participation in science has also been greater than previously realised. Despite widespread assertions of women's absence from the field, there are very few broad historical studies of women's participation in science in the modern period outside of the US.[18] As this book relates, Australian women's presence in science has ebbed and flowed in response to a variety of influences. Their early prominence did not result in a continuous upward trajectory for women in science. In the years after the Second World War, the size and prestige of Australian science, and its employment prospects, increased dramatically. Men were, for the first time, attracted into the field in large numbers and women's previously strong presence evaporated. Women's representation in science did not reach the levels seen in the 1930s again until the late 1970s.[19]

This history is not a straightforward tale of progressive development – of women's advancement from exclusion to acceptance. Even today, while women are equally represented among Australian university science students, they are still woefully under-represented at the top levels of the profession.[20] This pattern persists internationally. And women's capacity for higher scientific work is still sometimes called into question.[21] This is also not a simple celebratory story of unsung heroines. The impact of Western science has not been uniformly positive

and women were certainly associated with some of its darker episodes. Their involvement in colonial science, particularly anthropology, had some deeply harmful consequences, as did their strong promotion of eugenics in social reform movements in the early twentieth century.

What emerges from this history is also an understanding that, rather than being 'rebels', 'pioneers' or 'exceptions', and certainly not saints, women scientists were a product of their class and culture. They did not view science as innately hostile to women. Their presence in the field is best understood not in terms of transgressions, but as the product of influences that supported both engagement with science and widening occupations for (some) women. They were as much a product of their class and culture as any 'typical' middle-class housewife. Their experiences are suggestive of the very real ability of white, middle-class women to circumvent apparent obstacles of gender in this period, particularly if they remained unmarried. This is not to diminish the intellectual energy, sheer hard work and long hours that a commitment to science requires. I hope that the absolute dedication of many of these women is conveyed in the history I have written about them. And even this highly advantaged group did not enjoy any sort of real 'equality' with men. They faced overt discrimination and limited employment opportunities, frequently accepting appointments well below the level of their qualifications and experience, and untold hours of unpaid work. Most had to leave their profession on marriage or motherhood. Many who stayed remained in positions or fields deemed 'low status'. I am sure these experiences will resonate with many women scientists of today.

Since the 1970s considerable efforts have been devoted to encouraging girls to study science, given its perceived importance and power, its impact on daily life and the increasing areas of employment requiring scientific qualifications. These efforts have been extraordinarily

successful. Women reached parity among university science students in Australia in the late 1990s.[22] But contrary to Elizabeth Blackburn's hope that her success would be seen as proof that women could not only do science but achieve success in the field, discussions of women and science remain highly discouraging. Women scientists are still presented as anomalies. And the continuing production of alarm around the supposedly low rates of women studying science problematically erases the enormous presence they do currently have, and have had in the past. This overwhelming focus on education (where women are actually doing very well) also diverts attention away from where the major barriers to women's achievement actually remain – within the institutions and structures of the scientific profession.

Misunderstandings of historical progress have removed women in science from historical memory. Contemporary discussions of women's representation in science are based on assumptions that things were (always and everywhere) far worse for women in the past. Generalised understandings of women's past lives – domestic and contained in apparent contrast to now – are a problem not only because these remove 'exceptional' women from history but also because they lull us into thinking things will just keep 'getting better' for women. Focusing only on women's exclusion from science unintentionally silences and disempowers actual women scientists, making them even more invisible and reinforcing, rather than dismantling, the association between science and masculinity. What new understandings of women and science might emerge if we start from the premise of women's presence rather than their absence?

Looking to history allows us to see that the relationship between women and science has not been static and nor was it marked solely by exclusion and disempowerment. While significant barriers have

Introduction

hindered women from being equal participants or sharing equally in the rewards of recognition, Australian science has certainly not been devoid of women. From Georgiana Molloy, who enlisted local soldiers in her quest to discover 'new' plants in Western Australia in the 1830s, to the maverick anthropologist Daisy Bates, to the important but largely forgotten parasitologist Georgina Sweet, Australia's first woman associate professor, and so many others. These women's lives, both ordinary and extraordinary, show that the contemporary 'problem' of women in science is not the product of any innate lack of interest in the field or incapacity for scientific creativity, but of our own presumptions about the impossibility of women scientists. This book seeks to redress such assumptions through a new story of the past that can account for the presence and possibility of women in science today.

Chapter 1

'Of Great Use to Science'

Women and Colonial Scientific Discovery

By the request of friends I am ... writing a short account of my life connected with Science, and the struggles I have had ... in making my discoveries known to the world ... I have had great pleasure in making my discoveries, which my friends tell me I should claim for the sake of all women.[1]

—Georgina King, Sydney, 1911

It was with these defiant words that Georgina King, by her own estimation amateur scientist extraordinaire, chose to describe her life devoted to the cause of science. Introducing the third edition of her (self-published) scientific writings, she asserted the significance of her work and publicly claimed that her discoveries had been stolen by some of Sydney's leading scientific men. Attempting to establish herself as a significant Australian scientist, Georgina emphasised her experience, as woman, of exclusion and intellectual theft. For nearly forty years,

until her death in 1932, this quest to achieve the scientific recognition she felt she deserved dominated her life. At every point, she maintained that 'the geologists' had taken her work without acknowledgement. As she later wrote, 'I have toiled and worked for the benefit of my country, and I have seen my discoveries and investigations given to others who got the credit for them.'[2] Despite her long quest, King's work was never published by any of the reputable scientific journals of the day and she lived and died in relative obscurity.

At first glance, this story seems a straightforward illustration of the barriers women faced when they tried to enter into science. Looking more closely at women like Georgina King reveals a somewhat different picture. Despite her grievances, King's very involvement in such activities upsets the common assumption that science in this period was something only men did. And she was by no means alone. King was a part of a significant tradition of women's participation in amateur science that stretched across the nineteenth century. In this era, women, typically from the colonial elite, were drawn into scientific work through their cultural background, family and social connections, and especially by their proximity to the 'undiscovered' natural landscapes of the Australian 'frontier'. This colonial setting has other implications. Through these activities, women were entwined with much larger imperial ambitions of claiming the 'new' land of Australia and the extensive violence of frontier conflict, dispossession and massacres of Indigenous peoples.[3] Some also directly contributed to the racial theories that underpinned colonialism. King's other major area of scientific interest was anthropology, where she promoted ideas about the 'primitive' nature of Aboriginal peoples. These facts require us to think carefully about how we should recognise the 'pioneering' achievements of women in colonial settings.

The Nature of Nineteenth-Century Science

Understanding King's story first requires an appreciation of the very different way that science was conceived and practiced in the nineteenth century. While science today is a profession only for highly trained specialists, this is a relatively recent development. In the nineteenth century, Western science was a largely amateur affair that was far more fluid. The word 'scientist' itself was only coined in 1839, and even then the number of people employed in science as a full-time, paid occupation was extremely small. This was particularly true in Australia. The vast majority of Australian scientists at this time were amateurs. Even those who enjoyed expert status usually earned their living through some other occupation. Although universities, geological surveys, astronomical observatories, museums and herbaria were established from the 1850s, by the 1870s there were still fewer than thirty full-time scientists employed across all of the Australian colonies.[4]

By contrast, amateur 'natural history' was an enormously popular pastime. This covered a range of areas that are now distinct fields, including botany, zoology and geology. From the earliest years of colonisation, the cultured classes collected and recorded examples of the natural life of the 'new' land around them. These activities often relied on the assistance and knowledge of local Aboriginal peoples, although this usually went unacknowledged.[5] Across the century, armies of amateur naturalists (including women) scoured the countryside, gathering specimens of the flora and fauna, rocks and minerals, often in response to eager requests from naturalists back in England.[6] As the century progressed, the few local experts created and directed extensive networks of amateur naturalists. In the case of

Ferdinand von Mueller, Victoria's Government Botanist and director of the Melbourne Botanic Gardens, such contacts numbered in the thousands – including hundreds of women.[7] Thus the tiny number of expert, professional scientists represents only the smallest fraction of scientific culture in nineteenth-century Australia.

A driving force behind the interest in natural history was its usefulness for the achievement of colonial ambitions. The 'discovery', naming and classifying of the contents of 'new' lands was an integral part of colonisation. Discoveries made in the colonies, especially Australia, also had an enormous impact on the biological science of the day, and British scientists were anxious to obtain such exotic specimens in order to stay at the forefront of their field.[8] Since the Indigenous peoples of the 'new' worlds were viewed as a part of nature, natural history encompassed the emerging field of anthropology as well.[9]

Not only was science a largely amateur enterprise, it also had strong connections – no longer evident today – to religion, literature and art. For most naturalists, science was inseparable from religion; it was part of the quest to understand God's Great Plan. Natural history, or natural theology as it was also widely termed, was accordingly recommended for its supposed moral and spiritual lessons. It was also closely linked to literary and artistic traditions of describing and illustrating the natural world.[10] Such literary, artistic and religious dimensions meant that there was a considerable overlap between natural history and respectable 'feminine' activities.

There was certainly a strong masculine culture around natural history, which was linked to hunting, the frontier and other 'manly' pursuits.[11] And women were almost entirely excluded from the proliferating number of 'expert' scientific societies. Yet at the same time, there was a real strength and depth of womanly scientific

culture. Women's participation in popular, amateur science was by no means unimaginable or undesirable.[12] In both North America and Britain, women were significant consumers and producers of scientific culture, reflecting the increasing construction of science as an appropriate pastime for 'ladies'. From the late 1700s elite women were strongly visible in popular scientific societies. In Britain, the Royal Institution, established in 1799, admitted women from the start and they soon formed a large proportion of its subscribers. And although women were initially excluded from the British Association for the Advancement of Science, founded in 1831, this regulation had little effect. Women turned up to its meetings in their hundreds, forcing the rule to be rescinded by 1837.[13] The increasing construction of science as an appropriate feminine interest was particularly evident in formal education. During the first half of the nineteenth century, science was more widely taught in girls' schools in Britain and the United States than it was in those for boys, which were generally dominated by 'classics' (ancient Greek and Roman culture and languages).[14] While few published in the scientific journals of their day, women were prominent as authors of popular scientific texts (and some more serious works). Jane Marcet's highly successful *Conversations on Chemistry*, first published in 1806, went through numerous editions in Britain and the United States.[15] Botany especially was viewed as a field suited to women, and women were also prominent as scientific illustrators and collectors. Significantly, natural history was often a family enterprise, undertaken within the domestic sphere, with wives and daughters sometimes making major contributions – although they rarely received public recognition for their work.[16] All of these elements contributed to shaping Australian women's participation in nineteenth-century science.

'Of Great Use to Science'

Botanical Collecting and Naming

One of the first women to make a major contribution to Australian natural history was Georgiana Molloy, who arrived in Augusta in southwest Western Australia in 1830 with the first wave of British colonists.[17] Her husband, Captain John Molloy, had been attracted by the economic opportunities that the new colony appeared to offer. The flora of the region was largely virgin territory for European naturalists, who were keen to obtain specimens. Consistent with her background as a country gentleman's daughter, Molloy had dabbled in botany while still in England, but in the first years after emigrating her botanising was mainly limited to her garden. This interest alone was enough to mark her out as a potential botanical collector. When British naturalist and Fellow of the Royal Society Captain James Mangles wrote to his cousin Ellen Stirling, wife of the Western Australian Governor, seeking potential collectors, she could suggest only three names, including Georgiana Molloy and another local woman.

When she accepted Mangles's commission in 1836 to send him botanical specimens, Molloy had no notion of cultivating her own scientific status. Instead, she described herself as 'one whose chief pleasure is her garden, but who does not enter the lists as a florist, much less a botanist ... I am not even acquainted with the names of the native plants'. Although bewildered as to what led Mangles to select her, she agreed to assist his 'laudable desire, and curiosity to possess a knowledge of our floral productions'.[18] Molloy was thus drawn into the project of cataloguing the botanical contents of the colony and dispatched many unique specimens.

Despite the lack of recognition it received, botanical collecting was highly skilled and labour-intensive. Molloy described to Mangles the

enormous work involved in preparing her shipments to England: 'Since Saturday last I have been engaged in your service ... working from after breakfast till 12.30 at night ... first I had to fix the specimens, to arrange them to paste on labels ... then write attempts on character, [and] make the bags and cases'. To help cement his position within British botanical circles, Mangles shared Molloy's specimens with several leading British botanists, who praised the value and quality of her work. Sir Joseph Paxton, of Chatsworth Gardens, wrote of the 'splendid things' Molloy collected 'comprising many new species ... far superior to any that we have received'.[19]

While not seeking recognition as a scientist, Molloy derived a deep sense of satisfaction and even identity from her work. She once noted her husband's amusement at 'the unparalleled devotion of all my spare moments to this all engrossing concern'.[20] When Mangles sent her a copy of *A Sketch of the Vegetation of the Swan River Colony* by Professor John Lindley of University College London, which described many of her specimens, she wrote of how this inspired her 'to greater exertion. To think how small an aid I have lent to your cause'.[21] Her letters revealed the pleasure she took in her 'small' discoveries and from doing her part for the progress of science. As she wrote in 1840:

> I discovered a plant I had been almost panting for – a very small, near white blossom on a furze looking bush ... A little further on a further enigma was solved, the beautiful white blossomed tree whose flowers I sent in my last, I found to be the identical tree which bears the wooden pears ... I was quite exhilarated at finding these treasures so unexpectedly.[22]

These activities also became a personal journey of forming an attachment to the landscape around her. When she first arrived, Molloy had been unimpressed by the 'unbounded limits of thickly clothed, dark green forests'. But her later letters were full of admiration for the country. She thanked Mangles 'for being the cause of my immediate acquaintance with the nature and variety of those plants that we have exchanged … From necessary duties, but for your request, I should have bestowed on the flowers of this wilderness only passing admiration'.[23]

This work was not perceived to be outside the bounds of respectability for a woman of Molloy's class and position. She had considerable support, enlisting the services of her children, servants, the military, local Indigenous people and even her husband. As she related to Mangles: 'The soldiers … are now seen to bring from [Augusta] specimens of all sorts of plants under their arms. The native herdsmen are also employed to bring in some desired plant or fruit'. While Molloy accepted her subordinate relationship to British botanists, within her own local circle she was recognised for her expertise. This authority was particularly evident in her relationship with the Indigenous owners of the land the Molloys had taken. Georgiana often relied on their assistance to guide her through the 'unknown' landscape and to locate new plants, a service she took for granted:

> The natives are much better auxiliaries than white people in flower and seed hunting. They ask no important questions, do not give a sneer at what they do not comprehend and, above all, are implicitly obedient; and, from their erratic habits and for penetrating every recess, can obtain more novelties.

She had little interest in Indigenous names for the local flora but was intensely interested in learning the 'proper names' of plants once British botanists had classified them.[24] Like her fellow colonists, Molloy simply assumed her right to the land and participated enthusiastically in claiming its contents. This was an inherently violent process. In 1841 her husband led a massacre of Wardandi Noongar people in reprisal for the spearing and death of their neighbour George Layman.[25]

Georgiana Molloy's contribution to botany ended with her early death in 1843, aged just thirty-seven, after complications during childbirth. Contrary to her own assessment, her work had been critical to the ambitions of British naturalists, and her position at one of the frontiers of colonial expansion meant both her services and her specimens were keenly sought. But despite the significance of her contributions, they were lost from view for over a century and were primarily attributed to James Mangles. While Molloy may have 'discovered' these new plants, it was British scientists who classified and named them. It was not until the 1950s that her importance to Australian botany was rediscovered.[26] It took much longer for the colonial violence she was embedded in to be recognised.

Art, Literature and Scientific Families

If elite women were drawn into botanical collecting through their cultural background, family and social connections to scientific circles, and their proximity to 'unexplored' landscapes, such skills and connections provided an entrance into a range of other scientific pursuits. Since amateur natural history was an activity undertaken largely from within the home, women were frequently drawn into science as part of a family enterprise. Wives and daughters often

'Of Great Use to Science'

provided essential assistance to scientific men, although this was usually unacknowledged.

Fanny Macleay's life, for example, revolved around her family's scientific interests. Her father, Alexander Macleay, Colonial Secretary of NSW from 1826, had been very active in natural history circles in England as a member of the Royal Society and secretary of the Linnean Society from 1798 to 1825. He also maintained extensive private collections of insects and botanical specimens. All the Macleay women dabbled in botany. But Fanny was the most heavily involved with her father's work, becoming his main scientific assistant. She preserved and extended his collections – drawing, recording, and storing specimens, organising exchanges across the globe and gathering specimens herself. She was in constant correspondence with her brother, entomologist William Macleay, on scientific matters. Fanny also devoted herself to scientific illustrating and botanical art and was sometimes the first to document new species.[27]

From the mid-nineteenth century at least, women became especially prominent in scientific illustration, as they were likely to possess the skills that this required since drawing was a typical part of middle- and upper-class girls' education. In the era before photography, hand-drawn illustrations were essential to scientific communication.[28] The sisters Harriet and Helena Scott were given their start as scientific illustrators by their father, collaborating in his work on Australian moths and butterflies. Alexander Scott was a politician, trustee of the Australian Museum, and later president of the Entomological Society of NSW. In 1864 he produced *Australian Lepidoptera* [moths and butterflies] *and Their Transformations Drawn from the Life*, illustrated by his daughters and possibly based mainly on their investigations.[29] When he visited the Scott family in the 1850s, Austrian naturalist Georg Ritter von Frauenfeld observed:

> The scientific entomological studies of both daughters ...
> afforded me great interest ... For a large number of species they
> have determined the Lepidopteran fauna of New South Wales
> completely through all states of metamorphosis ... [which] are
> captured and documented in a series of more than 100 folio
> plates.[30]

Alexander Scott's colleagues at the Australian Museum, particularly Gerard Krefft and William Macleay, also employed his daughters' services, as did many other leading scientific men. Both women were made honorary members of the Entomological Society of NSW in the 1860s, an unusual instance of recognition at this time.

But it was Ellis Rowan who became the most famous, and prolific, of the nineteenth-century botanical artists. Winning numerous medals at exhibitions in Australia, India, England, Europe and the United States from 1877, she exhibited 1,000 paintings in Sydney in 1920. Like other women of her time, she combined scientific, literary and artistic skills, publishing an autobiographical memoir *A Flower-Hunter in Queensland and New Zealand* in 1898. In her extensive travels Rowan uncovered many 'unknown' plants, particularly when she returned to Australia in 1905 with the ambition of finding and recording every species of wildflower on the continent. Her last major expeditions in 1916 and 1917 were to the Australian colony of Papua and newly occupied territory of New Guinea. There, she relied heavily on assistance from 'the natives' at the same time as she described them as 'hostile'.[31]

Nature writing was another field where women were conspicuous.[32] In this, Australian women also followed a tradition well established in Britain and North America. While scholarly publishing was considered

beyond their sphere, popular nature writing allowed women to exhibit scientific interests while not overtly claiming scientific authority.[33] One of the most prominent of these writers was Louisa Meredith. Having published four natural history books in England prior to her marriage and emigration to Australia in 1839, she wrote five more nature books, and several novels, all of which were widely read both in Australia and 'back home'.[34] Meredith was typical in the way she hid behind the identity of an amateur in her intrusion into the scientific realm. Introducing her first Australian book, *Notes and Sketches of New South Wales*, in 1844, she included this lengthy disclaimer:

> I would fain deprecate the censure of severe critics, which the superficial character of the following pages might otherwise call forth ... I cannot for a moment flatter myself with the idea of conveying information to those skilled in scientific detail; my desire was to give true and general descriptions of scenery, people, and the various objects which strike a new-comer as novel or remarkable ... however devoid of scientific lore.[35]

But Meredith's writing was infused with scientific references that contradicted this assertion. Her 'general descriptions' were minutely detailed, and she took every opportunity to exhibit her knowledge of the latest scientific theories, albeit within the respectable format of a mere travelogue. Meredith's description of her voyage to Sydney, for example, noted: 'Many evenings we spent in watching the beautiful phosphoric appearance of the sea after dark, and trying to reconcile the various theories advanced by naturalists respecting it. That it is caused by floating animalcula is the general opinion'. Such references were clearly designed to establish her writing as informed or even

authoritative. The detail and style of her descriptions would not have been out of place in many scientific journals of the time and she was probably attempting to emulate such writing. Her inclusion of detailed illustrations and the effort she went to in ensuring their accuracy also suggests an ambition to add to the state of knowledge about the new colonies. And Meredith was not afraid to contradict the theories of leading scientists based on her own observations. Commenting on her first sighting of flying fish, she noted the scientific arguments 'as to whether they really fly, that is, flutter and turn in the air … Some very eminent naturalists affirm that they can neither turn nor flutter; having seen them do both repeatedly, I am greatly inclined to differ from them in opinion'. Meredith's writing, too, traded on the English desire to 'know' the exotic Australian colonies. Unlike Molloy, this instilled Meredith with confidence in the value of her work:

> Knowing that many persons at 'Home' are deeply interested in these distant Colonies …. [and that] they really understand very little of the general aspect of things here, I believe that a few simple sketches from nature … would be a welcome addition to the present small fund of information.[36]

Meredith soon settled in Tasmania and turned her attention to that colony's flora and fauna. She also wrote extensively about Tasmania's Aboriginal peoples, though this mostly aimed at justifying the violence of white settlers, including her own family. In 1890 she asserted that Aboriginal people were 'the very lowest creatures in human form'.[37]

Her efforts were extremely well received: she won numerous medals at colonial and international exhibitions, and in 1884 the Tasmanian Government granted her an annual pension of £100 for her services to

science, literature and art. Prominent periodicals reviewed her books and brought her into contact with many leading Australian naturalists, including Ferdinand von Mueller and the amateur anthropologist William Howitt, who universally praised her contributions. She was well known in England too. Joseph Hooker, director of the Royal Botanic Gardens, Kew, even corrected the manuscript for her last book, the second volume of *Bush Friends in Tasmania*, in 1890.

Louisa Atkinson's nature writing similarly shows the connections between scientific and literary traditions in this period and the strong support that women could receive in this field. In the 1850s and 1860s Atkinson became a well-known naturalist, writing columns for various newspapers and journals. Residing in several regions of rural NSW in her short life, Atkinson had unusual access to, and familiarity with, 'new' flora that was a continuing source of fascination to the general public and scientists alike. In pursuing these interests, Atkinson also followed a strong family tradition. Her father had written two works on Australian agriculture in the 1820s, while her mother Charlotte's *A Mother's Offering to Her Children* (1841) was the first children's book to be published in Australia. This could also be considered Australia's earliest children's science text, as it included descriptions of nature. Atkinson also wrote several novels, and her first book, *Gertrude, the Emigrant: A Tale of Colonial Life* (1857), was the first published work by an Australian-born woman writer. She began writing for local newspapers in 1853 but reached her widest audience through her column in the *Sydney Morning Herald*, 'A Voice from the Country', in the 1860s.[38]

This writing brought Atkinson into contact with the leading figures of Australian botany. In the mid-1850s, prominent amateur botanist William Woolls wrote to praise her writing and request her assistance in

botanical collecting. Woolls also introduced Atkinson to Ferdinand von Mueller and other prominent amateur scientists like William Macleay and the Rev. William Branwhite Clarke, with whom Atkinson also corresponded regularly. These men strongly supported, and publicly acknowledged, Atkinson's contributions. In a letter to the *Sydney Morning Herald* in 1861, responding to an article by his 'accomplished friend', Woolls concluded by expressing

> on behalf of Dr F. Mueller, as well as myself, the high sense I entertain of the untiring zeal of your correspondent of the Kurrajong, who has already furnished us with three hundred specimens of plants ... [M]ay a generous public afford every encouragement for the development of native genius![39]

On another occasion, Woolls wrote to encourage his 'countrywomen' more generally to take

> a more active interest in the natural sciences generally but Botany particularly ... [which] is particularly fitted, to attract the attention of the fair sex ... who admire the beauties of nature, and tend them with womanly care and anxiety ... [Such] employment is not only agreeable in itself, but of great use to science.[40]

The value of Atkinson's botanising to science is evidenced by the extent to which her specimens were used. They were cited 116 times in George Bentham and Ferdinand von Mueller's *Flora Australiensis*. She not only had several plant species named after her but an entire plant genus.[41] Despite this recognition, Atkinson never attempted to enter the inner circles of science through publishing in professional

journals or joining any of the local scientific societies. Nevertheless, she did claim both knowledge and authority. Her consistent use of scientific plant names and references to scientific publications displayed her command of the field. She was not afraid to interpret evidence or present her own theories and was confident enough to query the work of leading botanists.

Atkinson's writing, too, exhibited the continuing colonising impulse of science. Natural history did not simply endeavour to conquer the landscape by uncovering its secrets and treasures. In settler colonial societies, it represented a quest for national identity, distinct from the mother country. Australian natural history writers often employed a romantic style that sought to foster an attachment to the landscape and native wildlife among their readers. As Atkinson wrote in one of her earliest articles in the *Sydney Morning Herald*:

> It is a pity that so few of our native flowers have popular names
> … Hardly would the English child hail the delicate blossoms
> of the snowdrop so warmly as the harbinger of spring, did he
> recognise it by no name but *Galanthus nivalis* … Yet surely on
> that account we need not turn away from the lovely flowers of
> our land with indifference.[42]

Exceptional Women?

Women like Louisa Atkinson, and her amateur scientific sisters, are generally presented as pioneers, and as highly exceptional. That such women were able to participate in science without any formal training or qualifications might be seen as remarkable. It must be remembered,

Taking to the Field

however, that this was true for most men as well. For most of the nineteenth century, virtually no formal scientific education was available in Australia. What little science was taught in secondary schools was similar for both boys and girls.[43] While universities were founded in Sydney and Melbourne in the early 1850s, enrolments were tiny and only elementary science courses were offered. It was not until the 1880s that science degrees were introduced, and by that time women had been admitted to the universities. Most scientific men, even those who enjoyed expert status, earned their living through some other occupation. William Woolls taught in Sydney private schools, while the Rev. William Branwhite Clarke, commonly referred to as the 'father of Australian geology' and credited with the first discovery of gold in Australia, was an Anglican clergyman. Real scientific authority remained concentrated back in Britain and Europe. In many ways, women's experiences mirrored those of men, both in terms of the nature of their activities and the status they could aspire to.

There were certainly limits to the ways women could participate in scientific culture, and their contributions often remained hidden. Elizabeth Gould, for example, produced many of the drawings for her husband John Gould's highly influential scientific books. But she received little credit for this work, even though these illustrations were pivotal to the success these books enjoyed.[44] Similarly, despite the extent of Fanny Macleay's involvement in her family's scientific activities, only her father and brother are recognised for fostering the development of Australian science. Women were particularly limited by their exclusion from emerging scientific societies. Jane Franklin, wife of the Colonial Governor and explorer John Franklin, attended meetings of the Tasmanian Society of Natural History in the early 1840s, but as a patron rather than a practitioner of science.[45] It was

not until the 1880s that women began to participate more fully in local scientific societies. Without access to such public spaces, most women's scientific activities remained a private pastime.

Georgina King: A Mixed Legacy

It was in this context that Georgina King began her scientific career. Born in 1845 into a family with strong interests in natural history, King's interest in science was fostered from an early age. Her father was a clergyman who dabbled in anthropology while her mother's hobbies included botanical painting and taxidermy. Through various family connections, particularly her father's position on the council of Sydney University's St Paul's College, King met many members of the university and scientific community, some of whom encouraged her interests. Her main mentor was George Bennett, the family physician who was also a keen naturalist. Despite his lack of qualifications, Bennett was one of Sydney's leading scientific figures from the 1840s to the 1880s, publishing over 115 papers in local and international journals.[46] Bennett in turn introduced King to other key figures of Australian science. From the 1860s King engaged in a broad range of amateur scientific pursuits – writing up her scientific observations and theories for Bennett, collecting botanical specimens for Ferdinand von Mueller and undertaking geological fieldwork in Australia and Britain.[47] In 1888 she attended the first meeting of the Australasian Association for the Advancement of Science and held a reception for over fifty of the attending scientists and their wives. By this stage, she was corresponding frequently with scientific men from a range of fields.

King's scientific endeavours in the 1860s–1920s coincided with a period when Australian science was undergoing enormous change.

It was transformed from a largely amateur generalist pursuit into a professional activity informed solely by the ideals of objectivity, rationality and progress.[48] Her experiences are thus particularly revealing. In her early amateur endeavours, King received considerable encouragement and support. Her unpublished autobiography relates that when she was young, her father dubbed her 'his little philosopher' and fostered her intellectual aspirations.[49] She frequently repeated the story of how George Bennett 'said he noticed even when I was very young that I had such high perceptive powers that they amounted to a sixth sense', and how, shortly before he died, Bennett 'held my hand and made me promise to persevere with my scientific investigations'. She maintained that from an early age, she had devoted herself entirely to the cause of science, a decision that was supported by those closest to her:

> [My father] said I was never to marry … [H]e thought there were great possibilities for me, as I had so much originality. Dr Bennett [also] advised me not to marry, as he said I had talent and individuality which would not be developed if I married, so I took natural science as my Liege Lord instead.[50]

A moderate inheritance later allowed her to devote herself fully to scientific pursuits.

Several other leading male scientists were also apparently impressed with her talents and encouraged her endeavours. Both Henry Russell, Government Astronomer of NSW, and Frederick McCoy, professor of natural history at the University of Melbourne, wrote enthusiastically about her work and abilities. In 1888, responding to a paper that King had sent him, Henry Russell noted that her ideas about rainfall were

'Of Great Use to Science'

better than those of many 'distinguished men'.[51] McCoy was even more effusive:

> I do not indeed wonder at other scientific men of N. S. Wales being jealous and envious of the firm and comprehensive grasp you have of so many abstruse subjects in Physics and Geology and the allied sciences, and the clear light you show on anything you touch, for I cannot help sharing a somewhat similar feeling of inferiority.

His numerous letters to King were filled with references to her 'singularly brilliant' work.[52]

It was only when she attempted to enter the emerging ranks of professional science, through publishing articles and engaging in theoretical debates, that she faced rejection and exclusion. King was not content to remain merely a collector of specimens and amanuensis to leaders in the field. As she later wrote, 'I have always had my own ideas of cause and effect.' Nevertheless, she claimed it was only Bennett's insistent urging which propelled her to formally write up her discoveries, rather than simply passing her specimens on for others to interpret.[53] From the late 1880s she began writing geological papers and articles on the physical sciences, particularly relating to magnetism and atomic forces, and occasionally botany. Several of these appeared in the *Sydney Morning Herald*. Later, drawing initially on her father's work, she became interested in anthropology, publishing several articles in the local pseudoscientific journal *Science of Man*. While her work was acceptable in such popular forums, her papers were all rejected by local (and international) scientific journals. Undeterred, she continued her quest for the recognition she felt she deserved, reprinting all of

her work numerous times in at least five self-published pamphlets between 1895 and 1926.[54]

Georgina King's story is not just one of exclusion from the male scientific community, but of outright plagiarism. She alleged that in the late 1880s and early 1890s, two professors at the University of Sydney, chemist Archibald Liversidge and geologist Edgeworth David, along with Edward Pittman, the Government Geologist of NSW, stole her ideas and her evidence. In 1921 she summarised her accusations thus:

> I discovered when I visited home [Britain] in 1881 that our formations were different to those abroad. Before that the Geologists were working on European lines. I [also] discovered that our alluvial mineral wealth was intrusive and found in eruptive rocks ... Professor David and the other Geologists took my discoveries as their own.[55]

She thus claimed to have made two of the most significant discoveries in Australian geology.

The veracity of her allegations is difficult to determine, in part because none of her early scientific writing has survived. In 1890 she certainly sent several papers to Edgeworth David, who responded that he had 'particularly studied [her] essay on the origins of precious stones, and there is much in it which I should like to discuss'.[56] In 1892 a paper she submitted to the Royal Society of NSW was reviewed by Edward Pittman and rejected on the basis that its contents were 'not new'. King's paper argued that the current geological classification of large areas of NSW were incorrect. Pittman claimed this was already recognised, although it had not been widely published.[57] This reply

does not provide an entirely convincing rebuttal of her accusations. On sending a second paper to the Royal Society in 1894, after finding what she believed to be definitive proof of her theories, King received even less cordial treatment. Professor Liversidge apparently sent this curt reply: 'I have read your paper and examined your specimens. It is hardly suitable for the Royal Society ... I am sorry I cannot do anything for you.'[58]

King's work was clearly read by those she accused of the theft of her ideas. And her claims were strongly supported by her mentors. After Bennett's death in 1893, Professor McCoy became her staunchest ally, in part because King's theories supported his own controversial views about geological age of Australia's coal deposits. When she sent him one of Edgeworth David's papers in 1896, McCoy replied:

> I <u>was</u> amused at the cool extract you sent me and your old discoveries clearly elaborated by yourself will apparently make more Sydney Scientific reputations ... A graceful acknowledgment of the source of their knowledge would not hurt them if they had the sense to see it.[59]

The *Sydney Morning Herald*'s review of the 1906 reprint of her pamphlet *The Mineral Wealth of New South Wales* also supported her accusations:

> Miss Georgina King is well advised in re-publishing her instructive pamphlet ... [presenting] a theory of geology ... which has since been adopted by its former opponents ... She would naturally be glad to find what she first proclaimed to be the truth accepted generally, but, equally naturally, she expected that whatever credit was her due should be paid to her.[60]

Although some of her observations seem to have been correct and may have been stolen, her broader theory of the eruptive origins of NSW's mineral resources was disproved by the early 1900s (although this was not the case when King first put forward her ideas). Her articles may also have been deemed deficient on other grounds. Her first publication in the *Sydney Morning Herald*, which McCoy edited, conformed to the new, professional, conventions of scientific writing. But many of King's other papers were written in a whimsical style, with little attention to logical progression and drawing on a wide range of evidence from a variety of fields. Indeed, like many before and after her, King believed she had discerned a universal pattern in nature, and she emphasised that her discoveries were 'all dove-tailed'.[61] She even claimed that Einstein had stolen her ideas about relativity.

King continued her unsuccessful quest for recognition through newspaper articles, her self-published pamphlets and a letter-writing campaign that grew increasingly frenzied. Throughout the 1910s and 1920s she particularly canvassed members of the Royal Society and the University of Sydney for support. In 1914 she wrote several letters to Edward Pittman himself attempting to persuade him to admit the 'truth'.[62] The response she received from the Royal Society in 1917 reveals the closing of the scientific ranks against her:

> You appear to be annoyed that the Royal Society did not publish some of your papers but ... the Royal Society does not undertake to publish all papers submitted to it. The Society consists of a body of men who subscribe towards publishing a Journal embodying the work of the members of the Society. It does not exist for publishing the work of outside writers.[63]

The new experts, now organised into 'a body of men', could by this stage simply exclude amateur enthusiasts.

Georgina King could easily be portrayed as one of the overlooked 'great women' of the past, a pioneering feminist heroine who struggled to achieve within the male domain of science. But presenting her in this light is questionable, not least because the major theories upon which she sought to establish her scientific reputation were all later disproved. While King's experiences illustrate the ease with which women's contributions *could* be appropriated, her claims were clearly exaggerated. And King's amateur status was as problematic as her gender. In the range of her interests, the nature of her activities, and her lack of a paid scientific position, King was an exemplary nineteenth-century amateur naturalist. But she began her attempts to publish her work at precisely the time when amateur contributions were becoming unwelcome. The growing numbers of men with formal scientific training in paid professional positions were seeking to enhance the status of their field – in part by excluding interested amateurs. King was once apparently told 'if I attended some of the [university] classes of the Professors, my discoveries would come out as their pupil. Otherwise they would not be received (as I had no elementary knowledge Professor Liversidge said)'.[64]

King's story equally illustrates the cultural support that existed for some women to engage in certain kinds of scientific pursuits. She enjoyed the strong backing of some of the key figures in Australian science. Writing in 1892 about one of her papers, Henry Russell encouraged King to join the recently formed Australasian Association for the Advancement of Science, of which he was president (and which unlike the Royal Society welcomed the general public): 'Many of the papers to be read would be of great interest to you. We have already

several lady members and expect many more ... At Manchester last year they had 500 lady members who seemed to take the greatest interest'.[65] McCoy similarly expressed delight at King's 'incomparable contributions' and urged her to continue seeking recognition through publication (although King took his advice that she should initially publish anonymously).[66] He also helped King to edit her papers. In this process, he alluded to the significance of gender in how she was treated:

> I enclose the first page which you have excellently added to the state of our knowledge ... [I]t's now perfect ... and show[s] like Mrs [Mary] Sommerville the wonder of science in the popular charming literary style which none of the scientific men can on such difficult subject matter.

He had earlier expressed his appreciation of King's 'kind offer' permitting him to

> appropriate and mark up as my own any portions of your essay that I might desire, but I have never thought of soaring to fame on others' pinions ... and hope that local scientific men of your colony will take it as an example of what ladies can do when they give their minds to such matters.[67]

A White Woman's Vision: Daisy Bates and Colonial Anthropology

Perhaps in response to her rejection from geology, King's scientific interests turned towards anthropology, and it was here that she achieved

the greatest validation and recognition. In 1900 she presented a paper on 'The Aborigines of Australia and Tasmania' to the Australasian Association for the Advancement of Science meeting in Melbourne. Although omitted from the published conference proceedings, the paper eventually appeared in the pseudoscientific journal *Science of Man* in 1903. It was based largely on her father's work, who King claimed was the first to discover 'the great antiquity of our Aborigines ... and that they were a lower type in the scale of humanity'.[68] The article promoted the prevailing belief – recurrent in other editions of *Science of Man* – that 'primitive' races represented a lower phase of human evolution.[69]

King published several further articles in this journal and became an active member and elected Fellow of the Royal Anthropological Society of Australia, which published it. While few members had scientific qualifications, this Australian anthropological society claimed support from many leading political figures and businessmen. Its president, Alan Carroll, boasted a string of degrees including an MD and a DSc and worked hard to establish its scientific credentials.[70] The society had a broad agenda, aspiring to collect the languages, weapons, tools, mythologies, customs and 'crania' of Australia's Indigenous peoples – although it had limited capacity to fulfil this ambitious program. It also encompassed what would now be seen as distinct fields – particularly psychology and sociology – and strongly promoted eugenics (the racist 'science' of creating human perfection through selective breeding). *Science of Man* continuously proclaimed the society's grandiose, patriotic ambitions, seeking nothing less than to 'lead to the production of Australians of the highest types, to advance the confederated Australian nation and its interests among all the peoples of the earth'. Anthropology was seen as central to these ambitions since the study of 'primitive races' could teach 'what to do, and what to

avoid' and reveal factors conducive to 'the greatest advancements, the highest developments ... so as to prevent the race from degenerating'.[71]

Women's assistance in this cause was eagerly invited. When the society began to hold monthly meetings in 1902 it was stressed that 'ladies' would be admitted. The 'ladies of Sydney' were encouraged 'to take up this movement earnestly, as they can if they will'. King's scientific work was singled out for special mention on several occasions, as were her indefatigable efforts in support of the society. Women like King, with money and social connections, were more than acceptable allies, and women's involvement in it shows their popular and welcome engagement with science.[72]

Anthropology, which was still in the process of disciplinary formation in the late nineteenth century, was overwhelmingly male dominated. But King was not the only woman who sought to contribute to the field.[73] Many women naturalists before her had recorded observations of Australia's Indigenous peoples. Both Louisa Meredith and Louisa Atkinson had described Indigenous peoples in great but disdainful detail in their work, representing them as objects for scientific observation and Christian control. Meredith particularly commended them to the attention of 'zealous Missionaries' who might 'raise the moral and social condition of these wretched creatures'.[74]

By the late nineteenth century a few women began to make more overtly scientific observations. In the 1890s Katie Langloh Parker published two volumes of the 'myths' of the Yuwaalaraay people, the Indigenous owners of the land in northern NSW on which Parker's husband ran a large cattle station.[75] The Oxford scholar Andrew Lang wrote introductions for both works, presenting them as valuable contributions. Parker received enthusiastic reviews in the *Sydney Morning Herald* and in *Science of Man*, which noted: 'To anthropologists ... they

represent far more interesting characteristics than mere amusement or fairy tales … we hope it will not be long before Mrs Parker again favours her readers with some more of her collections, in which there is so much to instruct about the aborigines'.[76] Lang's introduction to her next book, *The Euahlayi Tribe*, which she consciously presented as more strictly scientific, was laudatory. He particularly mentioned the knowledge women might contribute to the field: 'It is hardly possible for a scientific male observer to be intimately familiar with the women and children of a savage tribe … Mrs Parker's new volume, I hope, will prove that she is a close scientific observer, who must be reckoned with by students'.[77] Parker described her scientific methods in great detail, and, at several points, directly contradicted leading male anthropologists such as Herbert Spencer. But despite this strong bid for recognition, her efforts were soon to be written off as mere popular ethnography by professional anthropologists.[78]

Parker's work, too, depended on the position of authority enjoyed by white women on colonial frontiers. She viewed Indigenous people as legitimate objects for her investigations and determined to do her 'mental digging in their minds'. She 'adopted' several local girls, deciding that they 'should be one of my experiments'. In reality, they became her servants, as depicted in her educative regime: 'To wait at table in summer I dressed them in little white frocks with red sashes and gave each a palm leaf fan with which to fan us on the gaspingly still nights as we sat at dinner.'[79]

But it was undoubtedly the infamous author (and bigamist) Daisy Bates who achieved the greatest prominence as an Australian woman anthropologist. Despite her lack of academic qualifications, Bates gained considerable popular recognition due to her prolific journalism and was widely viewed as the leading authority on Aboriginal people in

the early decades of the twentieth century.[80] For nearly ten years, from 1904, Bates was employed by the Western Australian Government to collect information about the Indigenous population and was also appointed an Honorary Protector of the Aborigines. Interest and enthusiasm were seemingly sufficient qualifications to gain her this initial foothold in the field. Her appointment, when she was well into her forties, was a highly unlikely development, as was her later, extremely unusual, career.[81]

Born in Ireland in 1859, Bates was orphaned young and immigrated to Australia in 1883 to work as a governess. She soon married the man who would later become known as 'Breaker' Morant of Boer War fame, but quickly separated from him and in 1885 (bigamously) married first Jack Bates, a drover, and then Ernest Beaglehole. She returned to Jack, and her only child was born in 1886. In 1894 Bates travelled alone to London. She remained there until 1899, somehow obtaining work as an assistant to W. T. Stead, editor of the influential monthly journal *Review of Reviews*, and misleadingly styling herself as a journalist. To cover up her colourful past, she also fabricated a more respectable personal history for public consumption, which remained unquestioned in her lifetime.

She returned to Western Australia in 1899 purportedly with a commission from the *Times* to write about the treatment of Aboriginal people there. Although she had not previously exhibited any interest in this topic, she took to this assignment with great zeal, travelling extensively to gather information. In 1903 she again left her family to devote herself to this work and the following year obtained her appointment with the Western Australian Government. She camped alongside various Indigenous communities as a part of this work, although she always emerged from her tent in the full Victorian costume

she wore throughout her life. She claimed that one community there named her 'Kabbarli' (grandmother). She subsequently wrote up her investigations, assuming they would be published, but instead found herself dismissed from service with the government claiming it could not afford to publish her manuscript.[82] In 1910 she joined an anthropological expedition from Cambridge, led by A. R. Radcliffe-Brown – one of the founding fingers of modern anthropology. She then spent time in various camps along the transcontinental railway before moving to Ooldea, an Aboriginal community in western South Australia, in 1918 where she spent much of the rest of her life, until her death in 1951.

Throughout this time Bates published hundreds of newspaper and magazine articles, as well as contributions to *Science of Man* and a few scientific papers. In 1938, she published her only book, *The Passing of the Aborigines* (written with considerable assistance from the journalist and writer Ernestine Hill), which became an international best seller. She also continuously lobbied various government officials and others to have herself officially appointed as a Protector of the Aborigines and received considerable support from women's groups interested this cause.[83]

It would be easy to write Bates off as a mere eccentric, were it not for the influence she exerted over attitudes towards Australia's Indigenous peoples. Bates is credited with creating widespread acceptance of the 'dying race theory', a major underpinning of Australian racial policy.[84] She also circulated false claims that cannibalism and infanticide were frequent among Aboriginal people and advocated total racial segregation based on her extreme abhorrence of 'miscegenation' and the belief that 'half-caste' children were irredeemably 'degenerate'. As she wrote in Perth's *Sunday Times* in 1921, 'with very few exceptions, the only good half-caste is a dead one'.[85]

Bates consistently represented herself as engaging in a selfless mission to 'smooth the dying pillow' for Aboriginal people. As she outlined in an article in the *Australian Women's Weekly* in January 1934, after repeating her descriptions of cannibalism and infanticide, her work entailed endless hours 'of service, of patience and above all of cheerfulness under all conditions to these irresponsible children of the Stone Age'.[86] She was awarded a CBE in 1934 for this work. She was, however, never again formally employed in anthropology or as a Protector of Aborigines, the post she most desired, and was never recognised within scientific circles proper. Her work was largely ignored, or openly denigrated, by the emerging ranks of professional anthropologists.

Daisy Bates also became Georgina King's firm friend. They were drawn together by their shared anthropological interests and their quests for official and scientific recognition. Both were Fellows of the Anthropological Society and Bates also published in *Science of Man*. They became frequent correspondents from 1913 and strongly supported each other's endeavours.[87] Bates wrote lengthy letters to King about her desire to be appointed a Protector of Aborigines, since 'the natives should have a woman to go amongst them to tend them when they are ill, and to look after the women and children'. This would also allow her to conduct 'a systematic scientific collection of aboriginal weapons and implements ... all for the benefit of future Australians and for Science'.[88] King responded by supporting Bates financially and writing numerous letters to government officials, politicians and others emphasising Bates's qualifications to undertake the protection of the 'poor children of the bush', since 'Mrs Bates, by knowledge of dialects and influence with the Aborigines, is the most efficient and suitable person to undertake their protection ... she alone can render them

'Of Great Use to Science'

useful … as she has so much influence over them'.[89] Bates reciprocated by seeking to have King's scientific contributions acknowledged by the University of Sydney. Writing to Professor Mungo MacCallum in 1926, Bates asserted:

> She is, like myself, unscientific, but even if your higher authorities pronounce her work valueless through unscientific training – you all know her as one of the finest women in all Australia … Will you give her the crowning joy of her life by recognising her work in the conferring of a degree upon her … some University recognition of her work.[90]

Bates hid her efforts to claim authority as a significant scientist under the acceptable guise of feminine duty and selfless devotion to a worthy a cause. Much the same could be said of King, who often stressed that she had worked only 'for the benefit of my country'. The preface to the third edition of her scientific writing dwelt at great length on her selfless dedication: 'If the geologists had at first acknowledged my smallest investigations, I would have let them have all my discoveries, for I just worked from a love of science … [and Dr Bennett] said I had a mission to my country.'[91] Yet King also asserted the significance of her work, claiming she had 'revolutionised ideas in science' and that her discovery of the source of Australia's mineral wealth 'was the most important discovery next to the discovery of gold'. On another occasion, revealing the extent of her egotism and self-delusion, she claimed, 'People have told me I should have got the Nobel Prize'.[92] King's letters and pamphlets reveal her as an unabashed self-promoter, constantly drawing on the names and words of eminent scientific men to enhance her own standing.[93]

King's scientific interests, and the way she represented her endeavours, illustrate the close ties between science and colonialism. Geological investigations like King's work on the origins of Australia's mineral wealth ranked high among colonial priorities because of their potential to uncover economically valuable resources. Anthropology and related areas of racial science were much more direct in their legitimisation of white colonial supremacy.[94] Colonial ideas about race were also central to another area of King's interest – the new women's movement. King was a member of the Women's Literary Society and close friend of leading Sydney feminist Rose Scott. The scientific frameworks of anthropology, Social Darwinism, eugenics, and other concepts of racial difference and hierarchy underpinned feminism in this period.[95] The intertwined nature of these interests is evident in King's most fascinating foray into anthropology and evolutionary theory. One of her earliest articles in *Science of Man* argued, contrary to most evolutionary theory, that modern humans had developed through the female line. That is, women evolved, and became human, *first*. Drawing on anatomical differences between the sexes, King proposed that women were more suited to walking upright and thus, 'It was woman who appeared as a "sport" [mutation] in Nature, with an upright carriage, and became the ancestor of mankind.'[96] She further claimed that since the muscles of the tongue were more developed in women, they probably learned to speak first. Once again, she believed she had made a major intervention – discovering the 'missing link' between man and ape in the evolutionary tree. She had created an ancient world in which women walked upright and could communicate, while men remained dumb and walked with stooped shoulders and bent knees.

Her account directly challenged the prevailing assumption that women were inferior because they were less evolved and that male

attributes and activities were the driving forces of evolution. In support of her theory, King cited 'a drawing of a group of Western Australian aborigines made in 1842 by the writer's mother, [which shows] that the primitive aborigines there had quite a perceptible bend in the knee'.[97] Her argument was thus grounded in the belief that modern white women were far more advanced than this 'primitive' race. This article also gave King some of the recognition she so craved. It was reprinted three times in *Science of Man*, which also published numerous positive responses to her propositions, particularly in 1910 from Dr William Sharpe of Ireland, who praised King's 'very convincing arguments which can hardly be set aside or refuted'.[98]

In a rare explicit reference to the significance of gender in her life, King declared, 'I was one of the pioneer women, who had a very hard time, but I am making things easier for women coming after me.'[99] Generally, though, King claimed recognition only for herself, not womankind. Asserting this pioneering status could have been just another means of establishing her own significance. She could equally be viewed as a privileged white woman who used her status in less than laudable ways, seeking fame partly through the promotion of racist theories.

Conclusion

When Amalie Dietrich, the only woman to work as a full-time, paid collector in nineteenth-century Australia, wrote home to Germany about her experiences, she described feeling as though she'd been given 'the whole great continent as a present'.[100] The women who engaged in such activities rarely questioned their right to accept this 'gift'. Rather, they enthusiastically contributed to the enterprise of

colonial science. In Dietrich's case, while the vast majority of her collecting was botanical and zoological, she also 'collected' a number of Aboriginal skeletons – and was later accused of having paid local settlers to murder Aboriginal people in order to obtain these. There is no evidence to support this claim, but she was certainly connected to grave-robbing and the desecration of human remains.[101]

Nineteenth-century scientific culture encompassed far more than the activities of the tiny groups of 'experts' in Britain and Europe. Across much of the Western world, women were an accepted part of nineteenth-century amateur science, though they were certainly excluded from positions of real authority or status. This was especially true in Australia. In the absence of large numbers of qualified or interested men, and little provision of higher education, women's participation was more encouraged and valued. The status enjoyed by elite women on the colonial frontier, and their proximity to 'unexplored' landscapes, were fundamental to their ability to participate in nineteenth-century science. Such women, who were likely to possess some scientific knowledge and to have social connections to scientific circles, were far more able to engage in such pursuits than most of their contemporaries, male or female. Women's participation was thus supported, even as it was simultaneously limited. As collectors and illustrators, writers, popularisers and consumers, women were integral to amateur, colonial scientific culture. And as the turn of the twentieth century approached, they would soon create a significant space for themselves in the emerging world of academic science.

Chapter 2

'Pioneers'

Studying Science, 1880–1920

On 16 December 1885, Edith Emily Dornwell became Australia's first woman science graduate and the first woman to graduate from the University of Adelaide. The university chancellor delivered the customary speech at her graduation ceremony, much of which he directed to Dornwell personally:

> Will you allow me to say that we are all proud of you? You are the first bachelor of science; you are the first woman graduate in the University of Adelaide. No graduate of this University has ever taken a more distinguished degree … In your distinguished undergraduate career, and the manner in which you have taken this degree, you have not only done honour to this University but have vindicated the right of your sex to compete on equal terms with other graduates for the honors and distinctions of the University.[1]

Dornwell's graduation was proudly presented as evidence that the university was a modern and progressive institution. There was no suggestion that science was in any way an unsuitable field for women.

In the 1880s the essential prerequisites for Australian women's participation in modern science were established: women's admission to the universities and the creation of science degrees. Science was a very new addition to universities throughout the world at this time, and 1885 was the very first year that science degrees were awarded in Australia. Dornwell was among the first three science graduates. Women were present in Australian university science courses from their very beginnings.[2] She was not alone. Although it is usually assumed that, historically, higher scientific studies were an entirely male affair, at many Australian universities women flocked to these new science courses. Leonora Jessie Little became the University of Melbourne's first woman science graduate in 1893. From this point, while most women studied arts, they represented nearly a third of Melbourne's science graduates up to 1920, the highest proportion of women in any course of study.[3] Women were similarly well represented at the universities of Queensland (established in 1909) and Western Australia (established in 1911).[4] They were even more prominent at the University of Sydney. Fanny Hunt was the first to graduate, in 1888, and up to 1920, women made up a remarkable 40 per cent of all science graduates.[5]

Georgina King may have been correct in her assessment that she was 'making things easier for women coming after me'.[6] As science moved into the academy, the amateurs of the nineteenth century were increasingly excluded. Internationally, this shift also saw an even greater exclusion of women.[7] In Australia, although they were marginalised in significant ways, the next generation of middle-class women moved

quickly into the new science. Women's entry into science was made possible by changes in the Australian scientific community as well as broader shifts that expanded the horizons for white, middle-class women in education and professional employment – encapsulated in the 'new woman' of the era. Ironically though, while they achieved greater standing than the 'amateurs' who preceded them, few left behind any substantial personal papers, making them difficult to know. We thus have only fleeting impressions of them. But even these fragments reveal the strong sense of freedom and future possibilities these 'pioneers' saw for themselves, and for women in science more broadly.

Women, Modernity and the New Science

In the late nineteenth and early twentieth centuries, across the Western world, the practice of science underwent enormous change. It was transformed from a largely amateur activity into a professional occupation. The status of 'scientist' became limited to those with university qualifications who actively engaged in research – and scientific research in turn became more exclusively located within the laboratory, rather than in the field or the home. In Australia, this modernisation began in the 1880s with the introduction of science degrees into the three (very small) universities in Sydney, Melbourne and Adelaide. The introduction of science into the university system meant expanding the science staff – initially men recruited almost exclusively from Britain – and building laboratories where practical classes could be taught. These new science professors sought to establish schools animated by 'the atmosphere of research', as Melbourne's professor of chemistry, Orme Masson, put it in 1887.[8] For staff and students alike, the major benefit of these reforms was new opportunities

for undertaking modern scientific research within the newly equipped university laboratories.[9]

The colonial press reported widely and approvingly on the development of science. The Adelaide *Advertiser*, for example, noted with 'great satisfaction' in 1885 that

> the study of natural history is rapidly gaining in popularity in this colony. It is not many years since naturalists who really made a study of any particular branch of the science could be almost counted on fingers and toes ... We [now] have naturalists ... by the score ... [and this leads] us to hope for a bright future for the colony in respect to scientific research.[10]

The *Sydney Morning Herald* praised the efforts of Archibald Liversidge, Sydney's professor of geology and mineralogy, to promote 'real' research through raising the standards of local scientific societies. In a review of the *Proceedings* of the Royal Society of NSW in 1882, the paper asserted: 'Everyone must see from this volume how rapidly Professor Liversidge is succeeding in raising the Royal Society to what a scientific institution of its character should be.'[11] The formation of the Australasian Association for the Advancement of Science (AAAS) in 1888, again largely the result of Liversidge's efforts, confirmed the growth and popularity of science. Its inaugural meeting in 1888 attracted 850 people, and throughout the 1890s and early 1900s AAAS congresses were consistently well attended.[12] While most members of these societies continued to be enthusiasts, rather than paid professionals, they were led and inspired by the new science professors and their students.

University expansion into this area was seen as especially important for developing the natural resources of the colonies: science was central

to the continuing colonial project of 'discovery', (dis)possession and extraction. As the *Melbourne University Review* put it in 1885: 'The certain prospect of golden finds in science ought to induce many to enter in and possess the land which is free to us all.' In 1887 it reported that there would soon be 'a trained class, constantly emanating from our Universities, well fitted to investigate the products of their native land'. Science also brought new hope for social progress in the 'general feeling, which is taking possession of the enlightened public mind, that Science has its mission, and that it will yet solve many of our social problems, sweeten existence, and create new sources of wealth'.[13] By 1888 the *Review* was full of optimism for the future of Australian science: 'Until comparatively lately Science has been the Cinderella among the University courses, but things are now greatly changed.'[14]

Women were admitted to all three Australian universities (Sydney, Melbourne and Adelaide) virtually simultaneously between 1880 and 1881, and they were part of the founding of the tiny University of Tasmania, without any debate, in 1890. Unlike Britain, where a vigorous movement had campaigned for women's admission into universities, in Australia these reforms were achieved largely without such activism.[15] There are a few reasons for this. Australian women did not have to fight against the weight of centuries of tradition, something that was a critical obstacle in institutions like Oxford and Cambridge. There was also the positive influence of the precedents being set in newer universities in Britain and other colonies such as New Zealand. As the chancellor of the University of Sydney indicated in his motion supporting the admission of women in 1881, 'The tendency of modern opinions on this question and the example set by other Universities both at home and in some British Colonies, appear to render it almost imperative that we should open our own University to women equally with men.'[16]

In 1883 Bella Guerin became Australia's first woman graduate, gaining her Bachelor of Arts from the University of Melbourne. According to newspaper reports, at her graduation ceremony the vice-chancellor 'congratulated her ... and expressed his great gratification at being privileged to admit the first lady as Bachelor of Arts'. There was apparently 'prolonged applause' from those present.[17] Guerin made good use of her degree and in many ways embodied the modern, 'new woman' of her time. After graduating, she taught at Loreto Convent in Ballarat and was also 'lady principal' of the Ballarat School of Mines (where she was in charge of university matriculation classes) until her marriage in 1891. A committed suffragist, Guerin returned to teaching after her husband's death a few years later and became increasingly involved in public activism. In this phase of her life, Guerin manifested the worst fears of opponents of women's education as an independent working woman, suffragist, socialist and anti-war propagandist.[18]

Women's higher education was not universally supported at this time. Beliefs in women's intellectual inferiority, and especially their domestic destinies, persisted and constricted women's horizons well after formal educational barriers were overcome. Pronatalist policies and fears created in the light of the declining birth rate among white women in the early twentieth century produced some extremely negative assessments of the impact of education on Australian women. These came most notably from the medical community – and it is no coincidence that the greatest hostility to women's higher education in Australia emerged around their entry into medical degrees, which was blocked for some years after their admission to all other degrees.[19] Doctors like Melbourne's Walter Balls-Headley believed that higher education damaged women's capacity to reproduce. James Barrett, physician and later vice-chancellor of the University of Melbourne,

argued that women's education should focus on domestic topics and that academic subjects distracted them from their primary purpose and duty to the nation to produce children.[20] At the 1914 meeting of the British Association for the Advancement of Science in Melbourne, the vice-president commented: 'Most serious and irreparable damage is being done to women by forcing them to undertake the same studies and pass the same examinations as men ... [Some day] a rational section of women will found a women's university where women can be taught in ways suitable to themselves.'[21] But given that formal barriers to women's education were overcome, it is equally clear that there was broad support for women in higher education, at least among Australia's elite and educated middle-classes. This was, after all, the era of the suffrage movement and the 'new woman': women were riding bicycles, going out unchaperoned in public, travelling the world, and, from 1902, (white) women became voting citizens.[22]

The late nineteenth and early twentieth centuries also saw a growing faith in modernity and progress, particularly scientific progress. In many ways, modernity was synonymous with science. Increasingly, all areas of human activity came to be seen in scientific terms. As an 1880s article on 'Scientific Dresscutting' put it, 'everything in our time seems capable of being reduced to a science'.[23] The rise of science extended into other 'feminine' fields as well. Reformist organisations that wanted scientific knowledge and rationality applied to all areas of social and private life mushroomed.[24] Women were prominent reformers, and the ever-expanding women's movement increasingly used scientific arguments to support its claims for women's rights.

This was also a time of great expansion in professions open to middle-class women.[25] As budding journalist Florence Walsh wrote in the *Sydney Quarterly Magazine* in 1890:

> Formerly teaching was almost the only profession in which women's energies found an outlet, now clerical positions and professional callings are open to them. With what amazement would our ancestors ... of 1800 view what is going on in the present day, could they see 'our daughters' wearing collegiate caps and gowns, taking University degrees, working in telegraph and telephone offices, acting as law copyists, shorthand clerks and typewriters, house decorators, journalists, doctors, etc.[26]

In 1898 Agnes Milne, a South Australian factory inspector, attributed this enlargement of women's work directly to the rising scientific age: 'To passionless science must be credited the vastly extended area of the field of female employment which, during the latter half of the expiring century, has profoundly changed her character.'[27] As Milne suggested, cultural assumptions about women's place and capacities were in a state of enormous flux.

Women's increasing status and widening spheres of activity were often represented as an inevitable and positive consequence of the progress of Western civilisation. The concept of modernity implied that change and progress were inevitable, and this included changing gender roles and relations as well.[28] There were many positive discussions of the possibilities of female modernity beyond the domestic sphere. And women's status became an important barometer of the level of civilisation, or advancement, of a given society – but always in ways that reflected beliefs about the cultural and racial superiority of the West. Annie Golding, president of the Women's Progressive Association, based her address to the 1910 Australasian Catholic Congress on this concept:

> The industrial, social and moral development of a nation may be judged by the position of its women. In all decadent nations women are in a state of bondage or intellectual atrophy; regarded as slave or puppet. Maahommedan [*sic*] nations furnish a striking example. In British-speaking countries the progress of women in industrial and social avenues has been rapid during the past fifty years. This advancement is the logical corollary of the spread of education and its enlightening, humanising influence.[29]

The emancipated Western woman (with all the racial assumptions this figure carried) was often presented as *the* symbol of modernity – a positive product of the modern era. While modernity could be represented as strongly masculine – associated with rationality, linear progress, technology and the domination of nature – there were also deep connections between femininity and modernity, exemplified by the 'new woman'.[30]

The woman graduate was often invoked as a central example of the 'new woman' of this period.[31] When women were admitted to the University of Melbourne in 1880, a lengthy editorial in the *Age* reflected on the positive impact this would have and that now 'girls, like boys, are to be educated for use in the world, and not merely for show'.[32] Bella Guerin herself, writing on 'Modern Woman' in the *Sydney Quarterly Magazine* in 1887, declared that 'the peculiar feature of woman's advancement in our own day is her desire for intellectual advancement ... Tennyson's ideal of the "fair girl graduate with golden hair" is the ideal modern woman'. And to be modern was to be scientific, even for women. Guerin wrote of the expanding intellectual horizons of the modern woman 'not alone of the ideal and imaginative, but also

of the scientific and speculative faculty ... Classics, natural sciences, medicine, even law and the prophets, are the objects of her determined and successful efforts'.[33] For those women who had the option of attending university, science may not have seemed such a daring choice.

Australian women were also expanding their horizons by travelling overseas in increasing numbers, with many making trips back 'home' to Britain. In 1901 there were around 12,000 Australian-born women living in England and Wales. Some found greater freedom in the metropole and they could take this step without being 'condemned' for 'transgressive' behaviour.[34] If they had sufficient resources, some travelled for culture and pleasure alone. Many more travelled for work and education. A few studied at the elite Cambridge women's colleges Girton and Newnham,[35] and a greater number studied elsewhere. Although no Australian women completed science degrees overseas until the 1920s, several went abroad to study at dedicated women's medical colleges. Australia's first woman doctor, Constance Stone, went to America, completed her degree at the Women's Medical College of Pennsylvania in 1887 and graduated MD, ChM with first-class honours from Trinity College, Toronto, the follow year. She then travelled to London where she worked at the New Hospital for Women before returning to Australia to set up her own practice. Dagmar Berne began her medical studies at the University of Sydney, as Australia's first woman medical student, in 1886. However, the hostility she experienced caused her to leave and enrol in the London School of Medicine for Women – where Lilian Cooper also completed her medical degree in 1890.[36]

By 1890, women's presence in Australian universities was already becoming 'normalised'. As a Melbourne student explained in an article on 'Life Among the Women Students. By one of them': 'All sorts and

conditions of girls frequent the hallowed precincts of the University; all schools are open to them, and all but engineering have been entered by the ubiquitous woman-student.' Describing the great variety of the women – from the sporty to the musical, serious to frivolous – the anonymous writer introduced readers to 'the intellectual ladies who wear glasses and study the philosophies, the ladies whose delight is in dissected frogs, the cultured ladies who do classics … the would-be literary lady … the mathematical damsels, whose ponderous tomes are only equalled in mass by those of the medicos'. Only when it came to medicine were the forces of 'prejudice and conservatism' at work, and these women were presented as the true 'pioneers':

> Of the medicoes, the pioneers, what shall we say? Fighting bravely against the obvious difficulties of their position, and so paving the way, or, rather, clearing the path, for future generations of medical women – all honour to them, all sympathy with them in the disagreeables of their work, all encouragement to them to persevere.[37]

Most importantly, the introduction of science degrees and the admission of women to the universities occurred virtually simultaneously, which helped to place women at the frontier of the new scientific age. The coincidence of these events meant women's higher education and science were frequently presented together, as twin evidence of the progressive modernity of Australia's universities. Women's admission to these institutions was sometimes presented entirely in terms of their access to new *scientific* thinking. As the 1880 *Age* editorial on women's admission to the University of Melbourne suggested, 'With so much deadweight of barbarism and obstruction to sweep away, we

cannot afford to leave half the population on the learning that was thought respectable in the days before science.'[38] In 1884, the Adelaide *Advertiser* noted with pleasure that a 'lady' had won the Sir Thomas Elder's prize for physiology and similarly observed:

> It is not such a very long time ago since a famous French philosopher said that the modesty of her sex would shrink from science as instinctively as it would from contact with vice. Unfortunately that absurd opinion held sway in the counsels of female education a great deal too long.[39]

In a way, women scientists delineated the boundary between new and old, and represented the victory of progressive science over outmoded 'barbarism' – including the assumptions of Western superiority that were at the foundation of these beliefs.

The First Women Science Graduates

In 1885 the South Australian Minister for Education, reflecting on Edith Dornwell's recent graduation, proclaimed that 'the barrier which had hitherto opposed the higher education of women had been completely broken down'.[40] From a modest family background, Dornwell had been fortunate to be able to take full advantage of the new educational opportunities created for girls in the South Australian colony. In 1879 she received one of six bursaries to attend Adelaide's Advanced School for Girls – the first state secondary school in South Australia that had opened just that year. While her choice to go on to study the new science degree, rather than the more established Bachelor of Arts, may seem unusual, it is possible that Dornwell had

not studied Latin and Greek – which were required for entry in the arts degree at the time. But she was also directly encouraged by Professor Edward Stirling, who taught physiology at the Advanced School as well as at the university. And Stirling made sure that Dornwell was aware of the historic nature of her choice. As Dornwell later wrote: 'Dr Stirling said that if I were successful, and he was convinced that I would be, I would gain the distinction of being the first woman graduate of the Adelaide University, and the first woman to graduate in science in Australia.'[41]

Four years later, an article on 'Women and the Australian Universities' by the educational reformer Rev. Joseph Kirby quoted a report from the University of Adelaide's registrar that

> the most brilliant student in the science course, up to the present, has been a woman – Miss Dornwell, who passed the first, second, and third year of that course first class. In elementary physiology, as will be seen by reference to the winners of Sir T. Elder's prizes, the women have been distinctly superior to the men.

Kirby concluded, 'It is delightfully plain that equal justice to the sexes is the reigning principle in the Constitutions of the Australian Universities … Australian experience favours the belief in the mental equality of the sexes.'[42]

As this article indicated, other women had followed in Dornwell's footsteps at the University of Adelaide. By 1900 women graduates in science outnumbered those in any other degree (although this was still only eleven women in all).[43] The next Australian university to produce a woman science graduate was the University of Sydney, where Fanny Hunt received her degree in 1888. Like Dornwell, she became a teacher

and headmistress. Around 130 women took out a BSc at Sydney up to 1920. At the University of Melbourne, science degrees were not offered until 1887. Leonora Jessie Little became the first woman to graduate in 1893. She was soon followed by Ada Lambert (in 1895) and Georgina Sweet (in 1896) – both of whom would later also achieve significant 'firsts' for Australian women in science. All three went on to conduct research, with the support of various scholarships and bursaries, and all took out an MSc. In total, sixty-two women gained science degrees up to end of 1920, the highest proportion of women in any course of study.[44]

Women often constituted a substantial majority of students in the biological sciences. But they were attracted to a surprising array of other fields too. Edith Dornwell graduated with first class honours in physics as well as physiology.[45] At the University of Melbourne, most women studied botany, zoology or physiology, but nearly a third chose the physical sciences (mainly chemistry).[46] Women flocked to geology at the University of Sydney from the 1890s. Their numbers reached an extraordinary high during the First World War, when they made up 71 per cent of geology majors.[47] The same Professor Edgeworth David who had been so dismissive of Georgina King seems to have been more supportive of these women students.[48] On at least one occasion, in a speech to a Sydney girls' school in 1909, he specifically encouraged them to pursue geology: 'I want the girls to come to the University and join my geological class. Work up to the senior standard, and let us have geological excursions together.'[49] No doubt women were also drawn by the fame he achieved as an Antarctic explorer in the Shackleton expedition in 1908–9. Photographs of geology field trips from this period, showing numerous women scrambling up the

'Pioneers'

sides of rocky hills in long dresses, dramatically illustrate the extent of their participation.[50]

Although numerically there were more women at the University of Sydney, it was Melbourne's early women science graduates who took the greatest advantage of the new opportunities to engage in research. In this they enjoyed strong support and encouragement from some of the new science professors – particularly Baldwin Spencer, the founding Professor of Biology who came to the university in 1887 (the first year the new science degree was offered).[51] Leonora Jessie Little published her first scientific paper in 1894, the year after she graduated, in the *Victorian Naturalist* – the journal of the Field Naturalists Club, which also elected her as a member. That year she also married fellow Melbourne science graduate Norman Wilsmore, and in 1895 she took out her MSc (only the second awarded in Australia – her husband had taken out the first in 1893). They both wore their academic gowns for the wedding ceremony.[52] The couple then departed for England where, according to one newspaper report, they both intended to 'pursue their scientific studies for four years and take their DSc degrees'.[53] Leonora did not, in fact, do this. But she did return to research from 1904, when she enrolled at University College London (where her husband was a lecturer). While working under Professor James Hill, she published a further two papers on sea anemones in 1909 and 1911. Norman, by contrast, gained his DSc from the University of Melbourne in 1907 for his work as co-discoverer of ketene, a new organic compound. In 1912 he was appointed as the founding Professor of Chemistry at the just-established University of Western Australia (beating Georgina Sweet's application for this position). Leonora did no further research after the couple moved to Perth – but there were no laboratory facilities

Taking to the Field

at the university for some time, and Norman also did little research after taking up the professorship.[54]

Ada Lambert came from Adelaide where she, like Edith Dornwell before her, had studied at the Advanced School for Girls. Her father was a Presbyterian minister, a religion that placed high importance on education. She began her science degree in 1891, going on to a stellar undergraduate career – winning numerous prizes and scholarships, particularly in biology, which was her major area of study. For most of her degree, she was the only science student in her year. In 1894 she won a scholarship to continue on to more advanced biological research. She qualified for her MSc in 1897 and soon after published several articles in local journals from her work on Australian leeches. She produced the first identifications of several leech species and her work is still sometimes cited.[55] In 1899 she made history by becoming the first woman lecturer in an Australian university.

Georgina Sweet, who would become the most significant academic of this first generation of women, came from a scientific family. Her father, George, was a tradesman and later businessman who ran the Brunswick Brick, Tile & Pottery Co. But he was also a keen amateur geologist who built up an extensive fossil collection, now held by the Museum of Victoria, and was president of the Royal Society of Victoria in 1905. In the 1890s he collected fossils in the Mansfield area for Professor Frederick McCoy and in 1897 joined Edgeworth David's expedition to Funafuti atoll (now the capital of Tuvalu). He encouraged his daughter's interest in science and sent Georgina to the Presbyterian Ladies' College – founded in 1875 as one of Australia's first girls' schools and known for its academic rigor. She gained her BSc in 1896 and continued on to advanced research work for her MSc which she took out in 1898. Sweet's research career began with studies

62

of Gippsland's giant earthworms. These had only been 'discovered' by railway workers in 1878 and Frederick McCoy had declared that they were the largest worm in the world.[56] Sweet's work then moved on to marsupial moles. This research led to her being awarded a Doctor of Science in 1904, making her the first Australian woman to gain a doctorate in any field and only the fifth person in the country to receive this degree. This achievement was widely, if briefly, reported on in newspapers across the country. As the *Australasian* recounted of Sweet's graduation ceremony:

> The degree of Doctor of Science is only conferred for original research, and loud and long was the applause when Miss Georgina Sweet, the first Australian lady to receive it, came forward, applause that was renewed only to end in laughter when the Chancellor in his speech alluded to a 'sweet' girl graduate.[57]

A Strength of (small) Numbers

By the early twentieth century, women students were strongly present in many of the emerging disciplines of 'modern' science in the academy. Women were also participating in scientific societies in increasing numbers. Throughout the 1880s and 1890s, across the country, these societies were focused on increasing their membership, and this included explicit encouragement for women to become involved. In 1886, the University of Sydney's professor of natural history, William Stephens, urged the Linnean Society of NSW, of which he was president, to open its doors to women with 'full rights without distinction of sex, following the improved practice of the Sydney University in this respect'.[58] Government Astronomer Robert Ellery, in his 1884 presidential address

to the Royal Society of Victoria, was confident that his audience would 'be pleased to hear' of the success of the Field Naturalists' Club in attracting a large number of members, including six women. Ellery hoped the six ladies 'would soon become sixty'.[59] The following year, the president of the club reported, to 'much applause', that its 160 members now included twenty 'sisters of science', and he expressed the hope that 'before many years passed a lady president would deliver the annual address'.[60] In 1889, Helen Neild, daughter of the Royal Society's librarian, became the first woman to be nominated for membership to this group. The then president, ruling on this nomination, stated:

> After careful search through the laws, the council can find nothing to prevent a lady becoming a member of the Society. I believe the Society was formed on the supposition that ladies as well as gentlemen would become members of it. [But] The ladies had not hitherto come forward to claim their right.

Despite the president's conclusion that 'it was improbable that many others would follow [this] example', at the next meeting, a long list of 'ladies' were nominated for membership.[61]

It was in the AAAS that some of the greatest encouragement for women's participation emerged. When it formed in 1886, its rules explicitly stated that 'Ladies would be admitted'. The prolific botanical collector Flora Campbell gave the first paper by a woman to the association's first congress in 1888 on 'The Diseases of Plants'.[62] In his opening address at the 1891 congress in Christchurch, the Governor of New Zealand welcomed the strong presence of women, 'who can take an active and seemly interest in scientific research'. At the next congress, in 1892 in Hobart, a quarter of the 600 attendees were

women, a fact that was again mentioned approvingly in the opening address by the Governor of Tasmania.[63]

In the universities, women's strong presence as science students was not simply a product of their increasing interest in the field as it became more available to them; it also reflected the *unpopularity* of science among male undergraduates. Sydney and Melbourne had consistently small science enrolments. Despite the optimism of the 1880s, and great popular interest in science, this did not translate into large numbers of university students. In Melbourne, in 1902, there were only two students enrolled in the third year of the BSc, and only ten in 1909. In Sydney, while enrolments were larger, there were still fewer than fifty science students in 1910.[64] These small numbers were a constant source of regret for the new scientific professors. Orme Masson reflected on the situation the chemistry school at the University of Melbourne in 1890:

> The junior class of Chemistry is a large one, but ... the number of [senior] students ... has hitherto been extremely small. It is hardly necessary to point out that lecturing to a single student, or even to two or three, is not the most stimulating employment.

Throughout the 1890s, Masson's reports lamented 'the paucity of students'; in some years there were no students at all in his senior chemistry classes.[65]

While science today commands a great deal of power and prestige, this was not always the case. The small number of science students reflected the relatively low standing of the Australian scientific community in contrast to the centres of authority in Europe and the United States, as well as the lower status of the new science

course compared with the well-established arts degree and the various professional courses. 'Classics' were still widely viewed as the apex of intellectual endeavour, and the scientific community was acutely conscious of the need to increase the status of their field.

The limited employment options for science graduates didn't help matters; until at least the 1920s, there were few opportunities for either men or women to pursue research careers in science (although there was a constant strong demand for science teachers). University staffing was small, there were only a few positions within government departments and very few openings in industry. An article in the University of Melbourne's student magazine *Alma Mater* in 1898 reflected that 'the majority of our students are compelled to look to the business results of their University course, and frequently have to make the pursuit of Science secondary to the pursuit of bread and butter'.[66] As Edgeworth David bluntly put it in 1902, 'Pure science does not pay financially, at all events it does not pay those engaged in science research.'[67] Men were far more attracted to professional courses such as medicine, law and engineering, which had excellent, well-paid job prospects. This created space for women, although their association with a low-earning field cannot necessarily be read as positive.

At least initially, the small number of university science students also reflected the limited teaching of science in secondary schools. Science subjects were only introduced into the school examination subjects in New South Wales in 1867, and not until 1883 in Victoria. Even then, few schools offered substantial science instruction. By 1900 in Victoria, science still held only a small place in the school curriculum and few schools had science laboratories. Examiners' reports bemoaned the poor standard of school science teaching.[68] But while the standards might have been low, science was studied as much by girls

as it was boys (classics remained the cornerstone of boys' education). Victorian boys' schools began to teach more science and to invest in laboratories for chemistry and physics in the early 1900s. Girls then found themselves at a disadvantage as the physical sciences were rarely taught at girls' schools. There were some exceptions to this rule. The Presbyterian Ladies' Colleges in Melbourne and Sydney both offered high-quality scientific instruction, as did some other private girls' schools. Girls also had a better chance of accessing science subjects in coeducational high schools, and in the state selective girls' schools established in NSW from the 1890s, science and mathematics were mandatory. By the 1920s in the private school system, there was a strong trend for girls' schools to teach only the biological sciences and for boys' schools to offer physics. This was when the physical sciences began to dominate the subject choices of boys taking final school examinations.[69] In this sense, early women science graduates were at *less* of a disadvantage than those who followed them because they generally came to the university with a similar scientific education to that of male students.

University students in this period were drawn from an exceedingly narrow segment of Australian society. Apart from the University of Western Australia where tuition was free, university education was expensive and few scholarships were offered. Across the country only a tiny fraction of students completed the final year of secondary school and an even smaller number went on to university studies.[70] In Victoria especially, lack of state provision for secondary education meant that undergraduates were drawn almost exclusively from families who could afford private schooling. It was not until the 1950s that state secondary education became widely available. Reforms such as the expansion of the universities and increasing provision for the

education of women were openly presented as of relevance only to the colonial elite. The University of Melbourne's moves to raise the standards of girls' schooling by admitting them to the matriculation examinations in 1871 was described as a matter entirely concerned with 'advancing the great cause of Education among the girls of the middle and upper classes of our community'.[71] Since access to secondary and tertiary education was so limited, it was only women of a certain class, and race, who could take advantage of the full extent of educational opportunity.[72] While such women were disadvantaged on account of their gender, they nonetheless possessed considerable cultural, social and intellectual capital, compared with the majority of their contemporaries – men or women.

Both Ordinary and Extraordinary

Women scientists in this period were both exceptional and accepted. Inside the exclusive world of the academy, women soon enjoyed a strength of numbers that confirmed the legitimate, and increasingly unremarkable, nature of their presence. They quickly formed their own clubs and societies, which served as strong support networks. The Princess Ida Club – formed at the University of Melbourne in 1888 and named for Tennyson's poem about a princess who founded a women's university where men were forbidden to enter – was a well-known example.[73] Student publications commented frequently and favourably on women's activities and involvement in the university. By 1898, Melbourne's *Alma Mater* reported that 'women now play a great part in University life; a healthy sign … No longer are women restricted to the babyish or dollish lives which they led perforce but a short while ago. They are now unrestricted in development'.[74] Such claims about

the extent of new opportunities women now enjoyed were obviously overstated. The continuing small size of Australian universities and the tiny number of women actually completing degrees rebut such expansive appraisals of these new freedoms. They do, however, convey the widespread belief that a major revolution in women's roles was in process.

Women's involvement in science specifically was the subject of occasional supportive commentary in Melbourne's student journals. An article in 1887, celebrating recent advancements in Australian science, expressed the hope that

> this example will stimulate others to investigate … Lady-students, too, might lend a helping hand, for they are usually good observers and excellent describers. To take a most recent case, a lady has contributed to the last number of the [British] *Quarterly Journal of Microscopical Science*, and a Victorian Lady had a paper read on Plant Diseases before the October meeting of the Field Naturalists' Club. So they would not be out of the fashion even in constructing biological or other researches.[75]

Women featured prominently in the university Science Club, whose membership included both staff and students. From an early stage, the club's rules stipulated that 'two of the Committee should be ladies', and women students were particularly encouraged to attend its meetings. An 1897 report on the club observed, 'One very pleasing feature is the great access of new lady members, no less than ten having been elected.' Later that year, another report further emphasised the extent of women's presence: 'It is very pleasing to note the great interest taken in the Club this year by lady members. All the excursions have been

attended by them; and it was noticed at one meeting of the Club that the ladies outnumbered the men.'[76] A retrospective article on women's contributions to the university, written in 1916, observed that for years the women students 'practically held the Science Club together'.[77]

Women's scientific achievements at other universities were also celebrated. When Amy Elliott, the first woman to graduate with an MSc from the University of Tasmania, was appointed to the newly formed Commonwealth Customs Service in 1902, her achievement was cited in the Tasmanian Parliament as a vindication of the university's very existence.[78] At the inauguration ceremony of the University of Queensland in 1911, Chancellor William MacGregor remarked,

> About a dozen years ago, a woman, for the first time in the history of science, added a new element to the previously known list. That lady has thereby revolutionised science … We only now begin to see dimly the enormous vista opened up to us by the immortal discovery made by Madame Curie and her husband.[79]

In drawing on this example, the chancellor destabilised the masculine image of science. At the University of Sydney, an anonymous letter published in the second issue of the university's *Science Journal* in 1917 protested the widespread representation of all scientists as male and argued the value of women's presence in the field:

> The papers daily tell us of the case of natural resources in Australia waiting to spring into being at the touch of the scientist's wand. But in all this the scientist is always referred to as 'he' … [D]o you not think that the value of woman scientists is not sufficiently emphasised. Forgetting all the women scientists who are taking

their place in the professional work of the world ... the layman has hitherto persistently refused to recognise their importance.[80]

Seven years later, another reader wrote to protest the fact that while numerically 'women quite equal the men', none of the articles appearing in the journal were written by women.[81]

By the early 1900s, women science scholars were not especially remarkable within the Australian university community, but for the broader public they remained an oddity. The growing numbers of women conducting scientific research at the University of Melbourne attracted some attention from the local press, with more substantial treatments sometimes appearing in the women's pages of the newspapers and in women's magazines. While often supportive of women's scientific contributions and 'brilliant' achievements, such articles tended to emphasise women scientists' difference from the 'average' woman. As one said of chemistry research student Stella Deakin (daughter of three-time Australian Prime Minister Alfred Deakin) in 1911: '[She] is a clever student with a soul above ordinary feminine trivialities. Her interest is concentrated on "the rapidity of the formation of acids". To the average woman the scientific term will convey little meaning, but it is not with the average woman that Miss Deakin is concerned.'[82] The *Herald*'s women's pages, similarly described Georgina Sweet as 'one of those rare women with a passion for science' suggesting that to her 'laboratory tests are as fascinating as are frocks and frills to the average woman'.[83] This article was covering Sweet's success in becoming the first woman to win the David Syme Research Prize in 1911 – the most prestigious prize for scientific research then available in Australia. The *Age*, which sponsored the Syme prize, published a more substantial piece on her scientific work; it cited her DSc on the marsupial mole of

central Australia and her extensive research on parasites in Australian native animals and cattle. The newspaper stressed the 'considerable economic value' of Sweet's work, which sought to find the local source of a worm that was infecting Australian cattle and causing exported beef to be rejected by British authorities.[84] By 1913, when Sweet was about to depart for nine months' leave to travel to Asia, Europe, the United Kingdom and North America to study recent developments in 'Economic Zoology', Melbourne's *Talk Talk* described her as 'the most conspicuous success that Victoria has produced in the shape of super-educated womanhood'.[85]

In a somewhat contradictory fashion, articles in the women's press also portrayed women's scientific work as compatible with traditional feminine activities. One 1911 article on chemistry and agricultural science research student Brenda Sutherland (later superintendent of Melbourne's College of Domestic Economy) observed: 'On first thoughts, it seems rather strange for a girl to be bothering her head about phosphates, manures and other soil nourishers … but, after all, it is an occupation only very slightly removed from gardening, and almost every woman is interested in that branch of horticulture.' The writer suggested that Sutherland's specimen jars were 'something the shape of the thrifty housewife's jam jars'.[86] Georgina Sweet's research in parasitology was similarly explained as an extension of 'womanly' interests: 'It was probably an outlet for her inherited housewifely instinct and thrift.' The reporter then went on to concoct an entirely fanciful account of the limits restricting what women scientists could or should do:

> Dr Sweet is determined that she will never touch any branch
> of the work that would be in any way repellent to her feminine

instincts. She seldom goes afield for information … [I]t would be impossible for a woman, no matter how great her cleverness and enthusiasm might be, to take up the valuable practical work done sometimes by male professors. A short time ago Professor Gilruth had to wade through the abattoirs doing research work for the Victorian Government.

The reporter was obviously unaware of some of the work Sweet had actually done, or the fieldwork that had already been undertaken by other scientific women across the country. Still, the account was highly positive. It also conveyed a clear picture of Sweet's actual scientific work, relating how, during a visit to Sweet's laboratory, she held up 'a tiny phial in which floats something that looks more like small pieces of dirty brown thread than anything else. But it is not thread, it is a specimen of a nasty little worm that has been disturbing the eyesight of fowls in Queensland'. The reporter then drew on terms they clearly thought would be relatable to female readers:

A long narrow bottle, similar to an eau de cologne bottle, only longer, and white in color, reveals a new species of worm … In this laboratory, certainly things are not what they seem. The new species is not unlike the golden spike of the garden lily, only of paler shading.[87]

The intense excitement, commitment and privilege these early women in science felt also came through strongly. Sweet was depicted as an 'enthusiastic student, who is devoting her life to a branch of research work as yet in its infancy'.[88] Stella Deakin was quoted as feeling that 'it would be a great privilege to be able to offer one tiny particle of

knowledge to the gigantic scientific whole'.[89] When interviewed in her later life, Hilda Cleminson, who began her science degree at the just-established University of Queensland in 1911, recalled the sense of privilege, but also responsibility, she and other students felt: 'It was such an interesting and exciting experience to be in at the beginning of things, and we, first students, had the unique responsibility of establishing traditions for those who came after us.'[90] Cleminson also made clear that women were not completely integrated or accepted within the university or in science. Her chemistry lecturer addressed the class as 'gentlemen' and women were assigned to take care of the food and cooking on field trips. Such experiences were common. Some male staff and students expressed open hostility to women's presence. Women students generally sat in the front rows of lecture theatres and had their own clubs and rooms in which to spend their time in between lectures – practices which both separated and supported them. The language used to describe them – as 'lady students' or 'sweet girl graduates' – also explicitly set them apart.

Conclusion

When Bella Guerin wrote so optimistically of the coming age of new womanhood in the early 1890s, she envisaged a future that would be dramatically altered by women's access to higher intellectual culture. Even such small fragments are suggestive of the state of flux in ideas about women's roles and capacities in the late nineteenth and early twentieth centuries. Guerin's belief in the coming influence of educated women seems quite extraordinary given the tiny numbers who had access to this 'higher culture'. The impact of reforms in women's education were clearly overstated, given that access to tertiary education

remained so restricted. And these ideas coexisted easily with moves to ensure that 'ordinary' girls received a thorough domestic education in their schooling.

Nevertheless, within broader public discussions, surprisingly positive statements about the possibilities for women's scientific creativity abounded. And as they moved into university degrees, women were part of the 'new science' from the very beginning. While these women were in many ways 'pioneers' – since science in the modern, professional, sense only began to develop in this period – their entry into this field perhaps cannot be portrayed as one of 'breaking into' a longstanding male domain. There was, in fact, remarkably little resistance to women's entry into this emerging field. The barriers they did face were not necessarily any greater than those in other more seemingly 'feminine' areas. Their success was a product both of their privileged position and emerging influences encouraging women of this class to engage with science. And their experiences are suggestive of the real ability of such women to circumvent apparent obstacles of gender in this period. They reflected a broader atmosphere of freedom for women at the turn of the twentieth century that has often been lost in our understandings of women's history in Australia. All of this was soon extended into academic employment as well.

Chapter 3

Taking on the Profession

Women Working in Science, 1900–1920s

Miss A. Lambert enjoys the proud distinction of being the first lady graduate in the history of the biological school, if not in the University, to be appointed lecturer.

—*Weekly Times*, 20 May 1899

In April 1899 Ada Lambert (MSc) became Australia's first woman university lecturer. Her appointment to a temporary post in the biology school at the University of Melbourne was the first its kind in any of the Australian colonies (soon to be united as a nation). This significant 'first' for women was achieved in science, not in the more 'feminine' humanities. Lambert's appointment was widely noted in the press. Most reports highlighted the historic nature of her appointment and presented it as a significant step for women generally. Melbourne's *Table Talk* suggested that the 'unique distinction conferred upon

Miss Lambert confers a lustre upon the sex generally'. The Broken Hill *Barrier Miner*, along with numerous other regional newspapers, described it as 'another victory for woman in a new field'. The *Critic* in Adelaide ran a large photo of Lambert in her academic robes, with the caption 'Miss Ada Lambert, First Lady Lecturer'. This report, like others in Adelaide newspapers, highlighted her early life in South Australia prior to her stellar undergraduate career at the University of Melbourne.[1]

Ada Lambert's appointment was a major milestone for women's entry into the emerging world of academic and 'professional' scientific work in Australia. Although Edith Dornwell's graduation in 1885 had set an important precedent, she did not become a 'scientist' but turned instead to the already established women's profession of teaching.[2] Teaching dominated early university women's destinies, claiming up to 90 per cent of graduates. And the demand for science teachers, men and women, continually outstripped the available supply of graduates well into the 1960s.[3] But the next most significant area of employment for women science graduates was in the academy.

From the early 1900s, women were prominent not only as science students but also as staff in the expanding university science departments. Contrary to the common belief that the humanities have been more welcoming of women, in Australia it was in science that they were first appointed to university positions in significant numbers. Starting with Lambert, a growing number of women science graduates found a place for themselves in the academy. From 1900 to 1930, nearly half of all appointments to departments of zoology and biology were women, although most were in junior posts and many were only briefly employed.[4] They were in the majority in botany. By the 1930s women dominated the ranks of junior staff in the biological sciences

across the universities of Adelaide, Melbourne and Sydney, and some were in more senior positions.[5] At the same time, even as Australian universities proudly asserted their record of 'equal justice to the sexes', this was far from the reality.[6] Only unmarried women were able to pursue academic careers and even they faced an overt preference for hiring men. Most were relegated to junior teaching positions, with little opportunity for research, received lower pay than their male colleagues, and came up against strong views about women's (in) capacity for leadership that meant they were far less likely to be promoted. A very few managed to break through this 'glass ceiling', including the first two associate professors, zoologist Georgina Sweet and botanist Ethel McLennan, whose careers represent the height of women's achievement in this period.

These new academic women were emblematic of the broader 'revolution' in educational and professional opportunities for white, middle-class women that began in the late nineteenth century.[7] Women took up research scholarships and teaching positions not only in botany and zoology, where they thrived, but also in chemistry, physics, geology and other emerging fields. In the process, they helped to lay the essential foundations for the modern scientific enterprise in Australia, which, from its beginnings, depended heavily on women's work.

Breaking into the Profession: The First Academic Women in Science

Ada Lambert's landmark appointment in 1899 was not her first university position or her last. She assisted with Melbourne's biology examinations in 1898, covering for Professor Baldwin Spencer who

was conducting fieldwork in the Northern Territory that would see him established as Australia's pre-eminent anthropologist (and architect of ideas that would underpin the Stolen Generations).[8] In 1901 she was appointed as a demonstrator and assistant lecturer and given even greater seniority, taking over Spencer's professorial duties for the whole year while he was again away on an extended anthropological expedition.[9] Other women soon followed in her footsteps. At least twenty-six of Melbourne's sixty-two women science graduates up to 1920 worked at the university at some stage. This included six biology graduates who reached lecturer status or higher.[10] At the University of Adelaide, May Burgess was the first woman appointed to the academic staff as a demonstrator in chemistry from 1900 to 1911. She was followed by Ellen Benham, who lectured in botany from 1901 to 1912. In 1908 Margaret Deer was the first woman appointed to the academic staff of the University of Sydney as a junior demonstrator in geology. From this point, up to the end of the Second World War, the great majority of women on Sydney's academic staff were employed in science and medicine.[11]

Outside of Melbourne, the University of Sydney was the only other university to employ more than a handful of women scientific staff prior to the 1920s, though it was slower to accept them. When Marion Horton, the university's third woman science graduate, was recommended for appointment as junior demonstrator in biology in 1897, the university senate 'declined to entertain the proposal',[12] with no reason given. Later, Horton was apparently told that it was because she was a woman and 'too pretty'. After Deer's appointment, women staff became most visible in geology, reflecting the discipline's large number of women students: twenty-five of the thirty-nine appointments to Sydney's geology department up to 1945 were women (although it was

not until the late 1930s that any were appointed to senior positions).[13] Appointments in other areas were fewer, in part due to the slower development of the biological sciences in Sydney. From 1915, however, women began to feature as demonstrators and curators in botany and zoology, and several spent many years on research scholarships. Three women were appointed to junior positions in zoology in 1917, including Eleanor Chase, who became a lecturer in 1923, the first permanent lectureship for a woman in the science faculty. Her career ended with her early death in 1926. From this point, women gradually took over junior positions in the biological sciences.

In Sydney's physical sciences, women were conspicuously absent. It was only during Robert Robinson's brief tenure as professor of organic chemistry from 1913 to 1915 that women featured in chemical research. Robinson and his wife, Gertrude, who was appointed as a demonstrator, led an extremely productive research team, producing twenty-five papers. Five of their seven co-authors were women. A couple of these women served briefly in junior positions, but none went on to long-term academic careers in chemistry. Ellen Hindmarsh moved into the physiology department in 1916, retiring in 1938 as a senior lecturer. In physics, Edna Sayce was the first woman appointed in 1917, serving as a demonstrator for two years. The professor of physics had reputedly barred women from majoring in his department before this. By 1921 women had been employed in eleven scientific departments, compared with only three women in the arts faculty.[14]

At the other universities, prospects for both women and men were hampered by the extremely small size of the academic staff. In Adelaide, the slower development of the biological sciences and the absence of a master's degree proved particularly limiting for women. After the death of Professor Ralph Tate in 1901, the only biology teaching in

the university was the botany course delivered to pharmacy students by Ellen Benham. It was not until 1912 that a professor of botany was appointed from England (at which time Benham's services were dispensed with). The new professor, Theodore Osborn, was substantially assisted by his wife, Edith, a distinguished botanist in her own right, during his term as professor from 1912 to 1927. In 1920 she even deputised for her husband while he was on leave in England. In 1917 Sydney graduate Marjorie Collins was appointed demonstrator in botany, a position she held for two years before returning to Sydney for a research scholarship. The only other woman who had a long-term appointment in this period was May Burgess – the demonstrator in chemistry from 1900 to 1911.

At the tiny University of Tasmania, opportunities were even more limited. By 1913 there were still only fifteen academic staff. It was not until the 1920s that there were any long-term appointments of women – and these were in economics and mathematics. Nevertheless, Mary McAlister and Enid Hughes were demonstrators in the chemistry department in 1913 and 1916, and Nancy Hutchison was a demonstrator and research scholar in physics in the 1920s. At the somewhat larger University of Queensland, Freda Bage, who had been a junior demonstrator in Melbourne's biology school, served as lecturer-in-charge of biology in 1913. Four other women demonstrated in biology and chemistry during the First World War, including Mavis Walker who, in 1920, was appointed acting lecturer in biology in the absence of Professor Johnston. Few other such appointments were made prior to the Second World War, but several women were prominent in the research activities of the university.[15]

Women were more strongly represented at the University of Western Australia, beginning with Melbourne graduate Gwynneth Buchanan's

brief tenure as acting lecturer-in-charge of the biology department in 1920 (she returned to Melbourne to a lectureship in zoology the following year). Three other women lectured in biology in the 1920s, and several more were demonstrators and curators. Eileen Reed enjoyed the longest career as assistant lecturer in biology from 1921 to 1928 and then lecturer-in-charge of the botany department for the next four years, remaining in this position despite her marriage in 1931. In 1954, after the death of her husband, she returned to the university as a temporary lecturer.[16]

The University of Melbourne features prominently in the story of Australian women in science. It was here that women made the greatest inroads into the academy and in research. Baldwin Spencer played a major role in encouraging and employing many of his women students. Leonora Jessie Little was Melbourne's first woman science graduate and also the first woman to apply for an academic position in any Australian university. In 1893, the year she graduated, she applied for the post of demonstrator in the biology school. While she was unsuccessful, there was no question that she was eligible to apply. At Melbourne, as for other universities, there were no formal barriers to women's entry into academic employment. Melbourne's university council even requested further information from Baldwin Spencer as to why he had not recommended Little, given her 'brilliant record', and that since this was the first time a woman had applied for academic post, 'she should not be set aside without good reason.'[17] In reviewing the applicants, Spencer commented, 'Whilst I am fully aware and have a high appreciation for the distinguished career of Miss Little, I feel that it would be almost impossible for me to carry on the duties of my department if she were selected to fill the post.'[18] His alarm does not seem to have been related to her gender. Both the

82

other (male) candidates had substantial teaching experience while Little had only just completed her degree. Spencer later showed no hesitation in appointing some of his top women students. It was his request that resulted in Ada Lambert's appointment as the first woman on the academic staff of any Australian university in 1898.[19] In 1900, when Spencer again recommended Lambert's appointment, he outlined her high qualifications to the university council:

> She took the final scholarship in Biology [and] has devoted herself with great success to the work of original investigation and teaching: she has already on two occasions had experience in lecturing and examining in the University and I have no hesitation in recommending that ... she be entrusted with the work of the Department during my absence.[20]

Women were beginning to enter academic science just at the time when universities were expanding in this area. In the 1890s science departments in Australia's four colonial universities still typically consisted of a single professor recruited from Britain or Europe (sometimes with one assistant, demonstrator or lecturer). Laboratory facilities, and thus the capacity to conduct research, were limited. This began to change at the turn of the century. Although the number of academic posts remained small, there was a gradual expansion of science departments that provided some openings for local graduates, including women.

The advocacy of scientific professors, keen to increase the size and research profile of their departments, drove this expansion. In Baldwin Spencer's case, it was his women students who were the main beneficiaries of this drive. From 1900 to 1919, at he appointed at least

fourteen women (including Georgina Sweet) to his staff. Aside from Thomas Hall, the lecturer and demonstrator who had been appointed in 1893, only one other man was (briefly) employed. After Hall's sudden death in 1915, Spencer was left as the sole man in the department.[21] These women were mainly appointed as demonstrators, in charge of the large first-year laboratory classes (which were mainly for medical students). 'Demonstrating' quickly became established as a job that women were seen as extremely suitable for. These low-paid posts provided an opening for many women to continue in science and, for some, to engage in research.

Spencer's biology department was not unique. The pattern of predominantly hiring women was repeated in Melbourne's botany school (founded in 1905 with English-recruited Alfred Ewart as professor) and in physiology, biochemistry and bacteriology.[22] Jean White (later White-Haney) was the first botany appointment in 1909, the year she became the second Australian woman to gain a Doctor of Science. When she left in 1912 to establish and direct a prickly pear experimental station in remote rural Queensland, she was replaced by a series of other women as lecturers and demonstrators. Botany thus also had an all-women staff aside from Ewart as professor (and this happened despite Ewart's strong prejudices against employing women). Some went on to long academic careers – most notably Ethel McLennan, but also Isabel Cookson whose later research in palaeobotany would establish her as one of Melbourne's most internationally recognised scientists.[23]

This period also saw a large expansion in opportunities for Melbourne's graduate students to undertake research. The introduction of state government research scholarships in 1908 boosted scientific research and further increased the presence of women. Of the nine

scholarships awarded in its first year, five went to women. In 1910 women received eleven of the fourteen awarded. Women continued to gain a high proportion of these scholarships into the 1920s. They dominated in biological research but were also prominent in the research work of the chemistry department for many years.[24] Some women gained these scholarships for several years in a row, so that by 1914 the university could boast a small band of women with substantial research experience and publications.

Women's appointments at the University of Melbourne were not limited to the more 'feminine' biological sciences. In 1908 they represented half of the chemistry demonstrators – a presence which continued and increased into the 1920s.[25] Even in physics, women had a small but growing presence, beginning with Frances Campbell's appointment in 1902.[26] By 1918 women were half of the sub-professorial staff across Melbourne's science faculty, and the majority of demonstrators, a situation that again continued into the 1920s.[27] Although most women remained in low-status, low-paid positions, particularly in the physical sciences, by 1930 four of the eight senior staff in the botany and zoology departments were women. This included Australia's first two women associate professors.

Georgina Sweet had gained her BSc in 1896, MSc in 1898 and DSc in 1904 (the first Australian woman to attain what was then the highest scientific qualification available in Australia). But it was not until 1907 that she received her first official academic appointment as a junior demonstrator in biology.[28] Before this, she supported herself by teaching in girls' schools, lecturing in the university colleges, and acquiring a series of small research grants and scholarships. Her career then progressed reasonably well. She won a Government Research Scholarship in 1908 and was promoted to a lectureship (split

between biology and the new veterinary school) in 1909. She became an extremely productive researcher, publishing dozens of articles in local and international journals. In 1911 she was the first woman to win the Syme Prize, achieving recognition as Australia's leading parasitologist. In 1913–14 she took leave for an extended overseas trip to 'visit numerous Universities and other Institutions connected with research and teaching in Europe and America and also in the East, in order to familiarise myself with the most recent methods and results of research in Parasitology'. She was also commissioned to provide a report on 'parasites affecting Australian beef' for the Commonwealth government.[29] In 1916 she became the first Australian woman to be formally appointed as acting professor, standing in for Baldwin Spencer while he visited Britain for several months. The appointment of 'the first lady professor in Australia', according to news reports, 'did not occasion any surprise in university circles' as Sweet had 'long ago won laurels in the field of scientific research and proved her capability as a lecturer on biology'.[30] While her application for the chair of zoology in 1919 was unsuccessful, she was promoted to associate professor the following year: yet another first.[31]

Sweet was a strong supporter of women's rights. While it's unclear if she would have considered herself a 'new woman' or a 'feminist' (this term was not commonly used in Australia until the 1910s), from early in her career she was a leader in university women's causes. In 1899 and again 1901 she was a key signatory on petitions from women graduates for admission to the University of Melbourne senate. She was a founding member of Melbourne's Lyceum Club in 1912 and later the Victorian Women Graduates' Association, and was part of a committee that worked hard to establish the University Women's College. She was also very active in other women's organisations, particularly after

she stepped down from her full-time university position in 1924. She was Australian president of the Young Women's Christian Association from 1927 to 1934, and a vice-president of the world YWCA in 1934. In 1930 she became the first international president of the Pan-Pacific Women's Association.[32] She felt that university women had a particular responsibility to contribute and be leaders in public life and argued that politics offered them 'unlimited opportunities' to 'do good'. But she also believed that 'natural laws' placed some limits on women's capacities and that while these did not 'make her inferior', they should 'lead to her higher development in other directions'.[33]

Ethel McLennan developed her interest in science at Melbourne's Tintern Girls' Grammar, where Georgina Sweet was one of her teachers. She began her science degree in at the University of Melbourne 1911 and was appointed as a demonstrator in botany in 1914 while still an undergraduate.[34] Following in Sweet's footsteps, she went on to gain both a doctorate (1921) and the Syme Prize (1927), and was acting head of botany several times in the 1920s and 1930s. In 1925 she was awarded a fellowship by the International Federation of University Women. This allowed her to spend a year at London's Imperial College of Science and the famous Rothamsted Experimental Station, where she worked with W. B. Brierley on soil-borne fungal diseases. It was this work that gained her the Syme Prize in 1927 (it would be more than fifty years before this prize was next awarded to a woman). Again, like Sweet, much of her work in plant pathology had direct economic implications for Australian agriculture. She researched fungal diseases in crops, from peas to bananas to hops, sometimes commissioned by the Council of Scientific and Industrial Research (CSIR). She often travelled to the sites of specific infestations to collect soil samples for analysis.[35] Promoted to senior lecturer in 1923 and associate professor

in 1931, she, too, failed in her bid to reach the top of the academic profession when her application for the chair of botany in 1938 was rejected in favour of a much younger man with a Cambridge PhD.

McLennan was less comfortable in the public eye than Sweet. When she was interviewed in 1926, just after returning from her year in England, a reporter described her as 'charming to talk to, and with a shy diffidence that made her very reluctant to discuss her own achievements'. Nevertheless, her commitment to her work shone through. She wanted to put the methods she had learned at Rothamsted into practice in Australia, given the 'vital importance to agriculture' of this kind of research.[36] McLennan was an active member of the Australian Federation of University Women, becoming its national president in 1935. Opening her presidential address to the group's national conference that year, she reflected: 'To take up research as one's life work requires a dogged determination and a complete disregard of all the usual ambitions of life for fame and fortune.' Her speech focused on women's contributions to science. She wanted to correct the false impression that women were absent from the field: 'The remark is often heard that women have contributed nothing to the progress of science. In answer to that, I will tell you something of a few outstanding women of science, to refute the impression that women are not creative from a scientific point of view.'[37]

Breaking Boundaries and Creating Networks

Women's entry into the academy was one part of a much larger cultural shift. From the late nineteenth century, middle-class women were breaking the bonds of conventions and expectations in numerous ways, not just in education and employment. This was the era of campaigns for

women's suffrage (achieved for white Australian women in 1902). But it also saw a dizzying array of other changes, both legal and cultural. University women were often at the forefront of these changes and took part in public activities that would now be considered commonplace. For example, in October 1899 a group of twenty-five women attended a 'dinner, given entirely by ladies in honour of one of their own sex' at one of the large hotels in Melbourne.[38] The novelty of this 'women only' event, held in the evening in a public venue, attracted some comment. The *Adelaide Observer* reported, 'A woman's dinner is by no means a novelty in London, where the lady journalists' and women writers' dinners are annual affairs, and now Melbourne women have followed suit.'[39] The guest of honour was Helen Sexton, a medical doctor, and the group included Ada Lambert along with 'eight lady doctors, two lady dentists, several lady musicians, and a sprinkling of married women'. The group were reportedly 'gazed at' by 'wondering country visitors in the hotel', underscoring how new, and even radical, this gathering was.[40]

This dinner was a sign of things to come. As they had done as students, women graduates quickly formed a range of 'women only' clubs and other groups to maintain their connections with one another. These were in some ways intended to provide women with the kind of informal networks and 'power base' associated with the men's clubs of the day. Groups specifically dedicated to the interests of educated and professional women proliferated, gaining a strength of numbers which dispelled any notion of such women as isolated 'exceptions'. Among the first of these was Melbourne's Lyceum Club. Formed in 1912, largely due to the influence of Ethel Osborne (MSc and wife of physiology professor William Osborne) who had recently visited London's Lyceum Club, its membership was restricted to

women graduates or those 'distinguished' in art, music, literature, philanthropy or public service. It quickly became Melbourne's premier women's club and by 1930 had 900 members.[41] Georgina Sweet was a founding member. Other Lyceum clubs soon formed in Brisbane, Adelaide and Sydney, and in Perth the Karakatta Club (formed in 1894) held a similar standing. In 1922 the Australian Federation of University Women (AFUW) formed – based on the existing British Federation – and aimed to 'afford opportunity for the expression of united opinion and for concerted action by University Women on matters especially concerning them'.[42] By 1937 it was estimated that its membership included at least 20 per cent of the 6,000 or so Australian women graduates.[43] Like the Lyceum Clubs, the AFUW was a space where elite professional and educated women could cultivate useful contacts. International connections through the International Federation of University Women were especially useful for some, as were the travelling scholarships available to members.

Women scientists were also expanding their horizons beyond Australia. While no Australian woman completed a science degree overseas before the 1920s, many spent time conducting research in prestigious institutions mainly in Britain but also in Europe. Overseas research experience was critical for all Australian science graduates who wanted to progress their careers. Florence Martin, who spent eighteen months working in the Cavendish Laboratory in Cambridge in the late 1890s, was probably the first. The second was probably Leonora Jessie Little, who studied and conducted research at University College London from 1904 to 1912 while her husband was working there. In 1909–10 Stella Deakin completed advanced science courses at the University of Berlin, and then also did research at University College London. In 1910–11, Freda Bage gained a King's College research

fellowship and conducted research with Arthur Dendy there, as well as at the Plymouth Laboratory.[44] Both Gwynneth Buchanan and Georgina Sweet went overseas for research in 1913 – Buchanan with a free passage granted by the Orient Line.[45] Brenda Sutherland also gained a free passage in 1914, but chose to go to North America and also used this opportunity to move into a new field – studying home economics first at the University of Wisconsin and then a full degree in household science at the University of Toronto, winning a gold medal.[46] Ethel McLennan's research year in England in 1922–3 was made possible by an International Federation of University Women fellowship. This was a transformative time for her, and not just in terms of her research. As she reported to the University of Melbourne registrar, 'I have now been in London some little time and am beginning to feel quite at home in its vastness … South Kensington seems to attract students from all parts of the world, there are at present in the Botanical building many Indians, Egyptians, a Persian, Turk, Chinese men and a woman, not to mention Ireland, Scotland, S. Africa and the other dominions.'[47] At Rothamsted she similarly reported on the 'many nationalities' in the classes: 'Chinese, Latvians, Indians, and Koreans, who worked as enthusiastically as the English and American students'.[48]

In the 1920s Georgina Sweet also travelled for both work and pleasure, including across both Asia and Africa. After the devastating loss of her parents and sister in 1919–20, she found herself with an inheritance that made her independently wealthy. In 1922 she undertook a nearly nine-month journey from 'Cape to Cairo' with Jessie Webb, a lecturer in ancient history at the University of Melbourne. Both the route they followed, and Sweet's accounts of it, were firmly shaped by European colonialism across the continent. She described

how they made the most of the opportunity 'of studying the various kinds of government, problems of administration, native development, the potency of human and animal diseases in delaying progress, in which I was especially interested', and spoke about

> the abounding problems facing the Government of the South African Union with its white and coloured peoples; of the spontaneous devotion of the British in Rhodesia to the mother country: of the Belgian Congo, with its wonderful resources and rapid development, 'a bit of Continental Europe, in speech at least, in the heart of Africa' ... the [admirable] work that is being done by a handful of British officials in the mandated Tanganyika ... [and] the equally fine service to the Empire of the men stationed in Kenya Colony, Uganda, 'the pearl of Africa', and the Sudan.[49]

A lengthy article on their journey in the women's pages of the *Countryman*, with the headline 'Women in Pursuit of Science: Enthusiasts Who Toured Africa', reported that 'Dr Sweet and Miss Webb preferred the less to the more civilised parts'.[50] Their journey included an eight-day safari in Sudan, where they were carried in chairs and accompanied by around thirty-five porters and cooks. The novelty of Uganda, which was 'ruled by a native government' with a British Resident 'purely in an advisory capacity' was highlighted as a rare example of the 'government of Africa by Africans'. While Sweet saw this as a positive development, it sat alongside more belittling observations of racial capacities, as 'the negro when civilised wore his civilisation as easily as he wore his clothes, and cast it off with just as great celerity.'[51]

Beyond the Academy: Careers for (Unmarried) Women

Outside the academy, teaching remained the main avenue of employment for women science graduates (as it was for men). Some combined demonstrating work with school teaching. Both May Burgess and Ellen Benham worked full time as teachers while holding their part-time lecturing posts at the University of Adelaide and continued their successful teaching careers after their university jobs were terminated.[52] Others left university demonstrating to take up more permanent and better-paid teaching jobs. Isobel Travers was lecturer in botany at the University of Tasmania in 1930 before moving on to a highly successful career as a teacher and then headmistress.[53] While few women were promoted to the permanent staff at the University of Sydney, several had long careers at the Sydney Teachers' College. Margaret Deer moved on from her university job in geology to lecture in biology at the college from 1910 to 1940, and Edna Sayce went from demonstrating in physics to college lecturing from 1919 to 1922 before marrying a fellow physics graduate. Marie Bentivoglio taught geography at the college for over a decade from 1926. She had been the first Australian woman to win an 1851 Exhibition scholarship in 1921, which supported her to complete a PhD in geology (crystallography) at Oxford and a diploma in geography. She was also briefly acting head of the geography department at the University of Sydney when Thomas Griffith Taylor left in 1928. She also left Australia in 1936, partly due to her growing commitment to fascism.[54]

While these were good, well-respected positions, they mostly did not allow women to continue in research. This was true even for jobs in institutions closely allied to the universities. For example, after a year as lecturer-in-charge of biology at the University of Queensland,

Freda Bage's scientific career effectively ended when she became principal of Queensland's Women's College in 1914.[55] The same thing happened to Brenda Sutherland when she became superintendent of Melbourne's College of Domestic Economy in 1918. After gaining several research scholarships, demonstrating in the chemistry department, and completing her master's degree in chemistry in 1913, Sutherland went to Toronto to complete a degree in household science. She accepted the position at the College of Domestic Economy on the understanding that it was soon going to be developed into a major scientific centre, like the institutions she had recently seen in Canada and the United States. The college had close associations with the University of Melbourne, some of its classes were taught by staff from the physiology school, and there was a strong campaign afoot for a chair of domestic science at the university. When these grand plans came to nothing, Sutherland resigned and set up her own hotel in 1924.[56]

The reason Sutherland had moved into domestic science in the first place was that the door to her preferred career was closed. During an interview for the women's pages of a local newspaper in 1911, the reporter asked about her future ambitions. Sutherland replied, 'I should like to be on the staff of the Government Agricultural department, but, of course, that is hopeless. They never appoint a woman to any of those positions.' When pressed about the reasons for this she clarified, 'laughing', that 'a man would not be dictated to by a woman ... not in the Government Agricultural department'.[57] Sutherland was astute in her assessment. Public service rules, particularly marriage bars and sex-specific employment classifications, and a clear prejudice against women holding positions of authority meant few women were employed in government posts.[58] A significant number of women

were employed as 'star measurers' and 'computers' in the Adelaide, Sydney, Melbourne and Perth astronomical observatories in the 1890s and early 1900s – but none were university graduates. These were extremely low-paid positions, despite the high level of skills required, and women were employed because they were viewed as reliable cheap labour.[59] Jean White was very much an exception when she was employed by the Queensland Government to direct the prickly pear experimental station from 1912 to 1916. She conducted more than ten thousand chemical poisoning experiments and tested fungal cultures imported from overseas.[60] Sarah Hynes is credited as being the first woman scientist appointed to a government post, assisting Government Botanist Joseph Maiden at the National Herbarium in Sydney from 1900. Hynes had been the first student to major in botany at the University of Sydney, as an arts graduate, in 1891.[61] In 1903 Amy Elliott, the first Master of Science from the University of Tasmania, was appointed as an analyst with the newly established Commonwealth Customs Department in Melbourne.[62] Both these appointments ended in unpleasant circumstances. Elliott was dismissed after just a few months, apparently because of her 'difficult' personality. Hynes clashed with her (male) superiors from the beginning by demanding a higher grading and salary; she was found guilty of insubordination in 1910 and transferred to the Department of Public Instruction.

Irene Crespin (who completed her BA with a geology major in 1919) was virtually the only woman to start a long and senior government career before the 1930s. In 1927 she was appointed as Assistant Commonwealth Palaeontologist and was Government Palaeontologist from 1936 to 1961. Over her career, and well into her retirement, she published 87 papers as sole author, 23 joint papers and more than 100 reports and notes.[63] Florence Armstrong, also a geologist, joined

the Western Australian Geological Survey in 1928, although she was confined to office work, but she left to work for Western Mining from 1934–6 (resigning when she married).[64]

Armstrong's brief time working industry was a rare occurrence. Even fewer women were employed in industry than in government positions. When this did happen, it attracted attention. In 1916, for example, Elizabeth Preston (MSc) was celebrated in a lengthy article in the *Sydney Morning Herald* as the first Melbourne woman graduate to 'go into the industrial field as an analytical chemist'. Taking up work 'which hitherto had been done exclusively by men', it was reported that she had 'sole charge' of 'a large laboratory in a commercial house, which deals chiefly in malt'. Fellow Melbourne chemistry graduate Ruth Sugden was also working as an analytical chemist in a munitions factory and Jean Alexander was doing similar work in a large wholesale firm. The article concluded, 'It is gratifying to know that the work of an analytical chemist can be well done by a woman, especially now, when so many women are desirous of finding lucrative and congenial avenues of employment.'[65] As another article outlined, these women were not just seen as a temporary wartime phenomenon but as indicative of 'Women of Tomorrow' – among a range of other new fields from the 'banks and offices' to chauffeurs – and 'it would not be surprising to see in the future women supplanting men in the chemist shops'.[66] Professor of Chemistry Orme Masson speculated elsewhere that as most chemistry graduates, 'men and women alike', had to look to teaching to earn their living, 'this career for women will be popular in future'. His endorsement was double-edged. He claimed women had not yet proved their capacity for higher-level industrial chemistry research. Routine work was, however, 'eminently suited to women'.[67]

The Marriage Problem

No matter where they worked, women science graduates faced a stark choice between 'love and freedom' or marriage and career.[68] In 1911, only 6 per cent of married Australian women were officially listed as being in paid employment outside the home.[69] In most professions, including teaching, women were required or expected to resign on marriage. While officially the universities did not impose a marriage bar, in practice most academic women were unmarried.[70] Early university women chose 'freedom' in remarkably large numbers. Perhaps half of the women who graduated before 1920 remained unmarried and worked throughout their lives. Most worked prior to marriage – something that was in itself a new departure for women of the middle and upper classes.[71] These women entered university with a clear view to using their qualifications. Their high level of career commitment and marked disinclination for marriage were key factors promoting women's strong presence in early twentieth-century Australian science.

Stella Deakin's experience demonstrates both the new opportunities open to privileged women and the powerful constraints on their ambitions if they chose to marry. Deakin was one of Melbourne's early chemistry graduates and daughter of three-time Australian Prime Minister Alfred Deakin. In her early scholastic endeavours, Stella enjoyed the strong support of her father. When away from the family, Alfred wrote often to his children, enquiring about their progress and encouraging them in their academic work. He sent his daughters to the academically rigorous Melbourne Church of England Girls' Grammar and he supported Stella in her choice of science for her university degree.[72] Graduating with a BSc in 1906, and also among the first students to take out the new Diploma of Education

that year, Stella spent the next two years undertaking research in the Melbourne chemistry department, gaining final honours and an MSc, winning the Dixon research scholarship and co-authoring her first research paper. Following what was already an established progression for male science graduates aiming for an academic career, in 1909 she went overseas for further experience. First, she took advanced courses at the University of Berlin and then did research at University College London under William Ramsay and alongside fellow Melbourne chemistry graduate Norman Wilsmore. The results of her London research were published in the *Transactions of the Chemical Society* in 1910.[73]

Stella's family strongly supported her scientific ambitions while she remained single.[74] Writing to his daughter just before she left for Germany, Alfred Deakin expressed great pride in her achievements:

> Happy indeed should you be now that you are fortunate enough to have opening for you some insight into the very best methods of research at the very best universities. You have had excellent opportunities for cultivating your mind and have so far used them energetically ... You can do very much better than I have done ... [We] are accepting the terrible wrench involved in our separation for a long time – nothing less than the opportunities it presents and their influence on your whole future could induce us to submit to the trial ... [This should be] an inducement to rise to your highest level.[75]

Soon after arriving in Berlin in 1909, Stella became engaged to fellow Melbourne chemistry graduate, David Rivett (later Melbourne's professor of chemistry and then head of the CSIR). Despite this, her

letters home continued to be filled with tales of her research and her plans for work upon her return. She also studied the development of domestic science education in England in the hope this would enhance her employment prospects in Australia.[76] Alfred Deakin thus felt it necessary to point out to his daughter the significance of her altered circumstances: 'You appear not to realise how entirely your outlook and aim ... has been affected by your engagement.' David's future career, he was at pains to emphasise, 'is much more important than yours even to yourself.'[77] Alfred outlined his new vision for his daughter's future: 'Your own qualifications will be useful in the meantime but not essential – though of course it would be most fortunate if you are able to help him afterwards in his actual work while not neglecting the home to do so. Of course I mean real help.' In the same letter, he described his hopes for his younger daughter: 'Vera is beginning to look forward for herself and consider her future occupation ... it must be something so that if events are adverse she can maintain herself and face the world without ... [a] husband who can support her.'[78]

On the couple's return to Melbourne in 1910, Stella did continue her chemical research for two years, including the first year of her marriage, gaining government research scholarships and co-writing an article with David. When interviewed for a local newspaper in 1911, she expressed a continuing commitment to science despite her recent engagement: 'I feel it would be a great privilege to be able to offer one tiny particle of knowledge to the gigantic scientific whole.'[79] Nevertheless, her father's prediction proved largely correct. After 1912, while she took some part in the activities of the Melbourne University Chemical Society and was involved with several women's groups and reform campaigns, she never again engaged in scientific research or any form of paid employment.

A very few women worked briefly after they married and a few more, like Leonora Little, did some further research (usually unpaid).[80] Ada Lambert was highly unusual in the extent to which she worked as a married woman (although she did no further scientific research). Lambert resigned from her university post in 1903 after her marriage to solicitor Thomas à Beckett, the son of a judge of the Supreme Court of Victoria. But despite (or perhaps because of) having married into the upper echelons of Melbourne society, she returned to work in 1912 after the birth of her third son – first to teaching, mainly at the Melbourne Church of England Girls' Grammar School where she had taught in 1890s. From 1917 to 1920 she was back at the University of Melbourne as a demonstrator, working full time in 1918.[81] In 1921 she was appointed as head of the biology department at the elite Melbourne private boys' school Scotch College, where she remained until her retirement in 1937. While teaching was a common enough profession for women, it was not common for women, single or married, to teach in elite boys' schools in such a senior role. Her high qualifications, university lecturing career and the acute shortage of science teachers, not to mention her social position, probably outweighed the disadvantages of gender.[82]

Marriage meant that women like Stella Deakin would have their university careers cut short. Yet, as Deakin's privileged status equally demonstrates, women entering science at the turn of the twentieth century were a highly select group. The overwhelming majority came from white middle- and upper-class families. Most had strong family support, and some, like Georgina Sweet and Jean White-Haney, followed a family tradition in entering the universities or taking an interest in science. But another key factor in their transition from scientific education to employment was the lack of competition from men.

The Shortage of 'Suitable Men'

When Baldwin Spencer advertised for junior demonstrators in 1907, there were only three applicants – all women graduates from his department.[83] In 1912, the director of Melbourne's bacteriological laboratory described his many difficulties in obtaining qualified staff: 'Having lost the services of Dr Fitzgerald (a woman) I am about to lose the assistance of Dr Muriel Davies also ... The loss of two such valuable demonstrators is a serious one ... I have attempted unsuccessfully to obtain the services of one of my past demonstrators.'[84] The dearth of graduates in botany was so severe that in 1911 Alfred Ewart was obliged to appoint Bertha Rees, who was still completing her degree, to lecture in his department. In 1914, as Rees was leaving to be married, Ewart requested that Ethel McLennan, also still an undergraduate, be appointed to replace her. Although nominally a student demonstrator, McLennan in reality delivered two lectures per week during the final term of her degree.[85] When she expressed reservations about accepting a lectureship the following year, Ewart impressed upon her that if she refused the post, 'I shall be in a terrible difficulty as I have no one else.'[86] With so few men completing degrees in the biological sciences, there was little choice but to appoint women.

Many of Melbourne's science professors were concerned about the prevalence of women on their staff, fearful about what this meant for the status of their discipline. Several argued the need to increase salaries to attract male applicants. In 1914, as Bertha Rees was about to retire, Ewart asked that, 'In making a fresh appointment ... the salary be made £400 per annum [and] a man lecturer appointed.'[87] When Wilfred Agar arrived as professor of zoology in 1920, he was

dismayed to find all of his staff were women (even as he also pushed for both Georgina Sweet and Gwynneth Buchanan to be promoted).[88] As he wrote in 1923:

> Up to the present time my staff has consisted entirely of women, and I think it is most desirable that an attempt should now be made to introduce a man on to the staff. The best way of doing this is to make the post a senior one, with a good enough salary to attract, if necessary, some one from outside Australia ... I need hardly say that the Department would be strengthened in this way ... [Unless this is done] it might be many years before the staff was effectively altered from its present feminine character.[89]

Agar was extremely disappointed when his plans were thwarted when no suitable men applied for the new lectureship. He rejected the most qualified candidate, a woman, on the grounds that, 'as all of the rest of my staff are women, I think it is very desirable to appoint a man this time'.[90]

The search for suitable men was not limited to the University of Melbourne. Correspondence between the various biological departments across the country in the 1920s reveals both the extent of female domination of these fields and the scarcity of local qualified people. In 1924 the professor of zoology at the University of Adelaide, Harvey Johnston, wrote to his interstate colleagues seeking (male) applicants for a lectureship in his department. The University of Sydney's Professor Lancelot Harrison replied, 'There is no-one here I could recommend to you. My only men are Murray and Mackerras ... [who] do not wish to leave Sydney. There is a dearth of men students in zoology

at present.' Professor Nicholls of the University of Western Australia wrote, 'I greatly regret that I cannot name a man who might suit your requirements. Most of my students are women and the few men who have passed through my hands are provided for.'[91]

The scarcity of men and the encroachment of women was a 'problem' that extended beyond the biological sciences. When Melbourne's Professor Thomas Laby advertised for a physics demonstrator in 1924, he received only two applications, one from a man who was completely unqualified. He was reluctantly forced to recommend Edith Nelson, who had gained her MSc in his department in 1914, for the position: 'Her appointment will mean replacing a man by a woman demonstrator which is undesirable, as the proportion of women demonstrators is increasing, the salaries paid not being adequate to attract men.'[92] The following year, Laby faced the same dilemma when forced to recommend Nancy Hutchison for another position:

> It is with reluctance ... that I recommend her for appointment, for all our full-time demonstrators are now women, and ... she will make the fourth. I must strongly urge on the University the need for offering a salary for this class of position which will attract men to it, as it is unsatisfactory for such a large proportion of our staff to be women. A larger proportion of men is required if the students are to have the best advantages.[93]

As these problems continued, in 1927 the university council recommended that staff salaries 'should be made sufficiently attractive to secure the services of men of outstanding ability'.[94]

The shortage of qualified men was also a major concern for the new government institutions founded to further scientific research. During

the First World War, the newly created Advisory Council of Science and Industry was very worried that

> the supply of scientifically trained men ... is too small to meet the increasing demand and it views with alarm the prospect that, for some years to come such men may be practically inobtainable [*sic*] just at the time when they are urgently wanted to assist in carrying out the Government policy of the scientific development of Australian industries.[95]

The greatest shortage was in the highly feminised biological sciences. This became apparent after the founding of the Council for Scientific and Industrial Research in 1926. In 1927 David Rivett, the council's CEO, wrote to the registrar of the University of Melbourne seeking assistance with recruitment:

> During the past year this Council has approached you ... seeking the nomination of suitable young graduates to be sent abroad for training in scientific research. In spite of all the efforts that have been made, we have failed so far to secure a sufficient number of men or in some cases any at all, for training in entomology, mycology, veterinary science and plant pathology.[96]

Responses to this letter from the biological professors confirmed the almost complete absence of men in these fields. Summarising these, the registrar noted that while Professors Woodruff (in bacteriology) and Ewart (in botany) reported that they might have one or two candidates in a year or two, Professor Agar stated that in zoology, he had 'no one at present and is not likely in the near future to have anyone whom he

could recommend'.[97] To help counter this problem, Professor Ewart offered a radical suggestion:

> Has the Council considered the possibility of nominating suitable women? Two women could be nominated at once. One of these, Miss Jarrett, was I understand the runner up for the post of assistant mycologist at the Waite Institute. As compared with a man she has no disadvantage beyond the ever present possibility in the case of a woman of marrying and dropping her training or career.[98]

It seems that in this case at least, Ewart's proposal was acted on, as Phyllis Jarrett was given a studentship, studied abroad for two years and was briefly employed as a plant pathologist at CSIR prior to her marriage (when she was forced to resign).[99]

Correspondence about this 'problem' continued over the next few years. At the end of 1928, Rivett again wrote to bemoan the lack of applicants in the biological sciences: 'Of seven research studentships … it has been found possible to award only two … in mathematics and chemistry. There were strong fields in each case … In the other five, the case was very different.'[100] The University of Adelaide's registrar reply summarised the general feeling among the science professors that, 'the absence of suitable men especially in the Biological Sciences, [is] due to the fact that hitherto the prospects for men taking up those branches of science have been particularly uninviting'.[101] Professor Osborn, surveying his Sydney botany students in 1929, more optimistically looked forward to producing as many as *two male graduates* per annum' and intended to interview his male students regarding their futures.[102]

Discrimination and Resistance

The shortage of 'suitable men' was a significant enabling factor that provided an opening for women's entry into science. But anxieties around this equally demonstrate the strength of prejudices they faced even within the universities. Although Australian universities proclaimed that they recognised 'no distinctions of sex', and despite the pervasive myth that 'merit' alone determined status in the academy, the reality was very different. Overtly discriminatory practices were rife and severely curtailed women's prospects compared with those of men. Even men had to navigate a range of entrenched prejudices to succeed. Many factors aside from qualifications and ability were crucial. At the University of Melbourne, selection criteria for senior appointments included 'Moral character', 'Sound health', 'Good manners' and 'Suitable age: not less than twenty-five and not much over thirty-five'.[103] Personality and even physical appearance were all critical considerations. As the selection committee for the chair of geology reported in 1904:

> Dr E. W. Skeats ... is a man of good appearance and manners, high moral character, and is able to excite the interest and keep the attention of students of Geology. He is thirty years of age ... [Lomas] has done a fair amount of good original work and has proved himself to be a very capable organiser; but his age is 43.[104]

Such considerations were not limited to science. The desire to appoint a 'manly man' dominated discussions of the appointment of a new professor of history in 1913. Assessing the candidates, the selection panel dwelled at length on various personal and physical qualities:

> The character of both seems to be fully satisfactory, and it is
> probable that either would manage large classes and guide the
> studies of advanced students ... both in good health, though
> Mr Elder seems to be somewhat the more robust of the two ...
> Mr Elder struck us as a man of determination and grit, who has
> made excellent use of not very large opportunities.

The third applicant, who had strong claims 'on the ground of historical knowledge', was rejected solely on the basis of 'certain physical defects'.[105]

Leadership qualities were key for higher-level appointments and women were rarely seen to possess these attributes. When Harold Woodruff was appointed head of Melbourne's bacteriology department in 1929, he (like Agar) was dismayed to find it was being run by two women (Drs Hilda Rennie and Sara Gundersen): 'I am not satisfied they are assuming, or can assume, the responsibility (under me) that I require ... There is then the urgent need for the appointment of a male lecturer, to be second-in-command.'[106] Even questions of stamina could come into play. In 1928, Edith Nelson and Natalie Allen, who had both been demonstrating in the physics department for many years, applied for the position of lecturer for the evening classes. Making his selection, Professor Laby argued, 'I fully recognise the qualifications of Miss Allen and of Miss Nelson ... but I feel for an evening lectureship combined with day work severe demands on the strength of the lecturer will be made and a man and a young man at that is required for it.' Allen and Nelson remained as senior demonstrators in the department until 1948 when, near the end of their careers, they were both finally promoted to lecturers.[107]

Women were certainly valued as junior staff members, but this was based on assumptions about their limited capacities, prospects and

ambitions. This is abundantly clear in attitudes to women demonstrators. In 1920, responding to a proposal to limit demonstrators' tenure to three years, Professor Osborne argued for the benefits of what he saw as 'unambitious routine teachers' in his department, demonstrators (who were mostly women) with 'sufficient capacity' for the 'hard labour' of repeated teaching of 'junior classes' (and implicitly not for anything more). This work, in his view, was of 'the school teaching order'.[108] Professor Ewart pointed out that 'many women of considerable ability are quite content to accept permanently a salary of £200 with prospects of rising to £300'.[109] It was assumed men would not accept such low-paying positions with no prospects of promotion long term. Most professors opposed the proposal, their main concern being 'to keep a fairly efficient Demonstrator who has thoroughly learned the work of the Department'.[110]

Women were also consistently paid less than men at the same academic level. When Ada Lambert was appointed in 1901, Baldwin Spencer assumed she would be paid £400 as that was 'the salary attached at the present time to the post of Demonstrator and Assistant Lecturer'.[111] This practice was not continued. Standard pay rates for academic positions were not established until the late 1920s and women were often appointed at far lower pay than men.[112] This meant that employing women had some cost-saving attractions. This was particularly true for demonstrators, who, as Melbourne's registrar noted in 1921, were 'appointed at various times on terms which, at the moment, seemed reasonable'.[113] In 1907, for example, Baldwin Spencer recommended Georgina Sweet, who had a doctorate and several publications in international journals, and Freda Bage, MSc, as junior demonstrators. They were each to work two days a week for the first two terms, for the princely sum of £40 a year.[114] As Professor Ewart outlined in 1908 when

requesting an additional staff member: 'Lack of funds may prevent the appointment of a male lecturer at £400, [and] I suggest as a temporary expedient the appointment of a woman lecturer and demonstrator at £150–£200.'[115] The university was able to obtain the services of highly qualified and talented women at bargain rates.

At times, the science professors tried to improve the salaries for women on their staff – particularly if they felt their department was being devalued compared with others. In 1913 Professor Ewart wrote to the university's finance committee about botany lecturer Bertha Rees, pointing out the disparity of her position (and apparently forgetting that the lower salary she was receiving had been his suggestion):

> Frankly I have never been able to understand why a full time lecturer in Botany should be paid the same salary as a laboratory assistant or demonstrator … I feel I have not done justice in my previous application, and would ask the Committee to seriously consider … a salary of £300 per annum and so bringing the appointment more into line with that of other lecturers.[116]

In 1917, Ewart argued for 'an immediate rise of salary' for Ethel McLennan: 'She was originally appointed on £200 a year, which is the same salary as is paid to a woman demonstrator in the Physics Dept. Miss McLennan has exactly the same work to do as a teacher in Chemistry, Physics or Geology and should therefore not be classed with Demonstrators as regards salary.'[117] He was by no means the only professor to make such arguments. Interdepartmental rivalries often provided ammunition for women's claims. In 1921 Wilfred Agar wrote to the university registrar, 'My full time demonstrator, Miss Raff, receives, I believe, only £200 per annum, whereas I understand that

persons (women) occupying the same position in other departments receive a larger salary.'[118] While these interventions suggest a degree of support for women staff, the professors were at least equally motivated by the apparent insult to their departments that these low salaries represented.

Women staff did not simply sit back and accept this state of affairs. Many challenged their lower wages and status both individually and collectively. Ethel McLennan fought for equal recognition and remuneration right from the start. When she was first appointed in 1915, she was offered a salary of only £150 – less than had been paid to the previous, female, lecturer. McLennan stridently rejected this offer. With Ewart's support, she wrote to university registrar in strong terms: 'The Council can … hardly expect me to give up my present prospects and accept a lower salary than the previous lecturer, which would be an admission of inferiority on my part and subject me to monetary loss.' Ewart recommended that she could instead apply for a Government Research Scholarship: 'You will have the same salary as if you were teaching but will be improving your status still further.'[119] The council finally relented when Ewart emphasised that no other qualified candidates were available. But it soon became clear that even the higher salary she negotiated was much less than male lecturers in other departments. It was this that prompted Ewart to request an 'immediate rise of salary' for her in 1917. He again stressed that McLennan was unwilling to remain, there was no one who could easily replace her, and if the increase was not granted, he was 'likely to be in a position of considerable difficulty'.[120]

McLennan's protests were successful in that she was given the pay increases she demanded. But she was still far from parity with her male (and some of her female) colleagues. She was paid the same as

some demonstrators in other departments, despite her higher rank as a lecturer. The disparity of her position was stark. In 1919 the university's male lecturers petitioned for a general pay rise but did not include McLennan. When she discovered this, she wrote angrily to the university council, 'I am the only full-time lecturer excluded. My work in the Botany Department is as exacting as that of any other lecturer's ... [but] my salary is not only the lowest, but very considerably the lowest.'[121] Her protest inspired further collective action by women demonstrators in the science faculty seeking equal pay for equal work. On the same day, Isabel Cookson, Janet Raff and Leila Green also wrote to the university council. Pointing out that they represented 'three of the four <u>full-time</u> demonstrators in the Science departments', they urged 'consideration of the present lack of uniformity in salaries paid to us for equivalent work'.[122]

Conflicts over salaries and status continued throughout the 1920s, culminating in 1930 when Georgina Sweet wrote to the university registrar nominating four women for promotion to associate professor: Ethel McLennan, Gwynneth Buchanan, Jessie Webb and Enid Derham in English. As Sweet outlined, all were longstanding and respected members of staff:

> The time has arrived when the undoubted claims of these individuals to such appointments should be most carefully and conscientiously weighed ... [M]y belief [is] that impartial consideration of their work and service should result in such appointment. Three at least – if not all four – of these have been previously recognised as being fit to be Associate Professor, in as much as their several departments have been left in their charge during the absence on leave of the Professor.

She concluded by asking that 'their merits be considered severally and separately as individuals and irrespective of any question of sex'. Her proposal was rejected, as it was ruled she did not have the authority to make such nominations. Sweet reluctantly accepted this and instead sent her recommendations directly to the relevant professors.[123] Despite her efforts, Ethel McLennan was the only one who was ever promoted.

Pioneering Professors and the Glass Ceiling: Georgina Sweet and Ethel McLennan

The shortage of men provided women with some openings but their prospects were limited. Many found themselves 'stuck' in low-paid demonstrator positions, with no prospect of promotion and no opportunity for research. Academic careers were generally only available to white, middle-class, unmarried women who could afford to go to university in the first place. But even for these women, career progression was not guaranteed. It was not until 1959, for instance, that Queensland geologist Dorothy Hill became Australia's first female professor.[124] The careers of Georgina Sweet and Ethel McLennan are key examples of both opportunities and disappointment for women in science.

In 1912, Georgina Sweet became the first Australian woman to apply for a professorship – specifically the chair of biology at the newly established University of Western Australia. She observed, 'I have very little hope ... but feel I should not be doing rightly by other women and by my University and laboratory if I did not apply. We all expect a non-Australian man to be appointed.'[125] Her prediction proved almost correct. The chair went to Norman Wilsmore,

an Australian with substantial overseas experience (and who was married to Leonora Little). Sweet's application was, however, supported by many senior male scientists and academics who all wrote glowing references. Anticipating the likely concerns of the selection committee, many of these emphasised 'her ability to control classes of men'. Others addressed the issue of gender more directly. Dr Perrin Norris, the Commonwealth Director of Quarantine, wasted no time in pointing out that 'Dr Sweet is a woman, and recognising that her sex may in the first instance suggest itself as a disadvantage, I would refer to this matter straight away'. Richard Berry, Melbourne's professor of anatomy (a renowned eugenicist and 'collector' of Aboriginal remains), expressed the hope that Sweet's application would not be ruled out 'on the grounds of sex alone. I know from first hand observation that Dr Sweet can perform the duties of the Chair as well as any of her male competitors'.[126] Baldwin Spencer gave her application the strongest support, praising the high quality of her research and teaching, and concluding that 'if any doubt should exist in the minds of electors as to the advisability of appointing a woman to this Professorship, that doubt would be dispelled if they were acquainted with the nature of the work that has been done and the position that has been held by Dr Sweet in the Melbourne University'.[127] Spencer offered his full support for Sweet again when she applied for the Melbourne zoology professorship in 1919, which was created due to his own impending retirement. He even tried to have Sweet's specialist area of research included in the terms of the appointment.[128] Again, however, Sweet was overlooked in favour of a man with overseas qualifications. Although she was promoted to associate profession the following year, she never reached the highest academic rank.

Sweet enjoyed the strong support of Baldwin Spencer. Ethel McLennan was not so fortunate. On several occasions Professor Ewart undermined her position in the botany department. In 1922, when going on leave, Ewart ignored McLennan's claims to be appointed acting head in his absence, arguing that: 'Dr McLennan is senior to Mr Patton but … there are however advantages from a disciplinary point of view in a man holding the position.' When McLennan learned of Ewart's decision, she appears to have gone on strike, refusing to come in to university on Wednesday afternoons and Saturday mornings and then taking extended sick leave. Due to a range of other conflicts, their relationship deteriorated to an extent that Ewart attempted to have her dismissed.[129] In 1930 he finally recommended Ethel McLennan's promotion. His letter shows his extreme ambivalence about this, and he openly admitted that it was entirely based on her gender:

> I have been exercised for some time lately as to whether it has not become a duty obligatory upon me to recommend Dr McLennan for the title of Associate Professor. Any hesitation I had was, I am afraid, simply due to the fact that she is a woman. As a teacher, organiser and research worker her claims are outstanding and she is senior, with possibly one exception, to all those eligible now or at any future time for the title of Associate Professor.[130]

While McLennan was promoted in 1931, this proved to be the limit of her prospects. She failed in her bid for the Melbourne botany chair in 1937. Like Sweet before her, McLennan's application had strong support from some of her scientific colleagues. One member of the selection committee went so far as to write directly and at length to the vice-chancellor:

There is no [Australian] candidate whose claims are superior ... and out of this list I would have no hesitation in appointing her. Even supposing the applicants from abroad are of a good standard I would still think seriously before passing over Dr McLennan. Of her claims as a Scientist and Research worker there is no doubt. As to her ability to administer the Department and to re-organise it, I feel completely assured ... I believe that if this University is ever to appoint a woman to a Professorial Chair this opportunity should not be missed as we might go a very long time without ever again having so generally capable and fitting a person.[131]

The vice-chancellor then wrote to the Secretary of the Universities Bureau of the British Empire that there were 'complications' as 'the acting-Professor is a woman' but expected that if the English candidates were 'are as good as they sound' one of them would be appointed.[132] The selection committee was eventually swayed in favour of John Stewart Turner, with his Cambridge degree and experience of 'standards and methods of teaching elsewhere than Melbourne', despite his relative youth and inexperience.[133]

When the decision was made public, all five of the other women in the botany department wrote to the vice-chancellor of their hope 'that the Council might have seen fit to appoint her ... [F]airness to Dr McLennan demands that you should know something of the atmosphere of disappointment that prevails in this department today'.[134] David Rivett wrote to McLennan of his disappointment and assured her that 'You had more than earned the post.'[135] Even Professor Agar, who had made his distaste for women on the academic staff abundantly clear, had second thoughts about the choice. Writing to the vice-chancellor, he admitted:

115

I have been worrying about the decision ... especially as I feel that I perhaps was the strongest against the rejected candidate. I feel now that I did not fully enough realise one aspect of the case ... namely that we propose to appoint a man on his promise rather than on his established position.

He suggested it would be relatively easy to reverse as several members of the selection committee had clearly favoured McLennan.[136] The vice-chancellor did not act on this suggestion. Georgina Sweet then attempted to have the decision overturned by the university council – where she had recently been elected as its first woman member. She twice proposed a motion that McLennan be appointed instead of Turner, but her efforts were eventually defeated.[137] Ethel remained an associate professor until she retired in 1955.

Conclusion

In 1934 when Frances Thorn and Doris McKellar wrote the entry on 'University Women' for a centenary volume on Victorian women, they observed that it had been 'comparatively easy for women to study science and its various branches'.[138] This statement, while not without some truth, could only have come from women in a highly privileged position. It was only such women who could conceive of going to university or imagine themselves as scientists. At the turn of the twentieth century, a range of factors converged to provide a window of opportunity for women's entry into science. They were able to capitalise on this for quite some time. Science was a new and growing field, but there was a scarcity of men aspiring to become scientists. Women science graduates often found they were in demand – particularly as teachers,

but also in the lower rungs of academia. There were certainly greater opportunities for women in science than most other academic fields. Women's dominance in the biological sciences especially meant male professors' desire to recruit men into their departments was largely unachievable. They had little choice but to support and employ some of their numerous women students. Even in physics and chemistry, women's services had to be enlisted despite strong prejudices against them.

Women made substantial and important contributions in this critical period in the development of Australian science, both through their own research and in training the next generation of scientists. Their experiences are suggestive of the very real ability of white, middle-class women to circumvent apparent obstacles of gender in this period, especially if they remained unmarried. At the same time, even this highly advantaged group did not enjoy any sort of 'equality' with men. In pursuing their careers, they faced powerful individual prejudices and what is now called structural discrimination – obstructions that they both clearly recognised and fought hard to expose and overcome. These obstacles were not sufficient to exclude women from science altogether, but they were influential enough to limit their options and to stop them from reaching the top ranks of the profession.

Chapter 4

Making a Better World?

Women and the (Racial) Science of Social Reform, 1890–1940

The intellectual development of women will provide most valuable co-operation for the future social reformer ... [T]hey will prove themselves in the wide field of human suffering, where enlightened scientists will always find abundant scope for their benevolent labours.

—Bella Guerin, 'Modern Woman',
Sydney Quarterly Magazine, 1887

When Bella Guerin came to write about the impending age of educated women in the late 1880s, she stressed the enormous benefits that would flow from women's increased capacity to tackle the most pressing problems facing humanity. She attributed this not so much to their intellectual contributions, but to their new ability to undertake effective social reform. Contemplating the future impact of this 'new woman'

in the *Sydney Quarterly Magazine*, and writing enthusiastically about the emerging field of 'social science', Guerin concluded that women would 'prove themselves' as 'enlightened scientists' in this field.[1]

As Guerin's piece suggests, women's scientific interests in the late nineteenth and early twentieth centuries were by no means confined to the laboratory or the university lecture hall. They stretched across society as a whole. This was a time of great optimism that science would provide solutions to all social problems, particularly poverty. Across the Western world, science, rather than religion, was increasingly seen as the key to making a better world. Social reform was to become a scientific quest, rather than a Christian philanthropic endeavour. In Australia, this was portrayed as a 'general feeling which is taking possession of the enlightened public mind, that Science has its mission, and that it will yet solve many of our social problems'.[2] There was a proliferation of new organisations dedicated to applying science to improve the 'common weal', and the focus of many older groups moved accordingly.[3] This evolving reform movement overlapped strongly with charity work and philanthropy – areas where women's involvement was not just respectable, but expected.[4] Science also began to infuse other 'traditional' spheres of female activity. Reform movements were crucially concerned with childrearing, the home, health and education; they created spaces for educated, white, middle-class women not only to engage with the modern scientific age, but to claim authority within it.[5] Women were a major force in these new movements, initiating campaigns for hospitals, kindergartens, playgrounds, infant and maternal health centres, school medical examinations and other public health services, among many other causes. Many of these campaigns, which coincided with what has been called 'maternal feminism', were successful, resulting in the

creation of entirely new areas of state activity and intervention.[6] This in turn produced significant new fields of professional employment. And many of these new jobs were in areas that became 'women's work' – kindergarten teachers, educators, administrators, nurses and doctors in areas relating to women and children. Through these campaigns, women achieved important reforms that helped reshape Australian society, and they created new professions for themselves in the process.

Women's active involvement in scientific social reform in this period is not usually considered in histories of women and science; but just as an appreciation of women's popular, amateur pursuits in the nineteenth century reveals the extent of their earlier scientific endeavours, women's strong participation in scientific social reform shows their engagement with the broader culture of science. These activities show that rather than being alienated from the increasingly scientific modern world, some (usually privileged) women embraced and promoted it. But, again, like women's involvement in colonial science, not all of these activities can be seen as 'benevolent'. The rise of scientific social reform was fuelled by racist ideologies and prejudiced attitudes towards the 'degenerate' and 'inefficient' working classes. In Australia, these attitudes were bound up with the desire for a strong white population to ensure the nation's future.[7] This was the era when the White Australia policy reached its pinnacle as the defining foundation for the nation. Many reforming efforts drew on the pseudoscience of eugenics and were aimed at increasing and improving the 'white race' to secure this national foundation. Women's participation in these reformist movements shows that science and modernity were open to feminisation and underscores the significance of race science as a motor of modern social reform.

Women and the Science of Social Reform: Poverty, Parenting and Children

Writing in 1905, Adelaide doctor Rosamond Benham observed that the 'need for good conditions in life is just what all scientific reformers concern themselves with'.[8] The idea that scientific knowledge could be used to improve the conditions of human life excited the interest of many Australian women and spurred them into action. This belief in the power of science was clearly expressed, for example, in the work of Alice Henry, a prominent Melbourne journalist and member of the local branch of the Charity Organisation Society. Henry's journalism championed the causes of children's courts, women's hospitals, epileptic 'colonies', care for the handicapped and labour reform – all of which sprang directly from new scientific conceptions of social reform. Reporting in scathing terms in 1899 about the Brookside Reformatory for Girls, an institution in rural Victoria run entirely by women, Henry focussed on the inadequacies of the staff:

> Miss King is doubtless actuated by the best of motives ... but what are her training and qualifications for a post demanding the *scientific* treatment of such girls[?] ... [None of the staff] had the remotest conception of the *psychological* aspect of their work ... of the *thorough training* ... to which *she* must attain who would venture into a field like this.

Henry's concern was not just that the girls were being mistreated (which, as she documented, they most certainly were), but that they were not being 'reformed'. She emphasised the 'low character' of the inmates: 'Some are criminal, almost all are grossly immoral ...

[some] are mentally deficient.' The public expected the money given to the institution would be spent on 'taming the brutal impulses and developing the social ones ... the lessening of vice and the developing of the higher nature'. The 'unscientific' way the institution was run was a waste of government funds. Rather than moral or religious injunctions, Henry drew on new scientific and psychological theories that had produced new ideas about what could and should be achieved in these kinds of residential reformatory institutions through a combination of discipline, training and promoting 'fresh and wholesome interests'.[9]

Many other women were drawn to new organisations that sought to apply science to modern social problems. Among the earliest of these was the Royal Anthropological Society of Australasia, which actively courted women's participation (Bella Guerin was an early member of the society's council). The society, headed by Dr Alan Carroll, had a broad scientific and social-reform agenda that stretched well beyond Aboriginal Australia. Its journal, *Science of Man*, repeatedly asserted the society's contributions to 'scientific and sociological' advancements, emphasising that 'by anthropological methods sure knowledge would be obtained, and certain [social] reformations would be accomplished'.[10] To further this aim, in 1898 the society started a Laboratory Association to raise funds for an 'Anthropometrical, Psychological and Psychiatrical' laboratory, to conduct research primarily on (white) children.[11] Anthropometry had emerged in the nineteenth century as a method used by physical anthropologists to study human variation and evolution, and was strongly taken up by the Galton Eugenics Laboratory at the University of London from the early 1900s.[12] It was based in the (now discredited) belief that physical characteristics could be correlated with 'racial', intellectual and psychological traits

and involved taking dozens of detailed body measurements. Carroll believed that anthropometric and psychological testing would allow medical practitioners to identify 'abnormal', 'degenerate', or 'defective' traits in children, which might then be corrected through behavioural and other interventions, particularly diet.[13]

The society's prioritisation of children in its planned program increased its attractiveness to women and made them obvious allies. In 1900 one of Sydney's 'leading ladies' held a fundraising 'drawing room meeting' for the Laboratory Association. Not long after this event, *Science of Man* reported on the society's progress in petitioning female support:

> The Laboratory Association is advancing, letters are being addressed to those influential ladies in Sydney who have not already joined this movement, requesting them to hold drawing-room meetings, to bring the subject before those ladies who could assist, and to obtain their aid to help on this reform in education for the benefit of all the children of all classes, and to measure and test them.[14]

In another of its articles, the journal stressed that 'the ladies of the country' would be better engaged in supporting the Laboratory Association, with its scientific methods of reform, than charitable and religious societies whose methods had been found inadequate. The association became so female-identified that the editor had to spell out that 'gentlemen will also be invited to assist'.[15]

Women were even more prominent in Australia's first Child Study Association, also founded and headed by Alan Carroll and which he promoted as 'the most useful Society' women could belong to.[16]

The group's first meeting in 1898 featured an address by Miss Ridie Buckey (an American graduate of the Chicago Normal School then working as a trainer with the Kindergarten Union) and women were the majority of the association's membership and leadership. The scientific approach of this group was explicit: its work was to be 'principally of an anthropological nature, especially the branches of anthropometry and psychology'.[17] From 1903, with the Laboratory Association languishing through lack of funds, Carroll concentrated his attention on child study where his efforts met with greater success due, in part, to his engagement with women reformers. In this year, the Child Study Association was reinvigorated with a new, female-dominated committee, and held nine lectures, including addresses from Drs Mary Booth and Agnes Bennett. Carroll then split from this group and established a new organisation (confusingly with the same name) in conjunction with Mrs Sarah Izett, then president of the Political and Social League.[18] The list of 'instruments' the group wanted for the 'special treatment' of 'defective' children in a laboratory was long and expensive, including a range of obscure but impressive-sounding measuring and electrical treatment devices: 'Lombroso's gnometer (for measuring angles), the psychograph, the cranio electron, the Finsen light apparatus, the miograph, and the eograph'.[19] Despite her lack of qualifications, Izett became deputy president of this new group, delivered public addresses on its behalf, acted as 'chemist' for its dispensary and even wrote a 'Dietary Cook Book' and other pamphlets on the importance of 'fresh', 'pure' milk based on Carroll's theories. After Carroll's death, Izett published *Health and Longevity* – another book based on his writings with her own interpretations liberally added – and had it reprinted five times between 1915 and 1927.[20] The scientific aspirations of women involved in these groups

were emphasised in a 1906 *Daily Telegraph* report: 'This is the children's season. On every side and from every platform we hear ... dissertations on the upbringing of children, and the fearsome words psychology, anthropology, and such like drop lightly from ladies' lips as they talk of scientific education. The very latest idea is to treat youngsters scientifically.'[21]

Scientific social reform movements provided middle-class women with wide opportunities to engage with modern science and claim authority within it. These possibilities were even greater for university students and graduates. As Bella Guerin intimated, from an early stage, social work was a prominent feature of university women's conception of their new role and the contributions they could make. They were assumed to have the necessary knowledge, and mentality, for this 'uplifting' mission. The small but growing number of university women began to play a major role in these new social-welfare and reforming groups. They were thus centrally involved in the new scientific approach to solving social problems.

The Sydney University Women's Society, formed in 1891, is an early example of this. The group comprised students and graduates, and aimed to provide assistance to 'anyone requiring or deserving help'. Its members initially worked in local hospitals and asylums, and soon rented out rooms and established a club for working-class girls, which hosted various classes as well as social events. In 1908 the society founded a Settlement House in a working-class suburb near the university that became its main focus. The following year, the society started a Mothers' Club in the settlement where a nurse from the recently established Alice Rawson School for Mothers gave advice on childcare and the importance of cleanliness and hygiene.[22] Here they were following the 'settlement' movement that had emerged

in Britain in the 1880s and soon spread to the United States.[23] This movement was closely connected with universities and took a distinctly scientific approach to addressing poverty in large cities. In the United States, where it was particularly associated with women reformers, it was sometimes described as 'scientific philanthropy'. Settlement houses provided services such as education and healthcare intended to improve the lives of the poor and were key sites for the development of social work as a science-based profession. They were also the sites of some of the earliest large-scale social-research projects, reflecting the desire to investigate society more systematically and empirically. These social surveys collected all kinds of statistics and other information about the urban poor. Although the Sydney Settlement House never had the resources for work on this scale, its connection to this international movement gave it validation and boosted women's claims about the importance of their mission.

Women at the University of Melbourne undertook similar work, though on a smaller scale. Some of them were members of religious philanthropic groups that had adopted scientific approaches. Such groups reflected a growing belief that science and religion could work together towards common ends. In 1899 the Women Students' Christian Union founded a Factory Girls' Club.[24] While this club had a fluctuating existence, in 1908 Georgina Sweet, addressing the local Young Woman's Christian Association, reported that they had 'appointed a special committee to investigate conditions in Melbourne, and see where best to carry on operations ... A club [for girls] had therefore been started ... The object was to improve the girls morally, spiritually, socially, physically and mentally'. By 1912 they had rented a house and were calling for more university women to become involved so that the problem could be 'effectively dealt with'.[25] These small

beginnings were the starting point for the much larger leadership and authority that university women would soon assume.

Women graduates often presented their substantial and effective contributions to social-reform work as a vindication of women's admission to higher education. Speaking in response to a recent controversy over women's higher education at the Australian Federation of University Women conference in 1938, Melbourne lawyer Anna Brennan argued:

> It should be emphasised that in the most valuable constructive work for child welfare in the community it is [women] university graduates who are taking the leading part ... To mention only a few names, there are ... Mrs E. E. Waddell who has been associated with Dr Georgina Sweet, Mrs a'Beckett, and other graduates in the Sex Education Society; Dr. Mona Blanch, who is honorary medical officer for the Free Kindergarten Union; and of course, Dr Vera Scantlebury ... director of infant welfare.[26]

The association between educated women and science-based reform provided a platform for public activism as well as new professional openings. They were part of what has been called the shift from 'moral to professional authority' in women's public work taking place across the Western world.[27] As Frances Thorn noted in her presidential address to the 1924 conference of the Australian Federation of University Women, educated womanhood was now free to reach 'out to all weak and helpless things ... The woman doctor mothers the babies of a whole neighbourhood ... The social worker cares for the girls in factories and workrooms, and the woman legislator will help to make laws for their protection'.[28]

For the growing number of unmarried, middle-class working women, such activities were sometimes represented as alternative outlets for their maternal instincts. As Georgina Sweet suggested in 1926, for unmarried women, 'active social work' provided 'a new lease of life … that thus their lives need not be empty and unproductive' even if they could not 'fulfil woman's primal end'.[29] For married women graduates generally precluded from paid employment, voluntary work let them continue to exercise their intellect and authority in the public domain. A very few, like Vera Scantlebury, were able to combine marriage and motherhood with both paid and voluntary work.

Ada à Beckett's involvement with the kindergarten movement shows the leading role that university women with scientific qualifications were assuming in these reform groups. Following her university lectureship, à Beckett (nee Lambert) married and gave up paid employment for several years while having her three children. She nevertheless continued her voluntary involvement with women's groups, particularly the Free Kindergarten Union of Victoria. She was a foundation vice-president of the union in 1908 and later president from 1919 to 1939 (a role she maintained alongside her job as head of the biology department at Scotch College). The union grew quickly from four kindergartens in 1908 to thirty-four, with over 2,000 children, by the mid 1930s.[30] Kindergartens were conceived as a distinctly scientific intervention into child development closely associated with the child-study movement.[31] À Beckett's biology qualifications, although not directly connected to early childhood development, were highly valued by the union, bolstering its claims to authority. She had considerable influence over the development of the union's Training College. By 1922 its two-year course was dominated by psychology, physiology, hygiene and nature study, alongside the methods of education theorists Friedrich

Fröbel and Maria Montessori.[32] Although voluntary and unpaid, this work required much time and expertise. And it directly created a new profession for women as kindergarten teachers.

Only poor children were admitted to these early kindergartens. The movement was based on assumed deficiencies of working-class homes and mothers. It was believed that children needed to be saved from this environment, since 'it is a generally accepted fact that our working-class population needs lessons in … how to bring up their children'. It was also assumed that educated women from the middle and upper classes were ideally suited to deliver these lessons. This work required the 'right women … Women of education, from cultured homes'. The movement aimed to exert a scientific influence over working-class mothers too. In Victoria, mothers' clubs were established where 'lecturettes upon hygiene, care and upbringing of children, etc., were given' in the hope that kindergartens would also become 'centres from which the simple rules of hygiene in connection with child-life may be disseminated'.[33]

As state governments across the country increased their provision of services in public health and other areas, they created new professional opportunities for women. From the 1890s, women were appointed as factory inspectors, largely due to pressure from women's groups,[34] and from the early 1900s women took up positions in school medical services and maternal and infant health. These new openings particularly benefited women doctors. Dr Gertrude Halley became the nation's first school medical inspector in Tasmania in 1906, and in 1908 expressed the 'hope that many [future] appointments … will be filled by medical women'.[35] This hope was largely realised. Halley moved to the New South Wales Department of Education in 1909 and then went on to found the school medical service in South Australia in 1913.[36] Drs Mary Booth and Jean Greig were two of the three initial Victorian

appointees in 1910. This service remained female dominated until the 1930s with first Greig and then her long-standing colleague Eileen Fitzgerald becoming chief medical officers in Victoria's Department of Education.[37] Eleanor Bourne became the first medical officer appointed to the Queensland Department of Public Instruction in 1911, and in 1918 Roberta Jull was appointed as the first school medical officer in the Western Australian Public Health Department.[38] In New South Wales, a Department of Maternal and Baby Welfare was established in 1920 with Elma Sandford Morgan as assistant director from 1929, while from 1926 Vera Scantlebury was Victoria's first Director of Infant Welfare, combining marriage and motherhood with this role.[39]

Making a Better Race: Scientific Reform, Eugenics and White Australia

Scientific social reform was often couched in terms of general human betterment. But it was profoundly shaped by a much more specific national objective: the advancement of White Australia. This manifested in restrictions on the immigration of people from non-Anglo countries (the infamous White Australia policy), and diverse and devastating policies of segregation, incarceration, child removal, 'biological absorption' and other programs of state control directed at First Nations peoples under the banner of 'protection'.[40] Beyond this, there was a broad consensus, across the political spectrum, that Australia urgently needed a larger and healthier white population to secure the national future. This was where most women reformers focused their efforts.[41] Mary Booth, for example, believed school medical services should collect anthropometric data as a means of 'stock-taking of the physical fitness of the nation' for use by the 'eugenist' to determine

'what the race may become'.[42] The desire for racial improvement and concurrent fears of racial degeneration held great potency, and it was to eugenics that many reformers turned in the hope of countering the spectre of 'racial decay'.

Eugenics was founded by the British anthropologist, statistician and cousin of Charles Darwin, Francis Galton, who coined the word in 1883. Inspired by Darwin's evolutionary theory, and especially the concept of the 'survival of the fittest', Galton argued that human evolution could be advanced through selectively encouraging reproduction of 'superior' individuals (positive eugenics) and preventing reproduction of the 'inferior' or 'unfit' (negative eugenics), along with other medical, scientific and social interventions (environmental factors). As he defined it, eugenics was concerned with 'all the influences that improve the inborn qualities of *a race*; also those that develop them to the utmost advantage'.[43] In other words, it was dedicated to the production of the highest human 'types'. In the West, eugenics was deeply shaped by the belief that the white, Caucasian, Aryan or European races, as they were variously termed, represented the pinnacle of human evolution; they were placed at the top of the racial hierarchy. Galton was a confirmed racist with a fierce belief in Anglo-Saxon superiority and the importance of safeguarding its racial purity. In the United Sates, dire eugenic warnings about 'racial mixing' and impending 'race suicide' due to declining white birth rates reached their apogee in Madison Grant's, *The Passing of the Great Race; or The Racial Basis of European History*, which appeared in 1916, and Lothrop Stoddard's 1921 book *The Rising Tide of Color Against White World-Supremacy*.

The implementation of eugenic 'science' is most tragically associated with the Holocaust, a genocidal agenda designed to protect the purity of the 'Aryan race' from Jewish 'contamination'. But its influence

extended far beyond Nazi Germany. Organised eugenics movements emerged in Britain and the United States, as well as Germany, in the early 1900s, and spread to many other European countries, Canada, Central and South America, Japan, India and Australasia. In the early twentieth century, eugenic ideas enjoyed wide support among politicians of all stripes, public servants, doctors and scientists, as well as both conservatives and progressive reformers. It inspired programs for immigration restriction, segregation, sterilisation and biological absorption, but also more mundane strategies for 'racial improvement' from premarital health certificates to school medical services, kindergartens and programs for public health – especially maternal and infant health.[44] Eugenics thus strongly overlapped with many areas of women's social reforming activities and was an accepted part of this reform agenda.

In Australia, a rising commitment to eugenic thinking and the objective of white racial improvement emerged across a wide range of women's reform activities.[45] From the early 1900s, Australian reformers generally were increasingly drawn to the promise of scientific social intervention that eugenics seemed to offer.[46] Eugenics spoke to both their patriotic and scientific motivations. The view of women as 'mothers of the race' was a powerful unifying concept and rallying call for women to take special responsibility for saving and improving the 'white race'. It is hardly possible to read an issue of any Australian women's periodical in the years up to the Second World War without coming across some reference to the importance of racial improvement and women's duty to help the nation achieve this. Writing in 1930 for *Herself*, a magazine published by Sydney's women's organisations with a strongly eugenic focus, Irene Longman, Queensland's first woman member of parliament and sometime president of that state's

National Council of Women, reflected on the topic 'Women's Objective – A Perfect Race'. She argued:

> Many of our most pressing difficulties ... could be relieved by the scientific and courageous tackling of such problems as mental deficiency and other questions concerning the health of the race ... *We women must seriously consider this terrible problem of the unfit* ... The women of our day and generation are more fitted than those of any other period to continue the great traditions of the race from which we have sprung.[47]

As Longman suggested, through educating themselves and others in modern eugenic science, women could contribute to solving this vital national problem.

The Place of Women in Eugenics

Alan Carroll, like many other reformers, believed in 'the supreme right of the nation to an increasing population, every unit of which must be healthy and normal' and 'the right of the child to be well born'.[48] It followed, then, that women's natural place was in the home. But this did not necessarily preclude them from being active students, educators and advocates of the new science of eugenics. On the contrary, Carroll asserted the value of women's involvement and wrote enthusiastically about their growing influence: 'Crime, intemperance and madness can be stopped by the women, as these things depend upon heredity and environment ... The housing of the population, sanitation, prevention of the marriages of the unhealthy and unfit, or criminal ... may beneficially engage the attention and action thereon of women of influence.'[49]

A core belief in eugenic theory was that many 'undesirable' qualities or traits – such as epilepsy, physical disabilities, mental illness, criminality, homosexuality, poverty, alcoholism and prostitution – were inherited and passed on by sufferers to their children. Many eugenicists believed that the 'unfit' were untreatable and irredeemable. Others, including Carroll, believed that 'defective' children could be treated through changes to their environment.[50] The Child Study Association he founded promoted 'anthropometry and psychology' as instruments that could be used not just to detect 'harmful or abnormal, or degenerate' traits, but also to treat and train children towards perfection, instead of allowing them 'to waste or degenerate'.[51] The members of this organisation aimed to carry out 'active work' with 'defectives' and 'imbeciles'.[52] Ultimately, Carroll believed that 'children can, by proper means, be advanced to the highest types'.[53] Kindergartens were similarly intended to 'combat the evil which heredity has wrought' and to produce a 'loftier race'.[54] As the Victorian Kindergarten Union expressed it in 1915, 'Our work in the Kindergartens is in the highest sense a national service. We ... must continue to fight for opportunities for the children of our race ... [so] they may be trained physically, mentally and morally to become later worthy citizens of our glorious Empire.'[55] For these reformers, children were pivotal to building the health of the nation. As child rearing was the province of women, they were an especially important part of this strand of eugenics. They were also indispensable to the eugenic goal of 'racial improvement' through selective reproduction.

In Australia (as in Britain, North America and many other countries), women were active participants in the formation and membership of eugenic organisations.[56] Women's involvement in eugenic groups was often a key criterion for success. Australia's first formal eugenic

group was formed in 1911, as a short-lived subcommittee of the South Australian branch of the British Science Guild. This group was male dominated. But women represented half of the section on 'Infant Nurture', while the 'Scientific Nutrition' and 'Science in Schools' committees included Edith Devitt, Domestic Arts Officer in the South Australian Education Department, and botanist Ellen Benham, the University of Adelaide's first woman lecturer.[57] The following year, a branch of the British Eugenics Society formed in Sydney. This group was small and dominated by university and medical men. Nevertheless, in 1914 the secretary noted the presence of 'leading professional men *and women*' as evidence of the success of a recent lecture.[58] The same year, an article about the society appeared in the women's pages of the *Sydney Morning Herald*, inviting the 'serious-minded' to join, while its (last) report in 1921 report commented that audiences at lectures for the year had 'consisted chiefly of women'.[59]

Also in 1921, the Women's Section of the Workers' Educational Association of NSW formed a Eugenics Study Circle. By 1922 this group had twenty-five (mostly female) members, and the organisation's journal, the *Australian Highway*, published a series of three articles on 'Heredity in Relation to Eugenics' by Ellice Hamilton (BA, BSc, MB, ChM), demonstrator in physiology at the University of Sydney, based on the lectures she had been giving to the group.[60] Hamilton called for eugenics to be included in the university curricula and for the 'permanent segregation of defectives' in order to stop 'evils which are ever increasing and threatening our race with ruin and degeneration, mental, moral and physical'.[61] In 1929, the Workers' Educational Association formed a class on sex education due to the popularity of lectures given by the well-known local eugenicist Marion Piddington.[62]

Born in Sydney in 1862, Marion assisted at a school run by her mother before marrying the prominent Sydney barrister and later royal commissioner Albert Piddington in 1896.[63] For some time after her marriage and the birth of her only living child in 1906 she was not active in the women's movement or other local reforming efforts. But she did develop an intense interest in eugenics. In 1912 she attended the International Eugenics Congress in London with her husband, and she became an avid reader of the *Eugenics Review* – the journal of the British Eugenics Society.[64] Her strong adoption of eugenics was confirmed in her 1916 (anonymous) publication *Via Nuova, Or, Science & Maternity*, a short, whimsical tale of a 'celibate' mother and her child. The book advocated a program to allow women (of good stock) who were left husbandless by the First World War to have children through artificial insemination. Piddington emphasised that this scheme accorded with 'the principles of modern eugenics' and would enable women to contribute to rebuilding 'a nation in which the best men and the best women might become the parents of children and so produce the highest type of human being'.[65] As she later wrote in a letter to Marie Stopes (a leading British eugenicist and birth control activist), celibate motherhood represented her dream of achieving a 'new race' through 'eugenic procreation'.[66]

By 1918 Piddington had given up the cover of anonymity and began publicly to promote her scheme of 'eugenic', 'scientific', 'celibate' or 'faculative' motherhood, as she variously called it. Piddington wrote newspaper articles and pamphlets, spoke to a range of women's groups and held her own public meetings. In August 1918 the Women's Political Association held a woman-only conference on 'Scientific Motherhood', which drew 'a large audience' and gave Piddington's ideas 'a courteous and interested' hearing before being debated (and

vehemently opposed) by the author Mary Fullerton.[67] Piddington also sought support for her scheme from eugenicists internationally, sending her pamphlets to the Eugenics Society in England and to Charles Davenport, head of the Eugenics Record Office in the United States. For nearly twenty-five years, from 1919, she conducted an extensive correspondence with Marie Stopes.[68] Stopes had gained international fame for her 1918 best-selling book *Married Love*, a sex manual which advocated and gave some practical information about contraception, but which also reflected her intense commitment to eugenics. Like Margaret Sanger in America, Stopes was a feminist who wanted women to have autonomy and control over their reproduction, and enjoy sexual pleasure within marriage. But she also promoted birth control as a key tool for racial improvement and believed that the 'unfit' should be compulsorily sterilised. These two objectives were not mutually exclusive. As she wrote to US President Woodrow Wilson, Stopes believed that birth control would 'hasten the establishment of a new era for the *white race* when it may escape the sapping of its strength and the diseases which are the results of too frequent child-birth'.[69]

Piddington received little support for her scheme of eugenic motherhood either locally or internationally. She then began to write and speak widely on sex education, always with a strong eugenic focus, and here her efforts enjoyed a better reception. In 1931 she established an Institute of Family Relations (presumably inspired by the Institute of Family Relations founded in 1930 by the American eugenicist and father of marriage counselling Paul Popenoe). Although she had envisioned her organisation to be an Australian Eugenic Institute, it seems that, in reality, Piddington was its only member, and its main activity was organising sex-education classes, which

she delivered herself (although she also sold contraceptive 'sheaths', jellies and pessaries via mail-order).[70] Following Marie Stopes, she strongly supported sterilisation of the 'unfit' and 'feebleminded' as part of her sex-education agenda and claimed that sterilisation services were provided by doctors connected with her institute.[71] She was also instrumental in the formation of the Racial Hygiene Association of NSW in 1926, which became the largest and most influential of Australia's eugenic groups. The association was formed at a meeting instigated by Piddington and hosted by the Women's League of NSW, and the vast majority of its members were women. Its initial name was the Race Improvement Society, and it aimed to 'work for racial health improvement', which included 'sex education and the eradication and prevention of V.D.'[72] The group soon changed its name to the Racial Hygiene Association and adopted three aims: the promotion and provision of sex education; the 'prevention and eradication of venereal diseases'; and the 'education of the community on eugenic principles'.[73] Although the term 'racial hygiene' is most prominently connected with the Nazi approach to racial purity, the group took its lead primarily from the British and American social hygiene movements, which placed greater emphasis on the evils of prostitution and venereal disease.

Women initiated several further attempts to form eugenics societies in other states. In 1914, a short-lived 'Eugenics Education Society of Melbourne' was formed, inspired by its secretary Carlotta Greenshields, with Baldwin Spencer as president and committee members including Bella Guerin, Jean Greig and Ada à Beckett.[74] In 1933 the Women's Service Guilds of Western Australia wrote to the Eugenics Society in London to request literature for a eugenics study group. At the time, the guild included 'Racial Hygiene' among its four departments and was organising a lecture on 'Heredity and Environment' by the now

retired school medical officer Dr Roberta Jull.[75] Three years later, the Eugenics Society of Victoria was formed. This group originated from an attempt by the Racial Hygiene Association to form a Victorian branch at a meeting hosted by the Society for Sex Education (an organisation run by university women including Georgina Sweet).[76] While this attempt failed, the meeting inspired Wilfred Agar and others present to form a more strictly scientific eugenics society.[77] Women made up around a third of the small membership, including several women scientists.[78] Georgina Sweet and Gwynneth Buchanan were on the Consultative Council, and Ada à Beckett was an early member. The society was also affiliated with the National Council of Women.[79] Angela Booth, previously president of the Association to Combat the Social Evil and prominent member of the Australian Women's National League, was particularly active. She became vice-president, gave numerous lectures for the society, and in 1938 produced one of its two major publications, *Voluntary Sterilization for Human Betterment*. This pamphlet argued that people with hereditary 'defects' should be allowed to choose to be sterilised, so they could marry 'without the dread of producing defective children'.[80]

The Science of Segregation and Sterilisation

Eugenics is often seen as limiting white women to their domestic and reproductive roles as 'mothers of the race'.[81] It is also associated with efforts to forcibly prevent women deemed 'unfit' from having children, particularly through the sterilisation laws and practices enacted in North America (which disproportionally targeted Black and Indigenous women).[82] It is thus typically understood as inherently antifeminist. But since eugenics was primarily concerned with reproduction and with

child rearing, this was actually an area where women could and did assert authority. Many women's groups were deeply interested in, and advocates of, scientific approaches to the segregation and sterilisation of 'defectives'. Although the formal eugenics movement remained small, within the broader arena of social reform, eugenics enjoyed wide support. And women's groups were often at the forefront of campaigns for eugenic measures. This is clearly illustrated in the activities of the Australian National Council of Women – an umbrella organisation that encompassed hundreds of organisations across the country. From the early 1900s, the council identified 'mental deficiency' as one of the greatest threats to the future of White Australia and needing urgent attention. As Mrs Pymm argued at the 1912 national conference:

> The race problem … is a women's problem, and the proper care and supervision of mental defectives and the gradual elimination of the unfit should be one of the responsibilities undertaken by associations of this kind … [T]hese defectives are a heavy charge on the nation, and an endeavour should be made by us to prevent the race from degenerating.[83]

Discussions of 'mental deficiency' featured prominently at all the council's national conferences throughout the 1920s and 1930s. The group strongly advocated segregating such unfit bodies into 'farm colonies' or other institutions and at times also promoted sterilisation to further prevent their reproduction.[84]

This was a strategy recommended by Alice Henry, who had a particular interest in experimental 'farm colonies' for epileptics. Although Henry was 'untrained' (having completed her secondary education a decade before women's admission to Australian universities), she felt

confident enough of her own scientific credentials to present a paper at the 1902 meeting of the Australasian Association for the Advancement of Science on 'Industrial Farm Colonies for Epileptics'. In this paper, she described epilepsy as 'the most terrible of all maladies that afflict humanity ... the most cruel to the patient himself, the most dangerous to society'. She praised the 'the new methods of dealing with epileptics' that were emerging in the 'farm colony' approach in the United States. While the disease was not curable, sufferers were far better off being placed 'under scientific care and treatment' in such specialised institutions, where they would also engage in healthy and productive labour on the colony's farm to offset the cost of this 'care'. Henry emphasised the 'benefits' this model provided 'for the scientific study of the disease'. For Henry, epileptic patients were a 'danger' not only to themselves, but to future generations. By segregating them away from the 'normal' population, another benefit of the system was the 'strong and wholesome check' it provided against marriage, thus sparing society from the burden of a further generation of 'defective children'. She advocated legislation to ban marriage for those with the condition – pointing to some American states where this was already in place – and appealed to her audience to 'consider this a national question'.[85]

These national aspirations were reflected and reinforced in local initiatives by women's groups across the country. The Victorian National Council of Women, formed in 1902, campaigned for 'a colony for Epileptics'. Their efforts led to the establishment of the Talbot Epileptic Colony in 1907 and stimulated further campaigns. Later, in 1923, the council formed a special committee to consider the 'control and treatment' of the 'mentally unfit', with Jean Greig as a key member. Throughout the 1920s Greig used the council as vehicle to campaign for 'residential colonies' where 'mentally defective' children could be

'segregated and protected for the rest of their lives both from themselves and from the rest of the community'.[86] Many other women's groups joined the cause, with the Victorian Housewives' Association, Country Women's Association and Women Citizens' Movement all coming out strongly in support of proposed mental deficiency bills that would have legislated forced segregation into institutions.[87]

The New South Wales branch of the National Council of Women had first taken up this issue in 1899, with a lecture on 'special schools' for 'children of deficient intellect' in German and England.[88] But it was in the interwar years that the council's activism reached its peak. In 1919 Dr Grace Boelke, formerly a school medical inspector, convened a special committee to tackle the 'menace' of mental deficiency. She argued that the state 'should not be threatened by the existence of 9000 feebleminded who were free and were allowed to marry', and believed that this issue 'should rightly' be taken up by the council, so that it 'might be credited with accomplishing a great national work'.[89] The cause was also spearheaded by Dr Lorna Hodgkinson – a psychologist and first woman to receive a doctorate from Harvard – who was Superintendent of the Education of Mental Defectives in NSW from 1922 to 1924. In April 1923 she wrote to the Minister for Education of the pressing need for 'a "Cottage Colony System" where the definitely feeble-minded can be treated, trained and, if necessary, segregated for life'. She claimed that 'only a system of proper permanent care can ever solve this most fundamental of all social problems, namely, the propagation of the unfit'. All that was required for a 'self-supporting' colony was 'a suitable tract of fertile land' and a sufficient number of cottages. She stressed that such institutions were running successfully across America and that 'I have brought with me from abroad every kind of information for the organisation, establishment, and conducting of such an institution'.[90]

From the early 1920s, the Queensland National Council of Women, influenced by Irene Longman, hosted numerous lectures on the subject that stressed the importance of preventing 'propagation amongst the mentally deficient'.[91] In 1932, the council created the Association for the Welfare of Mental Deficients as an independent organisation to address the problem, with Longman as president. The association's objective was to establish a home where 'the feebleminded ... would be under observation and control'. It also sought to educate the public 'on the correct lines, with a view to demanding legislation based on scientific facts'.[92] It openly supported sterilisation policies. As Longman explained at the annual general meeting in 1934, 'In the interests of the individual and the race it must be seen to that there were not more mentally deficient born than they as a community could help. The Association holds no sentimental objection to sterilisation on the grounds of interference with the liberty of the subject'. Longman also advocated legislation to ban the marriage of 'mental defectives'. As she further explained: 'All children have the right be well-born ... No mental defective can make a good parent, and should not be allowed to have offspring. This is in the interest of both the individual and the race.'[93]

Such support for sterilisation – one of the more extreme measures recommended by eugenics – was quite common. At the 1933 conference of the Australian Federation of Women Voters, it was considered perfectly natural that 'a public meeting one evening concerned itself entirely with the question of the further multiplication of the unfit'. At this meeting, 'sterilization was advocated, but it was realised that public opinion was divided on this question'.[94] In 1935, the Mothers' Clubs of Victoria went further, passing a motion wholeheartedly in favour of voluntary sterilisation for the physically and mentally unfit.

Speaking in support of this motion, Mrs Priestly of Sale observed, 'In Australia there was the power to make the race what we wished. It should not only be a white race, but the best of white races.'[95]

Sex Education, Birth Control and Racial Improvement

The field of sex education was another area of women's social reforming activities that was suffused with scientific and eugenic visions. The sex-education movement drew on modern liberal and feminist ideas that sex should be knowable, that women should not be oppressed by it, that it should not be treated as shameful and, for some, that women should enjoy sexual pleasure within marriage. But it was also very focused on combating the dangers of 'illicit' sex and prostitution, and especially the 'racial poison' of venereal disease. Questions of race and reproduction, of how sex could and should be harnessed for racial purposes, were equally important and often led to advocacy for policies of segregation and sterilisation, as well as birth control.

From an early stage, the Australian sex-education movement advocated a scientific approach (teaching the biological facts of reproduction, beginning with plant and animal life) in part because of the link between nature study and religion. As one Woman's Christian Temperance Union lecturer observed in 1912, the 'ways of nature according to God's beautiful plan of life, can be simply and faithfully taught'.[96] Even groups advocating a moral or religious approach to the subject believed that accurate knowledge was an essential safeguard against the dangers of sex – a necessary counter to the flawed information which circulated through films, books and the press.[97] Most sex-education campaigners argued that information about sex should come from parents, ideally mothers. Marion Piddington, in her 1926

sex-education manual *Tell Them!*, argued that sex education was the second stage of mothercraft, surpassed in importance only by attention to children's bodily needs. Thus, 'mothers and potential mothers' were duty-bound 'to the race' to have a thorough understanding of sexual biology and conception.[98]

A variety of women's groups and female-authored publications emerged to give mothers this necessary information. In 1922 a sex-education committee, dominated by women with science degrees – particularly Georgina Sweet, Ada à Beckett and Gwynneth Buchanan – formed in connection with the Young Woman's Christian Association in Melbourne. The group was inspired by the conviction that for 'the welfare of our nation … Sex Education of a right kind is absolutely necessary', and it needed to be 'based upon accurate information'. To further this aim, they ran a lecture series, for women only, with presentations from Ada à Beckett on 'The Biological Approach to Sex Education', Dr Roberta Donaldson on 'Human Physiology', kindergarten trainer Ellen Pye on 'Psychology' and Dr Flora Innes, a scientist and Young Woman's Christian Association missionary to working girls.[99] Although none were experts on human physiology or reproduction, their gender and other credentials allowed them to claim expertise in this field.

Following the success of these lectures, the committee reformed itself as the Society for Sex Education, an almost entirely female organisation. In 1925, they ran what they claimed was 'The First Full Course of Lectures on Sex Education for Teachers, Leaders, and Social Workers and Mothers'. This was an even greater success, attended by around 120 women. The course, comprising fifteen lectures, was held in the biology school of the University of Melbourne. Ada à Beckett again delivered the bulk of the course on biology, beginning with

the reproduction of single-cell organisms and working her way up, followed by practical demonstrations in the university laboratories.[100] That year, the society also published one of Georgina Sweet's lectures, *The Responsibility of the Community towards Sex Education*, which she noted contained 'conclusions arrived at after years of thought, discussion and experiment by a small group of women graduates in Biology'. In this, Sweet advocated 'the simple study of nature' as an introduction for younger children, while later 'botany and zoology, physiology and hygiene' could provide more advanced information.[101] Science was the central focus of the society, and the scientific credentials of its members were paramount, as was their connection to the authority of the university itself. In a letter to the University of Melbourne, Gwynneth Buchanan thanked the council for the use of university facilities, which 'added materially to the success and prestige of the course'.[102]

The group presented science as a complementary extension of moral sensibilities. Georgina Sweet stressed that 'the scientific fact, the moral outlook, and the spiritual attitude *must go* side by side'.[103] The combination of science with a moral, religious spirit is evident in the long poem on 'Motherhood' that Ada à Beckett concluded her lectures with. This represented all the forms of motherhood throughout the animal kingdom from the 'first mere laying of an egg' to the evolution of human mothers; and from the 'little savage' to 'Motherhood: Semi-civilised':

> Motherhood: Civilised …
> The highest fruit of the long work of God.
> The highest type of this, the highest race …
> The motherhood of the fair new made world—
> O Glorious New Mother of New Men![104]

As this poem amply illustrates, eugenics and social Darwinian understandings of human evolution were key elements of this scientific approach to sex education.

Those promoting sex education frequently cited the prevention of 'race suicide' or the improvement of racial health to give greater weight and scientific authority to their cause. The Society for Sex Education was no exception. Georgina Sweet recommended that teachers be given a thorough grounding in 'Psychology, Eugenics, and Ethics' so they could provide proper instruction in this area. The society's lecture series was liberally sprinkled with eugenic propaganda. In particular, Professor Wilfred Agar's lecture on heredity explained that insanity and intelligence were inherited characteristics and that racial improvement could be achieved by 'careful selection of individuals' with desirable traits.[105]

Marion Piddington believed that accurate sexual knowledge was an essential foundation for achieving racial improvement. Her 1923 booklet on *The Unmarried Mother and Her Child* advocated early sex education for children to reduce the high rates of 'illegitimacy'. She urged women's organisations to promote 'sex training' as 'one of their foremost activities'. The key aim of sex education, she argued, should be 'the prevention of irregular unions and their dysgenic consequences', since these 'more than any other factor have affected the health of the individual and the race'. She quoted Marie Stopes's work at length, including her theories regarding women's 'Sex Rhythms', and stressed the need for reforms so 'the progress of the race will be advanced'.[106] *Tell Them!* was based on her numerous sex-education lectures and similarly filled with eugenic references. It opened with a prefatory note quoting at length from British doctor Mary Malendy's book *The Science of Eugenics and Sex Life*. While giving practical advice

to mothers on how to teach children about sex, it reads also as an instruction manual for raising good eugenically minded citizens – sex education should teach children their 'racial duty'.[107] She devoted an entire chapter to 'Dysgenic Habits', particularly masturbation. The last two chapters, on 'Racial Prophylaxis', argued that 'to achieve the eugenic ideal', children must be taught to 'feel how important it is to others, to themselves, and to the race, to take no part in acquiring the characteristics of racial inferiority, to be passed on and maintained for generations to come'. She emphasised the need for both physical and mental 'race improvement', the need to combat the 'racial poison' of venereal disease, and 'the eugenic value of fear for the race'.[108]

As we have seen, Marion Piddington was a driving force behind the establishment of the Racial Hygiene Association of NSW, which had sex education as one of its primary aims. The association was influenced by Marie Stopes and Margaret Sanger, and in 1933 opened Australia's first birth control clinic as part of its eugenic work.[109] As Australia's largest and longest-standing eugenic group (and forerunner of the present-day Family Planning NSW), the Racial Hygiene Association represents the high point both for Australian eugenics and for women's involvement in the movement. As a newspaper report on its first meeting observed, 'It was noticeable that it was nearly all women who were bent on improving the race. Men were conspicuously absent.'[110] The association was led, at first, by its enigmatic co-president Ruby Rich, a pianist and Sydney socialite, and devoted secretary Lillie Goodisson, a trained nurse who was the mainstay of the organisation until ill health forced her to resign in 1941. Beginning with Ellice Hamilton, it drew on a long list of medical and scientific women for its advisory board (although this included many more men), including Dr Kate Ardill Brice who ran the association's birth control clinic in

the 1930s. In 1927 the leading feminist Jessie Street and Millicent Preston Stanley, the first woman elected to the NSW parliament, became vice-presidents, and its executive and membership included many other prominent figures of the women's movement. Early activities included film screenings accompanied by lectures giving dire warnings about the racial dangers of venereal disease. By 1927 it was claimed that numbers attending such meetings had grown from fifty to over five hundred.[111] Piddington initially ran its sex-education classes, though she soon fell out with the group.

While some historians have downplayed the significance of eugenics within the association, focusing instead on sex education and birth control as feminist issues, all its endeavours were eugenically motivated. A pamphlet outlining the association's activities, produced in the mid-1930s, described how the group's sex-education lectures emphasised 'the responsibility of the Community and the individual for preserving and improving the quality of future generations'. The birth control clinic was specifically listed under its 'eugenic' work and it offered 'advice [by] qualified medical women ... for the improvement of the Race, by suitable mating, by clean living, and by preventing the propagation of the Mentally Unfit'.[112] The association did not advocate indiscriminate use of contraceptives. Their use was supported primarily on the grounds that it would help stop the 'promiscuous breeding of degenerate children'.[113] The association's pamphlet on the birth control clinic explained that 'modern methods' of birth control were advised in cases where there was 'Hereditary Disease', 'Mental Deficiency' or a lack of 'finance to support any further children'. It also proposed that birth control would reduce (then illegal) abortions.[114] In response to concerns about the declining birth rate, the association argued, 'We want quality ... Not people who are unfit!'[115] In 1936, the association

established the Marriage Advisory Centre to provide premarital medical examinations. Dr Maurice Schalit, Ruby Rich's husband and one of the doctors who conducted these examinations, explained that the centre aimed 'not only to find out that the candidates are bodily fit to marry, but also ... that the candidates are also mentally and morally healthy'. The centre discouraged marriage 'between those whose mental and hereditary history is tainted with the same strain ... in the interest of future offspring (children, if you prefer the word)'.[116] From its earliest days, the Racial Hygiene Association campaigned for legislation to make such examinations compulsory.

That all these efforts were specifically directed at White Australia was made explicitly clear at the launch of the association's appeal for funds in June 1927. At this high-profile event, Judge Walter Bevan addressed the audience in the following terms: 'Are we going to have a White Australia; not merely white in skin, but white at heart – a really good, clean Australia?' Achieving this, he argued, would require radical interventions: 'There should be, from cradle to the grave ... repeated mental tests on everyone in the community', the results of which should become 'the foundation of future reforms along eugenic lines'.[117]

The centrality of eugenics was also displayed in the three-day national Racial Hygiene Congress hosted by the association in 1929. Women featured prominently as speakers. Angela Booth gave two lectures on sex education and the eradication of venereal disease, one of which was broadcast from the conference, with Marion Piddington making 'an impassioned speech' in her support. Booth ended her second address with this chilling conclusion: 'There are, on this earth, people who should never have been born, and Nature should have taken them away. Society does not want animals.'[118] Several sessions discussed the

'feebleminded'. Lorna Hodgkinson warned that 'mental defectives are breeding freely and bringing … all the evils which are associated with mental degeneracy, such as crime, pauperism, venereal disease'. She argued that 'money should be spent on scientific preventive measures … for our national progress'. This demanded 'permanent care and control in properly established working colonies'.[119] The final conference sessions were devoted to 'Eugenics' and 'Sterilization', after which seven resolutions supporting voluntary sterilisation for the physically and mentally 'defective' were passed unanimously. As Lillie Goodisson reflected in her closing comments, 'We all expected much hot discussion on this debatable subject, but not so.' Congratulating the participants, she concluded, 'I know we are going to do great things to help build up a healthy virile race in Australia.'[120]

Conclusion

Women's strong participation in early twentieth-century scientific social reform reveals the extent of their engagement with broader cultures of science in this period. The rising influence of science gave some women new ways to conceive social possibilities and new platforms from which to act and claim public authority. As an *Age* editorial expressed it in 1911, women were now charged with 'the duty of consciously striving to apply scientific guidance to the improvement of the human race'.[121] For some women, this was an empowering vision. Just as Christianity had given many women a rationale for public activism, so, too, science gave them a confidence in their real ability to contribute to making a better world.

As with the nineteenth-century feminisation of botany, scientific social reform was closely associated with women, and many

enthusiastically took up this cause. Recognising these reforming activities as 'scientific' further complicates the idea that science has always excluded women. Rather than being alienated from the modern scientific age, these women sought to garner it for their own ends. In a world increasingly dominated by scientific frameworks, they sought to carve out new women's spheres of scientific expertise which would also, they hoped, lead to new arenas of professional employment for middle-class women. For university women, the possibilities opened up by these reform movements were even more expansive, especially given the exceedingly small numbers of university-trained scientists (male or female). Indeed, it was probably here that they had the greatest impact.

These frameworks were, however, ultimately limiting – both because they depended on notions of female 'difference', particularly as actual or metaphorical mothers, and because of their classed and racial basis. This was a heavily circumscribed authority that rested on wider constructed hierarchies of race, class and intellect. Women who were not part of the social elite could not lay claim to the power of science and were more likely to be regarded as the needy recipients of the expertise and instruction of scientific women of the middle classes. And as much as reformers were clearly motivated by the desire to make a better world, and many of the reforms they achieved had a positive impact, scientific social reform was also strongly attached to the darker side of science. Eugenics, alongside the widely held commitment to White Australia, profoundly shaped this movement. Since eugenics was primarily concerned with reproductive protocols and child rearing, this was an area where privileged white women could and did assert authority as 'mothers of the race'. Women's work was presented as essential in implementing eugenic programs. Indeed, this was sometimes claimed as *exclusively* women's work. This meant that women were among the

most active and prominent exponents of eugenics in Australia in the first half of the twentieth century.

This is not to suggest that such women were unusual or especially extreme in their views. Belief in racial difference was pervasive across White Australia – it was part of the 'everyday' race consciousness. In taking up these causes, women were responding to some of the major anxieties about race in Australia and across the Western world. Despite working largely through informal organisations, these women carried on the national project through their activities. While women's campaigns against the 'menace of mental deficiency' and other 'race problems' were certainly not 'benevolent', they do reveal how scientific and racial thinking inspired reform agendas and supported white women's agency.

Chapter 5

Neither Rebels nor Radicals

Studying and Working in Science, 1930s–1950s

At the second conference of the Australian Federation of University Women in 1924, then president Frances Thorn implied in her opening speech that Australian women had won the battle for entry into higher education and professional work. Celebrating the rise of 'a new force' of educated womanhood, she reflected:

> It is difficult for us to realise the tremendous odds against which
> the pioneers of the education of women had to work. Ignorance,
> prejudice, sentiment ... There was as yet no idea of a woman as
> a human being, with individuality and capacity to develop apart
> from her relationship to a man ... [Now] the fight has been won.[1]

This confident appraisal of the progress made by educated women stands in stark contrast to the scholarly emphasis on the (very real) obstacles women faced in this period.[2] Thorn was not alone in making such assertions. They are a common feature in the life stories of women scientists from the 1930s and 1940s – decades that were a high point

for Australian women's presence as both students and staff in university science departments. Women scientists, in Australia and elsewhere, have often rejected feminist interpretations of the significance of gender in scientific practice. Most believed in the meritocracy of their profession; like their male colleagues, they viewed science as 'a place where the matter of gender drops away'.[3] By taking these comments seriously and looking for the influences behind them, we can explain women's actual presence in science and discover elements at work supporting women's entry into the field in a period when science was widely perceived as a male domain.

I'm attempting here to create a broad picture of the women who gained science degrees between 1930 and 1955 by exploring the educational and employment opportunities available to women in the context of their own perceptions of their experiences.[4] In this period, the voices of women themselves are far more available. My account is based, in part, on interviews and a survey of over 300 women science graduates I conducted in the late 1990s. These life histories provide a unique insight into the world of university women of this era in Australia. While some disclose experiences of sexism and structural discrimination, their stories also challenge the common understanding of science as an exclusively male field, allowing for a more complex understanding of the relationship between women and science in this period. The survey material opens a window into more 'typical' experiences that would otherwise be inaccessible. I also relate some of the major successes and achievements of the 'great women' of Australian science in this era. This was the period when women's representation as university science students and staff reached a peak, and when geologist Dorothy Hill became Australia's first woman professor. But I am equally concerned with the 'everyday' experiences of the majority.

And while success stories are duly noted, these are positioned not as exceptions, but as the product of wider influences supporting women's entry into the field.

The life stories of women who entered into science in this period reveal more about the forces supporting women into the field than they do about any disjunction between femininity and science. Their experiences show how scientific studies and careers could be encouraged and endorsed for *some* women, at the same time as such activities were unreachable for most. In conjunction with other sources, they reveal the influences that supported women's movement into science – at least among the urban educated elite from which most university students were drawn. Class was integral to the many advantages these women enjoyed, especially in terms of access to education, and this worked to mitigate, although not entirely negate, the disadvantages of gender.

Educating Women into Science: Opportunities and Inspirations

In 1997 I invited women science graduates to participate in a survey that asked them about their lives. I was overwhelmed by their response. Three hundred and thirty-eight women generously provided detailed information about their family backgrounds, education and employment, marriage and children, as well as their perceptions of the place of women in science. They represent just over 20 per cent of all women who gained science degrees between 1930 and 1955 from the universities of Melbourne and Sydney, as well as a small number of graduates from other institutions.[5] This survey opens an extraordinary window into women's experiences in science and reveals the cultural spaces that facilitated their interest and achievement in the field.

Women who studied science from the late 1920s into the postwar period remained a highly select group. Most came from middle- and upper-class families supportive of girls' education, and their parents' educational level was far higher than that of the general population.[6] They were also exceptional in their own educational attainments. Access to secondary education, beyond the compulsory school years, was extremely limited well into the 1950s and university fees remained high. School completion rates were much higher for boys than for girls, and most students at state schools either did not have access to, or did not complete, the full years of secondary education necessary for university entrance. In Victoria and Queensland particularly, secondary schooling was dominated by the private schools, and fees for state high schools were not removed in Victoria until 1947, meaning higher secondary schooling was largely limited to those whose families who could afford it.[7] The vast majority of women in my survey attended metropolitan, single-sex private schools or selective state high schools. Nearly half of those based in Victoria attended one of Melbourne's three largest girls' private schools – the Presbyterian and Methodist Ladies' Colleges and the Melbourne Church of England Girls' Grammar School (MCEGGS) – or the selective state school MacRobertson Girls' High. In New South Wales, over 40 per cent came from Sydney's five selective girls' high schools.[8]

Girls had uneven access to scientific instruction. Barbara Falk, a student at Lauriston Girls' School in Melbourne in the 1920s, described its teaching as ranging from excellence in the classics and English to 'hopeless mediocrity in maths and geography and science … In comparison to the girls from University High School … I had had a very indifferent formal education'.[9] Mollie Holman, who later gained her PhD from Oxford and became professor of physiology at

Monash University in 1970, had similar recollections of her education at Launceston's Church of England Girls' Grammar School in the 1940s: 'There was not really anything much in the ways of science taught at a girls' school in a smallish town like Launceston … So I went to night school at the Launceston Technical College to do introductory physics.'[10] Holman moved to MCEGGS for her final school years to take a full science program. Students like Holman felt the absence of scientific instruction keenly and went to great lengths to study science at school. Similarly, in Adelaide in 1934, Annie Welbourne, herself a science graduate, moved her daughter from Girton to Walford so she could 'get a foundation in science subjects'.[11]

In the 1920s and 1930s there was a marked gender disparity in science offerings at single-sex secondary schools, with girls' schools far more likely to offer biology, botany and physiology than physics or chemistry. As a report on science in Victorian schools from 1924 lamented, 'It can hardly be maintained that, as occurs now in many cases, boys should leave the secondary school with little or no knowledge of the biological sciences, and girls with little or none of physics and chemistry.'[12] In Sydney, all the selective girls' high schools offered biology subjects and chemistry, but only Sydney Girls' High offered physics (and this was a popular subject).[13] Sydney's private girls' schools generally only offered biological sciences. Even the Presbyterian Ladies' College, which had the strongest reputation for science teaching, only introduced chemistry in the 1940s and did not teach physics.[14] Similarly, in Adelaide's girls' schools only botany and physiology were widely available. St Peter's Girls' School was a notable exception in that, by the 1930s, the school offered both chemistry and physics. Joan Cleland, a student of this time, recalled, 'We were the only girls' school, I think, that actually ran classes in the school', and the students eagerly took advantage of this fact.[15]

Melbourne was something of an exception. Smaller private girls' schools were rarely able to afford the laboratories required to offer the physical sciences, although generally at least one biological science was taught. But by the 1920s both the Presbyterian Ladies' College and MCEGGS offered a full science program including physics. At the Methodist Ladies' College, chemistry was available as a 'leaving' subject from at least 1921, and the introduction of physics in 1931, previously taught at only lower levels, reflected a decision to 'strengthen the Science work in the school' for the benefit of girls considering science or medical degrees.[16] Melbourne (later MacRobertson) Girls' High School, the state's only selective girls' school, also offered the full range of sciences, including physics, and girls who attended one of the few Victorian coeducational high schools also, nominally, had access to the full range of subjects.[17]

By the 1940s, in both Victoria and NSW, boys' exclusion from the biological sciences was far more marked than girls' exclusion from the physical sciences. Biology was still rarely offered in boys' schools.[18] And although biology was more studied by girls, the physical sciences were still popular. More than three-quarters of the Melbourne graduates in my survey took chemistry and over 70 per cent studied physics. By comparison, the Sydney graduates took fewer sciences at school and only a tiny proportion studied physics. Even so, chemistry, not biology, was the most popular subject for this group.[19]

At private schools like MCEGGS, scientific studies were supported and girls were encouraged to consider tertiary education and professional careers. Over a third of MCEGGS students who went on to university up to 1927 studied science or medicine, demonstrating the extent to which the school promoted 'non-traditional' interests.[20] MCEGGS students rated the quality of education they received highly. Diana Dyason, who

attended the school from 1928 to 1937, stressed that the headmistress, Kathleen Gilman-Jones, 'assumed professional careers were the proper domain of women' and that MCEGGS, like the Presbyterian Ladies' College, 'had a strong academic tradition, particularly in maths and science ... it never occurred to me to do anything other than science'.[21] Students of Melbourne's Fintona Girls' Grammar similarly recalled it as 'a school with a strong science background and [the] expectation that girls would continue to university'.[22]

Perhaps surprisingly, many of my survey respondents believed that science offered attractive employment opportunities. As one woman described it: 'Science seemed to be the "coming thing".' Respondents recalled being inspired by reading about Marie Curie and the well-publicised scientific advances of the 1930s and 1940s.[23] The desire to contribute to scientific progress was reinforced by the advent of the Second World War when 'there was great encouragement for *women* to study science, to assist the war effort'.[24] The Department of War Organisation of Industry even took some steps to improve science teaching in girls' schools at this time, since girls with science qualifications were 'urgently needed'.[25] As science became increasingly essential to the war effort, women scientists were at a premium. Nor were they unilaterally pushed out of these jobs at war's end. The continued shortage of qualified men and the great expansion of scientific jobs meant women with science degrees remained highly employable. As a 1945 physics graduate summed it up, 'I think initially we were fortunate. The war made science very important and men were scarce.'[26]

Expanding Horizons

Beyond formal education, there were wider cultural shifts supporting women's entry into science. While it is true that, within the popular imagination, 'scientists' were pictured as men, there were also forces encouraging women into such areas. Diana Dyason recalled the late 1930s and 1940s as a time when women were 'going places', and their achievements were 'expiated on in the news (not the social) pages of the press'.[27] Although there were certainly conflicting currents at work, newspapers and many women's magazines frequently featured articles urging women to take a greater role in all spheres of public life. From its inception in 1933, the *Australian Women's Weekly* reported on a range of 'remarkable' women. One of its earliest issues, for instance, detailed the career of Mrs F. McKenzie, 'Australia's only woman electrical engineer and licensed electrical contractor'.[28] Mainstream newspapers proudly and approvingly reported 'firsts' for women and covered women's achievements in the universities, including graduates' activities (predominantly, but not exclusively, in the women's pages). The biennial national conferences of the Australian Federation of University Women (AFUW) were widely covered. These large gatherings of women graduates prompted many positive comments on the varied ways they were contributing to society. One report on the 1935 conference congratulated 'the number of clever women Australia has produced, and the earnestness with which they enter into everything that concerns the life of the community'.[29]

The 1930s, too, saw a steady increase in vocational-guidance columns directed at girls. Women's magazines and the women's pages of newspapers ran articles and series with such titles as 'Careers for Girls', or, more adventurously, 'Interesting Careers for Girls'. Their emergence reflected the increased participation of all classes of women in paid

employment, at least prior to marriage. These columns were based in assumptions about the differing prospects for, and interests of, boys and girls, but they also reflected an increasing belief that all girls needed to be prepared for the world of work. The *Australian Women's Weekly* claimed to pioneer this field when it began its regular column on 'Careers for Women' in its first issue in June 1933. Aimed at 'women searching for careers or for just plain jobs', the column offered 'practical help and guidance of a type never yet attempted in Australia'. Since it was now 'imperative' for both men and women to work, advice on the problem '"What is my daughter going to do?" is equally as important as the older, if equally serious, "What is my son to do?"'[30]

While the column covered more humble vocations, it also expressed a broad vision of potential fields for women's work. In the ensuing months, the magazine fulfilled its promise that it would 'explore in thorough detail what professional openings there are for women in such a way as to make it much easier to decide what many young women are pondering at the moment: "Shall I be a doctor, a lawyer, an engineer, a chemist, or—?"'[31] Traditional women's professions such as nursing, clerical work and dressmaking were covered alongside more unusual fields. One column, for instance, suggested that 'An Estate Agency is Worth While'.[32] Another focused on the new field of radio work as

> a new career for girls who have ambition to rise above the ruck, and would aspire to something more interesting than thumping a typewriter or selling ready-to-wear frocks. The ever-increasing popularity of radio has opened up a new avenue for the brilliant girl with outstanding qualifications … Radio may be said to be yet in its swaddling clothes, and announcing offers a definite opening for women in the future.[33]

The very first article explored 'What the University Offers' and listed a wide range of potential professions for women graduates, including doctor, dentist, barrister and architect. Even engineering was included, although no Australian woman had yet completed a degree in this field. The article also canvassed scientific occupations, illustrated with a picture of 'a girl student in the laboratory'. While it was stressed that the greatest opportunities for the average woman science graduate were in teaching, for the brilliant woman, 'occasional opportunities … will always occur'.[34]

Some of the major metropolitan newspapers soon followed suit. Again, while already accepted areas of women's work were duly covered, more adventurous options were also suggested. Several articles promoted the careers of veterinarian and dentist. One on law contended that opportunities for men and women were equal. Emerging 'women's professions' such as library work and dietetics were prominent.[35] Several newspaper series and articles were inspired by careers conferences organised by the state branches of the AFUW. Since few schools provided formal guidance in this area, these conferences represented almost the only form of career advice available to girls outside the media. The Sydney branch had been holding such conferences since at least 1922. Topics covered in the 1920s included teaching, domestic science, nursing, medicine, law, architecture, dentistry, massage, silvercraft, physical training, kindergarten training, veterinary science, social service and work on the land. In the 1930s, more unusual occupations such as bee-keeping, as well as scientific research and dietetics, were added to the list.[36] Similar conferences, held in Adelaide from 1931 and Melbourne from 1938, covered an equally wide range of both typical and unconventional fields.[37]

Even where women's domestic duties were presented as paramount, this was not necessarily meant to apply to all women. University women could prescribe a domestic destiny for the 'average' woman in a way that was entirely consistent with a belief in a wider role for 'exceptional' women like themselves. As Melbourne's premier women's columnist 'Vesta', herself a working mother with a master's degree, put it in a 1930 editorial arguing that women should relinquish paid employment on marriage: 'In most cases it is the desire for the salary rather than zeal for her special work that prompts a girl to try to retain her post. I am speaking now not of the able professional women, whose zeal for their work is such that many of them give up the idea of marriage altogether.'[38] Similar sentiments were expressed at the 1938 AFUW conference:

> There are two types of women who usually wish to continue in paid employment after they are married. One is the woman who has something definite to contribute, and the other is the woman who needs the money, and I do not see that any possible objection can be made to these two types of women.[39]

University women clearly felt that they fell into the category of those with 'something definite to contribute'.

Women's increasing status, and their increasing fields of activity, continued to be represented as an inevitable and positive consequence of the progress of society. Since science was one of the prime symbols of the modern age, women's entry into this field could be represented as a natural and positive progression. As one 1944 article noted, 'This is a century of scientific development and an age of increasing fields of activity for women. With such parallel trends "Women and Science"

is but a logical outcome. But, in addition to being natural and logical, it is also a desirable and essential development.[40]

Women scientists received frequent, and positive, coverage throughout the 1930s. For example, one lengthy article in 1934 covered the unique posts held by agricultural scientist Lorna Byrne, the women's organiser for the NSW Agricultural Bureau, and geologist Florence Armstrong, the only woman employed by the Western Australian Department of Mines, as well as Betty Wilmot's appointment as dietitian to the Victorian Railways.[41] Another piece on four women employed as researchers at Adelaide's Institute of Medical and Veterinary Science in 1939 celebrated the achievements of both women and science: 'Adelaide should be proud of its fine new Institute … and Adelaide women should be proud … [of] their fellow women'.[42] Some went beyond 'exceptional' individuals to comment on women's wider involvement in the field. An article on Eder Lindsay's research on cockroaches at the University of Melbourne noted: 'Increasing numbers of young women are embarking on scientific studies which … can lead to some unusual and interesting careers'.[43] A 1936 article detailed a number of women working at the Waite Institute and concluded that 'there are many girls and women in Adelaide engaged on important work as bacteriologists, laboratory assistants and research workers'.[44] A 1937 article in the *Herald* described the work of more than a dozen Melbourne women. It observed that in the last fifty years, 'the number of women research workers has grown rapidly', and reported the view of Dr Kellaway, director of the Walter and Eliza Hall Institute, that 'Science in Australia already owes much to women scientists'.[45]

Women's prominent involvement in the congresses of the Australian and New Zealand Association for the Advancement of Science was widely reported. One article on the 1935 meeting observed: 'An interesting fact is disclosed by the list of women graduates who are

expected to visit Melbourne for the science congress next week, in the number who have taken science degrees.[46] Adelaide's *Mail*, proudly reporting on 'Our Women Scientists', pointed out that 'several of our clever Adelaide women scientists attended the recent science congress in Melbourne'.[47] Reports on women's work in the universities, and on AFUW conferences, often focused on women scientists due to their strong numbers. The 1938 AFUW conference in Sydney inspired a long piece in Melbourne's *Age* on 'Women and Research', which declared, 'Women are playing an important role in the vast field of research work that is speeding up the progress of science and industry and adding to the well-being and the happiness of the individual.' The article then turned its attention to Victoria, where there were 'scores of women' at work in laboratories and detailed a long list of women scientists.[48] There was extensive coverage of the 1935 conference in Melbourne, where Ethel McLennan delivered her presidential address on 'Some Scientific Women and their Contribution to Science'. None of the reports contained any hint of surprise at her choice of topic or any contradiction of her assertion that women had already made important contributions to science.[49]

Unsurprisingly, journalists were often preoccupied with female scientists' physical appearance. One article on the 1935 AFUW meeting gave this description of one of the speakers:

> Senior lecturer and examiner in French at the University of Sydney, Miss Gladys Marks has once already been acting professor in this subject and will again hold this office next year. Miss Marks has an excellent dress sense. She looked most attractive ... wearing a raspberry hat and frilly blouse with a grey and black flecked suit.'[50]

Another piece on the 'Charming Scientists' at the conference observed:

> At the University, where Australia's learned women are pooling their brains in conference one of the outstanding qualities is charm. And one of the most charming is the president, one of our own Melbourne women, Dr Ethel McLennan, who in her presidential address yesterday, did what she set out to do – proved that women can do creative scientific work.[51]

While this preoccupation with physical appearance is at first glance belittling, such articles did also present these women in a positive light, especially compared with later representations of women scientists. They suggested, for instance, that respectable femininity was compatible with women's occupation in a 'male' field: where descriptions of a 'masculine' occupation led straight into those of feminine appearance, there was an implied continuity between the two attributes.

During the war years, positive images of women scientists proliferated and numerous articles explicitly encouraged women to enter technical and scientific fields to assist the war effort. These reached their zenith in a 1941 article which declared, 'Never before in the history of the world has there been so great a demand for women with scientific knowledge.'[52] Such articles tended to focus on the importance of the work such women were undertaking, although sometimes they stressed the fact that the women had also retained their femininity. Another 1944 article on Jean Millis, then lecturer in nutrition at the University of Melbourne, entitled 'Beauty and Brains Can Go Together', was neatly divided into two sections, the first of which dealt with the importance of Millis's work on nutrition in times of food rationing. The second gave her 'Simple Rules for Health and Beauty':

Millis is a fresh complexioned blonde. She has perfect teeth and blue eyes … Not at all like an academic spinster … Her rules for health and beauty are simple and easy. Make sure you have three-quarters of a pint of milk each day. Have some fresh fruit or raw vegetable daily and include potatoes in your daily menu.[53]

Her status as a nutritionist was used to give weight to this advice. But the emphasis on beauty also served to reassure readers that she was still a woman.

A Rising Presence

Women enrolled in science degrees – encouraged by their families, schools and the growing prominence of science – had little sense of any barriers to their participation in the field. During the Second World War, the absence of men meant that women were encouraged into the science rather than the reverse. Once at university, they faced few overt obstacles to their ambitions and had little reason to feel unusual or out of place. They found themselves among numerous fellow travellers. In the 1930s women made up around 35 per cent of science students at the University of Melbourne and 30 per cent at the University of Sydney. Women's representation in university science courses naturally peaked during the war years. In 1945 women made up just over 37 per cent of science graduates across the country.[54]

Many of my survey respondents, particularly those who completed their degrees before 1945, were at pains to emphasise that, in their time, 'a large proportion of the science students were girls', even if they were concentrated in the biological sciences.[55] Although this suggests their exclusion from more 'prestigious' scientific fields, it also meant that

they predominated in these subjects. Madeline Angel, who completed her degree in 1931, recalled of her zoology class at the University of Adelaide, 'I think we only had one man in our group of half-a-dozen in third-year.'[56] Anne Conochie had similar recollections of her experiences at the University of Western Australia in the 1930s: 'I didn't get the impression that we were in any way unusual … [C]ertainly there were more boys than girls … but there were enough of us for us to feel a part of it.'[57] In direct contrast to prevailing understandings of women scientists as 'pioneers' or 'exceptions', few felt that they were doing anything particularly unusual for a woman of their class and times. When asked if women felt they were 'blazing a trail' by studying science, Madeline Angel replied, 'No I don't think we did … [I]t must have been back to 1920, I imagine, that there had been women doing science.'[58] By the 1930s women studying science was no longer radical.

By the 1930s, as Diana Dyason noted, it had 'already become the norm for women with science degrees to make use of them'.[59] Women assumed they would move into a job with some sort of career structure and that this was not necessarily incompatible with marriage and children. The later working lives of these women bear out these observations. My survey participants had an extremely high workforce-participation rate and, in a marked break with earlier generations of women graduates, very few stopped work permanently on marriage or after having children. Hospital work and teaching were key areas of employment, but the academy continued to be a place where many pursued careers. Around a third worked in a university at some point.[60] Although few maintained continuous careers — many took a long break from the workforce while their children were young — most returned to paid employment. They were part of the first generation of

university women who routinely combined marriage and motherhood with professional careers.[61]

Women studying science in the 1930s and 1940s also had the benefit of numerous roles models and mentors, especially in the biological sciences. Women on the academic staff of Australian universities reached a peak in the late 1940s, and women continued to be better represented in scientific departments than elsewhere. In 1950 official published staff lists show women were 20 per cent of science staff across the country, and more than a third at the University of Melbourne.[62] Since women were concentrated in the biological sciences, they were very well represented in these fields. Some of the earlier generation of women academics remained and were joined by many more. At the University of Melbourne, for example, by 1935 women were three of the seven senior academic staff in zoology (Gwynneth Buchanan) and botany (Ethel McLennan and Isabel Cookson) and were the vast majority of junior staff and research students.[63] This representation continued and increased into the war years. Of these dozens of women, a few completed their higher degrees only, others spent a decade or more on various research scholarships and demonstrating, and several went on to long academic careers.[64] In botany, Margaret Blackwood completed her MSc and worked as a research scholar in the late 1930s, returning to the department in 1946 after a period of war service before heading to Cambridge for her PhD (awarded in 1954). Since Cambridge had only recently admitted women as full members of the university, she became one of the first women to receive a doctorate from this revered institution. A heavy teaching load meant she only published five papers between 1953 and 1968. But she pioneered research into cytogenetics in Australia and by her retirement in 1974 reached the rank of reader (equivalent to an associate professor).[65] Sophie Ducker, who joined the

staff as a technical assistant in 1944 while completing her degree part time, had a similarly long career, also gaining a readership just prior to her retirement in 1974. She then continued an already extremely productive research career, publishing some 120 papers in total and gaining her DSc in 1978.[66]

Official staff lists suggest women were less active in science at other universities. But since these only included permanent staff, they hid a much larger group of women. At the University of Sydney, the undergraduate *Science Journal* recorded many more women engaged in research work in botany and zoology in the 1920s and 1930s.[67] In the botany department, throughout the 1930s and the war years, women were the majority of demonstrators, curators and research scholars.[68] Several gained prestigious Linnean and Government research fellowships – some, like Frances Hackney, remained on these for many years in a row.[69] Gladys Carey, although not officially listed, was a mainstay of the department. As demonstrator and secretary from 1930, she collaborated in several research projects. In 1937 she became curator of the department's museum, remaining in this position until her retirement, and in 1941 she published *Botany by Observation: A Text-Book for Australian Schools*.[70] Several women worked in the geology department. Ida Brown (BSc, 1922; DSc, 1932), was a demonstrator and research fellow before becoming an assistant lecturer in 1934. Promoted to senior lecturer in 1945, she resigned in 1950 to marry the professor William Browne. Germaine Joplin (BSc, 1930), after completing her PhD at Cambridge, also lectured in the department from 1936 to 1950 – when she, too, resigned, initially to become a social worker. Two years later, she returned to geology, joining the Australian National University's new Department of Geophysics as a research fellow, where she had a long career.[71]

At the University of Adelaide, the establishment of the Master of Science degree in 1925 created opportunities for local graduates to pursue research and gain employment. Effie Best was appointed the first zoology demonstrator in 1927, the only other staff member apart from Professor T. Harvey Johnston. She was followed by a small flood of women who were informally referred to as Johnston's 'harem'.[72] It was not until 1947 that another man was appointed to the department. Best was replaced by Kathleen Day and Elizabeth Cleland, who in turn were followed by Madeline Angel and Patricia Mawson. Angel remained as a demonstrator and research assistant until the 1960s. Mawson became a lecturer in 1941, continuing to work part time after her marriage to departmental colleague Ifor Thomas in 1947, retiring in 1980. From 1942 to 1955 Doreen McCarthy took charge of a newly established general biology course. There were a few more men in the botany department, but women still occupied most of the junior positions and a few gained more senior posts. Beryl Barrien, who began her career as a junior demonstrator in 1935, was promoted to a lectureship during the Second World War. The longest serving woman in the department was Constance Eardley, who was appointed curator of the herbaria at the university and the Waite Institute in 1933, retiring as a senior lecturer in 1971.[73]

A key factor behind the ongoing strong presence of women in the biological sciences was the continued absence of men from these fields. This became even more acute during the Second World War. Opportunities for women in academia and research abounded. As Adelaide's *Advertiser* reported in 1942, 'At the Waite Institute are three women in responsible positions because the men who held these positions have joined the fighting forces.'[74] After the lecturer in biology Consett Davis enlisted in 1940, a steady stream of women

were enticed to the rural New England University College, which was constantly searching for qualified staff. Throughout the 1940s its biology departments were entirely staffed by women. Gwenda Davis, Consett Davis's wife, was pressed into service as lecturer in 1945 after her husband's death meant that the university's anti-nepotism rules no longer applied. She remained until the 1960s, reaching the rank of associate professor.[75] In the same year, Amy Crofts, a Melbourne botany graduate, found herself confronted with a choice of academic positions – one at New England and another at Christchurch University College. She elected to go New Zealand, although wartime manpower regulations almost prevented her from leaving the country to take up the position.[76] Meanwhile, at the University of Melbourne, Professor Turner of the botany department was able to convince the Soil Conservation Board that, owing to the 'shortage of suitable men', they would be well-advised to employ Maisie Fawcett as their field ecologist, despite the board's explicit preference for a male research officer.[77]

At the universities of Adelaide and Melbourne, women's dominance in the biomedical sciences was also reflected in appointments to the academic staff. In Melbourne, Dr Hilda Rennie was appointed acting director of the bacteriology department in 1927, following the death of the professor. The only other senior staff member at the time was Sara Gunderson, though the department's gender imbalance was soon redressed by the appointment of Harold Woodruff as professor and T. S. Gregory as senior lecturer. Gunderson remained in the department until the late 1940s, joined in 1939 by Nancy Hayward, and later Joan Gardner (niece of Nobel laureate Howard Florey) and Rose Mushin – who all reached lecturer status or higher. Numerous other women were on the demonstrating staff, including Nancy Atkinson, who went on

to a long career in Adelaide.[78] In the 1950s Nancy Millis, with a PhD from the University of Bristol already to her credit, joined the staff. She became one of the most eminent microbiologists of her generation, pioneering the study of fermentation technology in Australia and gaining a personal chair in 1982.[79] Women were even more prominent in biochemistry from the late 1920s. Kathleen Law, who began her demonstrating career in 1927, gained a lectureship in the late 1930s by which stage women represented most of the department's research workers. By the mid-1940s Jean Millis, Muriel Crabtree and Audrey Cahn were also lecturing in the department. In physiology, perennial demonstrators Blanche Brewster and Margaret Hutchinson were joined by many other women in the 1940s, including Patricia Keogh who was later promoted to a lectureship.[80]

The most outstanding example of women's colonisation of these fields was at the University of Adelaide, where, from the early 1940s to the late 1950s, the bacteriology department was an almost entirely female domain headed by Nancy Atkinson. Atkinson joined the staff in 1937 and took charge of the department in 1941 after Professor Platt's resignation. By 1944, Atkinson observed that 'the Department ha[d] grown enormously ... [I]t rivals, in numbers of students, many of the long established senior science subjects'. The majority of these students were women, as were the junior staff members. In 1945, Adelaide's *Advertiser* reported, 'Miss Atkinson has at present a qualified staff of seven persons, of whom six are young women.'[81] Gwen Woodroofe, who joined the staff in 1943, was Atkinson's de facto second-in-command from 1948 to 1950, when she left for a long research career at the Australian National University (initially working with Frank Fenner on myxomatosis). Sibely McLean then stepped into this role, where she remained until 1958.[82]

Outside the academy, many hospitals also began expanding their laboratories and medical research institutes were established. These provided new avenues of employment for many women such that by the 1940s hospital laboratories became another feminised domain. Some were able to establish significant research careers. After working at the Walter and Eliza Hall Institute and gaining a Diploma of Bacteriology from the London School of Tropical Medicine, Phyllis Rountree became research bacteriologist at Sydney's Royal Prince Alfred Hospital in 1943. She gained international recognition for her work on golden staph.[83] A long string of women worked as research assistants for Macfarlane Burnet at the Hall Institute, and some went on to significant independent careers. Dora Lush, who worked with Burnet in the 1930s and co-authored many of his key papers, was celebrated as a scientific martyr in 1943 when she contracted typhus from the samples she was working on in the search for a vaccine. She died three weeks later.[84]

Others worked at prestigious research institutes overseas. After working in the radiophysics laboratory during the Second World War, physicist Joan Freeman (BSc Sydney 1940) was given a CSIR studentship to go to Cambridge for her PhD. In 1951 she became a senior scientific officer at the Harwell Atomic Energy Research Establishment and in 1976 became the first (and only) woman to receive the Ernest Rutherford Medal and Prize for nuclear physics.[85] Rita Harradence, who completed her MSc in organic chemistry at the University of Sydney in 1937, had a similarly long research career in the United Kingdom. After winning an 1851 Exhibition scholarship she went to Oxford for her PhD in biochemistry, along with fellow Sydney chemistry graduate John Cornforth. They married in 1941 and stayed in the United Kingdom working first at the National Institute

for Medical Research and then at Shell's Milstead Laboratory of Chemical Enzymology. Harradence collaborated with her husband, who won the Nobel Prize for Chemistry in 1976.[86]

By the 1950s women had dominated as university teachers and researchers in biology and biomedical sciences for decades, but none reached the highest ranks of the academia. This happened in geology. In 1959 Dorothy Hill became Australia's first woman professor – finally breaking this 'glass ceiling' for Australian women in science. Her career had been exemplary. She completed her BSc at the University of Queensland in 1929, with first class honours and a gold medal for the most outstanding graduate. The following year, she received a travelling scholarship from the university that allowed her to study for a PhD in palaeontology (on coral fossils) at Cambridge. She lived at Newnham College, where two other Australian women (Germaine Joplin and Betty Ripper) were also studying geology. Her supervisor was Gertrude Elles, the first woman to gain a readership at Cambridge. Completing her PhD in 1932, Hill gained several further scholarships to remain in the United Kingdom and continue her research. When she returned to Australia in 1937, she received a grant from the CSIR and worked as a research fellow and lecturer at the University of Queensland until 1942, when she took up war work in the civilian cypher service (although she still spent much of her spare time doing research). Hill later joined the Women's Royal Australian Naval Service. Returning full time to the university in 1946, she was steadily promoted. She was also heavily involved in the Great Barrier Reef Committee. In 1956 Hill was the first woman elected to the Australian Academy of Science – a prelude to her 1959 professorship. An enormously productive researcher, she published over 140 papers.

Hill believed strongly in women's equality, but, like most of her generation, was also convinced that equal treatment had already been achieved in academia. Speaking to a Queensland Federation of University Women meeting in 1975 (International Women's Year), she claimed, 'Women academic staff are able, in complete equality with men, to give full rein to their intellectual interests; the delights of research are possible to all.' If the number of 'outstanding' women scholars was 'few' (as they were, comparatively, by the 1970s), in her view this was because women en masse had yet to develop 'ambitions to succeed' and success did not come from 'complaining'.[87]

Assuming Equality

Given all of this context, it is perhaps unsurprising that women who studied or worked in science in this period provide accounts that concentrate on the freedom they felt and not on any obstacles they might have faced. Indeed, this is one of the most striking continuities in the life stories of women science graduates.[88] It is generally presumed that women have never found it easy to pursue a career in science, that all struggled in isolation to achieve in a male-dominated area, and that the decision to enter science must have involved some kind of rebellion against the norms of feminine socialisation. The life stories of Australian women entering science in this period contrast sharply with these assumptions.

A 1980s study of women academics at the University of Melbourne concluded that academia 'was for the most part a realm where ability was respected in either sex ... Those who sought careers within the university continued to sense an egalitarian professional environment, where such discrimination as existed was informal and largely

unconscious'.[89] Kathleen Fitzpatrick, an arts graduate of the 1920s who joined the staff of the history department in the late 1930s, concurred: 'One of the things I liked at the University of Melbourne was the position of women in its community. The old struggle for equality had been fought and won in the nineteenth century; now there were women on the academic staff, receiving equal pay.'[90] Diana Dyason, a physiology graduate of the 1940s who went on to a long career as an historian of medicine, similarly recalled: 'There was little of the overt discrimination against women that had been so obvious in earlier times. After all, most women, particularly in science, had strong family support and assumed the rightness of their ambitions and their equality with men.'[91]

My own research also revealed a strong commitment to what I call a 'narrative of equality' among women science graduates. Only a tiny number of the women I surveyed reported any sense of differential treatment in their undergraduate years. As Valerie May, who studied at the University of Sydney in the early 1930s, put it: 'If we were up to standard it didn't matter what sex you were … We were treated equally, male and female, we had equal opportunities, equal marking exams, equal scholarships and equal prizes.'[92] Women's recollections of studying at the University of Adelaide in the 1930s also stressed the equitable treatment they received. Patricia Mawson, daughter of Professor Douglas Mawson of Antarctic exploration fame, put it most forcefully: 'I don't think there was *anything* against higher education for women here in any way in those days.'[93] For many, this sense of egalitarianism extended into their working lives. Despite the widespread application of marriage bars and unequal pay, over half of my survey respondents claimed that they were never aware of any sort of differential treatment. One felt the need to state strongly and specifically, 'I have never seen discrimination against women in appointments in

my profession.'[94] Even where issues such as pay and marriage bars were noted, most emphasised that everything was equal apart from this. For example, one woman explained that she 'was required to retire from CIG [Commonwealth Industrial Gases] on marriage in 1947. No other differential treatment – [this is] usually in the mind of the "oppressed"'.[95] Many seemed to become annoyed at questions which implied that all might not have been equal in science. Some felt the need to write NO in large capital letters, thickly underlined. Others were moved to comment further. A Melbourne graduate of the 1940s protested the presupposition 'that women in science had difficulties. Sorry but I didn't'. Another simply asked with clear frustration, 'Who has drummed up this idea of discrimination in the past 20 years or so?'[96]

The denial (or lack of awareness) of discrimination was especially true of women who worked in universities. Despite clear and extensive evidence of discrimination against women in the academy, few expressed any sense of differential treatment. Patricia Mawson reflected the sentiments of her many female colleagues at the University of Adelaide when she stated, 'I just don't see that we were badly treated ... [I] don't think we were squashed at all because we were women.'[97] Diana Dyason described Melbourne's department of physiology, where she worked in the 1940s, as 'in my experience completely free of sexist attitudes'.[98] Even some who worked in male-dominated areas like physics asserted that women experienced no problems in these departments. Jean Laby, the only woman lecturer in Melbourne's physics department from the late 1950s (and daughter of the former professor of physics), contended, 'At the University I do not believe there were any significant barriers for women in general.'[99]

While these life stories are obviously later interpretations of their experiences, other contemporary evidence also reflects a similar sense

of freedom and agency. A survey of women scientists conducted in 1941, for example, found that women employed in universities expressed a far lower perception of discrimination that those employed elsewhere.[100] The activities of the AFUW are also extremely revealing of these women's confident assessment of their own status and position. Perhaps surprisingly, improving the status of university women was not a focus. And women's involvement in this group cannot be read as indicating they felt restricted by their gender at a personal level. Aside from social gatherings, many activities were directed towards helping those 'less fortunate than themselves'. This reflected, as I have discussed, university women's strong participation in social reform and philanthropic causes. In the 1930s, for example, the AFUW conducted research into youth unemployment caused by the Depression, and the Victorian branch devoted itself to the curious cause of sending books to lonely women and children in isolated lighthouses. The federation also took an interest in issues of general public concern, such as the content of radio broadcasting.[101] Few of the topics discussed at national conferences centred on problems for women in universities or professional employment.

The AFUW agenda reflected a strong belief in university women's ability, and indeed obligation, to offer their expertise to the community. As Hilda Strugnell suggested at the 1928 conference, 'University women of Australia, trained to think and lead, must accept the responsibility and privilege of cultivating it and seeing that it bears fruit.'[102] In 1935 Enid Lyons, wife of the then prime minister and later the first woman elected to the federal House of Representatives, similarly impressed on the conference that they 'had the great advantage of university education and the knowledge thus gained should be used for the benefit of the community'.[103] Freda Bage at the 1930 conference reflected: 'We of my

generation ... and still more those of the younger generation ... take our present position in the universities on the basis of equality for men and women students for granted.' But she did go on to acknowledge, 'We fail to recognise that there are some places, even on the staffs of universities and schools, where all is not yet well so far as equality in the treatment of women and men for the higher positions is concerned.'[104] This was one of the very few times the position of women academics was identified as an area of, albeit minor, concern.

I am not suggesting that science in this period was, in fact, egalitarian. But it is important to understand the influences that led some women to characterise their experiences in this way. There were many factors that made this belief in women's equality possible and reasonable. Some were clearly aware of the great advantages they enjoyed. In an interview in 1979, Margaret Blackwood described how most university women of her generation were very conscious that they were highly privileged people: for her, attending university was a privilege not a 'right'.[105] Lesley Nelson, a Melbourne chemistry graduate of the 1940s, similarly noted, 'I consider myself very fortunate that opportunity and encouragement were there for me to pursue tertiary studies.'[106] It may have felt impolite, even absurd, to complain when they had enjoyed such good fortune. It also made them unlikely to think of their lives in terms of barriers or restrictions. As Barbara Graham, a geology graduate of the 1950s, described it:

I freely grant that women have had a rough trot over the years, and the less educated ones particularly so ... But it hasn't really been a bother to me personally ... because I've been in professional circles and apart from minor things ... like not getting paid as much as men, which I used to resent a bit ... I was alright Jacqueline.[107]

Graham could characterise her experiences in this way even though she worked in a male-dominated area where there were still some restrictions on women conducting field research.

These women graduates were undeniably a highly privileged group. Access to universities was even more limited than secondary education. With the exception of the University of Western Australia, university fees were high and few scholarships were available before the introduction of the Commonwealth Scholarships Scheme in 1951. In 1940 less than 3 per cent of Australians aged between eighteen and twenty-one were enrolled in a university course, and only 1.7 per cent of women in this age group.[108] These highly educated, middle-class women held a status that contributed to the sense of freedom they felt. Compared with most women, and indeed men, of their time, they were extremely fortunate.

Some of my survey respondents clearly and deliberately chose to represent their experiences through this lens. The denial of discrimination and assertions of equality were also, in part, a reaction against more recent feminist interpretations of their lives. Few identified with the feminist movement of the 1970s. For Patricia Mawson, women's liberation was 'just a lot of nonsense as far as I was concerned'.[109] Leonie Kramer, the University of Sydney's first woman professor, expressed the views of many of her generation when, at the 1974 conference of the AFUW, she stridently stated, 'I am *not* a supporter of Women's Lib. I dislike its propaganda, I find its philosophy and its diagnosis of social problems superficial.'[110] Margaret Blackwood expressed similar sentiments in 1980: 'I am not a feminist or a women's libber … I do get stinking mad when I see prejudice against women, but it's no good having a chip on your shoulder. You don't get anywhere.'[111] Gretna Weste, although she would not call herself a feminist, allowed that the

movement was probably 'very necessary in many places, [but] maybe not in our Botany School'.[112]

These women's commitment to science may also have contributed to their views since the ideal of meritocracy is a major pillar of scientific claims to impartiality. Admitting to gender bias could amount to an attack on the integrity of the field they had devoted their lives to. As Adele Millerd expressed it, 'I doubt that among really good scientists, sex discrimination does influence matters *very* much. I will keep my naivety and continue to believe that it is progress in science which is the important thing.'[113]

Women in the universities had some justification for their belief in the equitable treatment they received. Most women academics by this stage enjoyed equal pay (even if they were still often channelled into junior positions and were slower to be promoted) and, while in practice most were unmarried, generally there was no marriage bar in place. Gretna Weste contrasted her experience at the Forests Commission – where, despite being employed for her scientific qualifications, she was classified as a temporary typist and paid a pittance – with the university, where she 'was never penalised for being a woman'.[114] University women were doing very well, in terms both of their status and their salary.

The fact that few had any difficulty finding work, and indeed found that their services were in demand, seemed evidence enough for some of the acceptance of women in science. Many, too, found themselves working in female-dominated professions as laboratory workers and dietitians in hospitals, or teachers in girls' schools. As one woman pointed out, '[You] can't discriminate against women in a girls' school.'[115] Female dominance of subordinate positions in health and education was often taken as evidence that no barriers existed, and

only a few survey respondents reflected on the structural significance of the very low status of, and salaries paid to, such workers.[116]

Many had close family connections to the scientific and university communities, which influenced how they perceived their position within these spaces. In a continuity with the nineteenth century, and with previous generations of university women, many followed in their fathers', and sometimes their mothers', footsteps in pursuing scientific careers. At the University of Melbourne, many professors, particularly in the sciences, lived on campus. Their children grew up in this environment and had access to the social networks that would allow them to continue on to academic careers. Many of them turned to science.[117] Jean and Elizabeth Laby, daughters of the physics professor, went on to careers in physics and statistics. Ruth Sugden, daughter of the master of Queen's College, demonstrated in the chemistry department for over twenty-five years from 1921.[118] Margaret Blackwood's father was the sub-warden of one of the university colleges. Audrey Cahn followed both her parents (professor of physiology William and scientist and later medical doctor Ethel Osborne) in entering academic life.[119] Family connections were even more pronounced at the University of Adelaide, where, in the 1930s, a large proportion of women employed in science were professors' daughters – including Patricia and Jessica Mawson, and Elizabeth, Joan and Margaret Cleland (daughters of the anatomy professor). Effie Best's uncle was the professor of music, and her daughter, also Effie, followed in her mother's footsteps when she completed a science degree in the early 1950s.[120] For these women, such close family connections made the academic world feel very familiar. Diana Dyason met many academics as a child through her uncle, Professor of History Ernest Scott. She later reflected that it was 'hardly surprising that I wafted into an academic career without

thinking of it as anything unusual. As the saying goes, "Some of my best friends were and are professors"'.[121]

Conclusion

When Madeline Angel was asked if she ever felt unusual because of her profession, she answered, 'No I don't think so ... [A]s far as my friends were concerned, they tended to be mostly academic ... I didn't ever feel different from them.'[122] Overwhelmingly, women scientists of this period did not feel they were doing anything particularly unusual. And while all was not, in fact, equal in the world of science, women's lack of acknowledgment of this should not simply be dismissed as some kind of false consciousness. Such a reading would overlook the factors that created this belief. Many of these women came from families that supported higher education for women and could afford to send their children to university. They had mostly attended single-sex schools, which encouraged academic achievement and supported scientific studies, and many also had close family ties to the scientific or university communities. Few had to struggle to follow their scientific interests. Once at the university, the generation of women who studied science up to 1945 had little reason to feel out of place, especially in the biological sciences where women students were in the majority and there were numerous women on the university staff. When they graduated, they mostly found that women with science degrees were in great demand. Those who found employment in the universities continued, with some justification, to perceive an egalitarian working environment. In the immediate postwar years, reconstruction training schemes saw an influx of ex-service personnel into university degrees, so women's services remained indispensable.

Below the level of professorships, women would have had little reason to view their gender as a hindrance to advancement. Outside the academy, many found themselves working in female-dominated professions. Few attempted to break into areas where women were not already reasonably well represented and accepted.

In looking at women scientists from this period, it is quite easy to identify how they were restricted by their gender. But this involves placing a construction on their lives that they would not have identified with. Though their faith in the ideals of meritocracy may have been misplaced, we need to recognise that such beliefs do have currency and are the reason women have been able to envisage a place for themselves within science. Although evidence from numerous other sources shows that gender did count in the world of science, this was not the primary lens through which this group of women interpreted their experiences. Like earlier generations, these women believed that all the major battles for women's higher education and professional employment had already been won – and they had good reasons to believe this in terms of formal and legal restrictions – and there was thus no need for further feminist agitation. The strength of the more 'informal', 'hidden', structural and cultural constraints on women's achievement had yet to become fully apparent. Class status gave many of these women a confidence and security about their place in the world, which allowed them to feel free to follow any interests or path in life they chose and to ignore the possibility of any obstacles to their interests. Their experiences reveal that there were spaces in which the decision to pursue higher education or a scientific career did not seem particularly unusual or unconventional. These sat easily alongside the 1950s glorification of domesticity and motherhood as vocations offering women complete and ultimate fulfilment.

The accounts of women scientists of the 1930s and 1940s reveal that they were neither rebels nor radicals. Their decision to enter science, and the freedom they felt within it, were as much a positive product of their class and culture as for any 'typical' middle-class housewife. Although they may be seen as 'exceptional' when placed in a broader context, within the comfortable surrounds of their own social circles, this was certainly not the case. Compared with most women, and indeed men, of their time, they were extremely fortunate, and many were clearly, even acutely, aware of this. This made them unlikely to think of their lives in terms of impediments or restrictions. These women had escaped the barriers that restricted the majority of women (and many men) so completely. The influences facilitating women's entry into science were limited to a very small group. They did not provide a significant foundation for 'other' women to build on. This highlights the dangers of extrapolating from overarching gender ideals to specific individuals and groups, times and places. We should not assume that these constructions represent or create the experiences of specific women in particular historical contexts. While there is certainly much evidence that they were not as equal as they felt, these women knew no barriers to their participation in science.

Chapter 6

A Profession for Men

The Transformation of Australian Science, 1940–1960

Reflecting back on the women academics of the 1930s at the University of Melbourne, who were mostly scientists, the historian Kathleen Fitzpatrick observed: 'It is true that none of these women had yet achieved the rank of a full professor, nor was this to happen for another half-century, but in relation to the number of women qualified for academic appointments, I am inclined to think that their achievement was greater then than now'.[1] Her impressions, written in the early 1980s, were perceptive. The 1930s and 1940s were a high point for women's participation in science, particularly in the universities. But this period also saw dramatic changes in the size, scope and status of Australian science. These changes meant that in the postwar period women's participation would be more muted. The prestige of science was greatly enhanced by the Second World War, as science was seen to be making invaluable contributions to the war effort, and government funding for research greatly increased. This expansion continued into peacetime, accompanied by an exponential expansion in higher education. Employment opportunities abounded both in research and

in a multitude of jobs requiring scientific qualifications in the public and private sectors.[2] For the first time, science became a viable and recognisable career choice. In this sense, true professionalisation of science came comparatively late to Australia.

It was in this era that the sciences became masculinised. As more men began to flow into scientific studies and employment, women were edged out of the field. In the postwar years, while the number of women studying science remained almost unchanged, they were overwhelmed by the vastly increased numbers of men. The relative proportion of women in science degrees dropped dramatically. Initially, this reflected an influx into universities of ex-service personnel (overwhelmingly men) supported by the Commonwealth Reconstruction Training Scheme. By 1948, at the height of this scheme, the student population in Australian universities had more than doubled compared with prewar levels. The downturn in women's relative presence continued over the next two decades. It was not until the late 1970s that women's representation in science degrees again reached the levels seen in the 1930s and the war years. Women's representation on the science staff of the universities also declined dramatically after 1950, and they were largely excluded from the new high-status arenas of scientific research (such as the CSIR, renamed the Commonwealth Scientific and Industrial Research Organisation/ CSIRO in 1949) which developed rapidly outside the academy.[3]

In contrast to the positive portrayals of equality by women scientists themselves, other sources attest to the highly gendered nature of Australian science in this period. The archival record tells a very different story of discrimination and exclusion. It was not just that there were far more men. Numerous other influences led to a dramatic decline in women's relative status – even in the previously highly 'feminised' biological sciences. In this era, Australian women's experiences

converged with those of women in other Western countries.[4] Patterns set in place in the postwar years were enduring and many are still apparent today. Although science was never a gender-neutral domain, neither was it always exclusively masculine; science in Australia did not necessarily begin as a masculine practice, but its transformation as such was a conscious and active historical process. Science was remade in such a way that women's earlier strong presence was rendered invisible and even inconceivable.

A Highly Gendered Profession

The influx of men into the scientific workforce following the Second World War accentuated pre-existing gendered assumptions about the kinds of work deemed appropriate for women and created new ones. In contrast to the 1930s, careers-advice literature from this period stressed the very different prospects for men and women in science. Job advertisements routinely specified the gender of the person required, and 'male' and 'female' openings were placed in separate sections of the newspapers, even into the late 1960s. As one woman pointed out in a letter to the *Sydney Morning Herald* in 1967, 'There are no advertisements for graduate chemists in the women's section of the paper. Out of necessity, therefore, a woman must apply for positions advertised in the men's section.'[5]

In 1940 the recently formed New South Wales branch of the Australian Association of Scientific Workers (AASW) was asked to prepare two vocational guidance booklets outlining opportunities in science: one on scientific careers generally and one specifically for girls and women.[6] The latter pamphlet was prepared by a diverse group of at least thirteen women scientists coordinated by Kathleen Sherrard (nee

McInerny), who was a demonstrator and assistant lecturer in geology at the University of Melbourne for ten years before she married and moved to Sydney in 1928. It was titled 'Science Careers for Women' and covered many different scientific fields and jobs, though it appears it was never published. In it, the authors began with a positive assessment of women's place in science. Its introductory section optimistically noted, 'In some scientific professions there is still some prejudice against employing women', though 'undoubtedly the women already holding positions can help most to sear this prejudice' and that the 'best safeguard against any prejudice is for the woman to equip herself with the best possible qualifications'. The marriage bar was not mentioned, despite the strong argument of one contributor that 'avenues of employment are permanent only as long as the woman remains unmarried – particularly Public Service jobs; that is the real objection in most cases to the employment of women, i.e. the uncertainty concerning their future'. The majority decision of the committee was that 'this aspect would not influence girls of 15 or 16 very strongly'. Sherrard made the hopeful yet erroneous prediction that, in any case, 'by the time they are older this reactionary regulation may have been discarded'. The marriage bar was not fully abolished until 1966.[7]

Most entries, however, painted a bleak picture of women's prospects and were extremely candid about the strength of prejudice against women in almost all fields. One section on the variety and levels of responsibility of the work available to women starkly stated, 'At the present day there are no great prospects of promotion for any woman scientific worker, though here again exceptional technical qualifications, and perhaps more important exceptional personal qualifications will assist her.' Pharmacy was the only field identified as having 'little, if any prejudice against women', and teaching was also recommended

as an 'alternative occupational opening' since there was 'a constant demand for Science teachers'. For agricultural science it was simply stated that avenues of employment 'appear to be few as men are almost invariably chosen in preference to women'. The entry on geology, written by Sherrard, reflected the difficulties she had faced finding a job after her marriage (even during the height of wartime shortages).[8] Apart from teaching, Sherrard could only suggest that avenues of employment were 'not numerous', though 'women have occasionally been appointed palaeontologists'. Geology was an extremely popular subject with women students at the University of Sydney earlier in the century,[9] but this had not translated into acceptance as workers in this field. Sherrard also emphasised the legal obstacles to their employment, 'as the law prohibiting women to work underground ... automatically closes some geological work to them'.[10] She was referring here to geological surveys and mining (which was set to become a key area of employment for geologists). The entry on physics and mathematics, written by Ruby Payne-Scott, was similarly discouraging: 'There is probably more prejudice against employing women in mathematics and physics than in any other science except geology.' Here, teaching was held out as virtually the only area of employment. Even then, while maths teachers were in high demand, women interested in physics would have needed to move interstate, as very few girls' schools in New South Wales taught physics.

Sherrard's committee presented a highly negative assessment of opportunities even in the biological sciences – fields that women had dominated as university students for decades. Botany was held out as offering little promise, since 'pure Botany as a career for girls hardly exists', and where fieldwork was involved, 'female appointments are rare'. Men were reportedly preferred in applied areas of zoology, and

while women were offered 'reasonably permanent' positions in teaching, museums, the CSIR or government, this was only on the condition that they remained unmarried. For the biomedical sciences, which were portrayed elsewhere as promising fields for women, it was noted that most graduates were employed in routine testing work in hospitals where the 'prospects of promotion [were] not great'.

Universities also emphasised the very different prospects for male and female graduates in their careers advice, and women science graduates were often singled out for special mention. In its very first report in 1924, the University of Sydney appointments board had noted: 'Great difficulty has been experienced in learning of positions suitable for women graduates, the majority of whom are from Arts and Science. Outside of teaching and a few library appointments, there appear to be no regular avenues of employment.' Women graduates were advised to supplement their degrees with training in shorthand and typing.[11] The Melbourne board was giving similar advice, and there is some evidence that women took it seriously. Jean Halsey, a Melbourne botany graduate with an MSc (first class honours) and a further year's research work behind her, took care to point out to potential employers in the mid-1930s that 'with a view to increasing my value as a member of a research laboratory staff, I have undertaken a course of typing and shorthand'.[12]

In 1937 the Melbourne board identified the placement of women graduates as 'one of the biggest problems which must be dealt with', particularly because women 'were not welcomed to industrial laboratories'.[13] Earlier predictions that industrial chemistry would become a popular career for women had proven completely misplaced. One woman describing her appointment to ICI (Imperial Chemical Industries) observed, 'To appoint a woman to a commercial position in

a chemical company at that time (late '50s) was extraordinary.'[14] Barbara Graham felt 'undeservedly lucky' when she secured a job as a geologist with the British Petroleum Company in Papua New Guinea in 1954 just months after finishing her undergraduate degree. She recalls that at the time, 'the company had 8 women and 500 men'.[15] Teaching remained the exception. The acute shortage of science teachers, 'especially in the girls' schools', was often noted by the appointments boards.[16] In 1938 the Sydney board expressed the view that 'probably not half the women who graduate in Science find it possible to get work directly in line with their training'.[17] In 1940, its secretary concluded that of the women who had graduated in science in the previous four years:

> some have gone into official research organisations like the CSIR, a few more have remained in the University as research assistants, demonstrators and the like, one or two have gone into hospital laboratories ... [a small number] have obtained employment with private firms and the remainder have either taken up teaching or qualified themselves for secretarial work'.[18]

By the following year the situation had drastically altered. Women students were being 'snapped up by employers before they have even completed their training' and those 'who once refused to take women scientists for the reason that they were likely to marry and leave ... are now begging for them'.[19]

This was a short-lived phenomenon. Women prospered in science during wartime labour shortages, but these opportunities quickly contracted again with the end of war. Both employer inquiries and newspapers advertisements largely reverted to the prewar practice of including gender in their job specifications, and most of these were for

men.[20] In 1946 the Sydney board advised: 'Owing to the present very limited opportunities for women in industrial chemistry, graduands were advised to consider starting dietetics, teaching or technical training … Pass graduates in Science, particularly women, should be prepared to spend at least another year in further training.' In 1947 they repeated the advice that 'enquiries for women chemists in industry are very infrequent', but that 'women Science graduates who have completed the dietetics course are in very great demand' and 'men graduates in the technical faculties have been very quickly placed'.[21] An article in the *Argus* in 1947 entitled 'Demand for Women Science Graduates Declining' echoed the Melbourne board's opinion that the options for women were decreasing, but that 'if they are prepared to teach … there are many vacancies, and some will no doubt also obtain positions as scientific librarians or information officers'.[22] In the 1950s appointments boards frequently recommended that women be trained as scientific librarians and technical secretaries, and they singled out hospital laboratories as having the greatest demand for women science graduates due to the shortage of biochemists and bacteriologists. While women science graduates were certainly far more employable than those in arts, and they generally did find work of some kind, their prospects and options were far more limited than those of similarly qualified men.[23] Women's prospects were particularly poor for research-based jobs, and research was and is the essential requirement for status as a 'scientist'.

Disciplinary Exclusion and Dietetics

Most of the fields that held good prospects for women were the least prestigious and lowest-paid areas of scientific work. Teaching provided no opportunity for research. The promotion of areas such as dietetics

and the biomedical sciences to women reflected the low status of jobs in these fields and the limited research opportunities. This was starkly illustrated in a survey of biochemistry and bacteriology graduates conducted by the Melbourne appointments board in 1953. This found that women were the vast majority of graduates in these fields, and they were mainly employed in low-status, low-paid, hospital laboratory work. The few higher-status research positions were largely occupied by men. These fields were female-dominated, but only the very occasional woman, such as Phyllis Rountree, was able to conduct research and achieve a significant scientific status working in hospital laboratories. The Melbourne board's report emphasised the low salaries and poor promotion prospects in the hospital system where science graduates took second place to 'medical men' and were generally relegated to routine work. Some respondents suggested that 'intending students should be warned about the low status of the profession itself, due to the fact that it consists mainly of women who rarely practice for long'. These poor conditions were, however, only seen as a deterrent for men. As one of the medical graduates surveyed observed, bacteriology 'was a profession whose rewards were suitable for women science graduates, for they did not demand as much as men', while another respondent suggested that 'only women should major in Bacteriology'. Among the women biochemists, it was reported several 'thought Biochemistry an ideal profession for women, as long as they were warned of the poor remuneration and status, which would not satisfy men'.[24] Its low status was the rationale for promoting biochemistry as 'ideal' for women. Some women were clearly aware that the low status and female dominance of their profession were connected. As one hospital biochemist observed, 'Initially in my day, pay was low, men were not interested in the field.'[25]

A Profession for Men

Dietitians suffered from the same problems and there were even fewer opportunities for research. As Constance Wilson, a Sydney dietetics student of the 1950s, put it, dietetics was consistently presented as a 'sunrise' profession for women.[26] The emergence of dietetics as *the* ideal profession for women science graduates in the postwar period had a long history that stretched back to early 1900s campaigns for domestic science degrees to be taught in Australian universities (led by women professors). These campaigns were unsuccessful. But they did bear fruit in relation to dietetics training (which had been envisaged as a central component of the never realised domestic science degree).[27] Melbourne's Alfred Hospital instituted the country's first dietetics course in 1930, soon followed by St Vincent's Hospital in 1933. The University of Melbourne took over from both these when it established a postgraduate diploma in dietetics in 1937. This required completion of a BSc with a major in the new subject of nutrition, along with bacteriology, biochemistry and physiology, followed by a year of hospital placement. In NSW, from the late 1930s the Certificate of Dietetics required a BSc with physiology and biochemistry, and then a year of residential training at the Royal Prince Alfred Hospital.[28]

From its inception, dietetics was established as a 'woman's' profession and seen as a scientific field that would welcome them. Audrey Cahn (daughter of professor of physiology William Osborne) was one of the first students to complete the St Vincent's Certificate of Dietetics in 1934. Cahn had originally completed a degree in agricultural science in 1928 but found it impossible to get work in this area (she was also married with twins). She recalled, 'In those days, if you were a woman and married and with children you had very little hope of getting a job in the profession that you had chosen … It was very difficult for women particularly in something odd like agriculture.' Her decision

to move into dietetics was also influenced by her mother, Ethel, who had been instrumental in establishing the St Vincent's certificate and then pushed hard, along with her husband, to establish the university diploma. Cahn had no trouble finding work after retraining in dietetics (and separating from her husband), becoming chief dietitian at St Vincent's before moving to a similar position at Perth Hospital where she helped set up its dietary department. During the war, she served as chief dietitian at the Heidelberg Military Hospital, with the rank of major in the Australian Army Medical Women's Service. In 1938 Cahn and Betty Wilmot were the first students to gain the new diploma of dietetics from the University of Melbourne.[29] From this point, the field grew exponentially.

Both the Sydney and Melbourne appointments boards strongly promoted the new field of dietetics to women science graduates. In 1944, the Sydney board drew attention to openings 'particularly for women in the nutrition field' and made 'special arrangements' for 'women graduates with chemistry and biochemistry to take post-graduate training in Dietetics'.[30] After the war, both boards continued to stress the demand for women dietitians and to advise women science students that dietetics training would improve their employment prospects.[31] In 1947 the head of the Melbourne board reported that he was 'continuously trying to encourage women students to obtain the Diploma [of Dietetics]'.[32] In 1952 the women's adviser on the Sydney appointments board stressed that 'the dietetic profession is offering excellent opportunities for women and in my opinion is one of the most satisfactory openings for women graduates in Science'.[33] Reflecting on why so many women entered this field in the 1950s, Constance Wilson observed, 'I think it [was] because at the time there weren't that many openings ... for women in science ... [dietetics] was virtually purely

female, and so women saw it as an opening.'[34] Another Sydney dietetics graduate recalled: 'After rejection of several job applications with the excuse of "no toilets for women" at our research station, I decided to study nutrition and dietetics, a predominantly female field.'[35] Ultimately, women's movement into dietetics, while represented as an opportunity, reflected the limited options available. It also meant they were being channelled into a low-status, low-paid field. Wilson never enjoyed dietetics, found the pay and conditions poor, and felt fortunate when she was able to return to university to complete a PhD in zoology.

Women were being steered away, or explicitly excluded, from higher-status areas. And their concentration in the biological sciences became a significant disadvantage in the postwar years. The most dramatic expansion in Australian science occurred in the physical sciences with the growth of university physics and chemistry departments, the CSIR/O, and industrial laboratories. The numbers of students undertaking higher degrees in the physical sciences began to outstrip those in the biological sciences in the 1930s. By the 1940s, most science students were majoring in physics and chemistry, but women were conspicuously absent from these fields. In physics departments at Melbourne, Adelaide and Sydney, women constituted a tiny proportion of majors; in Adelaide, it was not until 1948 that the first woman completed an honours degree in chemistry, and of the 111 students who completed honours degrees, master's degrees and PhDs in chemistry from 1930 to 1960, only five were women.[36]

The demarcation of scientific fields along gender lines became even more apparent in secondary education, where the physical sciences came to dominate the subject choices of boys completing the final school years, but not those of girls.[37] By the early 1950s, Sydney's professor of physics, Harry Messel, observed that there was not one

metropolitan secondary school in Sydney offering physics to girls.[38] One student who attended North Sydney Girls' High School in the mid-1940s recalled that the principal's opinion was that 'Physics isn't ladylike'.[39] The absence of physics from the curriculum of girls' schools in Sydney by the 1940s seems to have almost amounted to a government policy and certainly reflected assumptions about the kind of education that girls should be given. In Victoria, the proportion of girls taking chemistry and physics dropped dramatically from the late 1940s, and their relative representation was further diminished by the larger numbers of boys taking these subjects.[40] In 1944 an *Argus* article warned that 'unless women are to be fewer in medical and science courses at the University girls' schools will need to improve the present inadequate training ... [where] they encouraged and taught "cultural" subjects, such as English and History, at the expense of science'.[41] This prediction was largely borne out. By the 1950s, gender divisions in science education became firmly entrenched just as school retention rates began to increase dramatically.

This period also saw marriage rates for Australian women reach unprecedented levels. With the marriage boom after the Second World War, matrimony once again became the destiny of most women. Only about 6 per cent of Australian women who turned twenty in the 1940s would never marry. While marriage rates among tertiary educated women remained lower than those of the general population, the single-career-woman path became far less popular among women science graduates.[42] Barriers relating to marriage thus became far more pronounced in the postwar period. And very few women who had children were able to maintain the continuous research necessary for high-profile scientific status. Taking a break to have children almost invariably meant giving up a research career.[43]

The CSIR/O and the Marriage Bar

Many of the new opportunities in science were created within government institutions and departments where the marriage bar was in place, most significantly in the CSIR/O. Prior to the Second World War, the limited amount of scientific research undertaken in Australia had been conducted almost exclusively within the universities. During and after the war, CSIR/O took pre-eminence in this sphere. Here the marriage bar, although not always strictly enforced, served to dampen the career prospects of all women within the organisation, since all could potentially be forced to resign under this regulation. Women represented only around 10 per cent of all CSIR/O staff (both 'scientific' and 'non-scientific') from 1930 to 1950. The very small presence of women in research positions at the CSIR/O alone goes a long way to explaining their poorer status in Australian science in the postwar years.[44]

Only a handful of women were employed in research positions prior to the Second World War. Between 1929 and 1939, seventeen women were 'ambiguously' listed in positions that sat between or across the 'scientific' and 'non-scientific' classifications. This included Ellinor Archer, the CSIR/O's first woman scientist, who had worked for its two predecessor organisations as a secretary, investigator and librarian since 1918. She became librarian and scientific assistant in 1926 and chief librarian from 1946 to 1954. Most of the other librarians employed from the 1940s were also women. Helen Newton Turner, who became one of the world's leading authorities on sheep genetics, began her career at CSIR/O in 1931 as a clerical officer. From 1956 to 1973 she was Senior Principal Research Scientist in the Division of Animal Genetics and her work had a major impact on Australia's wool industry.[45]

While Archer and Newton Turner remained single, most other women's careers were cut short by marriage. Betty Allan was awarded a CSIR studentship to study in Britain in 1928. She went to Cambridge – studying mathematics, statistics and applied biology – and then to the Rothamsted Experimental Station to work under the world-leading statistician (and renowned eugenicist) Ronald Fisher. On her return in 1930, she was appointed as CSIR's first biometrician, where she remained until her marriage in 1940, contributing to numerous research projects across the organisation. Allan was joined in 1936 by Mildred Barnard, who had had followed in her footsteps and also gained her PhD with Ronald Fisher in his new position as head of the Galton Laboratory at University College London. Barnard also married and left in 1941. The only other woman employed for an extended period was Josephine Mackerras, a medical scientist and entomologist employed from 1930 to 1941. She was married to fellow CSIR entomologist Ian Mackerras and was one of the very few who managed to evade the marriage bar. The couple later moved to the Queensland Institute of Medical Research (Ian as director), where they had extremely productive careers, both in collaboration and individually.[46] During the Second World War, many women were recruited into CSIR. Most prominently, the physicist Ruby Payne-Scott was, from 1944, a pioneer of the discipline of radio astronomy and helped place Australia at the forefront of a vital new field. She hid her marriage for several years, finally resigning in 1951 when she was pregnant.[47] The most tragic example of the impact of the marriage bar was Mary Fuller – the first woman officially appointed in a purely 'scientific' role in 1929 whose ground-breaking research made key contributions to the field of carrion ecology. Fuller's suicide in 1938, soon after the birth of her first child, was widely reported,

and the coroner concluded that fear of losing her job had contributed to her death.[48]

In addition to the marriage bar and lower pay rates, some individual scientists at the CSIR displayed a marked antipathy towards employing women. Physicist Rachel Makinson, who had come from England with a Cambridge degree (and a husband) and joined CSIR in 1944, was informed by the head of her division that he would 'not have a woman in a senior position if I can help it'.[49] Correspondence relating to appointments reveal the wider bias that existed against the employment of women, even in the highly feminised field of botany. Sydney's professor of botany, Eric Ashby, wrote often regarding his students' applications for positions at CSIR/O. The issue of gender was invariably raised. In 1943, for example, he wrote regarding one of his students: 'Miss Fraser ... would make an excellent research assistant ... but I think the CSIR would prefer a man if they can get one.'[50] In this same year, when two of his students, a man and a woman, applied for the same position, Ashby wrote to the secretary of the CSIR outlining their relative merits:

> There is no doubt whatever that Miss [Margaret] Mills is a far better candidate ... However if it is necessary to have a man for this position, and Miss Mills is therefore not eligible, I suggest that consideration be given to Mr Simpson ... a very steady and sincere worker but he is not gifted with very much originality.

He followed this up with a letter directly to the head of the division where the position was located: 'I have written to Dickson supporting an application from a member of my staff for the job in your section. If you are prepared to take a woman, I think it would be worth

while giving serious consideration to this application.'[51] Ashby went to considerable efforts to assist many of his women students and, in some cases, was instrumental in securing them positions despite the strong preference for men. As one wrote to thank him for his help in securing her a job as a librarian: 'You must have written a very eulogistic reference about me, as I have applied for several positions in the CS & IR in the past without any result.'[52]

Professor Turner of the Melbourne botany school also received frequent inquiries from CSIR seeking potential applicants for positions. Despite the continuing dearth of men in the field, these almost invariably specified male applicants. In 1945 the Chief of the Division of Plant Industry wrote regarding opportunities his division, 'The principal obstacle to the realisation of the programme envisaged is the shortage of qualified personnel ... [M]en who may be interested are invited to write to me directly.'[53] Two years previously, due to wartime student shortages, Turner had been forced to write in response to one of these queries, 'I think it is going to be difficult to find a male graduate whom we could recommend for the post ... If you would consider a woman, please let me know immediately.'[54] The CSIRO's preference for male applicants continued into the 1950s. As Turner wrote in 1956:

> I have just received the advertisement for an ecologist for the Land Research and Regional Survey Section. I am sorry that we appear to find it almost impossible to provide CSIRO with properly trained men in this field ... The difficulty is to get first-class men to take the full course these days, as Agriculture is a greater attraction.[55]

The same problems applied to scientific positions in other government departments. As one of Ashby's former students wrote about her application for a position at the National Herbarium, 'Of course the Public Service Board has definite preferences for a male appointee, so it is difficult to estimate my chances of success.' Ashby replied:

> There is considerable competition for the Herbarium job, but frankly I think your qualifications are better than most ... So long as we can overcome the serious misfortune of your not being a man (which as you say weighs heavily with the Department of Agriculture) the chances of your getting this appointment are good.[56]

And even when women did manage to secure a government job, the marriage bar loomed large. Nancye Perry, a Senior Research Officer with Plant Quarantine in the mid-1950s, was 'devastated when marriage ... put an end to [her] career' in 1957.[57] Throughout the 1940s and 1950s, women's prospects continued to be restricted, despite the shortage of science graduates in all fields that was documented in report after report.[58] The bias against women also extended into the supposedly 'meritocratic' realm of academic science.

Universities and the Myth of Meritocracy

When the University of Melbourne appointed its first female professor in 1975, coincidentally International Women's Year, Vice-Chancellor David Derham proclaimed, 'In making appointments to its academic posts the University ... has not, for many generations, considered the

sex of candidates for appointments to be a relevant matter.'[59] Yet a study conducted in the same year found that women were proportionally no better represented on the academic staff of the university than they had been in 1951, despite their increased student numbers, and they were concentrated in the lower ranks.[60] Fictious claims like Derham's had been made for decades. Universities were certainly more welcoming to women than many other institutions. But they were still rife with discriminatory attitudes and practices.

University appointments were, in theory, solely based on academic merit. But there were a few institutional barriers to women's employment. There was, for example, an unwritten, although often cited, anti-nepotism rule preventing the appointment of husbands and wives at the same institution, which adversely affected women who married fellow scientists (a relatively common occurrence).[61] Prior to the mid-1950s, there was only one university in each Australian state, meaning that only one of a married couple in this situation could have a university job. There was also some differential treatment of women staff in terms of employment conditions. At the University of Tasmania, women's pay was reduced to 90 per cent of the male rate in 1948.[62] At the University of Adelaide, until 1963, women were required to retire five years earlier than their male colleagues.[63] When Nancy Atkinson strenuously protested this regulation – pointing out that 'no distinction is made between men and women on the academic staff in salary and I had no reason to expect any difference in retiring age' – the university council responded not only by reaffirming the policy but by writing to all women staff members to ensure they were aware of its existence.[64]

The most glaring case of institutional discrimination was at the University of Western Australia, where married women were not appointed to the permanent academic staff until 1968, even though

this was a clear violation of the university's Act of Incorporation. The official nature of this policy was spelled out by the university registrar in 1966 (the same year the marriage bar in the Commonwealth public service was abolished): 'The principle at present in force relating to the employment of married women on the teaching staff is that those who are not required to provide for their own means of financial support, be not appointed in a permanent capacity.' Further justification for this policy was provided in a letter from the vice-chancellor to the Western Australian Association of University Women the following year:

> Academics are employed not from 9.00 am to 5.00 pm, but are required to devote their whole time and attention to teaching and research. As you can probably imagine, this creates somewhat of a problem for the young married woman unless she is fortunate enough to be able to ensure continuously the services of a competent housekeeper and nurse.[65]

Sibely McLean's prospects were materially affected by this regulation, when, in 1959, she married and moved to Perth with her husband who had recently been appointed to the university. Even with her thirteen years' experience at the University of Adelaide, she was only ever a visiting lecturer in the department of microbiology in Perth.[66] Despite this, one of the university's professors felt able, in 1962, to refer to 'the very real freedom which the University had over the years extended to all members of its staff and student body, regardless of their sex'.[67]

Women's representation on the science staff plummeted in the 1950s. From a high point of 20 per cent in 1950, it dropped to just 11 per cent by 1955.[68] And they were even more confined to lower-status

positions and excluded from the more prestigious physical sciences. In 1991, women were still only 14 per cent of academics at the level of senior lecturer and above in the science faculties of Australian universities. At University of Melbourne, the proportion of female staff in the chemistry department fell from 36 per cent in 1942 to just 10 per cent in 1952. It was not until 2005 that Frances Separovic became the first woman professor of chemistry not only at the university but in the whole of Victoria.[69] In marked contrast to earlier in the century, their representation in science was far worse than most other disciplines.[70] As late as 1995, women represented only 10 per cent of staff at lecturer level or above on the staff of chemistry departments in all Australian universities. Women's representation in physics was even lower.[71]

Women's claims to promotion were routinely overlooked. In 1954, Doreen McCarthy resigned her part-time lectureship in biology at the University of Adelaide, which she had held for twelve years, after her demonstrator, a man, was appointed to a more senior position over her. Professor Wood justified this on the grounds that the demonstrator was about to be married and would have family responsibilities.[72] Gwen Woodroofe had resigned in 1950 due to mounting dissatisfaction over the university's reluctance to appoint her to a permanent position, even though she had held a 'senior degree' for five years, had been a 'full-time member of the University staff for eight years', had been lecturing for six of those years, and had been 'left in charge of the Department … on many occasions'.[73]

Nancy Atkinson's position was even more invidious. Although she was, by 1948, the head of the bacteriology department, she still held only the status of lecturer. As she wrote to the university council, 'I should very much appreciate receiving for myself a more senior

title for next year. On the grounds of my having been head of the department for seven years.' Although promoted to reader-in-charge the following year, she was overlooked for the newly established chair of microbiology in 1958, despite her clear claim to the post. As she pointed out in her application:

> I have a special personal attachment to my Department as it has achieved its present stage of development entirely by my own efforts ... In 1943 I made the first penicillin in Australia ... I believe that I have been carrying out all the functions of a Professor of Microbiology in the University of Adelaide for many years ... My appointment to the Chair would give me great pleasure and satisfaction in enabling me to continue the guidance of the department which I have done so much to create.

Her CV showed she had produced over 100 publications, including three letters in *Nature*.[74]

When New England University College was granted full university status in 1955, the female dominance of the biological departments was almost completely redressed. Gwenda Davis was not even considered for the post of professor in the department she had headed for ten years. And while it was assumed senior positions would be filled by men, the opposite assumption applied to more junior ones. A letter outlining the appropriate salaries and duties for demonstrators at New England stated, 'A demonstrator may carry out some of the work of a technician; *she* will sometimes take tutorials and *she* may give some lectures.'[75] Even in botany, women tended to be concentrated in the lower ranks. While women still represented a large proportion of students in these fields, larger numbers of men were taking these

subjects and were recruited onto the academic staff at a far higher rate. The greater tendency for women graduates to marry also meant fewer pursued long-term academic careers, and those who worked in the universities were often demonstrators who were not engaged in research. At the University of Melbourne, many married women were employed for long periods as sessional demonstrators in botany. As Gretna Weste recalled: 'They called them later the "Golden Oldies" ... A lot of women ... [who] came demonstrating year after year and didn't do anything else.'[76]

Dietetics, which had long provided a small haven for women on the academic staff at the University of Melbourne, was increasingly besieged. Jean Millis, who had recently completed her MSc, was the first academic appointed to teach the diploma in 1937. In 1945 she went to Cambridge with a British Council scholarship to undertake specialist studies in nutrition and was promoted to a senior lectureship soon after her return.[77] By this stage, Audrey Cahn had been appointed to assist with the course. She took over as lecturer when Millis left for the University of Malaya in Singapore in 1950, and retired as a senior lecturer in 1968 (when the dietetics diploma was abolished). Cahn recalled that the Professor Trikojus was never happy about the inclusion of dietetics teaching in his biochemistry department: 'It was regarded as a woman's profession ... the university did all it could to get rid of the nutrition/dietetics course of subjects ... It was regarded as cookery, not fitting for [the university].' When the university established a Faculty of Applied Science in 1961, Trikojus ensured that nutrition was moved into this area and the course disappeared from the university entirely when the new faculty was abolished in 1968.[78]

Despite the general unwillingness of women scientists to discuss the possibility of discrimination in their profession, a few had a very

definite impression of its existence. Audrey Cahn referred to an 'anti-feminist movement' at the University of Melbourne: 'It was certainly made clear, in biochemistry, at any rate, that women could do a useful job, but they were not really suitable for the top jobs ... [They] were regarded as the workhorses of the department.'[79] Valerie May, who completed her MSc in botany at the University of Sydney in 1938, described the prospects facing women graduates in botany in the late 1930s and 1940s in detail:

> We did very well up to what is now called the glass ceiling ... [those who did very well] were employed as demonstrators, senior demonstrators and so on, but only for a limited time. And then they seemed to come to an end as to what opportunities there were ... no rising into the senior staff ... no promise of anything beyond this senior demonstratorship. Otherwise, you'd teach ... After all, most of us wanted a job ... [but women] didn't think they'd be doing it as science, only as teaching ... They didn't expect any individual sort of activity.[80]

Diana Temple, who became an associate professor of pharmacology at the University of Sydney in 1976, recalled that women were very much 'kept in their place' in the Sydney chemistry department where she worked in the 1940s and 1950s.[81] Audrey Bersten, who worked in the Sydney biochemistry department from the late 1940s, similarly observed that women there were not treated 'with enlightenment': 'I think there was a general feeling that it's alright for women to occupy these lower-level academic positions, but we don't really approve of women up in the higher echelons.'[82]

Taking to the Field

Botany and the Search for 'Suitable Men'

Nowhere were women's changing fortunes more forcefully illustrated than in the biological sciences, particularly botany, where they had previous enjoyed a strong presence. The botany professors drove this change. Writing in 1940 in response to an inquiry regarding the existing opportunities for women botany graduates, Eric Ashby outlined:

> If she is given a First Class, she is almost certain to get some kind of post-graduate scholarship ... Under these conditions she could do research and obtain a higher degree. The permanent positions in Botany for women are of the following kinds:
>
> (i) academic work (naturally depending upon chance positions)
> (ii) research work with the Council for Scientific and Industrial Research (there are several women with Honours degrees employed ...)
> (iii) research position in State Departments ... these are rare
> (iv) teaching schools ...
>
> Briefly I think we could launch a First Class woman graduate, but there may be some difficulty in finding a permanent appointment, other than teaching, for a Second Class Graduate.[83]

The late 1930s saw the re-emergence of attempts by botanists to promote their discipline to men. After the flurry of correspondence in the 1920s, following the formation of the CSIR, activity on this issue had receded. Professors in the biological sciences were now again devoting a great deal of energy to attracting men into the field. Almost from

212

the moment of his arrival from England in 1938, Eric Ashby entered enthusiastically into this endeavour. He was particularly worried to discover that biology was not taught in boys' schools in New South Wales.[84] While Ashby was very supportive of his women students, he was also greatly concerned that men should be encouraged into the field. As he stated in 1939, 'It is of greatest importance, now that Botany is expanding as a career, to attract young men of outstanding ability into the profession.'[85]

These concerns were shared by his Melbourne equivalent, John Stewart Turner, who arrived from England at around the same time (after beating Ethel McLennan for the botany chair). At a meeting of the AASW in 1940, Turner noted that only seventy-seven of the 150 secondary schools in Victoria taught any sort of biology, and of these, only five or six were coeducational or boys' schools. He voiced his strong concern that 'it appeared probable that in any one year only a hundred or two hundred boys in the whole of the State were introduced into a scientific study of animals, plants and man'.[86] These figures also meant that most Victorian girls were receiving biology education, but this was not of interest to Turner. Writing in the *Science Review* – the journal of the Melbourne University Science Club – in 1939 on 'The Neglected Science', Turner argued, 'Biology is no longer a soft option and an accomplishment for a polished female friend. It is rapidly taking its place as a mature science, becoming more quantitative each year.'[87] This may have been true, but it did not mean that any more men were attracted to the field.

Throughout the 1940s and 1950s, Turner wrote numerous letters seeking recruits for his department, most of which specified a preference for male applicants. The phrases 'a good man', 'a suitable young man', 'a fairly senior man', 'preferably a man', are repeated throughout this

correspondence. Turner sometimes had a very specific vision of the kind of man he desired, as he wrote to a colleague in 1961:

> I am writing to ask whether you can give me any help in finding a suitable young man for a lectureship here in Plant Pathology ... I think the job might suit a young and active, preferably unmarried, American anxious to see another part of the world ... The salary provided would not be enough, I think, for an American with a family of two or three children, but it should certainly be perfectly adequate for a youngster or for a young married couple.[88]

In 1956, as Ethel McLennan was about to retire, Turner wrote to several botanical colleagues in the hope of attracting further applicants for this upcoming vacancy:

> I was anxious to get if possible a fairly senior man to fill the post, so as to balance the department's activities ... Applications have now closed and the list is very disappointing ... I should be most grateful if you would let me know of any promising young men, preferably of post PhD level, who might be interested in this position.[89]

Turner also received similar requests from his professorial colleagues in other botany departments, and he sometimes assumed that a male was being sought, even when this was not specifically stated. In 1947 Professor Trumble of the Waite Institute wrote to Turner regarding two vacancies in his department, noting that 'in each case we are looking for a person of really good ability'. Turner replied, 'I have no

really good applicants at present ... both my recent men graduates of merit are staying on to do MSc'.[90]

While women struggled to gain good academic or research positions, and Ashby stated that only a 'First Class' woman could be 'launched', second-rate men did not have so much trouble. Responding to an inquiry from the Waite Institute, Ashby replied that he had one man who was 'a very pleasant man to work with and is very anxious to enter academic life. I would rate him as an average second rate man, no more'. He was more than acceptable to the institute.[91] The only positions for which women were specifically requested were as assistants, especially where they could paid a lower salary than a man in the same position would need to be paid.[92]

Turner expressed his personal biases more explicitly in 1957. Reflecting on which of his senior demonstrators should be promoted, he nominated one of his female staff members, even though he 'would normally prefer to promote one of the men'. Turner justified this decision at great length, citing a pressing need for someone with her specific area of specialty: 'I have so far persuaded her against applying for lectureships at other Universities, realising that we urgently need her services ... I cannot however continue to do this unless we can ourselves promote her.'[93] Such attitudes were common, and they persisted despite the great difficulties most departments were experiencing in attracting suitably qualified applicants for academic vacancies.

Throughout the 1940s and 1950s Turner bemoaned the small numbers of male botany students, as this meant the 'shortage of suitable men' for botanical positions would continue.[94] The numbers of students taking third-year botany in the 1950s were virtually the same as they had been in the mid-1930s, despite the enormous increase in overall student numbers.[95] In 1943, Turner complained that 'very

few men have been taking biology recently', while in 1954, the botany department was still finding itself 'very short of research men'.[96] Turner was not alone in this concern. As the University of Otago's professor of botany indicated in 1958, 'After a three-year gap we shall have an MSc student this year, one next year and probably one the year after. This is encouraging as they are all men and promising. But after that there will be another empty period I fear'.[97]

By 1959 Turner regarded the shortage of male staff in his botany department as acute: 'It is impossible to rely any longer on the supply of part-time demonstrators for our large classes ... The remaining part-time demonstrators are people in posts, some of whom can only work for us in the evenings, others are married women, and there are very few available for this work.'[98] When no 'suitable man' applied for a particular vacancy, Turner's solution was not to appoint one of the numerous female candidates available, but instead to appoint temporary female staff until a better male candidate could be found. In 1962, for example, after the only acceptable male candidate for a lectureship turned down the position, Turner proposed that 'Dr O[live] B. Lawson, who has been engaged as a temporary part-time Senior Demonstrator, should continue in that post until further notice'.[99]

Moments of Protest

As we have seen, in the 1920s and 1930s there had been ongoing individual and collective protests by women, particularly at the University of Melbourne, relating to issues of pay and promotion. Occasional individual voices also pointed to the broader disparity in women's treatment. For example, in 1937, Gladys Marks, lecturer in French at the University of Sydney, objected to the fact that a recent

advertisement for the chair of botany at the university had asked for applications from 'gentlemen', pointing out that many of the world's leading botanists were, in fact, women. Her belief that 'prejudice against women in high academic positions in Sydney University is very decided' was reported in one of Sydney's main daily newspapers under the headline 'Bluestockings Aspire to Professorial Chairs'.[100]

The 1940s, however, saw the formation of a group specifically dedicated to improving women's status in the profession. This group's activities reveal the real strength and ubiquity of the barriers women in science faced. In 1940, some of the women members of the New South Wales branch of the AASW came together to establish a Committee on the Status of Women Employed in Science. At its first informal meeting, it was resolved that 'the position of women scientific workers should be investigated in New South Wales, and that action to improve the position of women should be considered in the light of the results of this investigation if considered desirable'.[101] A subcommittee was appointed to carry out this investigation, headed by the strongly feminist Rachel Makinson and the ever-active Kathleen Sherrard. Its main work was conducting a survey of women scientists working in New South Wales. Over the following year, they gathered information on areas of work, salaries, conditions of employment, status and prospects for advancement, and problems of discrimination from a wide range of women. Their initial report in 1941 was based on seventy-nine responses received from women working in science (excluding teachers). Its findings were alarming, particularly in relation to salary and status, since *most of the salaries received by women scientific workers are too low for independence at a reasonable standard of living*. The report strongly recommended that 'in the interests of all scientific workers, women should receive the same salary as men for the same

work'. It also emphasised that *women have not the same opportunities for advancement or of obtaining executive and research positions as men*.[102]

Kathleen Sherrard elaborated on these findings in an article titled 'Are You Planning a Science Career?' in 1944 in the *Australian Women's Digest* (journal of the United Associations of Women), giving advice on career prospects for women in science. She pointed out that the average salary for women working in science was less than that of an adding-machine operator, who may only have a week's training, and that one government institution 'pays a woman science graduate only £12 per year more than it pays a gardener, while in another, qualified women scientific assistants are paid less than attendants'. She went on to warn of the 'lack of opportunity for advancement', as 'nearly half the women … were doing purely routine work, and only six per cent were entrusted with executive responsibility'.[103]

The report's findings were published in the bulletin of the AASW in 1941, and in 1944 copies were distributed to various members of the Scientific Man Power Advisory Committee.[104] The general committee of the AASW also took part in protests about the status of women scientists in the armed services, who were not receiving equal pay, in 1944.[105] The committee on women in science seems to have ceased activity by 1945. And with the demise of the AASW in 1949, spaces where the status of women in the field were, or could be, discussed largely vanished. The voice of protest this committee represented had been muted, and its activities were not necessarily representative. At its first meeting, a motion that 'the position of women employed in science could be improved' was opposed by five of the seventeen members in attendance.[106]

In the postwar years, such moments of protest were rare. In the 1950s and 1960s, women at the CSIRO, largely at the instigation

of Rachel Makinson, periodically organised themselves into equal-pay committees, with little success and less public profile.[107] In 1957 Catherine Le Fevre, wife of the University of Sydney's professor of chemistry and an accomplished (unpaid) research worker in her own right, publicised the poor status of women in chemistry in the journal of the Royal Australian Chemical Institute. She noted that despite the demand for graduates, little use had been made of women chemists: 'One can count on the fingers of one hand the number of women in industry, CSIRO and the universities who are permitted to hold positions of any seniority at all.' Le Fevre outlined how, even though women did better than men academically, they would be 'condemned to routine work', prevented from 'being promoted to a position where ... [they] may have to give orders to men' and forced to 'accept with equanimity a smaller salary than a male with the same qualifications for doing the same work'.[108]

Conclusion

By the 1960s Australian science had been definitively transformed into a male domain. Women were only visible at the margins and in the lowest rungs of the profession. Opportunities for research careers were largely closed. The fact that women were excluded so strongly, even in the face of the severe shortage of qualified scientific workers, is suggestive of the importance of masculinisation to the status and self-image of science in this period. Representations of women scientists in the media also reflected the more strongly 'male' nature of the profession and the increasing disjunction between the feminine and the scientific. One article from 1964 on Judith Robinson carried the headline 'The Professor Is a Brunette' and described her as speaking with 'authority,

conviction and a dash of frilly feminine charm'.[109] Another from 1968 reported on the 'doc' who was 'pretty and slim'. Although Dr Patricia Johansen was credited as a world leader in research into cystic fibrosis, she was also described as 'slim and vivacious. When she smiles, her whole face lights up and her big round eyes glow. It is easier to picture her as a charming hostess or a gay socialite'. After detailing her actual scientific work, the article ended with the fact that Johansen was not married.[110] Compared with earlier representations, by the 1960s, the images of academic and scientific women had become far more sexualised, and their occupations were being defined as more at odds with their feminine appearance.

Numerous factors had brought about this change. In the years after the Second World War, the proportion of women studying science dropped dramatically as men entered the field in vastly increased numbers. Women's representation among university science students did not reach the levels seen in the years prior to 1945 again until the late 1970s. Men received the major benefits of the postwar expansion in secondary and tertiary education. Prior to the 1950s, higher secondary education remained limited to the exceptional few, and the opportunities enjoyed by girls at this level largely reflected this 'exceptional' status. This ethos, however, did not spread as secondary education became more common. As more men took advantage of the expansion of secondary and higher education in the postwar period, the relative advantages enjoyed by highly educated middle- and upper-class women diminished.

As Australian science expanded to become a real career option for men, it also became more hierarchical, with the hardening of the boundaries between high- and low-status positions and occupations. Emerging areas of employment became designated either as men's or

women's work, and women were channelled into subordinate roles and allied professions such as dietetics, teaching and hospital laboratory work. Barriers relating to marriage also became more pronounced, as far fewer women graduates chose to remain single to pursue a career. Most significant was the conscious and active reclaiming by science professors of the previously 'female' domain of the biological sciences as a career for men – something that required women's exclusion from the field. The cumulative effect of these changes meant that the achievements of women entering science in the 1940s would, in relative terms, be considerably smaller than those of earlier generations. Science was re-made to such an extent that women's earlier strong presence was all but forgotten.

Conclusion

Where Did All the Women Go?

So where have all the women gone? The past 40 years have seen a spectacular decline in the proportionate numbers of women employed in the biological sciences departments of Australian universities. Since the early 1950s, the proportion of women recruited as research scientists for the biological divisions of the CSIRO has also declined markedly.

—Age, 7 November 1977

In 1977, an article in Melbourne's *Age* reported on a symposium on 'Women in Science' that had been held as part of the Australian and New Zealand Association for the Advancement of Science conference. Focusing on the 'spectacular decline' of women in Australian science from the end of the Second World War, particularly in the biological sciences, it asked, 'Where have all the women gone?' When I finally came to read the papers that had been presented in this symposium, after years researching this topic, I was somewhat disconcerted but also exhilarated to find that some of the key conclusions I had reached had been recognised over forty years earlier by Australian women

Conclusion

scientists themselves. This was for me what historians call an 'archives moment'. I had chased these papers down to an obscure unpublished microfilm collection, probably the first person to read them since the event. This is the nature of writing women's history: chasing fragments of evidence across diverse locations and then stitching them together is a labour-intensive process that is very different to most 'mainstream' histories of 'great men', where navigating the archival record is far more straightforward.

This was such an important 'find' for me. Despite the mountains of evidence of Australian women's scientific activities I had uncovered, I worried that my conclusions were wrong. They did, after all, go against the current of most prior writing and research on this topic – all the histories that had presented science as a world without women. The strength of this understanding has rendered the idea that women might have had a significant presence in the field almost inconceivable – even to me. Finding these women's words gave me renewed confidence.

Most studies of women, gender and science focus on the masculine construction of scientific practice, which is seen as a powerful determinant of women's experiences and in setting limits on their participation and achievements. But this approach can obscure the influences that supported women's presence and the fact that such influences must have existed for women to have been there at all. Recovering the forces supporting women's entry into science has been one of my key aims in this book. I have also spent much time counting and naming women. This is because the strength of their numbers remains difficult to comprehend. There is a power in the simple naming and claiming of these women – making them concrete – and this is necessary, too, given the extent to which it has been assumed they didn't exist.

The 'no women in science' narrative is too blunt to account for the actual changes in the field over time: it is not a simple story of absence, as this book shows. Despite the prevalent coding of science as male, from the earliest days of British invasion Australian women showed a keen interest in things scientific. The strength of this construction has also meant that it has only really been possible to talk about women scientists, or indeed about women who engaged with science in any way, in terms of transgressions or exceptions, and the women themselves as pioneers. These models are problematic if we want to recognise and explain women's presence in the field (and encourage more women to enter and succeed in science). To do this, we need to look in other places and tell other stories. And there are, as I hope to have shown, many other stories to tell.

As I promised at the outset, what emerges from this book is not a simple history of progressive development from exclusion to acceptance. Women's presence in Australian science has ebbed and flowed – from the highs of the 1940s, to the lows of the 1950s–1970s, to regaining this lost ground in recent decades. At the turn of the twentieth century, a tradition of women's participation in academic science and research was established quite quickly. Local circumstances meant that the nature and extent of their participation was, relatively speaking, far greater than in most comparable countries.[1] The extent of women's presence in science as students and staff in many Australian universities from the early 1900s to the 1940s has been vastly under-appreciated. Although they were mostly confined to the lower rungs, these women helped establish the foundations of modern Australian science.

One study of British women mathematicians around the turn of the twentieth century, on discovering their relative prominence and acceptance, suggested that they did not fit 'the category of "women

Conclusion

in science"'.[2] I would suggest that most women in science do not fit this category either. Acknowledging that science has not always been hostile to women does not contradict the reality that women have generally been precluded from positions of real power or authority, faced some extreme discrimination, were not given the opportunities they deserved to engage in research and were not always given due recognition for their contributions, or that the strongly masculine construction of science was not deeply implicated in this exclusion. What I am suggesting is that this thesis is not sufficient: such neat explanations override the complexity of these histories and hinder understanding. They also perpetuate narratives of the impossibility of women scientists.

Starting from the premise of women's presence in science, rather than their absence, I deliberately set out to recover more 'typical' and 'everyday' experiences, rather than just the exceptional few who 'made it to the top'.[3] The understanding of science as devoid of women has been largely based on their absence from the highest honour rolls of scientific achievement. Most 'mainstream' histories of science only look at the top of the profession – telling tales of heroic discoveries in the laboratory, of breakthroughs that are attributed to the singular genius of individual scientists. Women, for the most part, did not gain the heights of recognition, and this, until recently, rendered them invisible to historians.[4] But women's under-representation in the top ranks of academia or prestigious awards such as the Nobel Prize is not the best barometer of women's engagement, presence and contributions to the field. Delving just below these top rungs one can find a wealth of women.

I also set out to understand the very real and expansive sense of freedom and opportunity that many of these women felt (something

225

that again goes against contemporary assumptions about women's experiences in science), and how this might lead us to reconsider how we perceive (elite) Australian women's history in the first half of the twentieth century more broadly. This sense of freedom was clearly a product of the many privileges they enjoyed, and of the particular cultural spaces which facilitated women's interest and achievement in science among the urban educated elite. The women who entered science from the 1930s to the 1950s were clearly aware of the many advantages they enjoyed, which made them unlikely to see their lives in terms of barriers and restrictions. This led many to reject feminist interpretations of their experiences. They were also reacting against the feminist assumption that there had been no women in science, and the construction of science generally as an unhappy place for women to be.

In seeking out Australian women in science, I have looked in places that are often overlooked in histories of science – the broader cultures of nineteenth-century amateur science and in later social reform movements. Recognising these activities as 'scientific' significantly expands our appreciation of the extent of women's engagements with science. But they also require us to think carefully about how we should recognise these women's 'pioneering' achievements. The rise of science in the colonies was fuelled by excitement about the prospects of 'new' local knowledge. And women from the colonial elite enthusiastically contributed to the colonial scientific project of 'discovery' – naming and claiming the contents of the 'new' colonised land. The founding of Australian universities, key sites for the development of science, was bound to colonial and settler interests. They were built on stolen land and financed through the proceeds of dispossession, death and labour exploitation.[5] The knowledge they produced and the students

Conclusion

they educated were expected to make substantial contributions to the development of the colonies and later the (white) Australian nation. The academy produced the scientific 'knowledge' about race that justified colonialism and dispossession and inspired policies of 'protection', segregation, surveillance and control. The colonial roots of science would continue to offer opportunities for white women into the first half of the twentieth century. Because science itself was a new field, it was more open to women. And the emergence of the modern, progressive scientific age overlapped with the rise of the 'new woman'. Female-dominated social reform movements also based their claims to authority on science and more directly on the knowledge of university-educated women. Race and eugenics were at the heart of these scientific reform efforts, and elite women were prominent in promoting (racial) scientific knowledge through these movements.

But Australian women's strong participation in science in first half of the twentieth century was not just a product of the many privileges they enjoyed. It also rested on the marked absence of men from the field. It took quite some time for science to develop into a viable and high-status profession for men. This only occurred after the Second World War. Men, for the first time, flooded into science and women's representation dropped dramatically. The creation of science as a male domain was also an active historical process – one that can be clearly traced through the archive. Together, these shifts allowed the assumption to develop that women had never been significantly present in the field.

This assumption was the backdrop for of the 1977 'Women in Science' symposium, whose presenters confronted similar dilemmas to the ones I faced in writing this book. They set out to convince their audience that, historically, women had not been absent from science.

Diana Temple spoke on 'Academic Women Scientists'. She looked back to the long history of women in science at the University of Sydney (the institution where she worked and had recently been promoted to associate professor in the pharmacology department) – from the 'pioneer' students of the 1880s to the women employed in geology and chemistry from 1908 – and emphasised the strong presence of women scientists on the staff in the 1930s.[6] Heather Adamson, a botanist at Macquarie University who had completed her PhD at the University of Sydney in 1960, spoke on 'changing patterns of employment of women in the biological sciences'. She opened by observing the 'firmly entrenched' popular view 'that discrimination has ceased and that the trend is towards equality of opportunity' and suggested that this 'common sense' understanding 'prevents any easy acceptance of the notion that the employment position of women is deteriorating. Because it doesn't seem possible, evidence to the contrary is ignored'. To counter this, she presented extensive statistics that documented 'the spectacular decline in the proportion of women employed in the biological sciences in Australian universities over the past forty years', and in their recruitment to the CSIRO since the early 1950s.[7] Adamson was coming up against the misunderstandings of historical progress that I noted at the start of this book – particularly the assumption that if things are bad for women in the present then they must have been far worse in the past. The idea that things might have been better (for some women), and that women's position had declined, was inconceivable.

The late 1970s were certainly a low point for Australian women in science. In 1976, of the 194 members of the Australian Academy of Science, only two were women.[8] While women's proportional representation in university science courses had returned to the levels

Conclusion

of the 1930s, it would take much longer for women's presence on science staff to be regained. From the 1980s, a range of organisations (many founded by women scientists themselves) and government programs emerged to support this recovery.[9] Women continued to pursue science and achieved many more significant firsts. For instance, world-renowned plant geneticist Adrienne Clarke – who completed her biochemistry degree at the University of Melbourne in 1958 – held a personal chair at the University of Melbourne from 1982, was chair of CSIRO from 1991 to 1996, and became Laureate Professor of Botany back at Melbourne from 1999 to 2005.[10] Internationally renowned molecular biologist Suzanne Cory, a graduate of the 1960s, became director of the Walter and Eliza Hall Institute of Medical Research in 1996 and first woman president of the Australian Academy of Science in 2010.[11] American Penny Sackett, director of the Research School of Astronomy and Astrophysics at the Australian National University, was Australia's chief scientist from 2008 to 2011.[12] There are many others – far too many to list (even though I wish I could). Even at one of the lowest ebbs of women in science, examples of their scientific creativity and achievement abound.

As noted in the opening of this book, when Elizabeth Blackburn won the Nobel Prize in 2009, completely absent from the media coverage was any sense of the long and significant history of Australian women in science. Blackburn was, seemingly, a 'first' who had emerged out of nowhere. There was also a prevailing journalistic assumption that she must have faced and overcome extreme obstacles. The *Sydney Morning Herald* (erroneously) reported that 'Dr Blackburn's career path wasn't easy'.[13] Even in a year when three women scientists had won Nobel Prizes, this seemed to be the only prism through which women in science could be discussed. In reality, Blackburn had enjoyed a dream

career. She had strong family support in her childhood, received an excellent secondary education, and, after completing her MSc at the University of Melbourne in 1971, went on to work in a series of prestigious institutions first in the United Kingdom and then in the United States. When pushed, she could only recall one explicit instance of discouragement – from a male school teacher she met briefly while visiting Hobart during her undergraduate degree, who asked her, 'What's a nice girl like you doing in science?'[14] It was this single isolated incident, incorrectly attributed by journalists to a family friend, that was widely reported and transformed into evidence of the great barriers she had faced.

Blackburn's life story, like many of the others in this book, reminds us that looking at women who have succeeded in science reveals as much about the forces supporting women into the field as the difficulties they may have faced. For most of the nineteenth and twentieth centuries, the women who managed to enter science were those who escaped the barriers that restricted other women (and most men) so completely. This was, of course, just one current of women's experiences and only relevant for a very limited, privileged, group. These limits were profound. The trail blazed by early women in science did not necessarily provide a route that the women who came after them could follow, particularly those who did not share these privileges. Pioneering achievements and the breaking of glass ceilings may have less significance than we might think. They don't necessarily create the foundations for a trajectory of steady improvement (particularly if the underlying structures of exclusion remain largely intact). This again reminds us that history is not always (or even primarily) a tale of progressive development – where things naturally get better and better as human wealth and knowledge are

Conclusion

expanded, and the errors, evils and missteps of each successive present are identified and overcome.

This brings us to the present moment when women's progress in science, which had been steadily improving since the 1980s, has seemingly stalled. While the proportion of women studying science has been at parity in most fields for quite some time, report after report has documented their continuing low representation at the highest levels.[15] In the week that I am putting the final touches on this book, a series of disheartening reports have emerged about women's place in the academy: at the University of Melbourne, five academics were forced to leave after sexual harassment investigations, and Australia's Antarctic Research Station has been described as 'unsafe' for women to work in, following shocking revelations about women's treatment there.[16] There is still some way to go. And to a very large extent, the contemporary 'problem' of women in science is still being located with women themselves, rather than within the institutions and structures of the scientific profession.[17] I hope this book has shown what is possible for women, and for science, when they are given the opportunity to fully express their creativity and passion. And I look forward to seeing the future possibilities for Australian women in science.

Appendix 1

Women Studying Science at Australian Universities, 1885–2020

Sources: Figures for the years 1885–1938 are derived from student numbers and lists of graduates published annually in the *Calendars* of each university. Figures for 1939–82 are from University Statistics, Commonwealth Bureau of Census and Statistics/Australian Bureau of Statistics, Canberra, 1940–1983. Figures for 1983–2000 are from Department of Education Training and Youth Affairs, *Higher Education Students Time Series Tables 2000* (Canberra: Commonwealth of Australia, 2001). Figures for 2001–2019 are from uCube – Department of Education, Skills and Employment, Higher Education Data uCube, https://highereducationstatistics. education.gov.au. Figures for 2020 are from the Department of Industry, Science and Resources, STEM Equity Monitor, University enrolment and completion in STEM and other fields, https://www. industry.gov.au/publications/stem-equity-monitor/higher-education-data/university-enrolment-and-completion-stem-and-other-fields.

Notes on Sources: These statistics are not directly comparable over time as the collection and categorisation of data varied. Key changes and variables include the following:

Appendix 1

(a) Figures for women students enrolled up to 1981 are for bachelor degree enrolments. For 1982–2020 they are for all degree levels.

(b) Figures for science enrolments for 1967 to 1971 are indicative, as the categorisation of degrees in these years varied considerably.

(c) Figures for 1949–1973 are for universities only.

(d) Figures for 1974–1989 include Universities and Colleges of Advanced Education.

(e) Data from 1997 onwards were compiled in a different way to data for prior years to take into account the coding of Combined Courses to two fields of study.

f) There are variations over time as to what was included under 'Science', particularly in earlier years for mathematics. The field of study classification changed in 1987. Some courses were transferred from Science to Health reducing Science numbers. From 2001 onwards, a new Field of education classification (Australian Standard Classification of Education-ASCED) was introduced, replacing the less detailed field of study classification. Computer science and information technology (previously counted under the 'Science' field of education) was disaggregated into a separate category. This accounts for the large rise in the percentage of women in 'science' between 2000 and 2001. It also means that women almost certainly reached 'parity' in the natural and physical sciences in the mid- to late 1990s (or possibly early 1990s).

KEY

W	Women
T	Total

Appendix 1

Women Students Enrolled in Australian Universities, 1945–2020

Year	%W of total students	%W of science students	Year	%W of total students	%W of science students
1945	31.0	32.1	1983	46.3	35.6
1946	20.9	23.1	1984	46.6	35.9
1947	18.2	20.0	1985	47.6	36.2
1948	18.0	20.2	1986	48.8	36.9
1949	17.9	20.2	1987	50.1	36.4
1950	18.3	21.2	1988	51.1	36.6
1951	18.9	22.3	1989	52.1	37.8
1952	19.1	21.3	1990	52.7	38.8
1953	20.0	22.0	1991	53.3	39.5
1954	20.8	22.0	1992	53.4	40.0
1955	21.3	21.4	1993	53.4	40.2
1956	21.6	20.0	1994	53.5	40.7
1957	21.4	20.0	1995	53.9	41.5
1958	21.7	20.1	1996	54.3	41.9
1959	22.2	21.0	1997	54.4	41.0
1960	22.9	22.8	1998	54.7	40.9
1961	21.8	19.7	1999	55.0	40.8
1962	22.4	19.9	2000	55.2	40.4
1963	23.8	21.1	2001	54.4	51.7
1964	25.8	20.4	2002	54.4	52.3
1965	25.9	20.8	2003	54.4	52.8
1966	27.1	21.6	2004	54.4	52.8
1967	27.5	22.2	2005	54.4	52.6
1968	28.7	23.3	2006	54.8	52.4
1969	29.4	24.5	2007	55.0	52.1
1970	30.7	26.0	2008	55.3	52.0
1971	32.2	27.6	2009	55.5	51.6
1972	33.4	29.1	2010	55.6	51.6
1973	34.6	30.1	2011	55.7	51.6
1974	36.2	31.3	2012	55.8	51.0
1975	37.7	32.2	2013	55.6	51.1
1976	39.2	33.1	2014	55.4	49.8
1977	40.2	36.6	2015	55.3	49.7
1978	41.4	35.5	2016	58.0	50.0
1979	42.5	35.5	2017	58.0	50.6
1980	43.6	36.3	2018	58.1	50.8
1981	44.6	37.3	2019	58.1	51.1
1982	43.6	35.5	2020	58.9	51.5

Appendix 1

University of Melbourne, BSc Degrees Conferred, 1885–1950

Year	T	W	%W	Year	T	W	%W
1885	0	0	0.0	1918	13	5	38.5
1886	0	0	0.0	1919	14	6	42.9
1887	0	0	0.0	1920	22	5	22.7
1888	1	0	0.0	1921	28	8	28.6
1889	1	0	0.0	1922	33	9	27.3
1890	1	0	0.0	1923	46	12	26.1
1891	0	0	0.0	1924	39	8	20.5
1892	3	0	0.0	1925	46	12	26.1
1893	3	1	33.3	1926	38	12	31.6
1894	0	0	0.0	1927	31	11	35.5
1895	2	1	50.0	1928	37	15	40.5
1896	2	1	50.0	1929	30	11	36.7
1897	0	0	0.0	1930	37	13	35.1
1898	5	0	0.0	1931	32	13	40.6
1899	0	0	0.0	1932	38	13	34.2
1900	2	0	0.0	1933	44	16	36.4
1901	8	3	37.5	1934	47	18	38.3
1902	1	0	0.0	1935	39	14	35.9
1903	2	1	50.0	1936	58	21	36.2
1904	6	2	40.0	1937	55	16	29.1
1905	5	1	20.0	1938	41	12	29.3
1906	3	1	33.3	1939	75	25	33.3
1907	8	2	25.0	1940	69	23	33.3
1908	10	4	40.0	1941	84	33	39.3
1909	11	4	36.4	1942	74	28	37.8
1910	12	5	41.7	1943	65	30	46.2
1911	14	6	42.9	1944	63	17	27.0
1912	18	4	22.2	1945	87	32	36.8
1913	12	0	0.0	1946	111	38	34.2
1914	9	1	11.1	1947	136	33	24.3
1915	13	4	30.8	1948	177	35	19.8
1916	10	4	40.0	1949	207	33	15.9
1917	7	1	14.3	1950	167	24	14.4

Appendix 1

University of Sydney, BSc Degrees Conferred, 1885–1950

Year	T	W	%W	Year	T	W	%W
1885	2	0	0.0	1918	37	19	51.4
1886	0	0	0.0	1919	46	32	69.6
1887	3	0	0.0	1920	49	31	63.3
1888	2	1	50.0	1921	39	20	51.2
1889	0	0	0.0	1922	44	15	34.1
1890	0	0	0.0	1923	44	15	34.1
1891	1	0	0.0	1924	43	19	44.1
1892	0	0	0.0	1925	59	25	42.4
1893	4	0	0.0	1926	41	15	36.6
1894	6	1	16.7	1927	51	21	41.2
1895	2	0	0.0	1928	40	16	40.0
1896	1	0	0.0	1929	59	17	28.8
1897	0	0	0.0	1930	51	20	39.2
1898	4	2	50.0	1931	75	26	34.7
1899	2	0	0.0	1932	57	17	29.8
1900	2	0	0.0	1933	77	17	22.1
1901	9	0	0.0	1934	88	21	23.8
1902	4	1	25.0	1935	86	22	25.6
1903	2	1	50.0	1936	76	28	36.8
1904	2	0	0.0	1937	73	22	30.1
1905	4	0	0.0	1938	76	22	28.9
1906	6	0	0.0	1939	62	27	43.5
1907	11	2	18.2	1940	82	42	51.2
1908	11	4	36.4	1941	78	28	35.9
1909	10	1	10.0	1942	101	39	38.6
1910	16	7	43.8	1943	101	56	55.4
1911	6	2	33.3	1944	125	61	48.8
1912	9	2	22.2	1945	107	52	48.6
1913	16	3	18.8	1946	159	64	40.3
1914	19	2	10.5	1947	158	56	35.4
1915	17	4	23.5	1948	168	55	32.7
1916	22	10	45.5	1949	217	73	33.6
1917	15	11	73.3	1950	243	54	22.2

Appendix 1

BSc and BA Degrees Conferred, all Australian Universities, 1945–60

Year	BSc W	%W of total BSc	BA W	%W of total BA
1945	116	37.4	231	60.2
1946	129	36.8	240	60.2
1947	125	28.9	284	45.6
1948	123	23.2	316	42.6
1949	146	21.3	410	38.7
1950	128	18.2	421	34.0
1951	123	18.7	395	40.1
1952	123	23.0	384	45.2
1953	94	19.9	368	42.3
1954	106	23.2	358	44.0
1955	107	22.3	380	45.1
1956	116	23.5	374	45.4
1957	110	21.1	385	47.1
1958	112	19.4	444	44.0
1959	137	20.1	525	47.1
1960	165	19.5	587	45.8

Appendix 2

Women Staff of Australian Universities, 1929–1955

Source: *Yearbook of the Universities of the Empire/Commonwealth* (London: Universities Bureau of the British Empire/Association of the Universities of the British Commonwealth, 1929–56).

Note: These estimates should be read with caution as the published staff lists were often incomplete and there were variations between institutions in terms of the categories of staff included.

<div align="center">KEY</div>

W	Women
T	Total
Adel.	University of Adelaide
Adel.*	University of Adelaide excluding staff of the Waite Institute who were mainly CSIRO employees where the marriage bar applied.
ANU	Australian National University
Canb.	Canberra University College
Melb.	University of Melbourne
NUT	New South Wales University of Technology
Qld	University of Queensland
Syd.	University of Sydney
Tas.	University of Tasmania
UNE	University of New England
WA	University of Western Australia

Appendix 2

Women Staff of Australian Universities, 1929–1955

Year	Total staff (%)	Lecturer and above (%)	Science staff (%)	Science staff: lecturer and above (%)
1929	8.0	5.6	11.6	7.4
1934	8.5	5.7	13.9	7.7
1939	7.7	5.2	16.5	10.9
1946	11.7	8.1	17.8	10.5
1950	11.7	8.7	19.7	13.3
1955	8.1	6.8	11.0	8.1

Science Staff: Total by University

	1929			1934			1939		
	T	W	%W	T	W	%W	T	W	%W
Adel.*	20	1	5.0	18	2	11.1	28	5	17.9
Adel.	20	1	5.0	34	2	3.0	50	5	10.0
Melb.	36	9	25.0	43	11	25.6	54	15	27.8
Qld	15	0	0	14	0	0	23	0	0
Syd.	46	5	10.9	42	4	9.5	44	6	13.6
Tas.	6	0	0	5	0	0	6	0	0
WA	6	0	0	15	2	13.3	15	2	13.3
Total	129	15	11.6	137	19	13.9	170	28	16.5

	1946			1950			1955		
	T	W	%W	T	W	%W	T	W	%W
Adel.*	41	9	22.0	56	11	19.6	61	8	13.1
Adel.	64	12	18.5	82	12	14.6	87	8	9.2
Melb.	85	25	29.4	102	35	34.3	104	27	26.0
Qld	32	3	9.4	52	5	9.6	53	2	3.8
Syd.	46	3	6.5	45	2	4.4	65	4	6.2
Tas.	12	1	8.3	15	1	6.7	23	1	4.3
WA	20	1	5.0	24	4	16.7	31	4	12.9
UNE				15	3	20.0	21	1	4.8
Canb.							0	0	
ANU							43	3	7.0
NUT							63	1	1.6
Total	236	42	17.8	09	61	19.7	464	51	11.0

Appendix 2

Science Staff: Lecturer and Above by University

	1929			1934			1939		
	T	W	%W	T	W	%W	T	W	%W
Adel.*	18	1	5.6	16	2	12.5	22	3	13.6
Adel.	18	1	5.6	32	2	3.0	44	3	6.8
Melb.	29	4	13.8	31	4	12.9	37	5	13.5
Qld	15	0	0	14	0	0	19	0	0
Syd.	42	3	7.1	40	2	5.0	44	6	13.6
Tas.	6	0	0	5	0	0	6	0	0
WA	11	1	9.1	11	1	9.1	10	1	10.0
Total	121	9	7.4	117	9	7.7	138	15	10.9

	1946			1950			1955		
	T	W	%W	T	W	%W	T	W	%W
Adel.*	37	7	18.9	47	6	12.8	59	7	11.9
Adel.	61	10	16.4	67	7	10.4	84	7	8.3
Melb.	56	6	10.7	60	14	23.3	63	11	17.5
Qld	32	3	9.4	50	4	8.0	53	2	3.8
Syd.	46	3	6.5	45	2	4.4	65	4	6.2
Tas.	12	1	8.3	15	1	6.7	23	1	4.3
WA	17	1	5.9	24	4	16.7	31	4	12.9
UNE				15	3	20.0	21	1	4.8
Canb.							0	0	0
ANU							43	3	7.0
NUT							63	1	1.6
Total	200	21	10.5	256	34	13.3	421	34	8.1

Appendix 2

All Academic Staff by University

	1929			1934			1939		
	T	W	%W	T	W	%W	T	W	%W
Adel.	111	5	4.5	139	6	4.3	173	7	4.0
Melb.	172	25	14.5	206	28	13.6	254	39	15.4
Qld	43	2	4.7	45	3	6.7	120	6	5.0
Syd.	202	10	5.0	215	13	6.0	250	11	4.4
Tas.	26	1	3.8	27	1	3.7	33	1	3.0
WA	57	6	10.5	55	5	9.1	56	4	7.1
Total	612	49	8.0	687	56	8.5	886	68	7.7

	1946			1950			1955		
	T	W	%W	T	W	%W	T	W	%W
Adel.	206	24	11.7	221	23	10.4	245	17	6.9
Melb.	433	81	18.7	427	29	20.8	513	82	16.6
Qld	140	17	12.1	180	17	9.4	213	17	8.0
Syd.	297	10	3.4	390	19	4.9	462	20	4.3
Tas.	47	2	4.3	62	4	6.5	75	5	6.7
WA	67	5	7.5	80	8	10.0	134	13	9.7
UNE				37	5	13.5	62	6	9.7
Canb.				21	1	4.8	30	0	0
ANU							89	4	4.5
NUT							243	3	1.2
Total	1190	139	11.7	1418	166	11.7	2066	167	8.1

Appendix 2

All Academic Staff: Lecturers and Above by University

	1929			1934			1939		
	T	W	%W	T	W	%W	T	W	%W
Adel.	96	3	3.1	118	5	42	143	5	3.5
Melb.	144	11	7.6	165	14	8.5	193	15	7.8
Qld	41	0	0	43	1	2.3	99	4	4.0
Syd.	145	7	4.0	178	9	5.1	228	11	4.8
Tas.	26	2	7.7	27	1	3.7	33	1	3.0
WA	52	5	9.6	50	3	6.0	48	3	6.2
Total	504	28	5.6	581	33	5.7	744	39	5.2

	1946			1950			1955		
	T	W	%W	T	W	%W	T	W	%W
Adel.	181	18	9.9	203	18	8.9	235	16	6.8
Melb.	304	37	12.2	293	42	14.3	377	46	12.2
Qld	133	11	8.3	173	11	6.4	208	13	6.3
Syd.	254	7	2.8	300	14	4.7	378	19	5.0
Tas.	47	2	4.3	62	4	6.5	75	5	6.7
WA	62	4	6.5	80	8	10.0	134	13	9.7
UNE				37	5	13.5	62	6	9.7
Canb.				20	0	0	30	0	0
ANU							89	4	4.5
NUT							243	3	1.2
Total	981	79	8.1	1168	102	8.7	1831	125	6.8

Notes

Introduction

1 'Prize Announcement', http://www.nobelprize.org/prizes/medicine/2009/press-release; 'Elizabeth H. Blackburn: Interview', http://www.nobelprize.org/prizes/medicine/laureates/2009/blackburn-interview. See also Carol Brady, *Elizabeth Blackburn and the Story of Telomeres* (Cambridge: MIT Press, 2007).

2 'Illustrated Presentation', http://www.nobelprize.org/nobel_prizes/medicine/laureates/2009.

3 Andrew Darby, 'Nobel Crusader for Women in Science', *Age*, 7 Oct 2009.

4 Andrew Darby, 'Outspoken Australian Scientist Dropped by Bush Wins Nobel', *Sydney Morning Herald* (hereafter *SMH*), 6 Oct 2009.

5 Darby, 'Nobel crusader'.

6 *Advertiser*, 16 Dec 1885.

7 This book has its origins in my PhD thesis and related publications (although it is the product of substantial further research and complete rewriting). There is a small body of other historical work on Australian women scientists, mostly biographical, e.g. Claire Hooker, *Irresistible Forces: Australian Women in Science* (Melbourne: Melbourne UP, 2004); Farley Kelly, ed., *On the Edge of Discovery: Australian Women in Science* (Melbourne: Text, 1993). Nessy Allen has written numerous biographical articles on twentieth-century Australian women scientists, such as, 'Australian Women in Science: Two Unorthodox Careers', *Women's Studies International Forum* 15, nos. 5–6 (1992): 551–62, and 'The Contributions of Two Australian Women Scientists to Its Wool Industry', *Prometheus* 9, no. 1 (1991): 81–92. Two short, wide-ranging pieces by Ann Moyal were important early works: 'Collectors and Illustrators: Women Botanists of the Nineteenth Century', in *People and Plants in Australia*, ed. D. J. Carr & S. G. M. Carr (Sydney: Academic Press, 1981); 'Invisible Participants: Women in Science in Australia, 1830–1950', *Prometheus* 11, no. 2 (1993): 175–87.

8 For Sydney and Melbourne Universities see Appendix 1. For other universities see Chapter 2. Women's representation among Sydney science graduates actually had a much higher peak around WWI – reaching 73% in 1917 and only dropping below 50% again in 1922. In terms of university studies, this book is deliberately focused on what are termed the natural and physical sciences rather than the conglomerations of STEM (science, technology, engineering and mathematics) or STEMM (which also includes medicine). This is due to the great differences between these various fields, including the status of women within them (both historically and today). But my definition of 'science' also shifts throughout the

Notes

book, in line with shifting understandings of what this term meant in different contexts and over the historical periods I cover.

9 *Register*, 17 Dec 1885.

10 See e.g. Rod Home, ed., *Australian Science in the Making* (Sydney: Cambridge UP, 1988); Roy MacLeod, ed., *The Commonwealth of Science: ANZAAS and the Scientific Enterprise in Australia* (Melbourne: Oxford UP, 1988); C. B. Schedvin, *Shaping Science and Industry: A History of Australia's Council for Scientific and Industrial Research, 1926–1949* (Sydney: Allen & Unwin, 1987). No broad history of Australian science has been published since the 1980s. There has been substantial work on different fields, periods, institutions and individuals. For a recent overview see James Beattie & Ruth Morgan, 'From History of Science to History of Knowledge?: Themes and Perspectives in Colonial Australasia', *History Compass* 19, no. 5 (2021): 1–10.

11 There is a vast literature on this topic. Since the early 1980s, feminist scholars have explored how Western science both deliberately excluded women and was profoundly shaped by gender. Science also, of course, produced erroneous theories of women's intellectual inferiority. For some key works see e.g. Anne Fausto-Sterling, *Myths of Gender: Biological Theories about Women and Men* (New York: Basic Books, 1985); Ludmilla Jordanova, *Sexual Visions: Images of Gender in Science and Medicine between the Eighteenth and Twentieth Centuries* (Madison: University of Wisconsin Press, 1989); Carolyn Merchant, *The Death of Nature: Women, Ecology, and the Scientific Revolution* (San Francisco: Harper & Row, 1980); Londa Schiebinger, *The Mind Has No Sex?: Women in the Origins of Modern Science* (Cambridge: Harvard UP, 1989). See also David Noble, *A World Without Women: The Christian Clerical Culture of Western Science* (New York: Knopf, 1992); Londa Schiebinger, *Nature's Body: Gender in the Making of Modern Science* (Boston: Beacon Press, 1993). For one more recent work building on this literature see Heather Ellis, *Masculinity and Science in Britain, 1831–1918* (Houndmills: Palgrave Macmillan, 2017).

12 As one women's studies encyclopedia expressed it, 'Women have been more systematically excluded from doing serious work in science than from doing any other social activity except, perhaps, military combat'. Lynne Arnault & Maria Ditullio, 'Science and Women', in *Women's Studies Encyclopedia*, ed. Helen Tierney (Westport: Greenwood Press, 1999), 1269. Evelyn Fox Keller concluded, 'To a remarkable extent, to learn to be a scientist is to learn the attributes of what our culture calls masculinity'. 'How Gender Matters, or Why Is It So Hard for Us to Count Past Two?', in Gill Kirkup & Laurie Keller, eds, *Inventing Women: Science, Technology and Gender* (Cambridge: Polity Press, 1992), 47. There is a substantial and important field of feminist theorists and philosophers of science. In addition to works already cited, see e.g. Sandra Harding, *The Science Question in Feminism* (Cornell: Cornell UP, 1986) and *Whose Science? Whose Knowledge?: Thinking from Women's Lives* (Cornell: Cornell UP, 1991); Sandra Harding & Jean O'Barr, eds, *Sex and Scientific Inquiry* (Chicago: University of Chicago Press, 1987). For a more recent discussion, see Cordelia Fine, *Testosterone Rex: Unmaking the Myths of Our Gendered Minds* (London: Icon Books, 2017).

13 Evelyn Fox Keller, *Reflections on Gender and Science* (New Haven: Yale UP, 1985), 37. Bacon's ideas are explored in Genevieve Lloyd, *The Man of Reason: 'Male' and 'Female' in Western Philosophy* (London: Routledge, 1993), chap. 1.

Notes

14 J. F. A. Adams, 'Is Botany a Suitable Study for Young Men?', *Science* 9, no. 209 (1887): 116. The article argued that botany was indeed a 'manly' endeavour and aimed to encourage men study it. See also Ann Shteir, *Cultivating Women, Cultivating Science: Flora's Daughters and Botany in England 1760 to 1860* (Baltimore: Johns Hopkins UP, 1996).

15 For Australia, see e.g. Shino Konishi, Maria Nugent & Tiffany Shellam, eds, *Indigenous Intermediaries: New Perspectives on Exploration Archives* (Canberra: ANU Press, 2015); Penny Olsen & Lynette Russell, *Australia's First Naturalists: Indigenous Peoples' Contribution to Early Zoology* (Canberra: NLA, 2019). For the foundational text on the fraught relations between Indigenous peoples and academic research see Linda Tuhiwai Smith, *Decolonizing Methodologies: Research and Indigenous Peoples* (London/New York: Zed Books, 1999). Western science is belatedly beginning to comprehend this immense store of expertise, while Indigenous peoples are simultaneously asserting their intellectual sovereignty. For an Australian example bringing together Indigenous Knowledge and Western science, see Karlie Noon & Krystal De Napoli, *Astronomy: Sky Country* (Melbourne: Thames & Hudson, 2022). There is some debate as to whether Indigenous Knowledge should be labelled as 'science'. However, there have been significant Indigenous-led moves to incorporate what is coming be termed Indigenous or Deadly science into the academy, as well as work encouraging Indigenous women into this area. See Claire McLisky & Diana Day, *Black and White Science: Encouraging Indigenous Australian Students into University Science and Technology* (Sydney: University of Sydney, 2004); Tracy Woodroffe et al., 'Indigenous Women in Science: A Proposed Framework for Leadership, Knowledge, Innovation, and Complexity', *Advances in Global Education and Research* 4 (2021). See also Elizabeth McKinley, 'Brown Bodies, White Coats: Postcolonialism, Maori Women and Science', *Discourse: Studies in the Cultural Politics of Education* 26, no. 4 (2005): 481–96.

16 Charles Perkins is often incorrectly identified as the first Aboriginal person to complete a university degree. Valadian, who became a strong advocate for Aboriginal education in her professional work, graduated a few months prior to Perkins: 'At Home', *Australian Women's Weekly* (hereafter *AWW*), 16 Oct 1963; 'Valadian, Margaret (1936–)', Australian Women's Register, http://www.womenaustralia.info/biogs/IMP0213b.htm; Leanne Holt, *Talking Strong: The National Aboriginal Education Committee and the Development of Aboriginal Education Policy* (Canberra: Aboriginal Studies Press, 2021). The first Aboriginal person to graduate from an Australian university (although not with a full bachelor degree) was also a woman – Margaret Weir, who completed her Diploma of Physical Education at the University of Melbourne in 1959. 'Weir, Margaret Williams', in *The Encyclopedia of Women & Leadership in Twentieth-Century Australia*, https://www.womenaustralia.info/leaders/biogs/WLE0768b.htm.

17 Lester Rigney, 'A First Perspective of Indigenous Australian Participation in Science', *Kaurna Higher Education Journal* 7 (2001): 9.

18 Much of what we know about women's participation in modern science comes from the United States, and the encyclopaedic work of Margaret Rossiter over 3 books: *Women Scientists in America: Struggles and Strategies to 1940*; *Women Scientists in America: Before Affirmative Action, 1940–1972*; *Women Scientists in America: Forging a New World since 1972* (Baltimore: Johns Hopkin UP, 1984; 1998; 2012). There is also

Notes

some important work on African American women scientists, e.g. Wini Warren, *Black Women Scientists in the United States* (Bloomington: Indiana UP, 1999). As Rossiter herself pointed out, we know very little about women's experiences in science in this period outside the United States. What work has been done 'suggests that circumstances and chronology ... were different': 'Which Science? Which Women?', in *Women, Gender, and Science: New Directions*, ed. Sally Gregory Kohlstedt & Helen Longino (Chicago: University of Chicago Press, 1997), 169. The field in Canada has been described as 'neglected': Marianne Ainley, 'Introduction', in her ed. *Despite the Odds: Essays on Canadian Women and Science* (Montreal: Vehicule Press, 1990), 20. See also Ainley's posthumously published *Creating Complicated Lives: Women and Science at English-Canadian Universities, 1880–1980* (Montreal: McGill-Queen's UP, 2012). Even Britain lacks a comprehensive study of women and science in the modern period. The work of Claire Jones has started to fill this gap: *Femininity, Mathematics and Science, 1880–1914* (Houndmills: Palgrave Macmillan, 2009). There are, however, numerous collected biographies of women scientists, mainly focused on the West, e.g. Marilyn Ogilvie & Joy Harvey, eds, *The Biographical Dictionary of Women in Science*, 2 vols (New York: Routledge, 2000); and the four volumes of Mary Creese, *Ladies in the Laboratory* (Lanham: Scarecrow Press/Rowman and Littlefield, 1998–2015), which include women active in science from 1800 to the early 1900s with separate volumes on Britain and America; Western Europe; South Africa, Australia, New Zealand and Canada; and Imperial Russia.

19 I'm speaking here of women's representation among university science students (see Appendix 1). Women representation on the science staff of Australian universities peaked in the 1940s, and they did not recover this position until much later. See Appendix 2 and further discussion in Chapter 6 and the Conclusion.

20 For the latest figures see the 'STEM Equity Monitor', https://www.industry.gov.au/data-and-publications/stem-equity-monitor. In 2019 more women were enrolled in undergraduate degrees in the natural and physical science (51%) than men and more women completed degrees (53%). The areas of concern for women are Information Technology (where women are only 17% of undergraduate and 28% of postgraduate enrolments), and Engineering (where women are only 17% of undergraduate and 23% of postgraduate enrolments). In 'non-STEM' areas, women vastly outnumber men in university enrolments. The problems for women emerge when they enter the workforce. In 2020, for the natural and physical sciences, women were still only 33% of full-time effective staff and only 21.5% of professors. In the academic workforce as a whole, women were 45% of full-time effective staff and 31% of professors. By comparison, across Europe and the UK in 2018, women were still only 26.2% of university professors. Engineering and IT were also the areas where women were most under-represented. European Commission, *She Figures 2021. Gender in Research and Innovation: Statistics and Indicators*, https://ec.europa.eu/info/publications/she-figures-2021_en.

21 For example, a recent controversial article suggested that women's low presence in physics could be due to biological differences in capacity. Alessandro Strumia, 'Gender Issues in Fundamental Physics: A Bibliometric Analysis', *Quantitative Science Studies* 2, no. 1 (2021): 225–53.

22 See Appendix 1. Up to 2001, IT and science were counted together, so the exact year women reached parity is hard to determine.

248

Notes

Chapter 1: 'Of Great Use to Science'

1 Georgina King, *The Mineral Wealth of New South Wales and Other Lands and Countries* (Sydney: William Brooks, 1911), 7–8.

2 King to the President, Vice-President and Council of the Royal Society of NSW, 7 May 1917, ML MSS 2117/2, Georgina King Papers, Mitchell Library, Sydney (hereafter King Papers).

3 Ann Curthoys & Shino Konishi, 'The Pinjarra Massacre in the Age of the Statue Wars', *Journal of Genocide Research* 24, no. 4 (2022): 511-528; Raymond Evans & Robert Ørsted–Jensen, '"I Cannot Say the Numbers That Were Killed": Assessing Violent Mortality on the Queensland Frontier', Social Science Research Network, posted 19 Jul 2014, http://dx.doi.org/10.2139/ssrn; Jane Lydon & Lyndall Ryan, *Remembering the Myall Creek Massacre* (Sydney: NewSouth Publishing, 2018); Lyndall Ryan et al., *Colonial Frontier Massacres in Australia 1788–1930*, https://c21ch.newcastle.edu.au/colonialmassacres. For two broad overviews, see Penelope Edmonds & Jane Carey, 'Australian Settler Colonialism over the Long Nineteenth Century', in *The Routledge Handbook of the History of Settler Colonialism*, ed. Edward Cavanagh & Lorenzo Veracini (London: Routledge, 2017); Tracey Banivanua Mar & Penelope Edmonds, 'Indigenous and Settler Relations', in *The Cambridge History of Australia*, ed. Alison Bashford & Stuart Macintyre (Cambridge: Cambridge UP, 2013).

4 Roy MacLeod, 'Organising Science under the Southern Cross', in *The Commonwealth of Science: ANZAAS and the Scientific Enterprise in Australia*, ed. Roy MacLeod (Melbourne: Oxford UP, 1988), 26.

5 See e.g. works cited in the Introduction, note 15, and Philip Clarke, *Aboriginal Plant Collectors: Botanists and Australian Aboriginal People in the Nineteenth Century* (Kenthurst: Rosenberg Publishing, 2008). For other colonial contexts, see Carey McCormack, 'Collection and Discovery: Indigenous Guides and Alfred Russel Wallace in Southeast Asia, 1854–1862', *Journal of Indian Ocean World Studies* 1, no. 1 (2017): 111–29; Jennifer Morris, 'Non-Western Collectors and Their Contributions to Natural History, c. 1750–1940', in *The Routledge Handbook of Science and Empire*, ed. Andrew Goss (London: Routledge, 2021).

6 There is a vast literature on this topic. For some key works on Britain and North America, see David Allen, *The Naturalist in Britain: A Social History* (Princeton: Princeton UP, 1976); Helen Curry et al., eds, *Worlds of Natural History* (Cambridge: Cambridge UP, 2018); Nick Jardine, James Secord & Emma Spary, eds, *Cultures of Natural History* (Cambridge: Cambridge UP, 1996); Elizabeth Keeney, *The Botanizers: Amateur Scientists in Nineteenth-Century America* (Chapel Hill: University of North Carolina Press, 1992); Anne Secord, 'Science in the Pub: Artisan Botanists in Early Nineteenth-Century Lancashire', *History of Science* 32, no. 3 (1994): 269–315. For Australia, see e.g. Ann Moyal, *A Bright and Savage Land: Scientists in Colonial Australia* (Sydney: Collins, 1986); Lindy Orthia, '"Laudably Communicating to the World": Science in Sydney's Public Culture, 1788–1821', *Historical Records of Australian Science* 27, no. 1 (2016): 1–12.

7 From around 1870, von Mueller specifically advertised for assistance from 'lady collectors'. R. W. Home et al. eds, *Regardfully Yours: Selected Correspondence of Ferdinand von Mueller*, 3 vols (Bern: Peter Lang, 1998–2006); Sara Maroske &

249

Notes

Alison Vaughan, 'Ferdinand Mueller's Female Plant Collectors: A Biographical Register', *Muelleria* 32 (2014): 92–172; Penny Olsen, *Collecting Ladies: Ferdinand von Mueller and Women Botanical Artists* (Canberra: NLA, 2013).

8 Again, there is a vast literature on science and colonialism. For one recent collection, see Goss, *Routledge Handbook of Science and Empire*. For some key earlier works, see e.g. Lucile Brockway, *Science and Colonial Expansion: The Role of the British Royal Botanic Gardens* (New York: Academic Press, 1979); Richard Drayton, *Nature's Government: Science, Imperial Britain, and the 'Improvement' of the World* (New Haven: Yale UP, 2000); Jim Endersby, *Imperial Nature: Joseph Hooker and the Practices of Victorian Science* (Chicago: University of Chicago Press, 2008); John Gascoigne, *Science in the Service of Empire: Joseph Banks, the British State and the Uses of Science in the Age of Revolution* (Cambridge: Cambridge UP, 1998); John MacKenzie, ed., *Imperialism and the Natural World* (Manchester: Manchester UP, 1990); Londa Schiebinger, *Plants and Empire* (Cambridge: Harvard UP, 2004); Helen Tilley, *Africa as a Living Laboratory: Empire, Development and the Problem of Scientific Knowledge* (Chicago: Chicago UP, 2011). For the (subordinate) relationship between colonial and metropolitan scientists, see e.g. Roy MacLeod, 'On Visiting the "Moving Metropolis": Reflections on the Architecture of Imperial Science', *Historical Records of Australian Science* 5, no. 3 (1982): 1–16. For the broader ways that British colonialism relied on knowledge exchange, see Zoë Laidlaw, *Colonial Connections 1815–1845: Patronage, the Information Revolution and Colonial Government* (Manchester: Manchester UP, 2005).

9 On anthropology and colonialism, see e.g. Talal Asad, ed., *Anthropology and the Colonial Encounter* (London: Ithaca Press, 1973); Efram Sera-Shriar, *The Making of British Anthropology, 1813–1871* (Abingdon/New York: Routledge, 2015); George Stocking, *Victorian Anthropology* (New York: Free Press, 1987); Sadiah Qureshi, *Peoples on Parade: Exhibitions, Empire, and Anthropology in Nineteenth-Century Britain* (Chicago: University of Chicago Press, 2011). On Indigenous peoples' involvement in anthropology, see e.g. Jane Carey, 'A "Happy Blending"?: Maori Networks, Anthropology and Native Policy in New Zealand, the Pacific and Beyond', in *Indigenous Networks: Mobility, Connections and Exchange*, ed. Jane Carey & Jane Lydon (New York: Routledge, 2014).

10 The artistic, literary and religious dimensions of natural history are discussed in many works cited in note 6 above. Some more recent work has also focused on the economics of natural history. Sarah Easterby-Smith, *Cultivating Commerce: Cultures of Botany in Britain and France, 1760–1815* (Cambridge: Cambridge UP, 2017); Anne Coote et al., 'When Commerce, Science, and Leisure Collaborated: The Nineteenth-Century Global Trade Boom in Natural History Collections', *Journal of Global History* 12, no. 3 (2017): 319–39; Alistair Paterson & Andrea Witcomb, '"Nature's Marvel": The Value of Collections Extracted from Colonial Western Australia', *Journal of Australian Studies* 45, no. 2 (2021): 197–220.

11 Tom Griffiths, *Hunters and Collectors: The Antiquarian Imagination in Australia* (Cambridge: Cambridge UP, 1996); John Mackenzie, *The Empire of Nature: Hunting, Conservation and British Imperialism* (Manchester: Manchester UP, Manchester, 1988).

12 Again, women's involvement in natural history is covered in many works already cited. See also Patricia Phillips, *The Scientific Lady: A Social History of Women's Scientific Interests, 1520–1918* (London: Weidenfeld & Nicholson, 1990).

250

Notes

13 Women were not allowed to be full members until 1848. Ibid., 193–4, 200–6. Phillips suggests women were the majority of the ~1,500 people who attended the group's first lecture in 1834. Ibid, 204.

14 Ibid., ix–xi, 242–9; Kim Tolley, *The Science Education of American Girls: A Historical Perspective* (London: Routledge, 2003).

15 Saba Bahar, 'Jane Marcet and the Limits to Public Science', *British Journal for the History of Science* 34, no. 1 (2001): 29–49; M. Susan Lindee, 'The American Career of Jane Marcet's *Conversations on Chemistry*, 1806–53', *Isis* 82, no. 1 (1991): 8–23.

16 Debra Lindsay, 'Intimate Inmates: Wives, Household and Science in Nineteenth-Century America', *Isis* 89, no. 4 (1998): 631–52; Donald Opitz, Staffan Bergwik & Brigitte van Tiggelen, eds, *Domesticity in the Making of Modern Science* (Houndmills: Palgrave Macmillan, 2016).

17 For a detailed biography (that does not discuss issues of gender), see William Lines, *An All Consuming Passion: Origins, Modernity and the Australian Life of Georgiana Molloy* (Berkeley: University of California Press, 1994).

18 Molloy to Mangles, 21 Mar 1837 and 25 Jan 1838, reprinted in the *Journal and Proceedings of the Western Australian Historical Society* 1, part IV, 1929 (hereafter Molloy Correspondence), 54, 57.

19 Sir Joseph Paxton to Mangles, 14 Jun 1839, Molloy Correspondence, 67.

20 Molloy to Mangles, Molloy Correspondence, Jun 1840, 75.

21 Cited in Bernice Barry, *Georgiana Molloy: The Mind That Shines* (Sydney: Picador, 2016), 295.

22 Molloy to Mangles, 1 Aug 1840, Molloy Correspondence, 77.

23 Molloy to Elizabeth Besley, 7 Nov 1832, and Molloy to Mangles, 21 Mar 1837, Molloy Correspondence, 38, 58.

24 Molloy to Mangles, 31 Jan 1840, 14 Aug 1840, 25 Jan 1938 and 21 Mar 1837, Molloy Correspondence, 71, 79, 54, 57.

25 Jessica White, '"Paper Talk": Testimony and Forgetting in South-West Western Australia', *Journal of the Association for the Study of Australian Literature* 17, no. 1 (2017): 1–13. See also Sam Carmody, 'The Ghosts are not Silent', https://www.abc.net.au/news/2021-09-17/wonnerup-minninup-massacre-the-ghosts-are-notsilent/100458938; Len Collard, *A Nyungar Interpretation of Ellensbrook and Wonnerup Homesteads* (Perth: Heritage Council of Western Australia, 1994).

26 For example, a 1909 article by the Government Botanist of NSW mentioned both Mangles and Lindley but not Molloy. J. H. Maiden, 'Records of Western Australian Botanists', *Journal of the West Australian Natural History Society*, no. 6 (1909): 5–33. While Molloy's correspondence with Mangles was published in 1929, it was not until her work caught the attention of two female historians in the 1950s that her significance to Australian botany was reasserted. Marnie Bassett, 'Augusta and Mrs Molloy', in *The Hentys: An Australian Colonial Tapestry* (Melbourne: Oxford UP, 1954); Alexandra Hasluck, *Portrait with Background: A Life of Georgiana Molloy* (Melbourne: Oxford UP, 1955).

27 Elizabeth Windschuttle, *Taste and Science: The Women of the Macleay Family, 1790–1850* (Sydney: Historic Houses Trust of NSW, 1988); Angela Woollacott, *Settler Society in the Australian Colonies: Self-Government and Imperial Culture* (Oxford: Oxford UP, 2015), 18–24, 29–32; Jim Endersby, 'A Garden Enclosed: Botanical Barter in Sydney, 1818–39', *British Journal for the History of Science* 33, no. 3 (2000): 313–34.

Notes

28 Women became even more dominant in this field in the twentieth century, although its importance diminished with the increasing use of photography.

29 While Alexander was listed as principal author, the full title of the work is somewhat ambiguous. *Australian Lepidoptera and Their Transformations Drawn from the Life*, by Harriet and Helena Scott with descriptions, general and systematic by A. W. Scott (London: J. van Voorst, 1864). The work is usually attributed to Alexander Scott alone. For the Scott sisters, see Vanessa Finney, *Transformations: Harriet and Helena Scott* (Sydney: NewSouth Publishing, 2018). See also Leonie Norton, *Women of Flowers: Botanical Art in Australia from the 1830s to the 1960s* (Canberra: NLA, 2009).

30 G. Frauenfeld, 'Notes, collected during my stay in New Holland, New Zealand and on Tahiti', *Reports of Sittings of the Mathematical-Scientific Section of the Imperial Academy of Sciences*, Vienna, 1860, 717–32, trans. G. L. McMullen, https://webarchive.nla.gov.au/awa/20220308064415/https://documents.uow.edu.au/~morgan/frauenfeld.htm.

31 'Romance of Flowers: The Beauty of New Guinea', *SMH*, 1 Dec 1916. See also Patricia Fullerton, *The Flower Hunter: Ellis Rowan* (Canberra: NLA, 2002); Ellis Rowan, *A Flower-Hunter in Queensland and New Zealand* (Sydney: Angus & Robertson, 1898). Many of her early 'discoveries' were classified and named by Ferdinand von Mueller, and her illustrations appeared in his publications.

32 Barbara Gates & Ann Shteir, eds, *Natural Eloquence: Women Reinscribe Science* (Madison: University of Wisconsin Press, 1997). Several women nature writers are included in Ann Standish, *Australia through Women's Eyes* (Melbourne: Australian Scholarly Publishing, 2008).

33 See e.g. Fanny Elizabeth de Mole, *Wild Flowers of South Australia* (London: Paul Jerrard, 1861); Susan Nugent Wood, *Bush Flowers from Australia* (London: J. Nisbet, 1867).

34 Meredith's more successful publications included *My Home in Tasmania* (London: John Murray, 1852); *Some of My Bush Friends in Tasmania* (London: Day, 1860); *Tasmanian Friends and Foes* (London: Marcus Ward, 1881); *Bush Friends in Tasmania* (London: Macmillan, 1891).

35 Louisa Meredith, *Notes and Sketches of New South Wales* (Sydney: Ure Smith, 1973 [1844]), vii.

36 Ibid., 8, 13, vii.

37 Vivienne Rae-Ellis, *Louisa Anne Meredith: A Tigress in Exile* (Hobart: Blubber Head Press, 1979), 208. Patricia Grimshaw & Ann Standish, 'Making Tasmania Home: Louisa Meredith's Colonizing Prose', *Frontiers: A Journal of Women Studies* 28, no. 1 (2007): 1–17.

38 These were reprinted in Louisa Atkinson, *A Voice from the Country* (Canberra: Mulini Press, 1978). Many of her other articles are in Louisa Atkinson, *Excursions from Berrima and a Trip to Manaro and Molonglo in the 1870s* (Canberra: Mulini Press, 1980).

39 *SMH*, 14 Mar 1861.

40 Cited in Sara Maroske, '"The Whole Great Continent as a Present": Nineteenth-Century Australian Women Workers in Science', in *On the Edge of Discovery: Australian Women in Science*, ed. Farley Kelly (Melbourne: Text, 1993), 24.

41 Patricia Clarke, *Pioneer Writer: The Life of Louisa Atkinson: Novelist, Journalist, Naturalist* (Sydney: Allen & Unwin, 1990), 137.

Notes

42 'A Winter's Garland', *SMH*, 2 Jul 1861. As Tom Griffiths suggests, through such writing, 'Europeans sought to take hold of the land emotionally and spiritually'. Griffiths, *Hunters and Collectors*, 5.

43 See Chapter 2 for a discussion of education.

44 The review of John Gould's *The Birds of Australia*, in the *Tasmanian Journal of Natural History* 1, no. 2 (1842): 139–46, dwelt at length on the quality of the illustrations but did not mention that Elizabeth Gould was the artist.

45 Alison Alexander, *The Ambitions of Jane Franklin: Victorian Lady Adventurer* (Sydney: Allen & Unwin, 2013).

46 Ann Moyal, *Scientists in Nineteenth Century Australia: A Documentary History* (Melbourne: Cassell, 1976), 74. See also Elizabeth Newland, 'Dr George Bennett and Sir Richard Owen: A Case Study of the Colonisation of Early Australian Science', in *International Science and National Scientific Identity: Australia between Britain and America*, ed. Rod Home & Sally Gregory Kohlstedt (Dordrecht: Kluwer Academic Press, 1991).

47 King collected at least 295 specimens for Mueller. See Maroske & Vaughan, 'Ferdinand Mueller's Female Plant Collectors', 105, 123–4.

48 Biographical details for King are taken from the King Papers, ML MSS 2117/1–3 and 273/1–5, especially her 'Autobiography', ML MSS 273/3; Georgina King Correspondence, G3/13, 8674, General Subjects Files, Registrar's Office Records, University of Sydney Archives (hereafter King Correspondence); King's preface to her *Mineral Wealth of NSW*, 7–13; Ursula Bygott, 'Georgina King: Amateur Geologist and Anthropologist', *University of Sydney Archives Record* 9, no. 2 (1982): 11–18; 'King, George (1813–99)', *Australian Dictionary of Biography*, https://adb.anu.edu.au (hereafter ADB). King has also been the subject of a (somewhat speculative) biography. Jennifer Carter & Roger Cross, *Ginger for Pluck: The Life and Times of Miss Georgina King* (Adelaide: Wakefield Press, 2013).

49 King, 'Autobiography', 9.

50 King, *Mineral Wealth of NSW*, 10; King, 'Autobiography', 13–14.

51 Russell to King, 9 Sep 1888, ML MSS 2117/1, King Papers.

52 McCoy to King, 20 Nov 1894, and 26 Nov 1895, ML MSS 2117/1, King Papers. See also McCoy to King, 17 Jun 1895, ML MSS 2117/1, King Papers.

53 King, 'Autobiography', 2 (quote), 27–8, 32, 35.

54 For her newspaper articles, see e.g. *SMH*, 27 Jul 1895; 6 Jun 1896; 2 Sep 1903; 20 Feb 1904; 21 Dec 1904, and 1 Jan 1921; *Sunday Times*, 16 Dec 1923. Her other self-published pamphlets were *The Palaeozoic Carboniferous Formations in NSW and the Occurrence of Our Mineral Wealth* (Sydney: Angus & Robertson, 1895); *The Mineral Wealth of NSW* (Sydney: Angus & Robertson, 1896), which was republished with additions in 1906; *The Antiquity of the Aborigines* (Sydney: William Brooks, 1924); *Evolution: The Discovery of the Missing Link* (Sydney: William Brooks, 1926).

55 King to Prof. MacCallum, 21 Aug 1921, King Correspondence.

56 Edgeworth David to King, Jun 1890, ML MSS 2117/1, King Papers. None of the extensive notes she claims to have written for George Bennett or the drafts of her early articles are contained in her papers.

57 Edward Pittman to King, 23 May 1892, ML MSS 2117/1, King Papers.

58 Cited in King, 'Autobiography', 43. The original letter does not seem to have survived. The papers she submitted to the Royal Society were also lost. King, 'Autobiography', 33.

Notes

59 McCoy to King, 26 Nov 1896, ML MSS 2117/1, King Papers, emphasis in original.

60 *SMH*, 28 Aug 1906.

61 King, *Mineral Wealth of NSW and Other Lands*, 12. For a geologist's analysis of King's claims see D. F. Branagan, 'Georgina King: Geological Prophet or Lost?', *University of Sydney Archives Record*, no. 2 (1982): 4–9.

62 For King's correspondence with Pittman, the Royal Society and the University of Sydney, see ML MSS 2117/2 and ML MSS 273/1–2, King Papers.

63 R. Greig-Smith to King, 17 May 1917, ML MSS 2117/2, King Papers.

64 King, 'Autobiography', 38.

65 Russell to King, 14 Oct 1892, and 9 Sep 1888, ML MSS 2117/1, King Papers. Russell's daughter, Jane, was among the earliest women graduates of the University of Sydney and the second appointed as tutor to women students in 1892.

66 McCoy to King, 26 May 1895; see also McCoy to King, 15 Sep 1895, ML MSS 2117/1, King Papers. Her first two articles in *SMH* appeared anonymously, although the second was significantly signed 'Truth'.

67 McCoy to King, 26 May 1895, and 14 Jan 1893, ML MSS 2117/1, King Papers.

68 King, 'Autobiography', 7.

69 King, 'The Aborigines of Australia and Tasmania', *Science of Man* 6, no. 4 (1903): 57–58.

70 Alan Carroll, *Health and Longevity*, published by Mrs D. Izett (Sydney: Workers Union Trade Print, 1927). For Carroll's earlier racist writings on Australian Aboriginal peoples, see e.g. 'Some of the Myths and Traditions of the Australian Blacks', *Sydney Quarterly Magazine* (Sep 1889); 'The Black Races of Australia', *Sydney Quarterly Magazine* (Sep 1892).

71 *Science of Man* 3, no. 7 (1900): 108; *Science of Man* 3, no. 1 (1900): 2; *Science of Man* 3, no. 7 (1900): 109.

72 *Science of Man* 5, no. 7 (1902): 101; *Science of Man* 3, no. 3 (1900): 29.

73 Jane Carey, 'A Transnational Project? Women and Gender in the Social Sciences in Australia, 1890–1945', *Women's History Review* 18, no. 1 (2009): 45–69; Julie Marcus, ed., *The First in Their Field: Women and Australian Anthropology* (Melbourne: Melbourne UP, 1993).

74 Meredith, *Notes and Sketches of NSW*, 104; Atkinson, 'Native Arts', *Illustrated Sydney News*, 4 Feb 1854.

75 Katie Langloh Parker, *Australian Legendary Tales* (London: D. Nutt, 1896), and *More Legendary Tales* (London: D. Nutt, 1898). See also Julie Evans, Patricia Grimshaw & Ann Standish, 'Caring for Country: Yuwalaraay Women and Attachments to Land on an Australian Colonial Frontier', *Journal of Women's History* 14, no. 4 (2003): 15–37.

76 *Science of Man* 1, no. 11 (1898): 233–4. Parker published at least one article in *Science of Man* 1, no. 1 (1898): 17–18. See also the review in the *SMH*, 28 Nov 1896.

77 David Lang, 'Introduction', in Katie Langloh Parker, *The Euahlayi Tribe: A Study of Aboriginal Life in Australia* (London: Archibald Constable, 1905), ix.

78 Parker, *Euahlayi Tribe*, 3.

79 M. Muir, ed., *My Bush Book: K. Langloh Parker's 1890s Story of Outback Station Life* (Adelaide: Rigby, 1982), 46, 87.

80 Henry Reynolds, *Nowhere People: How International Race Thinking Shaped Australia's Identity* (Melbourne: Penguin, 2005), 8.

Notes

81 Biographical details are from Bob Reece, *Daisy Bates: Grand Dame of the Desert* (Canberra: NLA, 2007). Bates has been the subject of several other popular biographies including Ernestine Hill, *Kabbarli: A Personal Memoir of Daisy Bates* (Sydney: Angus and Robertson, 1973); Elizabeth Salter, *Daisy Bates: Great White Queen of the Never Never* (Sydney: Angus and Robertson, 1971). See also Eleanor Hogan, *Into the Loneliness: The Unholy Alliance of Ernestine Hill and Daisy Bates* (Sydney: NewSouth Publishing, 2021); Ann Standish, *Australia Through Women's Eyes*, chap. 6.

82 It was eventually published in 1985. Daisy Bates, *The Native Tribes of Western Australia*, ed. Isobel White (Canberra: NLA, 1985).

83 Alison Holland, 'The Campaign for Women Protectors: Gender, Race and Frontier between the Wars', *Australian Feminist Studies* 16, no. 34 (2001): 27–42.

84 Daisy Bates, *The Passing of the Aborigines* (London: Murray, 1938). For Bates and the 'dying race' theory, see also Russell McGregor, *Imagined Destinies: Aboriginal Australians and the Doomed Race Theory, 1880–1939* (Melbourne: Melbourne UP, 1997), 54–6, 125–9. For the international influence of this theory, see Patrick Brantlinger, *Dark Vanishings: Discourse on the Extinction of Primitive Races, 1800–1930* (Ithaca: Cornell UP, 2003).

85 *Sunday Times*, 12 Jun 1921. See also Bates, *Passing of the Aborigines*, especially 11, 107, 192–93, 195–96, 230; Bates, *Native Tribes*, 141–42, 290.

86 *AWW*, 13 Jan 1934, 3. See also *AWW*, 16 Sep 1933, 4; and 6 Jan 1934, 14.

87 King's letters to Bates are in the Daisy Bates Papers, ML MSS 1492, Mitchell Library. Most of Bates's letters to King are in ML MSS 273/5, King Papers. For Bates's publications in *Science of Man*, see e.g. vol. 14, no. 10, 1911; vol. 14, no. 11, 1911. Bates's work often received special mention and it supported her campaign to be appointed Protector of Aborigines: *Science of Man* 11, no. 6 (1908): 7; vol. 14, no. 12 (1912): 109.

88 Bates to King, 15 Sep 1913, ML MSS 2117/2, King Papers.

89 King to Bruce Smith, member of the Association for the Protection of Native Races, 8 Oct 1913, ML MSS 2117/2, King Papers.

90 Bates to Prof. MacCallum, 15 May 1926, King Correspondence.

91 King, *Mineral Wealth of NSW and Other Lands*, 10.

92 King, 'Autobiography', 82; King, *Mineral Wealth of NSW and Other Lands*, 11; King to Prof. MacCallum, 14 Aug 1926, King Correspondence.

93 For example, King frequently claimed Thomas Huxley as one of her correspondents, but in reality she only ever received one brief note from him. King, 'Autobiography', 32; Huxley to King, 2 Jan 1895, ML MSS 2117/1, King Papers.

94 See also Patrick Wolfe, *Settler Colonialism and the Transformation of Anthropology: The Politics and Poetics of an Ethnographic Event* (London: Cassell, 1999), esp. chap. 2.

95 Louise Newman, *White Women's Rights: The Racial Origins of Feminism in the United States* (New York: Oxford UP, 1999). See Chapter 4 for a detailed discussion of eugenics.

96 Georgina King, 'The Discovery of the Missing Link: The Appearance of Woman as a "Sport" in Nature and Evolution of Anthropoid Man', *Science of Man* 5, no. 11 (1902): 185–87. The article was reprinted three times in *Science of Man*, vol. 8, no. 2 (1906): 8–11; vol. 9, no. 12 (1908): i–iv; and vol. 14, no. 11 (1912): 20–2 and in King's self-published pamphlets.

Notes

97 King, 'Missing Link', 186. For similar challenges to evolutionary theory by women in Britain and the United States, see Rosemary Jann, 'Revising the Descent of Woman: Eliza Burt Gamble', in Gates and Shteir, *Natural Eloquence*; Sally Gregory Kohlstedt & Mark Jorgensen, 'The Irrepressible Woman Question: Women's Responses to Evolutionary Ideology', in *Disseminating Darwinism: The Role of Place, Race, Religion, and Gender*, ed. Ronald Numbers & John Stenhouse (Cambridge: Cambridge UP, 1999); Evelleen Richards, *Ideology and Evolution in Nineteenth Century Britain: Embryos, Monsters, and Racial and Gendered Others in the Making of Evolutionary Theory and Culture* (London: Routledge, 2020).

98 *Science of Man* 13, 13, no. 9 (1910): 74; vol. 13, no. 10 (1910): 91. Sharpe and King became frequent correspondents.

99 King, 'Autobiography', 9.

100 Cited in Maroske, '"The Whole Great Continent"', 16.

101 Dietrich worked in Queensland from 1863 to 1872, collecting specimens for the Godeffroy Museum in Hamburg. On the controversies surrounding her see S. Affeldt & W. Hund, 'From "Plant Hunter" to "Tomb Raider": The Changing Image of Amalie Dietrich', *Australian Studies Journal/Zeitschrift für Australienstudien* 33/34 (2019–2020): 89–124; Ray Sumner, 'Amelie Dietrich and the Aborigines', *Australian Aboriginal Studies*, no. 2 (1993): 2–19; Ray Sumner, *A Woman in the Wilderness: The Story of Amalie Dietrich in Australia* (Sydney: University of NSW Press, 1993). There are now extensive campaigns for Indigenous remains and cultural objects in museum collections to be repatriated.

Chapter 2: 'Pioneers'

1 *Advertiser*, 17 Dec 1885.

2 In 1885 two men also gained BScs from the University of Sydney: D. Branagan & G. Holland, *Ever Reaping Something New: A Science Centenary* (University of Sydney Science Centenary Committee, 1985), 5.

3 See Appendix 1. The number and proportion of women was first noted by Farley Kelly, 'Learning and Teaching Science: Women Making Careers 1890–1920', in Farley Kelly, ed., *On the Edge of Discovery: Australian Women in Science* (Melbourne: Text, 1993), 36, 44.

4 At both universities, women were around 30% of science graduates up to 1940. Calculated from lists of graduates in University of Queensland Senate, *An Account of the University of Queensland During Its First Twenty-five Years, 1910–1935* (Brisbane: Government Printer, 1935), 64–95; *Calendar of the University of Western Australia* (1941): 196–200.

5 See Appendix 1. The proportion of women science graduates peaked at 73% in 1917 (the height of WWI).

6 Georgina King, 'Autobiography', 9, ML MSS 273/3, Georgina King Papers, Mitchell Library, Sydney.

7 For an early statement of this see Sally Gregory Kohlstedt, 'In from the Periphery: American Women in Science, 1830–1880', *Signs* 4, no. 1 (1978): 81–96. This is a key theme of many of the works cited in the Introduction, note 18. See also Robert Bruce, *The Launching of Modern American Science, 1846–1876* (New York: Alfred A. Knopf, 1987). On Australia, see e.g. R. W. Home, ed., *Australian Science in the Making*

256

Notes

(Cambridge: Cambridge UP, 1988). For a broader discussion of gender and professionalisation, see Anne Witz, *Professions and Patriarchy* (London: Routledge, 1992).

8 David Orme Masson, 'Inaugural Address', 23 Mar 1887, reproduced in Moyal, *Scientists in Nineteenth Century Australia*, 228–29. On the broader circulation of male scholars from Britain to the colonies, see Tamson Pietsch, *Empire of Scholars: Universities, Networks and the British Academic World, 1850–1939* (Manchester: Manchester UP, 2013).

9 For detailed descriptions of some of these new laboratories and their importance, see the reports by Richard Threlfall and Archibald Liversidge on the new physics and chemistry laboratories at the University of Sydney in *Report of the First Meeting* (AAAS, 1889), 95–105, 168–82.

10 *Advertiser*, 16 Jan 1885.

11 *SMH*, 31 Jul 1882.

12 For attendances at AAAS meetings, see *Report of the First Meeting*, xxv, and *Report of the Second Meeting* (AAAS, 1890), xxiii, which shows an attendance of over 1,000. See also Roy MacLeod, ed., *The Commonwealth of Science: ANZAAS and the Scientific Enterprise in Australia* (Melbourne: Oxford UP, 1988).

13 *Melbourne University Review* 3, no. 1 (1887): 28–30.

14 *Melbourne University Review* 4, no. 2 (1888): 69.

15 For an overview of key scholarship, see Julia Horne, 'The Final Barrier? Australian Women and the Nineteenth-Century Public University', in *Women in Higher Education, 1850–1970: International Perspectives*, ed. E. Lisa Panayotidis & Paul Stortz (New York: Routledge, 2016). See also Farley Kelly, *Degrees of Liberation: A Short History of Women in the University of Melbourne* (Melbourne: Women Graduates Centenary Committee, 1985); Alison Mackinnon, *Love and Freedom: Professional Women and the Reshaping of Personal Life* (Melbourne: Cambridge UP, 1997); Marjorie Theobald, *Knowing Women: Origins of Women's Education in Nineteenth-Century Australia* (Cambridge: Cambridge UP, 1996). On the difficulties faced by British women, see Carol Dyhouse, *No Distinction of Sex? Women in British Universities, 1870–1939* (London: UCL Press, 1995); June Purvis, *A History of Women's Education in England* (Milton Keynes: Open UP, 1991). For the United States, see Margaret Rossiter, *Women Scientists in America: Struggles and Strategies to 1940* (Baltimore: Johns Hopkin UP, 1984), esp. chaps 1 and 2.

16 William Manning, *The Tendency of Modern Opinions*, Memorandum read by the Chancellor to the University of Sydney Senate, 6 Apr 1881 (Sydney: Pump Press, 1973), 5. From 1877 to 1914, women comprised 20–36% of graduates from New Zealand's four university colleges. Kay Matthews, *In Their Own Right: Women and Higher Education in New Zealand before 1945* (Wellington: NZCER Press, 2008).

17 *SMH*, 3 Dec 1883. See also *Age*, 3 Dec 1883.

18 Theobald, *Knowing Women*, 68.

19 Kelly, *Degrees of Liberation*, esp. 10, 14–16; Robert Moorhead, 'Breaking New Ground: The Story of Dagmar Berne', *Health and History* (2008): 4–22.

20 Mackinnon, *Love and Freedom*, 12, 21–2, 47–70; James Barrett, *The Twin Ideals: An Educated Commonwealth*, 2 vols. (London: H. K. Lewis, 1918).

21 H. Armstrong, 'The Place of Wisdom (Science) in the State and in Education', *Report of the British Association for the Advancement of Science, 1914, Australia* (London: J. Murray, 1915), 615.

Notes

22 For an excellent recent study of some these developments, see James Keating, *Distant Sisters: Australasian Women and the International Struggle for the Vote, 1880–1914* (Manchester: Manchester UP, 2020).

23 *Adelaide Observer*, 21 Nov 1885.

24 See Chapter 4.

25 Hannah Forsyth, 'Reconsidering Women's Role in the Professionalisation of the Economy: Evidence from the Australian Census 1881–1947', *Australian Economic History Review* 59, no. 1 (2019): 55–79.

26 Florence Walsh, 'The Women's College', *Sydney Quarterly Magazine* 7, no. 3 (1890): 207.

27 Agnes Milne, 'Women Who Work', *South Australian Register*, 5 Mar 1898.

28 This was evident in women's fiction of this period. For Australian examples see Jane Carey, 'Utopian Visions of Evolution and Race in Feminist Fiction and Activism', *Lilith*, nos 17/18 (2012): 68–88.

29 Annie Golding, 'The Industrial and Social Condition of Women in the Australian Commonwealth', *Proceedings of the Third Australasian Catholic Congress* (1910), reprinted in Kay Daniels & Mary Murnane, *Uphill all the Way: A Documentary History of Women in Australia* (Brisbane: University of Queensland Press, 1980), 183.

30 Rita Felski, *The Gender of Modernity* (Cambridge: Harvard UP, 1995). For a key Australian study of women modernity and mobility, see Angela Woollacott, *To Try Her Fortune in London: Australian Women, Colonialism, and Modernity* (New York: Oxford UP, 2001). For the 'new woman' in Australia, see also Cecily Devereux, 'New Woman, New World: Maternal Feminism and the New Imperialism in the White Settler Colonies', *Women's Studies International Forum* 22, no. 2 (1999): 175–84; Penny Russell, 'A Woman of the Future? Feminism and Conservatism in Colonial New South Wales', *Women's History Review* 13, no. 1 (2004): 69–90.

31 See e.g. *Australian Woman's Sphere* 1, no. 2 (1900).

32 *Age*, 22 Mar 1880.

33 Bella Guerin, 'Modern Woman', *Sydney Quarterly Magazine* (Dec 1887), 324.

34 Woollacott, *To Try Her Fortune*, 6.

35 Josephine May, 'Empire's Daughters: The First 25 Australian-born Women at Girton and Newnham Colleges Cambridge, 1870–1940, as Insiders and Outsiders', *History of Education* 49, no. 6 (2020): 781–804. Marion Phillips was the first Australian woman to gain a DSc overseas (in 1909), but this was at the London School of Economics. She was elected to the British Parliament in 1926: Marian Goronwy-Roberts, *A Woman of Vision: A Life of Marion Phillips, MP* (Wrexham: Bridge Books, 2000).

36 In the 1890s, several other Australian women studied at the University of Edinburgh's College of Medicine for Women including Mary Booth, Katie Hogg and Agnes Bennett. See Moorhead, 'Breaking Ground', and entries for Stone, Booth, Cooper, Hogg and Bennett in the *ADB*.

37 'Life Among the Women Students. By one of them', *Argus*, 1 Nov 1890.

38 *Age*, 22 Mar 1880.

39 *Advertiser*, 18 Dec 1884. The article did also state that 'boys' would always significantly outnumber 'girls' at the university.

40 *Register*, 18 Dec 1885.

Notes

41 Cited in Alison Mackinnon, *The New Women: Adelaide's Early Women Graduates* (Adelaide: Wakefield Press, 1986), 32. Biographical details for Dornwell are from this source.

42 Women were still excluded from the University of Melbourne's Senate. Rev. J. C. Kirby, 'Women and the Australian Universities', *South Australian Register*, 7 May 1889. The article was reprinted in the *Dawn* (Australia's only feminist magazine at the time), 1 June 1889.

43 Mackinnon, *The New Women*, 27.

44 See Appendix 1.

45 Four of Adelaide's first 12 women science graduates had physics as one of their majors: E. Medlin, *Some Reflections on Physics at the University of Adelaide* (University of Adelaide, 1986), 59–68.

46 Kelly, 'Learning and Teaching Science', 59–60.

47 Calculated from list of geology graduates in David Branagan, ed., *Rocks-Fossils-Profs: Geological Sciences in the University of Sydney, 1866–1973* (Sydney: Science Press, 1973), 109–13. From 1891–1913, women were 46% of geology majors – rising to 71% during WWI. Over a third of Sydney's women science graduates up to 1920 had a geology major. See also David Branagan, *T. W. Edgeworth David: A Life* (Canberra: NLA, 2005).

48 See Chapter 1.

49 *Daily Telegraph*, 23 Jun 1909. See also *Advertiser*, 26 Jun 1909 and 30 Jun 1909; Branagan, *T. W. Edgeworth David*.

50 See the numerous photographs in Branagan, *Rocks-Fossils-Profs*.

51 On Spencer, see D. J. Mulvaney, *'So Much That Is New'. Baldwin Spencer 1860–1929* (Melbourne: Melbourne UP, 1985). On his support for his women students see also Kelly, 'Learning and Teaching Science'.

52 'Weddings', *Melbourne Punch*, 5 Jul 1894.

53 'Social Items', *Evening News*, 13 Apr 1894.

54 Mary & Thomas Creese, *Ladies in the Laboratory III: South African, Australian, New Zealand and Canadian Women in Science* (Lanham: Scarecrow Press, 2010), 65; 'Wilsmore, Norman Thomas Mortimer (1868–1940)', *ADB*.

55 *Age*, 7 Dec 1894, 6; Ada Lambert, 'The Structure of an Australian Land Leech', *Proceedings of the Royal Society of Victoria* 10, part 2 (1898): 211–35, and 'Description of Two New Species of Australian Land Leeches, with Notes on Their Anatomy', *Proceedings of the Royal Society of Victoria* 11, part 2 (1899): 156–63; 'a'Beckett, Ada Mary', in *The Encyclopedia of Women & Leadership in Twentieth Century Australia*, http://www.womenaustralia.info/leaders/biogs/WLE0168b.htm.

56 Frederick McCoy, '*Megascolides australis* (McCoy): The Giant Earth-Worm', in his *Natural History of Victoria*, vol. 1 (Melbourne: J. Ferres, Government Printer, 1878).

57 *Australasian*, 16 Apr 1904. Other details are from 'Sweet, Georgina (1875–1946)', *ADB*, and various files in UM312, Registrar's Office Correspondence, University of Melbourne Archives (hereafter UM312).

58 W. J. Stephens, 'Presidential Address', *Proceedings of the Linnean Society of NSW* 10 (1886): 865. Women were admitted as associate members in 1889, but not as full members until 1909.

59 Robert Ellery, 'President's Address', *Transactions and Proceedings of the Royal Society of Victoria* 18 (1882): xv.

259

Notes

60 *Argus*, 30 Apr 1885. See also Sheila Houghton, '"If It Is Not Against the Rules":
Women in the FNCV 1880–1980', *Victorian Naturalist* 122, no. 6 (2005): 290–306.

61 R. T. M. Pescott, 'The Royal Society of Victoria from Then, 1854 to Now, 1959',
Proceedings of the Royal Society of Victoria 73 (1961): 27.

62 "Objects and Rules of the Association', *Report of the First Meeting* (AAAS, 1889),
xiii; Sara Maroske et al., 'On the Threshold of Mycology: Flora Martin née
Campbell (1845–1923)', *Muelleria* 36 (2017): 51–73.

63 Sir James Hector, speech to the conference, 15 Jan 1891, *Report of the Third Meeting*
(AAAS, 1891), xxix; Sir Robert Hamilton, 'Inaugural Address', *Report of the Fourth
Meeting* (AAAS, 1893), 24–25.

64 Lecture Returns for 1901 and 1902, UM312, 1902/33, and Dean's Reports,
UM312, 1909/20; Clifford Turney, Ursula Bygott & Peter Chippendale, *Australia's
First: A History of the University of Sydney* (Sydney: Hale & Iremonger, 1991), 643.

65 *Annual Reports of Professors and Lecturers, 1890*, UM312, 1890/3; *Annual Reports
of Professors and Lecturers, 1893*, UM312, 1893/3. See also, *Annual Reports, 1891*,
UM312, 1891/4. Science departments in this period were highly dependent on their
provision of first-year subjects for the much larger numbers of students in medicine
and engineering.

66 *Alma Mater* 3, no. 3 (1898): 24.

67 Edgeworth David, 'University Science Teaching', *Record of the Jubilee Celebrations of
the University of Sydney, Sep 30th, 1902* (Sydney: William Brocks & Co., 1903), 114.

68 *Report of the Matriculation Examination Held in May, 1892*, 8, UM312, 1892/25.

69 Kathleen Fitzpatrick, *PLC: The First Hundred Years, 1875–1975* (Melbourne:
Presbyterian Ladies' College, 1975), 82 and 120–21; Noeline Kyle, *Her Natural
Destiny: The Education of Women in New South Wales* (Sydney: UNSW Press,
1986), 124; John McFarlane, *The Golden Hope: Presbyterian Ladies College Sydney,
1888–1988* (Sydney: PLC College Council, 1988), 26; G. Morris, 'The Development
of Science Subjects in Australian Secondary School Education', *Australian Journal
of Education* 8, no. 1 (1964): 46–61; Lilith Norman, *The Brown and Yellow: Sydney
Girls' High School, 1883–1983* (Melbourne: Oxford UP, 1983), 15; Ian Wilkinson,
'Science in Victorian Secondary Schools in the Late Nineteenth Century', *History
of Education Review* 17, no. 2 (1988): 159–69, and 'Science in Victorian Secondary
Schools, 1855–1910' (PhD thesis, Monash University, 1989), 26, 202, 302.

70 Don Anderson, 'Access to University Education in Australia 1852–1990: Changes in
the Undergraduate Social Mix', *Australian Universities' Review* 33, nos. 1–2 (1990):
37–50. In 1921 only 1.4% of 17 to 22-year-olds were university students.

71 G. Samson to the Registrar, 10 Nov 1871, Admission of Women Files, University of
Melbourne Archives.

72 The backgrounds of women university students are described in the work of Farley
Kelly and Alison Mackinnon cited elsewhere. For a detailed enumeration of many
characteristics of women students at the University of Melbourne up to 1901 see also
Carole Hooper, 'The University of Melbourne's First Female Students', *Victorian
Historical Journal* 81, no. 1 (2010): 93–112.

73 The poem was parodied in Gilbert and Sullivan's *Princess Ida* (1884). Kelly, *Degrees
of Liberation*, 30–1. See also Miss Jamieson, M. A., 'Princess Ida Club: History and
Objects', *Herald*, 1 Nov 1909. Similarly, the Victorian Medical Women's Society
formed in 1896, and a women medical students society in 1901.

Notes

74 *Alma Mater* 3, no. 2 (1888): 15. See also e.g. *Melbourne University Review* 3, no. 1 (1887); vol. 3, no. 2, (1887); vol. 4, no. 3 (1888); and *Alma Mater* 1, no. 1 (1895); vol. 1, no. 7 (1896); vol. 3, no. 1 (1898).

75 *Melbourne University Review* 3, no. 3 (1887): 144. The second woman referred to was Flora Campbell.

76 Gwynneth Buchanan, 'The Melbourne University Science Club, 1888–1937', *Science Review* (Melbourne University Science Club), no. 1 (1937): 17–18; *Alma Mater* 2, no. 1 (1897): 18; and vol. 2, no. 5 (1897): 24.

77 *Melbourne University Magazine* 10, no. 2 (1916): 51.

78 Kay Whitehead, 'Higher Education, Work and "Overstrain of the Brain": Amy Marion Elliott MSc, University of Tasmania, 1900', *History of Education Review* 29, no. 1 (2000): 16–31.

79 William MacGregor, 'Chancellor's Oration', in University of Queensland, *Report of the Inauguration Ceremony* (Brisbane: Government Printer, 1911), 30.

80 *Science Journal* (Sydney University Science Association) 1, no. 2 (1917).

81 *Science Journal* 8, no. 2 (1924).

82 *Herald*, 4 Jul 1911.

83 *Herald*, 18 Apr 1911.

84 *Age*, 11 Apr 1911. Another article about Sweet's work on parasitic worms appeared in *Sydney Mail*, 3 May 1911.

85 *Table Talk*, 14 Aug 1913. Details of Sweet's travels plans are from UM312, 1919/386.

86 *Herald*, 27 Jun 1911.

87 *Herald*, 18 Apr 1911.

88 Ibid.

89 *Weekly Times*, 8 Jul 1911.

90 'Memoir, c. 1908–1968', Hilda Brotherton Papers, Fryer Library, University of Queensland, cited in Megan McCarthy, '"We Were at the Beginning of Everything": The First Women Students and Graduates of the University of Queensland', *Crossroads* 2 (2011): 35–44.

Chapter 3: Taking on the Profession

1 *Table Talk*, 21 Apr 1899; *Barrier Miner*, 8 May 1899; *Critic*, 1 Jul 1899. See also *Argus*, 1 May 1899; 'Our Melbourne Letter', *Mercury*, 6 May 1899; *Advocate*, 6 May 1899; *Observer*, 20 May 1899.

2 Alison Mackinnon, *The New Women: Adelaide's Early Women Graduates* (Adelaide: Wakefield Press, 1986), 31–35. She taught at various girls' schools for several years (first in Adelaide, then Melbourne and finally Sydney), before marrying and moving to Fiji with her husband who worked for the Commonwealth Sugar Refinery.

3 Nearly 70% of women arts and science graduates from the University of Melbourne up to 1906 became teachers and 37 of Melbourne's 62 women science graduates up to 1920 were teachers at some point, although many moved between school teaching and university work. Farley Kelly, *Degrees of Liberation: A Short History of Women in the University of Melbourne* (Melbourne: Women Graduates Centenary Committee, 1985), 48; Farley Kelly, 'Learning and Teaching Science: Women Making Careers 1890–1920', in her, ed., *On the Edge of Discovery: Australian Women in Science*

Notes

(Melbourne: Text, 1993), 51. At the University of Queensland, 89.5% of women graduates up to 1929, went into teaching. M. Rorke, *The Vocational Contributions of Women Graduates of the University of Queensland* (Brisbane: University of Queensland Press, 1959), 10. See Chapters 5 & 6 for employment destinations of later graduates. For the acute shortage of science teachers, see e.g. UM312, 1921/245, Registrar's Office Correspondence, University of Melbourne Archives (hereafter UM312).

4 Figures compiled in Nike Grasset, 'Women Demonstrating Biology: A Demonstration of Discrimination in Early Australian Science' (MA thesis, Monash University, 1992). Grasset interprets these numbers quite differently and she excludes the highly feminised botany departments. Several women employed at the University of Melbourne are also missing.

5 For women on the science staff of Australian universities in selected years 1929–55 (and the total number of women academics employed), see Appendix 2.

6 Rev. J. C. Kirby, 'Women and the Australian Universities', *South Australian Register*, 7 May 1889.

7 From 1901 to 1921 the proportion of the female labour force employed in professional occupations rose from 12.8% to 18.4%, rising only slightly from this point into the 1940s. Beverley Kingston, *My Wife, My Daughter and Poor Mary Ann: Women and Work in Australia* (Melbourne: Nelson, 1975), 61. Women's overall representation in the paid labour force did not, however, increase, remaining at around 20% from 1901 to 1933. As Desley Deacon points out, these 'official' statistics did not count women working in family businesses or on farms: 'Political Arithmetic: The Nineteenth-Century Australian Census and the Construction of the Dependent Woman', *Signs* 11, no. 1 (1985): 27–47. For some recent studies of women's movement into new fields of employment in this period and the discrimination they faced, see Jeannine Baker, 'Australian Women Journalists and the "Pretence of Equality"', *Labour History* 108, no. 1 (2015): 1–17; Jeannine Baker, *Australian Women War Reporters: Boer War to Vietnam* (Sydney: NewSouth, 2015); Jacqueline Dickenson, *Australian Women in Advertising in the Twentieth Century* (Houndmills: Palgrave Macmillan, 2016); Diane Kirkby & Caroline Jordan, '"These Labourers in the Field of Public Work": Librarians, Discrimination and the Meaning of Equal Pay', *Labour History* 117 (2019): 79–107. See also Liz Conor, *The Spectacular Modern Woman: Feminine Visibility in the 1920s* (Bloomington/ Indianapolis: Indiana UP, 2004); Katie Holmes, *Spaces in Her Day: Australian Women's Diaries of the 1920s and 1930s* (Sydney: Allen & Unwin, 1995); Maria Nugent, *Women's Employment and Professionalism in Australia: Histories, Themes and Places* (Canberra: Australian Heritage Commission, 2002). For similar developments in Britain, see Heidi Egginton & Zoë Thomas, eds, *Precarious Professionals: Gender, Identities and Social Change in Modern Britain* (London: University of London Press, 2021), esp. the chapter by Claire Jones, 'Women, Science and Professional Identity, c.1860–1914'. The editors note that although many new professions opened for women in this period, they are still typically seen as exceptional pioneers.

8 Spencer to the Council, University of Melbourne, 15 Oct 1900, UM312, 1900/48. For Spencer's impact on Aboriginal policy, see Russell McGregor, *Imagined Destinies: Aboriginal Australians and the Doomed Race Theory, 1880–1939* (Melbourne: Melbourne UP, 1997); Ben Silverstein, *Governing Natives: Indirect Rule and Settler*

Notes

Colonialism in Australia's North (Manchester: Manchester UP, 2018); Patrick Wolfe, *Settler Colonialism and the Transformation of Anthropology the Politics and Poetics of an Ethnographic Event* (London: Cassell, 1999).

9 Spencer to the Council, 15 Oct 1900, UM312, 1900/48.

10 Kelly, 'Learning and Teaching Science', 53, 68. These appointments are discussed further below. See also Jane Carey, 'No Place for a Woman?: Intersections of Class, Modernity and Colonialism in the Gendering of Australian Science, 1885–1940', *Lilith: A Feminist History Journal* 10 (2001). Sections of this chapter are drawn from this article.

11 Mackinnon, *New Women*, 204–5; Diana Temple, 'Women in Science and Medicine', in Bettina Cass et al., eds, *Why So Few? Women Academics in Australian Universities* (Sydney: Sydney UP, 1983), 155.

12 University of Sydney Senate Minutes, cited in D. Branagan & G. Holland, *Ever Reaping Something New: A Science Centenary* (Sydney: University of Sydney Science Centenary Committee, 1985), 226. Helen Phillips was the first tutor to women in 1891, followed by Jane Russell from 1892–1899, but this was not considered an academic appointment. Ursula Bygott & Kenneth Cable, *Pioneer Women Graduates of the University of Sydney 1881–1921* (University of Sydney, 1985), 11.

13 See staff list in David Branagan, ed., *Rocks-Fossils-Profs: Geological Sciences in the University of Sydney, 1866–1973* (Sydney: Science Press, 1973), 57–9. See also Susan Turner, 'Invincible but Mostly Invisible: Australian Women's Contribution to Geology and Palaeontology', in *The Role of Women in the History of Geology*, ed. C. V. Burek and B. Higgs (London: Geological Society, 2007), 165–202.

14 Gretchen Poiner & Roberta Burke, *No Primrose Path: Women as Staff at the University of Sydney* (University of Sydney, 1988), 11.

15 For Adelaide, see Staff Cards, Series 467, Registrar's Office Files, University of Adelaide Archives; Mackinnon, *New Women*, 204–5; C. Twidale, M. Tyler & M. Davies, eds, *Ideas and Endeavours: The Natural Sciences in South Australia* (Adelaide: Royal Society of South Australia, 1986), 115–18; 'Benham, Ellen Ida (1871–1917)', and 'Osborn, Theodore George Bentley (1887–1973)', *ADB*. The Osborns met at the University of Manchester, where they were both lecturers, and married just prior to moving to Adelaide. Edith demonstrated in the department in 1913, as her husband argued no one else suitably qualified was available, and she continued to assist in demonstrating or lecturing when needed. She received only occasional small payments for this work. For Tasmania see relevant issues of the *Calendar of the University of Tasmania* and Hutchison's entry in Rod Home, *Physics in Australia to 1945: Bibliography and Biographical Register*, https://www.asap.unimelb.edu.au/bsparcs/physics/P001702p.htm. After a period with the Tasmanian Agriculture Department (1928–36), Hutchison returned to the University of Tasmania as a library assistant in 1937–41. For Queensland, see relevant issues of the *Calendar of the University of Queensland*; list of research papers in *The University of Queensland, 1910–1922* (Brisbane: Senate of the University of Queensland, 1923), 36; Grasset, 'Women Demonstrating Biology', 184–85. Bage had gained an MSc and numerous research scholarships – particularly a King's College London studentship in 1910–11, where the research she conducted resulted in her election as a Fellow of the Linnean Society of London: 'Bage, Anna Frederika (1883–1970)', *ADB*; UM312, 1907/51; 1908/35; 1909/62; 1911/70.

263

Notes

16 Relevant issues of the *Calendar of the University of Western Australia*, 1915–. Buchanan had worked as a research scholar and demonstrator in Melbourne's biology school since 1909 and as a lecturer in various university colleges. She gained her DSc in 1916 (following a year's leave when she conducted research at UCL). She returned to a lectureship in Melbourne's new zoology department in 1921 and was promoted to senior lecturer in 1923, remaining in this position until her death in 1945. UM312, 1909/62; 1911/40; 1911/70; 1913/29; 1913/273; 1915/305; 1916/30; 1916/42; 1917/33; 1918/43; 1919/38; 1920/471; 1923/62; 1923/485A.

17 *Argus*, 5 Sep 1893.

18 Spencer to the Council 20 Oct 1893, UM312, 1893/27, and University of Melbourne Council Minutes, 4 Sep and 4 Dec 1893, University of Melbourne Archives.

19 Spencer to the Council, 3 Oct 1898, UM312, 1898/26.

20 Spencer to the Council, 15 Oct 1900, UM312, 1900/48.

21 Key files on these appointments are UM312, 1907/51; 1908/67; 1909/62; 1911/70; 1913/398; 1916/30; 1916/31; 1916/260; 1917/33; 1918/43; 1919/38.

22 For botany see UM312, 1908/67; 1909/62; 1913/119; 1914/36; 1914/96; 1915/169; 1915/175; 1916/34; 1917/37; 1918/46; 1919/41; 1920/79; 1921/515; 1922/57; 1922/59; 1922/150; 1923/49; 1925/75; 1925/76; 1926/82; 1927/10; 1928/104. In the medical faculty, for bacteriology: UM312, 1900/2; 1901/4; 1902/51; 1907/51; 1909/62; 1912/11; 1913/237; 1914/25; 1915/13; 1916/19-22; 1917/27; 1918/32; 1919/27. For physiology and biochemistry: UM312, 1914/258; 1916/357; 1917/143; 1918/148.

23 James Riding & Mary Dettmann, 'The First Australian Palynologist: Isabel Clifton Cookson (1893–1973) and Her Scientific Work', *Alcheringa: An Australasian Journal of Palaeontology* 38, no. 1 (2014): 97–129; Kelly, 'Learning and Teaching', 68–74. On White see also *Woman*, 1 Jul 1911; *Herald*, 2 Apr 1912. When White left in 1912, Bertha Rees, who had been a research scholar in botany since 1909, was appointed to a full-time lectureship. She resigned in 1914 and was replaced by Ethel McLennan.

24 UM312, 1908/35; 1909/20; 1910/20; 1912/48; 1913/147; 1915/122; 1916/30; 1923/4? [Research Scholarships: Awards under Government Grant]; 1929/530. From 1909–11, of the 13 research scholars appointed in botany and zoology, only 2 were men. In 1911, 5 of the 9 research scholars in chemistry were women. UM312, 1911/40.

25 UM312, 1907/11; 1908/67; 1913/53; 1915/42; 1915/44; 1916/55; 1917/45; 1918/186; 1918/222; 1919/61; 1924/160; 1927/199; 1928/211; 1929/201.

26 UM312, 1902/51; 1905/48; 1913/463; 1915/346; 1916/10; 1916/374; 1917/230; 1918/222; 1919/123; 1920/315; 1924/160; 1924/383; 1927/199; 1928/211; 1929/201. Campbell left in 1905. The next woman appointed was Bertha Wood in 1913. She was joined by New Zealander Natalie Allen in 1916.

27 UM312, 1918/169; 1926/36; 1929/220.

28 Spencer to the Registrar, 8 Apr 1907, UM312, 1907/51. Unless otherwise cited, details on Sweet's career are from 'Sweet, Georgina (1875–1946)', *ADB*; and her CV in her application for the chair of zoology in 1919, UM312, 1919/386.

29 Sweet to the Chancellor and Council, 4 Jul 1913, UM312, 1913/398; 'Parasites: A Commonwealth Treatise', *Sun*, 31 Jul 1913; UM312, 1916/333.

264

Notes

30 *Daily Telegraph* (Launceston) 19 October 1916; *Herald*, 10 Oct 1916; Spencer to the Registrar, 2 Oct 1916, UM312, 1916/260. See also 'First Woman Professor', *Woman Voter*, 19 Oct 1916.

31 Agar to Finance Committee, 12 Mar 1920, UM312, 1920/472.

32 On the Pan-Pacific Women's Association see Fiona Paisley, *Glamour in the Pacific: Cultural Internationalism and Race Politics in the Women's Pan-Pacific* (Honolulu: University of Hawai'i Press, 2009).

33 *Register*, 8 Jun 1925; *Advertiser and Register*, 29 Apr 1931.

34 For McLennan's career, see UM312, 1914/36; 1915/169; 1917/37; 1917/187; 1919/291; 1920/266; 1926/374; 1931/290. See also the Ethel McLennan Papers, University of Melbourne Archives (hereafter McLennan Papers); 'McLennan, Ethel Irene (1891–1983)', *ADB*.

35 *Examiner*, 15 Nov 1926; *Examiner*, 14 Mar 1927; *Age*, 7 Jun 1933; *Telegraph*, 7 Jun 1933.

36 *Argus*, 27 Aug 1926.

37 *Argus*, 3 Sep 1935.

38 *Australasian*, 7 Oct 1899.

39 *Adelaide Observer*, 11 Nov 1899. See also *Brisbane Courier*, 9 Nov 1899.

40 *Australasian*, 7 Oct 1899. The *Port Augusta Dispatch* added more negative comment: 'It only wants two or three men to become mothers and the ridiculous farce would complete [*sic*]', 17 Nov 1899.

41 Joan Gillison, *A History of the Lyceum Club Melbourne* (Melbourne: Lyceum Club, 1975), 56.

42 Its other aims were 'to encourage independent research work by women', 'facilitate intercommunication and cooperation between the women of different universities' and 'stimulate the interest of women in municipal and public life': 'Initial Notice of the Formation of the International Federation of University Women', box LS 1/6, U81/55, Victorian Women Graduates Association Records, University of Melbourne Archives. The aims of the British Federation, formed in 1907, are from Carol Dyhouse, 'The British Federation of University Women and the Status of Women in Universities, 1907–1939', *Women's History Review* 4, no. 4 (1995): 472.

43 *Bulletin* (AFUW), no. 6 (1938): 55.

44 See also discussion of Bage above (p. 81) and Little in Chapter 2. Deakin is discussed further below.

45 UM312, 1913/273.

46 UM312, 1914/236; *Herald*, 4 Aug 1914 and 11 Jul 1916.

47 McLennan to the Registrar, 17 Dec 1925, UM312, 1926/374.

48 'Women's Views and News', *Argus*, 27 Aug 1926.

49 'Cape to Cairo Tour', *Argus*, 1 Mar 1923.

50 'Women in Pursuit of Science: Enthusiasts Who Toured Africa', *Countryman*, 11 Jul 1924.

51 *Age*, 20 Jun 1923. In 1926–7, Sweet went on another lengthy, 20-month tour of 'the East' including Indonesia, Borneo, the Philippines, Hong Kong, Formosa, China, Thailand and Burma, attending the Pan-Pacific Science Congress and the Chino-Medical Congress along the way. This trip was also widely reported, e.g. *The Week*, 5 Aug 1927.

52 Mackinnon, *New Women*, 204–5; 'Benham, Ellen Ida', *ADB*.

Notes

53 'Travers, Isobel Dieudonnée (1898–1982)', *ADB*.

54 'Marie Bentivoglio (1898–1997)', *Geographers: Bibliographic Studies* 38 (2019); *Dawn*, 14 Feb 1925; *SMH*, 4 July 1934.

55 'Bage', *ADB*.

56 *Herald*, 28 May 1918 & 27 May 1924; *Chronicle*, 11 Oct 1924; UM312, 31/8/1911, 1918/91, 1919/98, 1919/233; Danielle Scrimshaw, "'Lovely and Secret": The Life of a Poet's Muse, Katie Anna Lush', *Lilith*, no. 27 (2021): 168–69.

57 *Herald*, 27 Jun 1911.

58 Desley Deacon, 'The Employment of Women in the Commonwealth Public Service: The Creation and Reproduction of a Dual Labour Market', *Australian Journal of Public Administration* 41, no. 3 (1982): 232–50; Marjorie Theobald, 'Women, Leadership and Gender Politics in the Interwar Years: The Case of Julia Flynn', *History of Education* 29, no. 1 (2000): 63–77.

59 T. Stevenson, 'Making Visible the First Women in Astronomy in Australia: The Measurers and Computers Employed for the Astrographic Catalogue', *Publications of the Astronomical Society of Australia* 31 (2014): 1–10.

60 'White-Haney, Rose Ethel Janet (Jean) (1877–1953)', *ADB*.

61 Lionel Gilbert, *The Royal Botanic Gardens, Sydney: A History 1816–1985* (Melbourne: Oxford UP, 1986), 120, 130; 'Hynes, Sarah (Sally) (1859–1938)', *ADB*.

62 Kay Whitehead, 'Higher Education, Work and "Overstrain of the Brain": Amy Marion Elliott M.Sc., University of Tasmania, 1900', *History of Education Review* 29, no. 1 (2000): 16–31.

63 Turner, 'Invincible but Mostly Invisible'; 'Crespin, Irene (1896–1980)', *ADB*. Lorna Byrne (BSc, Agr. 1921) was a teacher for 6 years and then had a long career in the Agricultural Bureau of NSW from 1927 until she was required to resign when she married in 1948. Lorna Hayter (nee Byrne) interviewed by Hazel de Berg, 13 Feb 1978, Oral History Collection, National Library of Australia (NLA), Canberra.

64 Leonore Layman, 'Mining', in *The Encyclopedia of Women & Leadership in Twentieth Century Australia*, http://www.womenaustralia.info/leaders/biogs/WLE0382b.htm.

65 'Women Analytical Chemists', *SMH*, 19 Apr 1916.

66 'Women of Tomorrow', *Herald*, 18 Apr 1916. In 1919 another article encouraged NSW women to take up this career. *Smith's Weekly*, 26 Apr 1919. For similar developments in Britain, see Sally Horrocks, 'A Promising Pioneer Profession? Women in Industrial Chemistry in Inter-War Britain', *British Journal for the History of Science* 33, no. 3 (2000): 351–67.

67 'Chemical Industries: Field for Women', *Weekly Times*, 8 Apr 1916.

68 Alison Mackinnon, *Love and Freedom: Professional Women and the Reshaping of Personal Life* (Cambridge: Cambridge UP, 1997). Being unmarried didn't necessarily mean that women were single of course.

69 Deacon, 'Employment of Women', 234. Many widows, working-class and Aboriginal mothers worked. Shurlee Swain, Patricia Grimshaw & Ellen Warne, 'Whiteness, Maternal Feminism and the Working Mother, 1900–1960', in *Creating White Australia*, ed. Jane Carey & Claire McLisky (Sydney: Sydney UP, 2009).

70 On unmarried women and critiques of marriage in Australia, see e.g. Catriona Elder, "'The Question of the Unmarried": Some Meanings of Being Single in Australia in the 1920s and 1930s', *Australian Feminist Studies* 8, no. 18 (1993): 151–73; Katie Holmes, "'Spinsters Indispensable": Feminists, Single Women and

Notes

the Critique of Marriage, 1890–1920', *Australian Historical Studies* 29, no. 110 (1998): 68–90.

71 Nearly half of Adelaide's women graduates up to 1921 remained unmarried, as did least 28 of the 62 women science graduates from the University of Melbourne up to 1920. Mackinnon, *Love and Freedom*, 92; Kelly, 'Learning and Teaching Science', 45. See also Hooper, 'Melbourne's First Female Students', 104–8. This was in line with trends in Britain, New Zealand and the United States. Nearly 20% of all Australian women who reached 'marriageable age' from the 1890s to the 1920s never married. Peter McDonald, *Marriage in Australia: Age at First Marriage and Proportions Marrying, 1860–1971* (Canberra: Australian National University, 1975), 133–36, 174, 179. On women graduates working prior to marriage see also Madge Dawson, *Graduate and Married: A Report on a Survey of 1070 Married Women Graduates of the University of Sydney* (Sydney: University of Sydney, 1965).

72 Alfred Deakin to Stella Deakin, 10 Feb 1903, MS 4913, box 3, folder 16, Catherine Deakin Papers, NLA (hereafter Catherine Deakin Correspondence). See also other correspondence in this file.

73 Stella Deakin to the Dean, Faculty of Science, 16 Feb 1911, UM312, 1911/40.

74 For the consternation Stella's early ambitions caused her family, see John Rickard, *A Family Romance: The Deakins at Home* (Melbourne: Melbourne UP, 1996), esp. 139–42, 156–57.

75 Alfred Deakin to Stella Deakin, 1 Feb 1909, Catherine Deakin Correspondence.

76 See Stella Deakin to Vera Deakin, 4 Mar and 17 Jun 1910, MS 9056, folder 2, Vera Deakin Papers, NLA.

77 Alfred Deakin to Stella Deakin, 28 Dec 1909, Catherine Deakin Correspondence.

78 Alfred Deakin to Stella Deakin, 4 Jan 1910, Catherine Deakin Correspondence.

79 *Weekly Times*, 8 Jul 1911.

80 For example, at the University of Melbourne Olive Rossiter (nee Davies) continued as a demonstrator for several years after she married, during WWI when the shortage of staff was acute. Jean White-Haney and Ada à Beckett (nee Lambert) also returned to the biology department at this time. Dr (Mrs) Hilda Rennie, demonstrated in bacteriology for many years in the 1910s–20s becoming acting head of the bacteriology school in 1927. UM312, 1927/75. It is likely she was a widow.

81 UM312, 1917/33; 1918/43; 1919/38; 1921/515.

82 'à Beckett, Ada Mary' in *The Encyclopedia of Women & Leadership in Twentieth Century Australia*, http://www.womenaustralia.info/leaders/biogs/WLE0168b.htm.

83 Spencer to the Registrar, 8 Apr 1907, UM312, 1907/51. The following year, Masson wrote of his disappointment 'that only five applications [had] been made' for the 6 positions as junior demonstrators in chemistry; 3 of these applicants were women: Masson to the Registrar, 16 Mar 1908, UM312, 1908/67.

84 J. Bull to the Chairman, Finance Committee, 26 Aug 1912, UM312, 1911/70.

85 Ewart to the Finance Committee, 18 Jun 1913, UM312, 1913/119; Ewart to the Registrar, 11 Mar 1914, UM312, 1914/36; Ewart to the Council, 24 Jun 1914, UM312, 1914/96.

86 Ewart to McLennan, 2 Jan 1915, UM312, 1915/169. On the lack of applicants for junior positions across the science faculty see also UM312, 1917/230; 1918/217; 1920/133; 1924/160; 1925/52; 1929/464.

Notes

87 Ewart to the Council, 21 Apr 1914, UM312, 1914/97.

88 UM312, 1920/472; 1922/398.

89 Agar to the Registrar, 20 Sep 1923, UM312, 1924/581. See also Osborne to the Registrar, 18 Jul 1921, UM312, 1921/376.

90 Agar to the Registrar, 20 May 1924, UM312, 1924/581.

91 Harrison to Johnston, 9 Nov 1924, and Nicholls to Johnston, n.d., cited in Grasset, 'Women Demonstrating Biology', 188.

92 Laby to the Registrar, 26 Feb 1924, UM312, 1924/383.

93 Laby to the Registrar, 3 May 1926, UM312, 1926/405.

94 UM312, 1927/513.

95 E. Mann, Advisory Council of Science and Industry, to the Registrar, 23 Aug 1916, UM312, 1916/4.

96 A. D. Rivett, CEO, CSIR, to the Registrar, 22 Feb 1927, UM312, 1927/184.

97 Registrar to Rivett, 4 Mar 1927, UM312, 1927/184.

98 Ewart to the Registrar, n.d., UM312, 1927/184.

99 McLennan to the Council, 3 Mar 1930, UM312, 1931/290.

100 Rivett to the Chancellor, 10 Oct 1928, UM312, 1930/172.

101 Registrar, University of Adelaide, to the Registrar, University of Melbourne, 26 Feb 1929, UM312, 1930/172.

102 Osborn to the Registrar, University of Sydney, 23 Dec 1929, G3/13, 1256, General Subjects Files, Registrar's Office Records, University of Sydney Archives, emphasis added.

103 UM312, 1899/18, 1904/440.

104 UM312, 1904/26. See also correspondence relating to the Chair of Physiology and Histology, UM312, 1904/44.

105 Selection Committee to the Chancellor, 24 Jan 1913, UM312, 1913/171.

106 UM312, 1928/62.

107 Laby to the Registrar, 24 Aug 1928, UM312, 1928/457. See also entries for Allen and Nelson in Home, *Physics in Australia to 1945*.

108 108 Osborne to the Registrar, 8 Nov 1920, UM312, 1920/133.

109 Ewart to the Registrar, 5 Nov 1920, UM312, 1920/133.

110 Memo from the Finance Committee, 20 Oct 1931, UM312, 1931/131. On the other hand, this rule could be invoked by professors when it suited them, e.g. Ewart to the Registrar, 6 Nov 1924, UM312, 1925/76. In 1937 Agar penned a report on the research needs of the zoology department. High on his list was the appointment of 'a woman' who could act as a research assistant, typist and librarian, who would not do her own research. Handwritten memo, 10 Feb 1937, UM312, 1938/152A.

111 Spencer to the Council, 15 Nov 1900, UM312, 1900/48.

112 UM312, 1887/60; 1888/45; 1921/38; 1921/415; 1921/442; 1922/398; 1923/244; 1923/485A; 1924/285; 1924/497; 1927/513. One exception appears to have the bacteriology department, where even women staff were difficult to attract and higher salaries were authorised. UM312, 1914/25; 1915/13; 1917/27; 1919/27. This was probably also because many of these women were medical graduates.

113 Registrar to Agar, 16 Mar 1921, UM312, 1921/515.

114 Spencer to the Finance Committee, 18 Mar 1907, UM312, 1907/51.

115 Ewart to the Council, 1 Aug 1908, UM312, 1908/10.

Notes

116 Ewart to the Chairman, Finance Committee, 18 Jun 1913, UM312, 1913/119, emphasis in original. As Ewart pointed out, although Rees did not hold a higher degree, this 'has not militated against the success of other prominent [male] members of staff'. He also stressed that Rees had 'done very high class work in research', had 2 papers in the leading journal *Annals of Botany*, and was 'well known' to 'botanists outside Melbourne'. A similar disparity was also apparent in Georgina Sweet's salary. UM312, 1916/31.

117 Ewart to the Chairman, Finance Committee, 9 Sep 1917, UM312, 1917/37.

118 Agar to the Registrar, 12 Mar 1921, UM312, 1921/515. In 1915 Professor Masson similarly argued for chemistry demonstrator Leila Green's salary to be raised 'to £200, which I understand is the amount paid to a woman demonstrator of junior standing in another Science school'. Masson to the Registrar, 25 Mar 1915, UM312, 1915/42.

119 McLennan to the Registrar, 4 Jan 1915 and Ewart to McLennan, 2 Jan 1915, UM312, 1915/169.

120 Ewart to the Chairman, Finance Committee, 12 Mar 1917, UM312, 1917/37.

121 McLennan to the Council, 21 Mar 1919, UM312, 1919/291.

122 Cookson, Raff and Green to the Council, 21 Mar 1919, UM312, 1919/291.

123 Sweet to the Registrar, 7 May 1930 and 9 May 1930, UM312, 1930/46.

124 See Chapter 5 for further discussion of Hill.

125 Cited in Grasset, 'Women Demonstrating Biology', 181.

126 N. Macdonald, acting Prof. of Veterinary Pathology, 8 Sep 1912; Dr W. P. Norris, 11 Sep 1912; and Richard Berry, n.d., box 2, Georgina Sweet Papers, University of Melbourne Archives.

127 Spencer, 26 Aug 1912, in ibid.

128 Spencer, 'Report on the Biology School', UM312, 1919/113.

129 Ewart to the Council, 16 Oct 1922, UM312, 1922/150; Ewart to the Council, 20 May 1924, UM312, 1923/302. The continuing acrimony between the two led to several university inquiries into the botany department, in which McLennan's position and status were strongly supported and affirmed. UM312, 1923/49, 1925/76; 1925/77.

130 Ewart to the Council, 2 Apr 1930, UM312, 1931/290.

131 Prof. Woodruff to the Vice-Chancellor, 14 Dec 1937, McLennan Papers.

132 Priestley to Brander, 23 Dec 1938, UM312, 1931/290.

133 'Report to the Council by the Committee of Selection for the Professorship of Botany', 17 Jan 1938, McLennan Papers. One point noted in Turner's favour was that he was unmarried. See also UM312, 1938/91.

134 Isobel Cookson, Eileen Fisher, Rose Mishin, Stella Fawcett & Margaret Blackwood, to the Vice-Chancellor, 8 Mar 1938, UM312, 1938/91.

135 Rivett to McLennan, 9 Mar 1938, McLennan Papers.

136 Agar to the Vice-Chancellor, 15 Jan 1938, McLennan Papers.

137 University of Melbourne Council Minutes, 17 Jan 1938 and 7 Mar 1938.

138 Frances Thorn & Doris McKellar, 'University Women', in *Centenary Gift Book*, ed. Frances Fraser & Nettie Palmer (Melbourne: Victorian Women's Centenary Council, 1934).

Notes

Chapter 4: Making a Better World?

1 Bella Guerin, 'Modern Woman', *Sydney Quarterly Magazine*, Dec 1887, 324–28.

2 *Melbourne University Review* 3, no. 1 (1887): 28–30.

3 Lawrence Goldman, *Science, Reform, and Politics in Victorian Britain: The Social Science Association, 1857–1886* (Cambridge: Cambridge UP, 2002); Helene Silverberg, ed., *Gender and American Social Science: The Formative Years* (Princeton: Princeton UP, 1998); Eileen Yeo, *Contest for Social Science: Relations and Representations of Gender and Class* (London: Rivers Oram Press, 1996). For Australia, see Jane Carey, 'A Transnational Project? Women and Gender in the Social Sciences in Australia, 1890–1945', *Women's History Review* 18, no. 1 (2009): 45–69 (sections of this chapter are drawn from this article); Anne O'Brien, *Philanthropy and Settler Colonialism* (London: Palgrave Macmillan, 2015), chap. 5; Alison Turtle, 'Education, Social Science and the "Common Weal"', in *The Commonwealth of Science: ANZAAS and the Scientific Enterprise in Australia 1888–1988*, ed. Roy Macleod (Melbourne: Oxford UP, 1988).

4 Penny Russell, *'A Wish of Distinction': Colonial Gentility and Femininity* (Melbourne: Melbourne UP, 1994); Shurlee Swain, 'Women and Philanthropy in Colonial and Post-Colonial Australia', in *Women, Philanthropy, and Civil Society*, ed. Kathleen McCarthy (Bloomington: Indiana UP, 2001).

5 Rima Apple, *Perfect Motherhood: Science and Childrearing in America* (New Brunswick: Rutgers UP, 2006); Kerreen Reiger, *The Disenchantment of the Home: Modernizing the Australian Family, 1880–1940* (Melbourne: Oxford UP, 1985).

6 Marilyn Lake argues the creation of a maternalist welfare state was the major achievement of Australian post-suffrage feminists. Marilyn Lake, *Getting Equal: The History of Australian Feminism* (Sydney: Allen & Unwin, 1999). See also James Keating, '"Woman as Wife, Mother, and Home-Maker": Equal Rights International and Australian Feminists' Interwar Advocacy for Mothers' Economic Rights', *Signs* 47, no. 4 (2022): 957–85; Seth Koven & Sonya Michel, eds, *Mothers of a New World: Maternalist Politics and the Origins of Welfare States* (New York: Routledge, 1993); Marian Quartly & Judith Smart, *Respectable Radicals: A History of the National Council of Women of Australia, 1896–2006* (Melbourne: Monash University Publishing, 2015); Ellen Warne, *Agitate, Educate, Organise, Legislate: Protestant Women's Social Action in Post-Suffrage Australia* (Melbourne: Melbourne UP, 2017).

7 On these fears and desires, which were not limited to Australia, see e.g. Warwick Anderson, *The Cultivation of Whiteness: Science, Health and Racial Destiny in Australia* (Melbourne: Melbourne UP, 2002); Alison Bashford, *Imperial Hygiene: A Critical History of Colonialism, Nationalism and Public Health* (Houndmills: Palgrave Macmillan, 2003); Marilyn Lake & Henry Reynolds, *Drawing the Global Colour Line: White Men's Countries and the Question of Racial Equality* (Melbourne: Melbourne UP, 2008); Ann Stoler, *Carnal Knowledge and Imperial Power* (Berkeley: University of California Press, 2002).

8 Cited in Alison Mackinnon, *The New Women: Adelaide's Early Women Graduates* (Adelaide: Wakefield Press, 1986), 77.

9 'Reformatories and Reform', *Argus*, 2 Aug 1899, emphasis added. Henry left Australia in 1905 to work with the Women's Trade Union League in the United

270

Notes

States. Diane Kirkby, *Alice Henry, the Power of Pen and Voice: The Life of an Australian-American Labor Reformer* (Cambridge: Cambridge UP, 1991). See also Shurlee Swain & Margot Hillel, *Child, Nation, Race and Empire: Child Rescue Discourse, England, Canada and Australia, 1850–1915* (Manchester: Manchester UP, 2010).

10 *Science of Man* 1, no. 1 (1898): 2; vol. 3, no. 1 (1900): 3.

11 *Science of Man* 1, no. 2 (1898): 30. See also *Science of Man* 1, no. 2 (1898): 30–1; vol. 3, no. 1 (1900): 2; vol. 5, no. 12 (1903): 196.

12 For an excellent discussion of anthropometry and its links to anthropology and eugenics see Efram Sera–Shriar, 'Anthropometric Portraiture and Victorian Anthropology: Situating Francis Galton's Photographic Work in the Late 1870s', *History of Science* 53, no. 2 (2015): 155–79.

13 This is reiterated throughout *Science of Man*. See also Alan Carroll, *Health and Longevity: The Theories of the Late Dr Alan Carroll*, published by Mrs D. Izett (Sydney: Worker Union Trade Print, 1927).

14 *Science of Man* 3, no. 3 (1900): 27; vol. 3, no. 5 (1900): 72.

15 *Science of Man* 3, no. 8 (1900): 141; vol. 3, no. 3 (1900): 27.

16 *Science of Man* 2, no. 6 (1899): 107. Again, this reflected the growing interest in child study across the West. Sally Shuttleworth, *The Mind of the Child: Child Development in Literature, Science, and Medicine 1840–1900* (Oxford: Oxford UP, 2010); Alice Smuts, *Science in the Service of Children, 1893–1935* (New Haven: Yale UP, 2006). See also Jan Kociumbas, *Australian Childhood: A History* (Sydney: Allen & Unwin, 1997).

17 Annette Maclellan, 'Child Study. A Word about Its Introduction into Australia', *Science of Man* 6, no. 5, (1903): 74 (reprinted from *Australian Star*, 25 Mar 1903). See also *Science of Man* 2, no. 6 (1899): 108.

18 *Daily Telegraph*, 20 Dec 1906. Around 1905 Carroll secured premises to 'measure and test' children, and by 1908 he was holding meetings for 'practical treatment … No suffering or defective child refused'. *Science of Man* 11, no. 9 (1908): 95.

19 *Daily Telegraph*, 20 Dec 1906. Around 1905 Carroll finally achieved his ambition of premises to 'measure and test' children, and by 1908 he was holding meetings for 'practical treatment … No suffering or defective child refused'. *Science of Man* 11, no. 9 (1908): 95.

20 Mrs D. [Sarah] Izett, 'Preface', in Carroll, *Health and Longevity; Science of Man* 11, no. 4 (1908): 6, 17; vol. 11, no. 9 (1908): 95; vol. 14, no. 4 (1911): 11–14, 27; vol. 14, no. 5 (1911): 45.

21 *Daily Telegraph*, 20 Dec 1906. Reprinted in *Science of Man* 11, no. 9 (1908): 95.

22 Roma Williams, *The Settlement: A History of the University of Sydney Settlement and the Settlement Neighbourhood Centre, 1891–1986* (Sydney: University of Sydney, 1988), 12–13. For the Alice Rawson School for Mothers, see Philippa Mein Smith, *Mothers and King Baby: Infant Survival and Welfare in an Imperial World: Australia 1880–1950* (Basingstoke: Macmillan, 1997).

23 Martin Bulmer, Kevin Bales & Kathryn Kish Sklar, eds, *The Social Survey in Historical Perspective, 1880–1940* (Cambridge: Cambridge UP, 1991), esp. Sklar's chapter 'Hull-House Maps and Papers: Social Science as Women's Work in the 1890s'; Mary Jo Deegan, *Jane Addams and the Men of the Chicago School, 1892–1918* (New York: Routledge, 2017 [1988]).

Notes

24 *Alma Mater* 5, no. 6 (1899): 56.

25 *Melbourne University Magazine* 2, no. 1 (1908): 29; vol. 6, no. 2 (1912): 74.

26 *Argus*, 21 Jan 1938.

27 Angela Woollacott, 'From Moral to Professional Authority: Secularism, Social Work, and Middle-Class Women's Self-Construction in World War I Britain', *Journal of Women's History* 10, no. 2 (1998): 85–111. For Australia, see Shurlee Swain, 'From Philanthropy to Social Entrepreneurship', in *Diversity in Leadership*, ed. Joy Damousi et al. (Canberra: ANU Press, 2014). For the later development of social work in Australia, see Carey, 'A Transnational Project'; Jane Miller & David Nichols, 'Establishing a Twentieth-Century Women's Profession in Australia', *Lilith*, no. 20 (2014): 21–33.

28 Frances Thorn, 'Presidential Address', *Occasional Paper* (AFUW), no. 1, 1924, 22.

29 Georgina Sweet, *The Responsibility of the Community Towards Sex Education* (Melbourne: Ford & Son, 1925), 13.

30 Free Kindergarten Union of Victoria (FKUV), *Fourth Annual Report, 1912–1913*, 7; *Argus*, 15 Aug 1936.

31 This was an international movement inspired by Friedrich Fröbel and later Maria Montessori, through her book *The Montessori Method: Scientific Pedagogy as Applied to Child Education*, trans. Anne George (New York: Frederick A. Stokes Company, 1912): Larry Prochner, *A History of Early Childhood Education in Canada, Australia, and New Zealand* (Vancouver: University of British Columbia Press, 2010); Roberta Wollons, ed., *Kindergartens and Cultures: The Global Diffusion of an Idea* (New Haven: Yale UP, 2000). For Australia, see also Ada à Beckett, *A Historical Sketch: The Growth and Development of the Free Kindergarten Movement in Victoria* (Melbourne: Free Kindergarten Union [1939?]).

32 FKUV, *Thirteenth Annual Report*, 1921–1922, 16–18.

33 FKUV, *Eighth Annual Report*, 1916–1917, 7; *Fourth Annual Report*, 1912–1913, 6; *Third Annual Report*, 1911–1912, 5, 8.

34 Joy Damousi, 'Female Factory Inspectors and Leadership in Early Twentieth-Century Australia', in *Diversity in Leadership*; Kay Whitehead, 'Post-suffrage Factory Inspectors in New South Wales', *Labour History*, no. 80 (2001): 157–72.

35 Dr Gertrude Halley, 'School Hygiene', *Woman*, 25 Jun 1908, 233.

36 'Halley, Ida Gertrude Margaret (1867–1939)', *ADB*.

37 David Kirk & Karen Twigg, 'Regulating Australian Bodies: Eugenics, Anthropometrics and School Medical Inspection in Victoria, 1900–1940', *History of Education Review* 23, no.1 (1994): 19–37.

38 'Bourne, Eleanor Elizabeth (1878–1957)', and 'Jull, Roberta Henrietta (1872–1961)', *ADB*.

39 Scantlebury is discussed extensively in Mein Smith, *Mothers and King Baby*. See also Elma Sandford Morgan, *A Short History of Medical Women in Australia* (Adelaide: AFUW, 1969?).

40 For examples from this vast literature, see note 6 above and e.g. Lucinda Aberdeen & Jennifer Jones, eds, *Black, White and Exempt: Aboriginal and Torres Strait Islander Lives under Exemption* (Canberra: Aboriginal Studies Press, 2021); Katherine Ellinghaus, 'Absorbing the "Aboriginal problem": Controlling Interracial Marriage in Australia in the late 19th and early 20th Centuries', *Aboriginal History* 27 (2003): 183–207; Anna Haebich, *Broken Circles* (Freemantle: Fremantle Press, 2000);

Notes

James Jupp, *From White Australia to Woomera: The Story of Australian Immigration* (Cambridge: Cambridge UP, 2002); Russell McGregor, "'Breed Out the Colour': Or the Importance of Being White', *Australian Historical Studies* 33, no. 120 (2002): 286–302; Patrick Wolfe, 'Settler Colonialism and the Elimination of the Native', *Journal of Genocide Research* 8, no. 4 (2006): 387–409.

41 On the (white) women's movement's (limited) activism on Aboriginal issues and conversely their role in supporting oppressive policies and practices, see Victoria Haskins, *My One Bright Spot* (Houndmills: Palgrave Macmillan, 2005); Alison Holland, *Just Relations: The Story of Mary Bennett's Crusade for Aboriginal Rights* (Perth: UWA Publishing, 2015); Alison Holland, 'Wives and Mothers Like Ourselves: Exploring White Women's Intervention in the Politics of Race, 1920s–1940s', *Australian Historical Studies* 32, no. 117 (2001): 292–310; Fiona Paisley, *Loving Protection? Australian Feminism and Aboriginal Women's Rights, 1919–1939* (Melbourne: Melbourne UP, 2000). On Aboriginal women's fraught relationship with white feminists, see Jackie Huggins, 'Black Women and Women's Liberation', *Hecate* 13, no. 1 (1987): 77–82, and *Sister Girl: Reflections on Tiddaism, Identity and Reconciliation* (Brisbane: University of Queensland Press, 2022); Aileen Moreton-Robinson, *Talkin' Up to the White Woman: Aboriginal Women and Feminism* (Brisbane: University of Queensland Press, 2000).

42 Mary Booth, 'School Anthropometrics', *Report of the Thirteenth Meeting* (AAAS, 1913), 689–90.

43 Francis Galton, 'Eugenics: Its Definition, Scope and Aims', *American Journal of Sociology* 10, no. 1 (1904): 1, emphasis added. See also Karl Pearson, *The Life, Letters and Labours of Francis Galton*, 3 vols. (Cambridge: Cambridge UP, 1914, 1924, 1930).

44 For some key works in the vast international literature on eugenics see Alison Bashford & Philippa Levine, eds, *The Oxford Handbook of the History of Eugenics* (New York: Oxford UP, 2010); Dan Stone, *Breeding Superman: Nietzsche, Race and Eugenics in Edwardian and Interwar Britain* (Liverpool: Liverpool UP, 2002); Wendy Kline, *Building a Better Race: Gender, Sexuality, and Eugenics from the Turn of the Century to the Baby Boom* (Berkeley: University of California Press, 2001); Nancy Stepan, *'The Hour of Eugenics': Race, Gender and Nation in Latin America* (Ithaca: Cornell UP, 1991); Mark Adams, ed., *The Wellborn Science: Eugenics in Germany, France, Brazil, and Russia* (New York: Oxford UP, 1990); Daniel Kevles, *In the Name of Eugenics: Genetics and the Uses of Human Heredity* (Cambridge: Harvard UP, 1985).

45 I have written extensively on Australian women and eugenics. Sections of this chapter are drawn from this work. Jane Carey, 'The Racial Imperatives of Sex: Birth Control and Eugenics in Britain, the United States and Australia in the Interwar Years', *Women's History Review* 21, no. 5 (2012): 733–52; Jane Carey, "'Wanted! A Real White Australia": The Women's Movement, Whiteness and the Settler Colonial Project, 1900–1940', in *Studies in Settler Colonialism*, ed. Fiona Bateman & Lionel Pilkington (London: Palgrave Macmillan, 2011); Jane Carey, 'White Anxieties and the Articulation of Race: The Women's Movement and the Making of White Australia, 1910s–1930s', in *Creating White Australia*, ed. Jane Carey & Claire McLisky (Sydney: Sydney UP, 2009); Jane Carey, "'Women's Objective – A Perfect Race": Whiteness, Eugenics, and the Articulation of Race', in *Re-Orienting Whiteness*, ed. Leigh Boucher, Jane Carey & Katherine Ellinghaus (New York: Palgrave Macmillan, 2009).

Notes

46 The only (somewhat eccentric) book-length history of Australian eugenics is Diana Wyndham, *Eugenics in Australia: Striving for National Fitness* (London, Galton Institute, 2003). For some other key works, see Mary Cawte, 'Craniometry and Eugenics in Australia: R. J. A. Berry and the Quest for Social Efficiency', *Historical Studies* 22, no. 86 (1986): 35–53; Ann Curthoys, 'Eugenics, Feminism and Birth Control: The Case of Marion Piddington', *Hecate* 15, no. 1 (1989): 73–89; Stephen Garton, 'Sound Minds and Healthy Bodies: Reconsidering Eugenics in Australia, 1914–1940', *Australian Historical Studies* 26, no. 103 (1994): 163–81; Rob Watts, 'Beyond Nature and Nurture: Eugenics in Twentieth Century Australian History', *Australian Journal of Politics and History* 40, no. 3 (1994): 318–34. See also relevant chapters in Bashford & Levine, *Oxford Handbook of the History of Eugenics*; Diane B. Paul, John Stenhouse & Hamish Spencer, eds, *Eugenics at the Edges of Empire: New Zealand, Australia, Canada and South Africa* (Cham: Palgrave Macmillan, 2018). On eugenics and infant health, see Mein Smith, *Mothers and King Baby*. For wider links to public health, see Bashford, *Imperial Hygiene*.

47 *Herself*, Jul 1930, emphasis in original. See also 'The Eugenics Number', *Herself*, Apr 1929.

48 Carroll, *Health and Longevity*, 12.

49 *Science of Man* 6, no. 1 (1903): 4–5.

50 On these differing views in Australia, including those of Carroll, see Carol Bacchi, 'The Nature-Nurture Debate in Australia, 1900–1914', *Historical Studies* 19, no. 75, (1980): 199–212.

51 Maclellan, 'Child Study', 74.

52 *Science of Man* 11, no. 9 (1908): 95.

53 *Science of Man* 5, no. 7 (1902): 69.

54 *Report of the Third Annual Meeting of the Brisbane Creche and Kindergarten Association*, 1910, reproduced in Kay Daniels & Mary Murnane, *Uphill all the Way: A Documentary History of Women in Australia* (Brisbane: University of Queensland Press, 1980): 126; Lyndsay Gardiner, *The Free Kindergarten Union of Victoria, 1908–1980* (Melbourne: ACER, 1982), 6.

55 FKUV, *Sixth Annual Report*, 1914–1915, 12. See also the 1913 & 1916 reports.

56 For Australia see note 45 above and Curthoys, 'Eugenics, Feminism and Birth Control'. For international scholarship, see relevant chapters in Bashford & Levine, *Oxford Handbook of the History of Eugenics*; Ann Allen, 'Feminism and Eugenics in Germany and Britain, 1900–1940: A Comparative Perspective', *German Studies Review* 23, no. 3 (2000): 477–505; Amy Bix, 'Experiences and Voices of Eugenics Field-Workers: "Women's Work" in Biology', *Social Studies of Science* 27, no. 4 (1997): 625–68; Lucy Bland, *Banishing the Beast: English Feminism and Sexual Morality, 1885–1914* (London: Penguin, 1993), esp. chap. 6; Angela Wanhalla, 'To "Better the Breed of Men": Women and Eugenics in New Zealand, 1900–1935', *Women's History Review* 16, no 2 (2007): 163–82; Mary Ziegler, 'Eugenic Feminism: Mental Hygiene, the Women's Movement, and the Campaign for Eugenic Legal Reform, 1900–1935', *Harvard Journal of Law & Gender* 31 (2008): 211–35.

57 South Australian Branch of the British Science Guild, *Race Building* (Adelaide: BSG, 1916).

58 *Eugenics Review* 6 (1914–15): 344, emphasis added.

Notes

59 *SMH*, 11 Mar 1914; Eldridge to the Joint Hon. Secretaries, Eugenics Education Society, 21 Nov 1921, SA/EUG/E.5, Eugenics Society Records, Wellcome Library, London (hereafter Eugenics Society Records). See also *Eugenics Review* 5 (1913–14): 189–90, 343–4; vol. 7 (1915–16): 161.

60 *Australian Highway* 3, no 12 (1922): 15–16. Ellice Hamilton, 'Heredity in Relation to Eugenics' *Australian Highway* 4, no. 10 (1922): 174–6; vol. 4, no. 11 (1923): 195–7; vol. 4, no. 12 (1923): 211–13.

61 *Australian Highway* 4, no. 12 (1923): 212–13.

62 *Australian Highway* 11, no. 6 (1929): 100. See also vol. 11, no. 3 (1928): 46.

63 My discussion here draws on Curthoys, 'Eugenics, Feminism and Birth Control'. Author Eleanor Dark was Piddington's niece and eugenics was central to her dystopian novel *Prelude to Christopher* (Sydney: P. R. Stephenson, 1934) – illustrating the wider cultural impact of eugenics in this period.

64 *Australian Highway* 3, no. 10 (1921): 11–12.

65 Marian Piddington, *Via Nuova or Science & Maternity* (Sydney: Dymock's Book Arcade, 1916), 4, 7, 23.

66 Piddington to Marie Stopes, 14 Sep 1937, add. 58572, series B.9, Stopes Papers, British Library, London.

67 Vida Goldstein, 'W. P. A. Conference: "Scientific Motherhood"', *Woman Voter*, 15 Aug 1918; Mary Fullerton, '"Scientific Motherhood": Reply to "Eugenist"', *Woman Voter*, 5 Dec 1918; Piddington (writing as 'Eugenist'), '"Scientific Motherhood"', *Woman Voter*, 7 Nov 1918, 30 Jan 1919, and 13 Feb 1919.

68 Contained in add. 58572, series B.9, Stopes Papers, British Library; and PP/MCS/A.307, Stopes Papers, Wellcome Library.

69 Cited in *The Mothers' Clinic for Birth Control* (London: The Clinic, 1921), 10–11, emphasis added. For Sanger's account of this period, and the letter, see *The Autobiography of Margaret Sanger* (New York: Courier Dover Publications, [1938] 2004).

70 1934 pamphlet for Institute of Family Relations reproduced in Daniels & Murnane, *Uphill all the Way*, 153–54.

71 'Made Sterile by Surgeon at His Own Wish', *Smith's Weekly*, 10 Oct 1931.

72 *Sunday Times*, 20 Jun 1926.

73 Racial Hygiene Association (RHA), Minutes, 11 Jul 1927, MLMSS 3838, Family Planning Association Records, Mitchell Library, Sydney (hereafter RHA Minutes).

74 *Age*, 14 Jul 1914; Carlotta Greenshields to the Secretary, Eugenics Education Society, 24 Apr 1914, Eugenics Society Records. Guerin also promoted eugenic ideas in numerous speeches while involved in left-wing politics. *Socialist*, 28 Nov 1913, 9 Jan 1914, and 13 Mar 1914.

75 Dorothea Cass, General Secretary, Women's Service Guilds of Western Australian, to the Secretary, Eugenics Education Society, 2 Nov 1933, Eugenics Society Records. Jull had been lecturing on this topic since at least 1899. Roberta Jull, *Heredity and Environment*, paper read at the Karrakatta Women's Club (Perth: Upham & Edwards, 1899). In 1933, a Eugenics Society was formed at the University of Western Australia, but it lasted less than 4 years. Muriel Marion to the Secretary, Eugenics Education Society, 12 Aug 1933, Eugenics Society Records.

76 Minutes of the Meeting of the Provisional Committee, 12 Oct 1936, box 1, Victor Wallace Papers, University of Melbourne Archives (hereafter Wallace Papers).

Notes

77 Agar to Wallace, 7 Mar, n.d., box 1, Wallace Papers; Minute Book of the Eugenics Society of Victoria, 13 Apr 1938, box 2, Wallace Papers.

78 Grant McBurnie, 'Constructing Sexuality in Victoria: Sex Reformers Associated with the Victorian Eugenics Society' (PhD thesis, Monash University, 1989), esp. 84, 287. Membership never exceeded 100. After WWII, its activities were mainly committee meetings and it finally disbanded in 1961.

79 May Moss to Wallace, 28 Jul 1937, box 1, Wallace Papers.

80 Angela Booth, *Voluntary Sterilization for Human Betterment* (Eugenics Society of Victoria, 1938), 5. The title was probably modelled on the major American book which advocated forced sterilisation for the 'mentally defective'. Ezra Seymour Gosney and Paul Popenoe, *Sterilization for Human Betterment. A Summary of Results of 6,000 Operations in California, 1909–1929* (New York: Macmillan Co., 1929).

81 Anna Davin, 'Imperialism and Motherhood', *History Workshop Journal* 5 (1978): 9–65.

82 Erika Dyck, *Facing Eugenics: Reproduction, Sterilization, and the Politics of Choice* (University of Toronto Press, 2013); Molly Ladd-Taylor, *Fixing the Poor: Eugenic Sterilization and Child Welfare in the Twentieth Century* (Baltimore: Johns Hopkins UP, 2017); Leonardo Pegoraro, 'Second-Rate Victims: The Forced Sterilization of Indigenous Peoples in the USA and Canada', *Settler Colonial Studies* 5, no. 2, (2015): 161–73; Dorothy Roberts, *Killing the Black Body: Race, Reproduction, and the Meaning of Liberty* (New York: Pantheon Books, 1997).

83 'Women and the Race Problem', *Argus*, 2 Aug 1912.

84 See the minutes of annual meetings, box 12, MS 7583, National Council of Women of Australia Records, National Library of Australia (NLA), Canberra.

85 Alice Henry, 'Industrial Farm Colonies for Epileptics', *Report of the Ninth Meeting* (AAAS, 1902), 807, 812.

86 'The National Council of Women of Victoria … First Congress, Melbourne 28th and 29th Oct, 1903'; *The National Council of Women of Victoria. Hon. Home Secretary's Annual Report for 1906–7*; Minutes, 18 Mar 1904, 24 Mar 1904, 28 Aug 1923, 22 Mar 1923: National Council of Women of Victoria Minutes, Microfilm G7541–7544, NLA. In Western Australia, Roberta Jull also took up this cause, lobbying the prime minister and working with local women's groups. 'Mental Deficiency', *Western Mail*, 10 May 1923; 'Mentally Defective Children', *West Australian*, 19 Jun 1925.

87 Ross Jones, 'The Master Potter and the Rejected Pots: Eugenic Legislation in Victoria, 1918–1939', *Australian Historical Studies* 30, no. 113 (1999): 326–7.

88 Minutes, 30 Nov 1899, MLMSS 3739, box MLK 3009, National Council of Women of NSW Records, Mitchell Library, Sydney (hereafter Minutes, NCWNSW). See also minutes, 25 May 1899 and 29 Mar 1900.

89 Minutes, NCWNSW, 28 Aug 1919; and 25 Sep 1919.

90 Hodgkinson to the Minister of Education, in 'Mental Defectives', Legislative Assembly, New South Wales, 23 Apr 1923, *Debates*, vol. 1, pp. 985–6.

91 Minutes, 10 Apr 1922, National Council of Women of Queensland Records, Fryer Library, University of Queensland (hereafter Minutes, NCWQ). See also 28 Feb 1921 and 11 Mar 1921.

92 Minutes, NCWQ, 9 Dec 1932; 8 May 1933; and 7 Aug 1933.

93 *Courier Mail*, 20 Mar 1934.

94 *AWW*, 10 Jun 1933.

Notes

95 *Argus*, 10 Sep 1935. The motion passed with 144 in support and 23 opposed.

96 Mrs H. B. Harris, 'Mothers and Daughters', *Australasian Young Women's Christian Association Quarterly*, Oct 1912, cited in Ellen Warne, 'Sex Education Debates and the Modest Mother in Australia, 1890s to the 1930s', *Women's History Review* 8, no. 2 (1999): 315.

97 Lisa Featherstone, 'Sex Educating the Modern Girl: The Formation of New Knowledge in Interwar Australia', *Journal of Australian Studies* 34, no. 4 (2010): 459–69; Shurlee Swain, Ellen Warne & Margot Hillel, 'Ignorance Is Not Innocence: Sex Education in Australia, 1890–1939', in *Sexual Pedagogies: Sex Education in Britain, Australia, and America, 1879–2000*, ed. Claudia Nelson & Michelle Martin (New York: Palgrave Macmillan, 2004).

98 Marion Piddington, *Tell Them! Or The Second Stage of Mothercraft* (Sydney: Moore's Book Shop, 1926), 168.

99 Society for Sex Education Lectures, 612.6SEX, Special Collections, Baillieu Library, University of Melbourne (hereafter Society for Sex Education Lectures).

100 Ibid.

101 Sweet, *Responsibility of the Community*, 9, 11.

102 Buchanan to the Registrar, 17 Sep 1925, UM312, 1925/451, Registrar's Office Correspondence, University of Melbourne Archives.

103 Sweet, *The Responsibility of the Community*, 11, emphasis in original.

104 Ada à Beckett, Final Lecture, Society for Sex Education Lectures.

105 Society for Sex Education Lectures.

106 Marion Piddington, *The Unmarried Mother and Her Child* (Sydney: Moore's Book Shop, 1923), 3–4, 8–9, 10–13.

107 Piddington, *Tell Them!*, 11, 164 (quote).

108 Ibid., 155–6, 182.

109 109 RHA Minutes, 16 Dec 1927; 7 Nov 1929; 18 Mar 1930; 1 Jun 1931; 7 Nov 1932; 9 Nov 1932; and 22 Jun 1933. There is little scholarship on the history of birth control in Australia, but see the popular work Stefania Siedlecky & Diana Wyndham, *Populate and Perish: Australian Women's Fight for Birth Control* (Sydney: Allen & Unwin, 1990).

110 *Sun*, 24 Jun 1926.

111 'Wanted! A Real White Australia', *Sunday Times*, 23 Jun 1927. See also *SMH*, 21 Feb 1927. One of the key men involved with the RHA was Harvey Sutton: Grant Rodwell, 'Professor Harvey Sutton: National Hygienist as Eugenicist and Educator', *Journal of the Royal Australian Historical Society* 84, no. 2 (1998): 164.

112 RHA, 'What Racial Hygiene Means!!', folder 423, Rich Papers, NLA (hereafter RHA Rich Papers).

113 RHA Minutes, 18 Mar 1930.

114 'Birth Control Clinic' pamphlet, RHA Rich Papers.

115 RHA, 'Annual Report, 1940–41', RHA Rich Papers.

116 Typescript signed 'M. A. Schalit, 1938', RHA Rich Papers. See also 'Marriage Advisory Centre' pamphlet, RHA Rich Papers.

117 *SMH*, 23 Jun 1927.

118 Angela Booth, address to the Congress and 'Medical Prophylaxis and Venereal Disease', in *Australian Racial Hygiene Congress, 1929: Report* (Sydney: RHA, 1929), 12, 25–7.

Notes

119 Lorna Hodgkinson, 'Mental Deficiency as a Problem of Racial Hygiene', in ibid., 35–6.

120 Ibid., 65, 67–8.

121 *Age*, 8 Jul 1911.

Chapter 5: Neither Rebels nor Radicals

1 Frances Thorn, 'Presidential Address', *Occasional Paper* (Australian Federation of University Women (AFUW)), no. 1, 1924, 7–8, 22.

2 I am not suggesting this emphasis is unwarranted, but rather that most studies focus more on explaining women's absence from science than on their presence.

3 Evelyn Fox Keller, *Reflections on Gender and Science* (New Haven: Yale UP, 1985), 173. See also Pamela Baker, Bonnie Shulman & Elizabeth H. Tobin, 'Difficult Crossings: Stories from Building Two-Way Streets', in *Feminist Science Studies: A New Generation*, ed. Maralee Mayberry et al. (New York: Routledge, 2001); Anne Fausto-Sterling, 'Building Two-Way Streets: The Case of Feminism and Science', *NWSA Journal* 4, no. 3 (1992): 336–49; Sandra Harding, *The Science Question in Feminism* (Ithaca: Cornell UP, 1986), 178; Ruth Hubbard, Sandra Harding, Nancy Tuana, Sue V. Rosser & Anne Fausto-Sterling, 'Comments on Anne Fausto-Sterling's "Building Two-Way Streets" [with Response]', *NWSA Journal* 5, no. 1 (1993): 45–81; Evelyn Fox Keller, *A Feeling for the Organism: The Life and Times of Barbara McClintock* (New York: W. H. Freeman Company, 1983), 114.

4 Such life stories are, of course, a product of the present and cannot be simply interpreted as providing direct access to the past. Joanna Bornat & Hanna Diamond, 'Women's History and Oral History: Developments and Debates', *Women's History Review* 16, no. 1 (2007): 19–39.

5 Full details of the survey questions are in Jane Carey, 'Departing from Their Sphere: Australian Women and Science, 1880–1960' (PhD thesis, University of Melbourne, 2003), Appendix 3. Tables and summaries of responses are in Appendix 4. See also 'Engendering Scientific Pursuits: Australian Women and Science, 1880–1960', *Limina: A Journal of Historical and Cultural Studies* 7 (2001): 10–25. Sections of this chapter are drawn from this article. The survey was facilitated by the alumni departments of the universities of Melbourne and Sydney and sent to nearly 830 graduates. From the University of Sydney, there were 206 responses out of 989 women who graduated in this period (21%). For Melbourne, of 629 women who graduated in this period, 116 responded to my survey and information on a further 11 from the 1930s was generously provided by Carolyn Rasmussen who conducted a similar survey – representing 127 women (20% of the total). Three graduates from the University of Adelaide and 2 from the University of Western Australia also responded.

6 Among Melbourne graduates, at least 37% of fathers and 13% of mothers attended university. For Sydney graduates, 34% of fathers and 10% of mothers attended university.

7 A. M. Badcock, 'The Secondary Division', in *Vision and Realisation: A Centenary History of State Education in Victoria*, vol. 1, ed. L. Blake (Melbourne: Education Dept of Victoria, 1973), 473–80; Pavla Miller, *Long Division: State Schooling in South Australian Society* (Adelaide: Wakefield Press, 1986); W. Neal, ed., *Education in Western Australia* (Perth: UWA Press, 1979); H. Watkin, 'The Reform of Secondary

278

Notes

Education in Queensland', *Australian Journal of Science* 6, no. 2 (1962): 180–85; H. Wyndham, *Report of the Committee Appointed to Survey Secondary Education in NSW* (Sydney: Government Printer, 1957).

8 In all, 84% of Melbourne graduates and 88% of Sydney graduates attended a single-sex school.

9 Barbara Falk, 'The Unpayable Debt', in *The Half-Open Door: Sixteen Modern Australian Women Look at Professional Life and Achievement*, ed. Patricia Grimshaw & Lynne Strahan (Sydney: Hale & Iremonger, 1982), 14. Falk was a senior education academic and a historian in her 'retirement'.

10 Prof. Mollie Holman, BSc 1952 (Melb.), DSc 1957 (Oxon.), interview by Ragbir Bhathal, 7 Jul 1997, Oral History Collection, National Library of Australia.

11 Annie Welbourne diary, cited in Alison Mackinnon, *The New Women: Adelaide's Early Women Graduates* (Adelaide: Wakefield Press, 1986), 106.

12 P. Hansen, *Report on Science Courses and Science Laboratories in Secondary Schools* (Melbourne: University of Melbourne, 1924), 11.

13 Lilith Norman, *The Brown and Yellow: Sydney Girls' High School, 1883–1983* (Melbourne: Oxford UP, 1983), 97.

14 John McFarlane, *The Golden Hope: Presbyterian Ladies College Sydney, 1888–1988* (Sydney: PLC College Council, 1988), 27, 99.

15 Barbara La Nauze (nee Cleland) and Joan Paton (nee Cleland), interview by Penelope Paton, 31 Mar 1993, OH, 202/2, Sommerville Oral History Collection, Mortlock Library, Adelaide; Janet Philips, *Not Saints, but Girls: The First Hundred Years of St Peter's Collegiate Girls' School* (Adelaide: SPCGS, 1994), 92–3.

16 UM312, 1921/244; 1921/45; 1923/246; 1923/248; 1931/95, Registrar's Office Correspondence, University of Melbourne Archives (hereafter UM312); Report of the Headmistress, 1930, cited in Ailsa Zainu'ddin, *They Dreamt of a School: A Centenary History of Methodist Ladies College Kew, 1882–1982* (Melbourne: Hyland House, 1982), 210–11.

17 Barbara Green, 'The Girls of Melbourne High School, 1912–1934' (Master's thesis, University of Melbourne, 1998).

18 In 1952 none of Sydney's state boys' high schools offered biology, and across the state only a tiny number of boys took biology in the final school year. E. Meyer, 'Biology in New South Wales Schools', *Forum of Education* 14, no. 2 (1955): 63.

19 Only 14% took physics or combined physics/chemistry, 57% took chemistry, 24% took biology, 16% botany and 6% zoology. 41% took neither physics nor chemistry.

20 Of the 85 students who went on to university, over 20% did science and nearly 15% did medicine. See list of graduates contained in MCEGGS, *History of the School 1893–1928* (Melbourne: Ramsay, 1929), 75–7.

21 Diana Dyason, 'Diana Dyason', in *Memories of Melbourne University*, ed. H. Dow (Melbourne: Hutchinson, 1983), 89–90. On another occasion, she contended, 'The school provided what was probably the best academic education available to any Australian girl.' Diana Dyason, 'Preludes', in Grimshaw & Strahan, *Half-Open Door*, 308. Of the 15 survey respondents who attended the school, 11 rated it very highly (2 did not answer this question).

22 Survey no. 109. Each survey response for Sydney and Melbourne graduates was assigned a unique number. Respondents' names are only used where written consent to do so was granted.

Notes

23 Surveys nos. 3 (quote), 50 & 82. Employment opportunities were also emphasised in survey nos. 62, 63, 99, 100, 130 & 143. Carolyn Rasmussen had similar findings: 'Science Was So Much More Exciting: Six Women in the Physical Sciences', in *On the Edge of Discovery: Australian Women in Science*, ed. Farley Kelly (Melbourne: Text, 1993), 105–31.

24 Survey no. 41, emphasis in original.

25 Correspondence from the department, 1942, cited in Carolyn Rasmussen, *Lauriston: 100 Years of Educating Girls, 1901–2000* (Sydney: Helicon Press, 1999), 140.

26 Survey no. 7. See Chapter 6 for further discussion.

27 Dyason, 'Diana Dyason', 100. On how scientists are 'pictured' or imagined as men see David Chambers, 'Stereotypic Images of the Scientist: The Draw-a-Scientist Test', *Science Education* 67, no. 2 (1983): 255–65. On how this image may have recently shifted, see Laura Scholes & Garth Stahl, '"I'm Good at Science but I Don't Want to Be a Scientist": Australian Primary School Student Stereotypes of Science and Scientists', *International Journal of Inclusive Education* 26, no. 9 (2022): 927–42.

28 *AWW*, 24 Jun 1933; see also Susan Sheridan et al., *Who Was That Woman? The Australian Women's Weekly in the Postwar Years* (Sydney: UNSW Press, 2002).

29 *News*, 9 Sep 1935.

30 *AWW*, 10 Jun 1933.

31 Ibid. See also G. R. Giles, *Careers for Boys and Girls* (Melbourne: Boys Employment Movement, 1936). Giles, a Vocational Guidance Officer with the Victorian Department of Education, included auctioneer, builder, engineer and motor mechanic in a long list of occupations Victorian women taken up, although the detailed entries emphasised differing prospects for men and women in almost all fields. For other studies of women's movement into new or 'non-traditional' professions, see e.g. works cited in Chapter 3, note 7, and Clare Wright, *Beyond the Ladies Lounge: Australia's Female Publicans* (Melbourne: Text, 2003).

32 *AWW*, 2 Sep 1933. See also issues for 1 Jul, 9 Sep and 23 Sep 1933.

33 *AWW*, 19 Aug 1933.

34 *AWW*, 17 Jun 1933.

35 *Sun*, 15 Nov 1936; *Advertiser*, 3 Nov 1931, 5 Sep 1933, 20 Sep 1938; *Herald*, 5 Jun 1939; *Argus*, 10 Jun 1939.

36 *Occasional Paper* (AFUW), no. 1, 1924, 28; no. 2, 1928, 29; Minutes, 10 Nov 1931, 11 Oct 1932, and 5 Dec 1939, S14, box 1, AFUW NSW Records, University of Sydney Archives.

37 Box labelled 'VWGA (McKellar), Correspondence etc. 1930s', Victorian Women Graduates Association Records, University of Melbourne Archives; Minutes, 4 Aug 1931, 9 Oct 1933, and Annual Report 1936, series 1, AFUW Records, Manuscripts Collection, Barr Smith Library, University of Adelaide. For Adelaide conferences, see also *Advertiser*, 15 Aug 1931, 9 Jan 1934, 4 Aug 1936, 17 Sep 1936, 16 Aug 1938, 30 Nov 1938 and 14 Dec 1938.

38 *Argus*, 29 Jan 1930. See also Kathleen Pitt (later Fitzpatrick), 'Why Can't Those Brilliant Girls Marry?', *AWW*, 24 Jun 1933, on the continuing lower marriage rates for university women.

39 *Bulletin* (AFUW), no. 6 (1938): 24–5.

40 *Age*, 3 Jun 1944.

Notes

41 *Age*, 25 Jan 1934; *Argus*, 6 Mar 1934.

42 *Advertiser*, 2 Aug 1939.

43 *Sun News-Pictorial*, 24 Jun 1939.

44 *News*, 28 Apr 1936. A similar article on women at the University of Adelaide featured Madeline Angel and Patricia Mawson, among others. *Advertiser*, 29 Nov 1938.

45 *Herald*, 20 Jul 1937.

46 *Argus*, 12 Jan 1935. Another article reported that 'Sea slugs and fossils, insects and anthropology – these are a few of the attractions for Australia's clever women who are in Melbourne to attend the Science Congress'. *News*, 16 Jan 1935.

47 *Mail*, 2 Feb 1935.

48 *Age*, 18 Jan 1938.

49 *Age*, 3 Sep 1935; *Argus*, 3 Sep 1935; *News*, 6 Sep 1935. For the full text of this address, see *Bulletin* (AFUW), no. 5 (1935): 6–23.

50 *Herald*, 4 Sep 1935.

51 *Herald*, 3 Sep 1935.

52 'Girl Scientists in Industry: Demands of Wartime Exceed Supply of Trained Students', *Daily Telegraph*, 3 Jul 1941. For other examples, see *News*, 13 Nov 1940; *Daily Telegraph*, 14 Jun 1940, 3 Jul 1941; *Herald*, 21 Jul 1941; *Advertiser*, 4 Oct 1943, 4 Jan 1944; *Argus*, 4 Feb 1944, 15 Apr 1944.

53 *Sun News-Pictorial*, 15 Aug 1944.

54 See Appendix 1.

55 Survey no. 93. Similar statements were made in surveys nos. 45, 56, 70, 93, 108, 126, 145, 182, 202; and in Gretna Weste (nee Parkin), BSc 1937, MSc, 1939, PhD 1968 (Melb.), interview by author, 1 Dec 1998, Melbourne; Valerie May, BSc 1936, MSc 1940 (Syd.), interview by author, 6 Jul 1998, Sydney.

56 Madeline Angel, BSc 1931, MSc 1938 (Adel.), interview by Jennifer Barker, 16 Nov 1984, AFUW SA, Oral History Project, series 33, AFUW Records, Manuscripts Collection, Barr Smith Library, University of Adelaide (hereafter AFUW SA, Oral History Project).

57 Anne Conochie (later Davis), BSc 1938 (WA), interview by Jennifer Barker, 8 Sep 1989, AFUW, SA, Oral History Project.

58 Angel, interview.

59 Dyason, 'Diana Dyason', 109.

60 For Melbourne graduates the most common first employment destinations were hospital work (23%), university work (20%) and teaching (17%). However, teaching was the most common job for women returning to the workforce – 27% moved into teaching for the first time after a break from work. Overall, 43% were teachers at some point, 28% worked in hospitals at some point and 35% worked in a university at some point. For the Sydney graduates, 27% worked as hospital scientists or dietitians initially, 25% went into teaching and 15% worked in a university. 40% were teachers at some point and 30% worked in a university at some point.

61 Of Melbourne graduates, 18% remained single and worked throughout their lives. Only 15% stopped worked permanently on marriage or after having children. For Sydney graduates, 11% stayed single and worked continuously, and only 12% stopped work permanently on marriage or after children. Of Melbourne graduates, 86% worked after marriage and 78% worked after having children. Of Sydney

Notes

graduates, 92% worked after marriage and 86% after having children. For similar findings on employment destinations and marriage rates of Sydney and Queensland women graduates see Madge Dawson, *Graduate and Married: A Report on a Survey of 1070 Married Women Graduates of the University of Sydney* (Sydney: University of Sydney, 1965); M. Rorke, *The Vocational Contributions of Women Graduates of the University of Queensland* (Brisbane: University of Queensland Press, 1959). See also Alison Mackinnon & Penny Gregory, "'A Study Corner in the Kitchen': Australian Graduate Women Negotiate Family, Nation and Work in the 1950s and early 1960s', *Australian Historical Studies* 37, no. 127 (2006): 63–80.

62 See Appendix 2.

63 This does not include Georgina Sweet, who was still listed as an honorary lecturer in zoology.

64 These included Dorothy Dixon, Gwendolyn Cheney, Jean Halsey, Shirley Hoette, Eileen Fisher, Ilma Balfe, Frances Halsey, Leila Cutting, Kathleen Crooks, Edith Shackell, Margot Cowan, Lyly Refshauge, Amy Crofts, Rose Mushin, Eileen Crooks, Joy Girdwood, Stella Fawcett, Margaret Blackwood, Gretna Parkin (later Weste), Yvonne Aitken, Essie Mollison, Gwen Stillman, Jean Mathieson, Beth Noye, Susan Duigan & Sophie Ducker. Compiled from relevant years of *The University of Melbourne Calendar* and the Turner Collection, particularly boxes 56–65, University of Melbourne Archives.

65 Margaret Blackwood Papers, University of Melbourne Archives; Jane Carey, *Women and Science at the University of Melbourne: Reflections on the Career of Dame Margaret Blackwood* (University of Melbourne, History of the University Project, 1996).

66 Sophie Ducker Papers, University of Melbourne Archives; Nessy Allen, 'Cross National Careers: The Interchange of Women Scientists to and from Australia', in *Australia in the World: Perceptions and Possibilities*, ed. Don Grant & Graham Seal (Perth: Black Swan Press, 1994).

67 See, e.g. *The Science Journal* (Sydney University Science Association) 11, no. 1 (1927): 7–8; vol. 11, no. 2 (1928): 60–1; vol. 13, no. 3 (1934): 29–30, 32–3; vol. 14, no. 2 (1935): 40–2; vol. 15, no. 2 (1936): 38–9; vol. 16, no. 2 (1937): 44–5; vol. 17, no. 1 (1938): 48–9.

68 For senior appointments see *Calendar of the University of Sydney*. Details of junior appointments are revealed only in general correspondence files, and even these records are patchy. For the botany and zoology departments see Records of the School of Biological Sciences, G50, (hereafter Sydney Biology Records); and General Subject Files, G3/13, 789 & 2768, Registrar's Office Records (hereafter Sydney Registrar's Files), both in University of Sydney Archives.

69 Hackney started as a demonstrator in 1938 but did not seek an academic position, preferring to work as a research scholar from 1939 to 1950 on a succession of fellowships (seconded to the CSIR 1943–1947), gaining a DSc in 1949. She returned to the botany school in 1964 after having 6 children, retiring in 1982. She did not, however, return to research. Frances Frolich (nee Hackney), BSc 1938, MSc 1940 (Syd.), survey no. 131, and interview by author, 7 Jul 1998, Sydney. Ilma Pidgeon followed a similar trajectory: a research fellow and assistant lecturer from 1937–1942, DSc 1943, she resigned to join her husband in the US, returning in 1957 as a part-time demonstrator, retiring in 1978 as a senior lecturer. Ilma Brewer (nee Pidgeon) Papers, P141, University of Sydney Archives.

282

Notes

70 Osborn went to great lengths to retain Carey's services despite the regulation that demonstrators should only be employed for 3 years. Osborn to the Vice-Chancellor, 23 Jul 1932; Osborn to the Vice-Chancellor, 30 Jul 1937, G3/13, 789, Sydney Registrar's Files.

71 Susan Turner, 'Invincible but Mostly Invisible: Australian Women's Contribution to Geology and Palaeontology', in *The Role of Women in the History of Geology*, ed. C. V. Burek and B. Higgs (London: Geological Society, 2007), 165–202.

72 Patricia Mawson (later Thomas), BSc 1936, MSc 1938 (Adel.), interview by Jennifer Barker, 2 Sep 1989, AFUW SA, Oral History Project.

73 Madeline Angel stated she did not feel up to lecturing. Angel, interview. Anne Beckwith, demonstrator in zoology from 1943–1948, also did some lecturing. In botany, after Beryl Barrien resigned to be married in 1945, Donella Cruickshank, who had been demonstrator and research assistant since 1941, served as lecturer until 1948. She then went to Cambridge for further study and Professor Wood was very disappointed when she decided not to return to the department. For appointments up to 1940, see Staff Cards, series 467, Registrar's Office Files, University of Adelaide Archives; and Administrative Records, series 200, 140/1931; 1/1932; 3/3/1932; 70/1933; 191/1934; 220/34; 254/1935; 239/1936; 227/1937; 45/1938; 162/1938; 255/1938; 212/1940; 38/1941; 201/1942; 7/1943; 7C/1943; 214/1945; 289/1945; 504/1946; 516/1946; 544/1946; 254/1947; 372/1947; 491/1947; 503/1947; 903A/1948; 889A/1948; 680/1949; 698A/1949; 698D/1949, Registrar's Office Files, University of Adelaide Archives (hereafter Adelaide Registrar's Files). See also Constance Margaret Eardley Papers, MSS 0021, Manuscripts Collection, Barr Smith Library, University of Adelaide; and Mawson, interview.

74 *Advertiser*, 24 Jun 1942.

75 This institution was established in 1938 as a residential college affiliated with the University of Sydney. Women employed in biology included Elizabeth Pope, Margaret Cumpston (lecturer, 1940–45); Nancy O'Grady, (assistant lecturer, 1942–45); Barbara Cran; Gretna Baddams; Mary Todd; Anne Stokes; Janet Harker. Gwenda Davis was largely responsible for creating the botany department. Women also featured prominently in the geology department, including Elizabeth Basnett, M. Colditz and J. S. Hokin. G50/8, 3082, Sydney Biology Records; University of New England Registry Files, A262, boxes 49 and 129, New England and Regional Archives, Armidale. See also the Margaret Spencer Papers, New England and Regional Archives. Spencer (nee Cumpston) later researched malaria with her husband for over twenty years. Margaret Spencer, *Malaria: The Australian Experience, 1843–1991* (Townsville: Australian College of Tropical Medicine, 1994).

76 Amy Crofts to the Registrar, 6 Mar 1945, G3/13, 3082, Sydney Registrar's Files; *Herald*, 3 May 1945; Argus, 7 Nov 1946.

77 Turner to Mr J. O'Carroll, Soil Conservation Board, 26 Jun 1941, box 60, John Stuart Turner Collection, University of Melbourne Archives.

78 Rennie had been in the department for over ten years and was previously acting director in 1920. Gunderson joined the department in 1924. UM312, 1917/27; 1921/50, 1924/57; 1927/75; 1928/62; 1929/37; 1929/62; 1931/50; and relevant issues of the *University of Melbourne Calendar*. By comparison, at the University of Sydney, although Ellen Hindmarsh was lecturer demonstrator in physiology from 1921 to 1937 very few other women were appointed in the biomedical sciences prior to the

Notes

1950s. In the United States, physiology featured prominently in women's colleges, providing employment opportunities and a women's subculture in this field. Toby Appel, 'Physiologists in American Women's Colleges: The Rise and Decline of a Female Subculture', *Isis* 85 (1994): 26–56.

79 Millis's initial degree was in agricultural science (Melb., 1945). She worked briefly in Papua New Guinea for the Commonwealth Dept of Agriculture and Fisheries before severe illness forced her to retire from fieldwork. She then gained a Boots Studentship for her PhD at Bristol. Nessy Allen, 'Test Tubes and White Jackets: The Careers of two Australian Women Scientists', *Journal of Australian Studies* 52 (1997): 126–37; Ragbir Bhathal, *Profiles: Australian Women Scientists* (Canberra: NLA, 1999), 51–9.

80 UM312, 1927/199; 1930/76; 1931/154A; 1938/152A; 1938/357; and *University of Melbourne Calendar*. Jean Millis left in 1950 for a position at the University of Malaya in Singapore where her research in nutrition flourished until her marriage in 1957. Juliet Flesh, *Transforming Biology: A History of the Department of Biochemistry and Molecular Biology at the University of Melbourne* (Melbourne: Melbourne UP, 2015).

81 *Advertiser*, 5 Dec 1945.

82 Nancy Atkinson Papers, MSS 65, Manuscripts Collection, Barr Smith Library, University of Adelaide; Sibely McLean Papers, in possession of her son Andrew May; 205/1938; 185/1938; 205/1938; 210/1942; 175/1943; 165/1944; 201/1945; 239/1945; 528/1946; 522A/1947; 891/1948; 777/1949; 739C/1949, Adelaide Registrar's Files. Emma McEwin, 'Nancy Atkinson, bacteriologist, winemaker and writer', *Australian Journal of Biography and History* 1 (2018): 59. Among other achievements, Atkinson produced the first Australian-made Bacillus Calmette-Guérin (BCG) vaccine for tuberculosis.

83 Rountree Papers, Mitchell Library, Sydney; *Herald*, 21 Jul 1941.

84 *Sun*, 21 May 1943; *Argus*, 21 May 1943. 'Lush, Dora Mary (1910–1943)', *ADB*; Frank Fenner, 'Frank Macfarlane Burnet 1899–1985', *Historical Records of Australian Science* 7, no.1 (1987): 39–77. Some women medical doctors also did significant research in the biomedical sciences. Haematologist Dr Lucy Bryce (who also had a BSc), for example, held research posts at the Walter and Eliza Hall Institute of Medical Research (1922–8, then part time in 1934–46) and Lister Institute (1925–6) and worked with both Macfarlane Burnett and Phyllis Rountree. She is most famous for setting up the Red Cross blood donation service. 'Bryce, Lucy Meredith (1897–1968)', *ADB*.

85 Joan Freeman, *A Passion for Physics* (Bristol: Adam Hilger, 1990); 'Ernest Rutherford Medal and Prize recipients', www.iop.org/about/awards/silver-subject-medals/ernest-rutherford-medal-and-prize-recipients.

86 Rupert Purchase and James Hanson, 'Sir John and Lady Cornforth: A Distinguished Chemical Partnership', *Science Progress* 98, no. 3 (2015): 212–18. In 2000, Margaret Sheil and Sue Berners-Price became Australia's first two women professors of chemistry.

87 Dorothy Hill, 'Women as Agents of Change', paper presented at QFUW seminar, Jun 1975, UQFL25, box 22a, 1/1, Dorothy Hill Collection, Fryer Library, University of Queensland; K. Campbell & J. S. Jell, 'Dorothy Hill 1907–1997', *Historical Records of Australian Science* 12, no. 2 (1998): 205–28; Turner, 'Invincible

Notes

but Mostly Invisible'. Hill was not the only woman of her generation to reach professor status. Following hot on her heels was Beryl Nashar (nee Scott, BSc, Sydney 1947), who became foundation professor of geology at Newcastle University College in 1965. Allen, 'Test Tubes and White Jackets'. At least two other women who graduated prior to 1955 became professors at Australian universities – Nancy Millis at Melbourne University in 1982 and Mollie Holman at Monash in 1970. At least two others went overseas. June Phillips, another Sydney geology graduate of the 1950s, completed her PhD and went to America becoming professor at the Western Washington University in 1970 (Turner, 'Invincible but mostly Invisible'). Biophysicist Heather Donald Mayor went from a physics MSc at the University of Melbourne in 1950 to a PhD from the University of London in 1954 to a postdoctoral fellowship at Harvard and was a professor at Baylor College of Medicine in Houston for 26 years.

88 The small number of published interviews, biographies and autobiographies of Australian women scientists also suggest that few felt any discrimination. Nessy Allen, 'Australian Women in Science: Two Unorthodox Careers', *Women's Studies International Forum* 15, nos. 5–6 (1992): 551–62; Allen, 'Test Tubes and White Jackets'; Bhathal, *Profiles*; Freeman, *Passion for Physics*, 177.

89 Patricia Grimshaw, 'Introduction: Professional Women in Twentieth Century Australia', in Grimshaw & Strahan, *Half-Open Door*, 8.

90 Kathleen Fitzpatrick, 'A Cloistered Life', in Grimshaw & Strahan, *Half-Open Door*, 122–24.

91 Dyason, 'Diana Dyason', 99.

92 May, interview. Of the 316 responses to this question 81% were an unqualified no and only 5% an unqualified yes.

93 Mawson, interview. Evelyn Claridge (BSc Hons 1935 Adel.) recalled, 'There really was very little discrimination … I honestly don't think that there was much discrimination between serious women students and men.': interview by Jennifer Barker, 1 Nov 1991, AFUW SA, Oral History Project. See also Angel, interview.

94 Survey no. 56.

95 Survey no. 274. Similar statements were made in survey nos. 18, 40, 43 and 48.

96 Alison Lipp, survey no. 19; Margaret Henderson, survey no. 38. Another wrote, 'I feel you are looking for a bias against women in University and the work place. I would like to stress that at no stage of my university studies or in my working career did I find any such bias'. Survey no. 22.

97 Mawson, interview. See also Angel, interview; Margaret Horan (nee Cleland) and Elizabeth Simpson (nee Cleland), interview by Penelope Paton, 31 Mar 1993, OH 202/1, Sommerville Oral History Collection, Mortlock Library, Adelaide.

98 Dyason, 'Preludes', 333. In another piece, she asserted, 'I am personally unaware of any discrimination against me personally': 'Diana Dyason', 100.

99 Survey no. 25. Laby qualified this by noting that few women aspired to become professors.

100 Differential pay rates for men and women was the main issue reported. AASW, Status of Women Employed in Science, unpublished report, Jul 1941, B551, 1944/88/9396, National Archives of Australia.

101 Box LS 1/7/10, Victorian Women Graduates Association Records, University of Melbourne Archives; *Bulletin* (AFUW), no. 4 (1934): 17–24; no. 5, 1935, 41–3;

Notes

no. 6, 1938, 65–79. For the wider women's movement of this period, see e.g. Gisela Kaplan, *The Meagre Harvest: The Australian Women's Movement 1950s–1990s* (Sydney: Allen & Unwin, 1996); Zora Simic, 'A New Age?: Australian Feminism and the 1940s', *Hecate* 32, no. 1 (2006): 152–72; Zora Simic '"Mrs Street – Now There's a Subject!": Historicising Jessie Street', *Australian Feminist Studies* 20, no. 48 (2005): 291–303.

102 *Occasional Paper* (AFUW), no. 2, 1928, 9.

103 *Argus*, 31 Aug 1938.

104 *Argus*, 21 Jan 1930.

105 Margaret Blackwood, interview by Adrienne Bath, 9 Aug 1979, box labelled 'Correspondence/Invitations '70–86', Blackwood Papers.

106 Lesley Nelson (nee Chalmers), survey no. 97. As another 1940s graduate put it, 'I believe I have been very fortunate in my life. I have had opportunities to do and achieve whatever I wished.' Survey no. 155.

107 Barbara Graham, BSc 1954 (Syd.), interview by author, 11 Jul 1998, Canberra.

108 C. Sanders, *Student Selection and Academic Success in Australian Universities* (Sydney: Government Printer, 1948), 135.

109 Mawson, interview. Few of the women interviewed by Nessy Allen identified as feminist. See works cited in note 88 above.

110 Cited in Heather Nash, *By Degrees: History of the AFUW, 1920–1985* (AFUW, 1985), 71. For some even more extreme reactions against the women's liberation movement, see Michelle Arrow, '"How Much Longer Will We Allow This Country's Affairs to be Run by Radical Feminists?" Anti-Feminist Activism in Late 1970s Australia', *Australian Historical Studies* 52, no. 3 (2021): 331–47.

111 *Age*, 9 Apr 1980.

112 Weste, interview.

113 Adele Millerd, BSc 1942, PhD 1953 (Syd.), survey no. 122. Millerd worked in the CSIRO Division of Plant Industry for over twenty years, where there was a marriage bar and women were paid less than men.

114 Weste, interview. The major exception was the University of Western Australia, which did have a marriage bar. See Chapter 6 for more detailed discussion.

115 Survey no. 3. Another put it even more strongly, 'As far as I was concerned, in schools no one had any antipathy to women whether married or unmarried, mothers or not mothers. When I first began teaching, married women on the staff were the exception and by the time I finished, unmarried women were the exception'. Survey no. 38. Yet another stressed that 'women have always been strong influences in science education'. Survey no. 121.

116 Surveys nos. 20 and 28.

117 Audrey Cahn, *University Children* (Melbourne: Privately printed, 1987), esp. 2, 43.

118 Sugden was promoted to a lectureship shortly before her retirement in 1952. *University of Melbourne Calendar*, 1949 and 1953.

119 Audrey Cahn, BagSc 1929, Dip. Diet. (Melb.), interview by author, 17 Jun 1998, Melbourne. Gretna Weste similarly followed her parents into science. Her father had an MSc and worked in the customs laboratory. Her mother was a nurse. Weste, interview.

120 Effie Best (junior) taught briefly at the university before moving into teaching. She then rose through the ranks at Adelaide's Teacher's College and coedited Australia's

Notes

foremost school biology textbook, *Biological Science: The Web of Life* (Canberra: Australian Academy of Science, 1967). Effie Best survey. The Clelands' mother, Dora Paton, had been one of Adelaide's early women science graduates. Constance Eardley's father was the university registrar.

121 Dyason, 'Preludes', 322.

122 Angel, interview.

Chapter 6: A Profession for Men

1 Kathleen Fitzpatrick, 'A Cloistered Life', in *The Half-Open Door: Sixteen Modern Australian Women Look at Life and Achievement*, ed. Patricia Grimshaw & Lynne Strahan (Melbourne: Hale & Iremonger, 1982), 123–4.

2 For the impact of the war and postwar reconstruction on Australian science, see J. Gani, *The Condition of Science in Australian Universities* (Oxford: Pergamon, 1963), esp. 14–18; Rod Home, 'Introduction' and 'Science on Service, 1939–45', in *Australian Science in the Making*, ed. Rod Home (Cambridge: Cambridge UP, 1988); Roy MacLeod, ed., *Science and the Pacific War: Science and Survival in the Pacific, 1939–1945* (Dordrecht: Kluwer Academic Publishers, 2000); D. P. Mellor, *The Role of Science and Industry, Australia in the War of 1939–1945*, ser. 4, vol. 5 (Canberra: Australian War Memorial, 1958), esp. chaps 3 and 9; C. B. Schedvin, *Shaping Science and Industry: A History of Australia's Council for Scientific and Industrial Research, 1926–1949* (Sydney: Allen & Unwin, 1987).

3 See also Appendix 1 and Appendix 2. Later years are discussed further below, and in the Conclusion.

4 See e.g. Margaret Rossiter, *Women Scientists in America: Before Affirmative Action, 1940–1970* (Baltimore: Johns Hopkins UP, 1995).

5 *SMH*, 23 Mar 1967.

6 These requests came from different sources. The 'Careers for Women' pamphlet was requested by the NSW Public Service Board. Assistance with a general vocational guidance pamphlet was requested by the NSW Employment Council (although a representative of the NSW Public Service Board was chair of this committee). *Bulletin* (AASW), no. 6 (1940), & no. 7 (1940). It's unclear why a specific pamphlet for girls was requested first. This may have been due to wartime demands. Extensive correspondence and drafts for the 'Science Careers for Women' pamphlet are in the Kathleen Sherrard Papers, box K48979, ML MSS 2950, Mitchell Library, Sydney (hereafter Sherrard Papers). Unless otherwise stated, all quotes are from this source. Some further correspondence is in Scientific Careers for Women sub-committee, E101A, items 8–17, AASW NSW Division records (hereafter AASW Papers); N276, items 1–8, Rachel Makinson Papers, (hereafter Makinson Papers), both in Noel Butlin Archives, Canberra.

7 Margaret Cumpston to Sherrard, 3 Oct 1941; Sherrard to Cumpston, 21 Oct 1941, 8/17, AASW Papers. The marriage bar in the commonwealth public service (introduced in 1902) was removed in 1966. Marriage bars were not universally imposed at the state level and were removed earlier in some states for some areas (such as teaching).

8 See Sherrard's numerous unsuccessful job applications: box K48977, Sherrard Papers.

9 See Chapter 3.

287

Notes

10 Sherrard also mentioned this barrier in the introductory section and an article 'Are You Planning a Science Career?', *Australian Women's Digest* 1, no. 4 (1944). Restrictions on women working underground weren't lifted in NSW until 1989.

11 University of Sydney Appointments Board, *Report 1922–4*, 1924.

12 University of Melbourne Appointments Board, *Annual Report*, 1937, 1; Jean Halsey to the Secretary, CSIR, 2 Sep 1935, box 65, John Stuart Turner Collection, University of Melbourne Archives (hereafter Turner Collection). See also Halsey to the Director, Dept of Agriculture, Victoria, 4 Mar 1935 in the same box. Halsey had undertaken this training under the direct advice of the Secretary of the University of Melbourne Appointments Board. See also various media reports on career prospects for women graduates. *News*, 1 Jul 1938; *Herald*, 4 Dec 1947; *Argus*, 9 Nov 1948; *Age*, 9 Nov 1948.

13 *Advertiser*, 17 Feb 1937.

14 Survey no. 64. Similar sentiments were expressed in surveys nos. 90 and 122.

15 Barbara Graham, BSc 1954 (Syd.), interview by author, 11 Jul 1998, Canberra. Graham was the first woman sent out on field work by the Bureau of Mineral Resources when she worked there from 1962–70. For some of the few other women scientists in industry, see Nessy Allen, 'A Microbiologist in Industry', *Prometheus* 14, no. 2 (1996): 233–47 (on Margaret Dick who started at Kraft in 1942 and became their chief microbiologist in the 1970s); and Carolyn Rasmussen, 'Science Was So Much More Exciting: Six Women in the Physical Sciences', in *On the Edge of Discovery: Australian Women in Science*, ed. Farley Kelly (Melbourne: Text, 1993), 105–31 (which discusses chemist Eva Nelson [nee Klein] at Hortico and Kodak).

16 University of Melbourne Appointments Board, *Annual Report*, 1937, 3.

17 University of Sydney Appointments Board, *Annual Report*, 1938. That year the board received 59 requests for male chemists and only 2 for women. Overall, the board received 478 requests for men and only 111 for women.

18 Secretary, University of Sydney Appointments Board to Makinson, 25 Jul 1940, Makinson Papers. An attached list showed only 13 women had been found employment in industry over the previous 4 years.

19 'Girl Scientists in Industry: Demands of Wartime Exceed Supply of Trained Students', *Daily Telegraph*, 3 Jul 1941. As Melanie Oppenheimer has noted, Australian women were not recruited into the workforce to the levels commonly assumed during WWII. At the peak in 1943, only 32% of women over 14 were in paid employment: *Australian Women and War* (Canberra: Dept of Veterans' Affairs, 2008), 1. Women science graduates, and others with special skills and qualifications, were, however, a distinct cohort. See also Kate Darian-Smith, *On the Home Front: Melbourne in Wartime: 1939–1945*, 2nd ed. (Melbourne: Melbourne UP, 2009); Stuart Macintyre, *Australia's Boldest Experiment: War and Reconstruction in the 1940s* (Sydney: NewSouth Publishing, 2015).

20 University of Sydney Appointments Board, *Annual Report*, 1946–50; University of Melbourne Appointments Board, Annual Reports, 1946–56. The figures published by both boards now included a small category (usually less than 10%) of jobs that were open to either sex.

21 University of Sydney Appointments Board, *Annual Report*, 1946 and 1947.

22 *Argus*, 9 Jan 1947.

Notes

23 University of Sydney Appointments Board, *Annual Report*, 1947, 1951; University of Melbourne Appointments Board, *Annual Report*, 1946, 1953, 1954, 1956, 1958. These and other reports show employment prospects for women arts graduates was certainly worse than those in science. The strong demand for male science graduates is also clearly documented.

24 University of Melbourne Appointments Board, *A Survey of Conditions within the Professions of Bacteriology and Biochemistry in Victoria* (Melbourne: Melbourne UP, 1954?), 26, 24, 27. Copy contained in box 37, file 297, Turner Collection. The survey was sent to 468 graduates, including 311 women, representing almost all bacteriology (later called microbiology) and/or biochemistry graduates. 134 women and 82 men responded. 39% of women, but only 4% of men were employed in hospitals. On the other hand, 17% of men but only 1% of women were employed in research institutes outside the universities. 45% of the men but only 27% of women graduates were engaged in full-time research (10–11).

25 Survey no. 20. Similar comments were made in survey no. 28.

26 Constance Wilson (nee Jacobson), BSc 1952, PhD 1964 (Syd.), interview by author, 8 Jul 1998, Sydney. Wilson received a scholarship that required her to complete dietetics training and was then bonded to work for the health department for 3 years. She noted 'I never really liked being a dietitian … But the scholarship was extremely useful financially'. She left dietetics after a few years and completed a PhD in zoology.

27 Jane Carey, 'Recreating British Womanhood: Ethel Osborne and the Construction of White Middle-class Femininity in Early Twentieth-Century Melbourne', in *Exploring the British World*, ed. Kate Darian-Smith et al. (Melbourne: RMIT Publishing, 2004).

28 Heather Nash, *The History of Dietetics in Australia* (Canberra: Dietitians Association of Australia, 1989); Ministry of Post-War Reconstruction/Dept of Labour and National Service, *Dietetics and Nutritional Science*, Occupational Pamphlet no. 34 (June 1947); UM312, 1938/174 & 1938/192, Registrar's Office Correspondence, University of Melbourne Archives (hereafter UM312). The University of Melbourne diploma essentially entailed supervised hospital placements in students' fourth year.

29 Audrey Cahn, interview by author, 17 Jun 1998, Melbourne; Nash, *History of Dietetics*, 8, 16–17; boxes 2/1 & 2/3, William Osborne Papers, University of Melbourne Archives; UM312, 1929/480, 1931/141, 1938/103, 1938/174, 1938/192. In 1928–9 Ethel Osborne was commissioned by Melbourne's St Vincent's hospital to investigate hospital dietetic departments in the United States and report on the requirements for establishing a training school/department.

30 University of Sydney Appointments Board, *Annual Report*, 1944.

31 Ibid., 1945, 1947 and 1951; University of Melbourne Appointments Board, *Annual Report*, 1946 and 1947.

32 *Herald*, 4 Dec 1947.

33 Scobie to Miss Bagnall, Adviser to Women Students, New England University College, 15 Feb 1952, G3/13, 1212, General Subject Files, Registrar's Office Records, University of Sydney Archives (hereafter Sydney Registrar's Files).

34 Wilson, interview.

35 Survey no. 173.

Notes

36 For the number of academic vacancies in science from 1939–60, see Gani, *Condition of Science*, 94–5. See also B. Chiswell, *A Diamond Period: A Brief History of the Chemistry Department of the University of Queensland from 1910–1985* (Brisbane: University of Queensland, 1988); V. Edgeloe, *Chemistry in the University of Adelaide, 1876–1980* (University of Adelaide Foundation, 1987), 44–57; E. Medlin, *Some Reflections on Physics at the University of Adelaide* (University of Adelaide, 1986), 59–68; P. Murray, 'The Position of Biological Science in School and University', *Forum of Education* 12, no. 3 (1954), 121; University of Melbourne Appointments Board, *Annual Report*, 1956, 40–9.

37 J. Keeves and A. Read, 'Sex Differences in Preparing for Scientific Occupations', in *Sociology of Education: A Source Book for Australian Studies*, ed. R. Browne and D. Magin (Melbourne: Macmillan, 1976).

38 D. Millar, ed., *The Messel Era: The Story of the School of Physics and Its Science Foundation within the University of Sydney, 1952–1987* (Sydney: Pergamon Press, 1987), 51.

39 Survey no. 301.

40 See Jane Carey, 'Departing from Their Sphere: Australian Women and Science, 1880–1960' (PhD thesis, University of Melbourne, 2003), Appendix 5.

41 *Argus*, 4 Feb 1944.

42 Peter McDonald, *Marriage in Australia: Age at First Marriage and Proportions Marrying, 1960–1971* (Canberra: ANU, 1975), 209, 214. This was borne out in my own survey as discussed in Chapter 5.

43 In my survey, of the 272 women who became mothers, only 9 maintained a continuous career and only another 28 took fewer than 5 years out of paid employment.

44 Amaya Alvarez, 'Invisible Workers and Invisible Barriers: Women at the CSIR in the 1930s and 1940s', in Kelly, *On the Edge of Discovery*.

45 Nessy Allen, 'The Contribution of Two Australian Women Scientists to its Wool Industry', *Prometheus* 9, no. 1 (1991): 81–92; 'Archer, Mary Ellinor Lucy (1893–1979)', *ADB*.

46 Alvarez, 'Invisible Workers'; 'Mackerras, Mabel Josephine (Jo) (1896–1971)' and 'Mackerras, Ian Murray (1898–1980)', *ADB*.

47 Payne-Scott was employed at CSIR from 1941. W. M. Goss & Richard X. McGee, *Under the Radar: The First Woman in Radio Astronomy: Ruby Payne-Scott* (Heidelberg: Springer, 2010).

48 'Fears for Baby Led to Suicide', *Daily Telegraph*, 3 Nov 1938; 'Worried Woman Commits Suicide: Feared Loss of Position', *Dubbo Liberal and Macquarie Advocate*, 3 Nov 1938. The coroner incorrectly stated that Fuller (then Mrs Kipps) had no reason to fear for her job. Her key paper was 'The Insect Inhabitants of Carrion: A Study in Animal Ecology', *Bulletin of the Council for Scientific and Industrial Research*, no. 82 (1934).

49 Rachel Makinson, interview by Ragbir Bhathal, 1 Mar 1997, Oral History Collection, National Library of Australia. See also Allen, 'Two Australian Women Scientists'.

50 Ashby to Clunies Ross, 19 Oct 1943, G50/10, School of Biological Sciences Records, University of Sydney Archives (hereafter Sydney Biology Records).

51 Ashby to the Secretary, CSIR, 1 Nov 1943, G50/10; Ashby to Dickson, Division of Plant Industry, CSIR, 29 Oct 1943; Ashby to Angell, Forest Products Division, CSIR, 1 Nov 1943, G50/2, Sydney Biology Records.

Notes

52 Johnston to Ashby, 10 Aug 1938, G50/14, Sydney Biology Records.

53 Dickson to Turner, 25 Jun 1945, box 62, Turner Collection.

54 Turner to E. J. Ferguson Wood, Division of Fisheries, CSIR, 19 Feb 1943, box 61, Turner Collection.

55 Turner to Frankel, Division of Plant Industry, CSIRO, 22 Jun 1956, box 42, file 371, Turner Collection. See also other correspondence in this file and file 370.

56 Alma Melvaine to Ashby, 5 Apr 1940, and Ashby to Melvaine, 8 Apr 1940, G50/2, Sydney Biology Records.

57 Nancye Perry, (nee Kent) BSc Syd 1944. Only a very few women scientists had long-term careers in government departments in the immediate postwar period. Olga Goss, who worked in the Western Australian Department of Agriculture for thirty-five years, was one exception: Nessy Allen, 'Plant Pathology in Western Australia: The Contributions of an Australian Woman Scientist', *Prometheus* 15, no. 3 (1997): 387–98. Hope Black (nee Macpherson), Curator of Molluscs at the Musuem of Victoria from 1947–1965, was forced to resign when she married in 1965 – even though the marriage bar was just about to be lifted: Jane Carey, '"A Most Remarkable Job for a Woman": Women and the Museums of Victoria', in Carolyn Rasmussen, *A Museum for the People* (Melbourne: Scribe, 2001).

58 Australian Academy of Science, *Scientific and Technical Manpower: Supply and Demand in Australia* (Canberra: 1957); Australian National University, *Science in Australia* (Melbourne: F. W. Cheshire, 1952); K. Murray et al., eds, *Report of the Committee on Australian Universities* (Canberra: Government Printer, 1957), esp. 16–19, 26–7; University of Melbourne Appointments Board, 'The Shortage of Scientists', *Annual Report*, 1954, 39–41; University of Melbourne Appointments Board, *A Survey of Conditions*; Science and Technology Careers Bureau, *First Annual Report*, 1958, Science and Technology Careers Bureau Records, University of Melbourne Archives.

59 David Derham, 'The New Professor', letter to the *Age*, 8 Nov 1975.

60 University Assembly, University of Melbourne, *Women's Working Group Report, July 1975*, 1975.

61 Both Rachel Makinson and Catherine Le Fevre were barred from employment at the University of Sydney under this regulation: Makinson, interview; Le Fevre, C.G. Mrs, 17668, Sydney Registrar's Files. Similarly, the request from Consett Davis at New England University College that his wife Gwenda be appointed as a demonstrator in his department in 1939 was refused. Edgar Booth, Warden, NEUC, to the Registrar, University of Sydney, 6 Mar 1940, and 16 Mar 1940, and Registrar to Booth, 11 Mar 1940, 3082, Sydney Registrar's Files.

62 Richard Davis, *Open to Talent: The Centenary History of the University of Tasmania, 1890–1990* (Hobart: University of Tasmania, 1990), 122.

63 *The University of Adelaide, Monthly Bulletin*, no. 10 (1963).

64 Nancy Atkinson to the Registrar, 19 Jun 1956, and Memorandum from the University of Adelaide Council, 29 Jun 1956, series 200, 653/1949, Registrar's Office, Administrative Records, University of Adelaide Archives (hereafter Adelaide Registrar's Files); Registrar to Sibely McLean, 18 Jul 1956, Sibely McLean Papers, in possession of her son Andrew May (hereafter McLean Papers).

65 Patricia Crawford & Myrna Tonkinson, *The Missing Chapters: Women Staff at the University of Western Australia, 1963–87* (Perth: UWA, 1988), 16, 21. The only

Notes

married women on the staff were those who had first been appointed when they were single, and who had been permitted to retain tenure after their marriage.

66 Sibely McLean, CV, McLean Papers.

67 Crawford & Tonkinson, *Missing Chapters*, 11.

68 See Appendix 2.

69 Joan Radford, *The Chemistry Department of the University of Melbourne: Its Contribution to Australian Science 1854–1959* (Melbourne: Hawthorn Press, 1978); 'Trailblazing for Women in Science', *Pursuit*, University of Melbourne, 2018, https://pursuit.unimelb.edu.au/articles/trailblazing-for-women-in-science. In 2012 Separovic became the first woman chemist elected to the Australian Academy of Science.

70 Women represented only 4.1% of staff above the level of senior lecturer. Women in Science, Engineering and Technology Advisory Group, *Women in Science, Engineering and Technology* (Canberra: Australian Government Publishing Service, 1995), 63. At the University of Melbourne, by 2001 women were 25% of academic staff in the science faculty, but only 13% at senior lecturer and above. By comparison, in the arts faculty, women made up 44% of all staff and 34% at senior lecturer and above. Equal Opportunity Unit, University of Melbourne, *The University of Melbourne Faculty Employment by Gender 2001* (Melbourne: University of Melbourne, 2001), 31, 145.

71 Mary Garson Fraci, '"Cosi Fan Tutte" ... Women in Chemistry?', *Chemistry in Australia* 63, no. 5 (1996): 237.

72 Doreen McCarthy, BA 1931, BSc Hons 1940 (Adel.), interview by author, 6 Dec 1997, Adelaide. See also file 201/1942, Adelaide Registrar's Files.

73 Gwen Woodroofe to the Acting Registrar, 30 Nov 1949, 777/1949, Adelaide Registrar's Files.

74 Atkinson to the Registrar, 10 Dec 1948, 891/1948, and Acting Registrar to Atkinson, 20 Oct 1949, 653/1949; Adelaide Registrar's Files; Atkinson, application for the Chair of Microbiology, 20 Dec 1958, series 4, MSS 65, Nancy Atkinson Papers, Manuscripts Collection, Barr Smith Library, University of Adelaide. In 1968 Atkinson transferred into the Dental School.

75 Deputy Warden, to the Registrar, 14 Jan 1947, A262, box 129, University of New England Registry Files, New England and Regional Archives, Armidale, emphasis added. See also correspondence in box 156.

76 Gretna Weste, interview by author, 1 Dec 1998, Melbourne. Weste was one of the very few women who returned to a significant research career after taking a long break to raise her children.

77 UM312, 1938/37 and 1938/152A; *Sun*, 8 Aug 1944 and 15 Aug 1944; *Herald*, 3 Sep 1945.

78 Cahn, interview. Cahn notes Trikojus was forced to set up the nutrition department because of a dedicated grant. For other accounts of the fate of nutrition, also based on Cahn's recollections, see Nash, *History of Dietetics*; J. W. Legge & F. Gibson, 'Victor Martin Trikojus 1902–1985', Historical Records of Australian Science 6, no. 4 (1987): 519–31.

79 Cahn, interview.

80 Valerie May, interview by author, 6 Jul 1998, Sydney.

81 Diana Temple (nee Marmion), BSc 1946, MSc 1949, PhD 1962 (Syd.), interview by author, 6 Jul 1998, Sydney.

Notes

82 Audrey Bersten (nee Isaacs), BSc 1948 (Syd.), interview by author, 5 Jul 1998, Sydney.

83 Ashby to the Vice-Chancellor, 23 Feb 1940, G50/8, Sydney Biology Records.

84 Ashby to Mr Grice, Science Teachers' Association, 7 Apr 1938, G50/8, Sydney Biology Records. See also Eric Ashby, 'The Place of Biology in Australian Education', *Australian Journal of Science* 1, no. 1 (1938): 3–9.

85 Ashby to Dr Darnell Smith, 2 Mar 1939, G50/8, Sydney Biology Records.

86 AASW, Victorian Division, Minutes, 16 Apr 1940, box 65, Turner Collection. See also *Bulletin* (AASW), no. 5 (1950).

87 John Turner, 'The Neglected Science', *Science Review* (University of Melbourne), August 1939, 11.

88 Turner to Prof. R. Emerson, Department of Botany, University of California, 4 Oct 1961, box 69, file 494, Turner Collection. See also other correspondence in this file.

89 Turner to various academic colleagues, 11 Sep 1956, box 69, file 494, Turner Collection.

90 H. Trumble, Waite Institute, to Turner, 11 Feb 1947, and Turner to Trumble, 18 Feb 1947, box 63, Turner Collection.

91 Ashby to Adam, Waite Institute, 22 Jul 1943, and Adam to Ashby, 28 Jul 1943, G50/14, Sydney Biology Records.

92 Dr Petrie, Waite Institute, to Turner, 16 Jan 1940, box 59, Turner Collection.

93 Turner to the Registrar, 26 Feb 1957, box 65, file 308, Turner Collection.

94 See e.g. Turner to Prof. Trikojus, 14 Aug 1951, box 89, file 608, Turner Collection.

95 See the department's examination results, 1918–57, box 106, Turner Collection.

96 Turner to E. J. F. Wood, Division of Fisheries, CSIR, 19 Feb 1943, box 61, and Turner to Sir Archie Michaelis, 5 Mar 1954, box 69, file 498, Turner Collection.

97 Prof. G. Bayliss, botany dept, University of Otago, to Turner, 14 Mar 1958, box 49, file 422, Turner Collection.

98 Turner, 'Memorandum for the Dean of Science', 23 Jul 1959, box 89, file 608, Turner Collection.

99 Turner to Registrar, 11 May 1962, box 69, file 494, Turner Collection.

100 *Daily Telegraph*, 24 Sep 1937.

101 *Bulletin* (AASW), no. 3 (1940). Women present at the meeting included Rachel Makinson, Joyce Vickery, Lilian Fraser, Germaine Joplin, Marjorie Moore, Catherine Back, Muriel Holdsworth, Muriel Suttcliffe, Betty Lawrence, Kathleen Sherrard, Ruby Payne Scott, Valerie May, Dorothy Large, Delta Thompson, Rhoda Palmer and Helen Newton Turner: undated list contained in the Makinson Papers (which also contain extensive further correspondence relating to this committee). The AASW was founded in 1939. It folded in 1949, largely under pressure of accusations of communist connections. Jean Moran, 'Scientists in the Political and Public Arena: A Social Intellectual History of the Australian Association of Scientific Workers' (Master's thesis, Griffith University, 1983).

102 AASW, Status of Women Employed in Science, unpublished report, Jul 1941, B551, 1944/88/9396, National Archives of Australia, Canberra, 4, emphasis in original.

103 *Australian Women's Digest* 1, no. 4 (Nov 1944), 15.

104 *Bulletin* (AASW), no. 19 (1941).

105 See correspondence in E101B, AASW Papers.

Notes

106 *Bulletin* (AASW), no. 3 (1940). One woman replied to an invitation to join the group, 'I am strongly opposed to the formation of any sub-committee of women for the purposes of carrying out such an investigation ... I personally do not believe that anything at all should be done about the matter. I am sure there are more pressing matters.' Joyce Cooper, Dept of Pharmacy, University of Sydney, to Dr Fraser, 6 Mar 1940, Makinson Papers.

107 CSIRO Officers' Association, Equal Pay Committee, N43, Noel Butlin Archives, Canberra; Makinson Papers.

108 Catherine Le Fevre, 'Women in Australian Chemistry', *Proceedings of the Royal Australian Chemical Institute* 24, no. 12 (1957): 635. In 1955 Le Fevre husband's request she be appointed an 'honorary associate' was rejected. Le Fevre, C. G. Mrs, 17668, Sydney Registrar's Files. See also Nessy Allen, 'Woman Scientist or Scientific Woman', in *Contributions to the Sixth International GASAT Conference*, ed. Leonie Rennie et al. (Melbourne: University of Melbourne, 1991).

109 *Herald*, Dec 1964, clipping in 'Victorian Women Graduates Association News Cuttings 1960s', Victorian Women Graduates Association Records, University of Melbourne Archives.

110 Unsourced clipping in ibid.

Conclusion

1 Women's proportional representation in science was certainly higher in Australia from 1900–1950 than in the United Kingdom or North America. But Australia wasn't entirely unique. In the US in the early 1900s, research science was also a new field with uncertain employment prospects that men were reluctant to enter. Still, women employed in science-based university departments remained under 10% for the entire period from 1912 to 1975, although they were not necessarily worse off in science than other disciplines. The main places women scientists were employed were in departments of home economics and in women's colleges. See Penina Glazer & Miriam Slater, *Unequal Colleagues: The Entrance of Women into the Professions, 1890–1940* (New Brunswick: Rutgers UP, 1987). See also Margherita Rendel, 'How Many Women Academics, 1912–76', in *Schooling for Women's Work*, ed. Rosemary Deem (London: Routledge and Keegan Paul, 1980), esp. 152–4; Margaret Rossiter, *Women Scientists in America: Struggles and Strategies up to 1940* (Baltimore: Johns Hopkins UP, 1982). In Britain, women were certainly extremely marginal in places like Oxford and Cambridge, representing less than 10% of students taking the Natural Science Tripos at Cambridge from 1881 to 1914. Women were barred from employment at the university until 1923. But there were great differences between the different universities and variations between fields and over time. At the University of Manchester, for example, between 1899 and 1914 more women took out degrees in botany (30) and zoology (9) than men, although in this same period only 4 women completed physics degrees. In 1879–1911, 600 women took out BSc degrees from the University of London, accounting for 30% of internal students (although only 16% of total BSc degrees as many students studied externally). Roy MacLeod & Russell Moseley, 'Fathers and Daughters: Reflections on Women, Science and Victorian Cambridge', *History of Education* 8, no. 4, (1979): 321–33, and 'The "Naturals" and Victorian Cambridge: Reflections on the Anatomy of an Elite,

Notes

1851–1914', *Oxford Review of Education* 6 (1982): 177–96. Aude Vincent has collated 210 women geologists globally active in the period 1800–1929, 'a number exceeding what we generally imagine': 'Reclaiming the Memory of Pioneer Female Geologists 1800–1929', *Advances in Geosciences* 53 (2020): 129–54. There are also examples of women gaining a foothold in specific disciplines/laboratories for varying periods. Paula Gould, 'Women and the Culture of University Physics in Late Nineteenth-Century Cambridge', *British Journal for the History of Science* 30, no. 1 (1997): 127–49; Marsha Richmond, 'The Imperative for Inclusion: A Gender Analysis of Genetics', *Studies in History and Philosophy of Science Part A* 90 (2021): 247–64; and 'Women in the Early History of Genetics: William Bateson and the Newnham College Mendelians, 1900–1910', *Isis* 92, no. 1 (2001): 55–90. In Canada, women also developed a foothold in physics at the University of Toronto in the early twentieth century, although their representation dropped to zero by 1972 when the last of these early graduates retired. Alison Prentice, 'Three Women in Physics', in *Challenging Professions: Historical and Contemporary Perspectives on Women's Professional Work*, ed. Elizabeth Smyth et al. (Toronto: University of Toronto Press, 1999), esp. 121, 126, 131–4. There were again, however, great differences between different universities. At the University of Manitoba only two women were employed in the science faculty prior to 1950. The overwhelming majority of women on the academic staff were in home economics. Mary Kinnear, *In Subordination: Professional Women, 1870–1970* (Montreal/Kingston: McGill-Queen's UP, 1995), 34–35, 171. In New Zealand, women's representation as university science staff was almost entirely confined to the Department of Home Science. Tanya Fitzgerald, 'Claiming Their Intellectual Space: Academic Women at the University of New Zealand 1909–1941', *Paedagogica Historica* 56, no. 6 (2020): 819–30.

2 Claire Jones, 'Grace Chisholm Young: Gender and Mathematics Around 1900', *Women's History Review* 9, no. 4 (2000): 676.

3 As Sandra Harding notes, 'the study of "great women" gives us no more insight into the daily lives of most women than did the lives of great men into the "common man"': *The Science Question in Feminism* (Ithaca Cornell UP, 1986), 31.

4 On women's invisibility in histories of science, see e.g. Sally Gregory Kohlstedt, 'In from the Periphery: American Women in Science, 1830–1880', *Signs* 4, no. 1 (1978): 81–96; Amaya Alvarez, 'Invisible Workers and Invisible Barriers: Women at the CSIR in the 1930s and 1940s', in Farley Kelly, *On the Edge of Discovery: Australian Women in Science* (Melbourne: Text, 1993); Anne Barrett, 'Where Are the Women? How Archives Can Reveal Hidden Women in Science', in *The Palgrave Handbook of Women and Science since 1660*, ed. Claire G. Jones, Alison E. Martin and Alexis Wolf (Cham: Palgrave Macmillan, 2022); Kate Hannah, 'Finding Matilda: Deconstructing Women's Invisibility in Finding New Zealand's Scientific Heritage', *Journal of the Royal Society of New Zealand* 47, no. 2 (2017): 148–55.

5 Marcia Langton et al., 'Truth Telling and the University: The Legacy of Historical Racism at the University of Melbourne', roundtable, Australian Historical Association conference, Geelong, 28 Jun 2022; Joel Barnes, 'Australian universities and Atlantic slavery', *History Australia*, online ahead of print (2022), DOI: 10.1080/14490854.2022.2129265. See also K. Tsianina Lomawaima, et al., 'Editors' Introduction: Reflections on the Land-Grab Universities Project', *Journal of the Native American and Indigenous Studies Association* 8, no. 1 (2021): 89–97; Micah

Notes

Ward, 'Cambridge University Finds It Gained "Significant Benefits" from Slave Trade', *Guardian*, 23 Sep 2022.

6 Diana Temple, 'Academic Women Scientists', *Congress Papers*, 48th ANZAAS Congress, Melbourne, 1977, 2.

7 Heather Adamson, 'Changing Patterns of Employment of Women in the Biological Sciences: Summary of Main Points', *Congress Papers*, 48th ANZAAS Congress, 1. Adamson's showed that women's representation in Australian biology departments dropped from nearly 40% in 1935, to just 8% in 1975. See also Appendix 2, and Adamson's obituary, 'Biologist Committed to Research, Learning', *SMH*, 20 Feb 2010.

8 Patricia Grimshaw and Rosemary Francis, 'Women Research Leaders in the Australian Learned Academies: 1954–1976', in *Seizing the Initiative: Australian Women Leaders in Politics, Workplaces and Communities*, ed. Rosemary Francis et al. (University of Melbourne, eScholarship Research Centre, 2012).

9 For example, Diana Temple was a key founding member of the Women in Science Enquiry Network (WiSEnet) in 1984, which merged with Women in STEMM Australia in 2016: https://womeninscienceaust.org/2018/02/18/women-in-stemm-advocacy-looking-at-the-past-a-link-to-the-future/.

10 'Clarke, Adrienne (1938–)', in Encyclopedia of Australian Science and Innovation, https://www.eoas.info/biogs/P002212b.htm.

11 'Cory, Suzanne', in *The Encyclopedia of Women & Leadership in Twentieth-Century Australia*, https://www.womenaustralia.info/leaders/biogs/WLE0541b.htm; 'Suzanne Cory', in Ragbir Bhathal, *Profiles: Australian Women Scientists* (Canberra: NLA, 1999), 90–97.

12 'Sackett, Penny D. (1956–)', in *Encyclopedia of Australian Science and Innovation*, https://www.eoas.info/biogs/P005957b.htm.

13 Andrew Darby, 'Outspoken Australian Scientist Dropped by Bush Wins Nobel', *SMH*, 6 Oct 2009.

14 Jane Carey, '"What's a Nice Girl Like You Doing with a Nobel Prize?" Elizabeth Blackburn, "Australia's" First Woman Nobel Laureate and Women's Scientific Leadership', in *Seizing the Initiative: Australian Women Leaders in Politics, Workplaces and Communities*, ed. Rosemary Francis et al. (University of Melbourne, eScholarship Research Centre, 2012).

15 See e.g. Women in Science, Engineering and Technology Advisory Group, *Women in Science, Engineering and Technology* (Canberra: Commonwealth Office of the Chief Scientist, 1995); Sharon Bell, *Women in Science in Australia: Maximising Productivity, Diversity and Innovation* (Canberra: Federation of Australian Scientific and Technical Societies, 2009). For the latest figures see the 'STEM Equity Monitor': https://www.industry.gov.au/publications/stem-equity-monitor/workforce-data/teaching-and-research-workforce-stem-and-other-fields. In 2022 women were still only 18% of the 589 Fellows of the Australian Academy of Science: https://www.science.org.au/supporting-science/diversity-and-inclusion.

16 'Five Melbourne University Employees Leave after Sexual Misconduct Allegations', *Age*, 29 Sep 2022; 'Predatory Behaviour Exposed at Antarctic Research Centre', *SMH*, 30 Sep 2022.

17 The key program promoting equity for academic women in science in Australia is the much-lauded SAGE Athena SWAN 'accreditation and awards' program,

296

adopted in 2015 and modelled on the UK scheme established in 2005: https://sciencegenderequity.org.au/sage-accreditation-and-awards/sage-pathway-to-athena-swan. The most recent assessment of the UK program describes it as 'window dressing with limited impact' and concluded that it was 'failure' that had not 'challenged the ideal scientist norm in Science disciplines'. Ruby Christine Mathew, 'The Impact of Athena Swan Accreditation on the Lived Experiences of Early- and Mid-Career Researchers' (PhD thesis, University of York, 2021). Another study found that it had not impacted the gender pay gap and its benefits were spread unevenly across different groups of women. Fran Amery et al., 'Why Do UK Universities Have Such Large Gender Pay Gaps?', *Political Studies Association Blog*, 25 Apr 2019, https://www.psa.ac.uk/psa/news/why-do-uk-universities-have-such-large-gender-pay-gaps. An analysis of the Australian program – and the proliferation of 'women only' mentoring and networking programs more generally – is scathing, arguing that it works to entrench and replicate the very inequities it is supposedly intended to disrupt. It also highlights the enormous workload required for accreditation, usually undertaken by women STEM academics in ways that are unlikely to support their own career progression. Simone Dennis & Alison Behie, *Mentored to Perfection: The Masculine Terms of Success in Academia* (Lanham: Rowman and Littlefield, 2022), 1, 104. See also Briony Lipton, 'Measures of Success: Cruel Optimism and the Paradox of Academic Women's Participation in Australian Higher Education', *Higher Education Research & Development* 36, no. 3 (2017): 486–97; Meredith Nash et al., 'An Exploration of Perceptions of Gender Equity among SAGE Athena SWAN Self-Assessment Team Members in a Regional Australian University', *Higher Education Research & Development* 40, no. 2 (2021): 356–69; Sara Ahmed, *On Being Included: Racism and Diversity in Institutional Life* (Durham: Duke UP, 2012); Kalwant Bhopal & Holly Henderson, 'Competing Inequalities: Gender versus Race in Higher Education Institutions in the UK', *Educational Review* 73, no. 2 (2021): 153–69.

Index

AAAS. *See* Australasian Association for the Advancement of Science

AASW. *See* Australian Association of Scientific Workers

à Beckett, Ada. *See* Lambert (à Beckett), Ada

Aboriginal people. *See* Indigenous people

absence
 of men in science, 104–5, 168, 172, 227
 of women in science, 4–5, 224–5
 See also discrimination; exclusion; equality; presence

Adamson, Heather, 228

Adelaide
 girls' schools, 158
 Institute of Medical and Veterinary Science, 165
 See also Dornwell, Edith; Lambert (à Beckett), Ada; University of Adelaide

AFUW. *See* Australian Federation of University Women

Agar, Wilfred
 and eugenics, 147
 and Ethel McLennan, 115–16
 and shortage of men, 101–2, 104–5
 on women's salaries, 109–10

Alexander, Jean, 96

Allan, Betty, 202

amateur science, 6–7, 14–15, 226
 and the academy, 48
 and the family, 20
 and Georgina King, 13, 30, 35
 and women, 46
 See also scientific societies

Angel, Madeline, 169, 172, 185

anthropology
 and Daisy Bates, 39–42
 and colonialism, 13, 44
 and Georgina King, 13, 36–8
 and natural history, 15
 and Katie Langloh Parker, 38–9
 Royal Anthropological Society of Australia, 122–3, 38
 Science of Man, 37–8, 44–5, 122–3
 See also eugenics

anthropometry, 122–3

Archer, Ellinor, 201

Armstrong, Florence, 95–6

artificial insemination, 136
 See also contraception; sex education; sterilisation; venereal disease

Ashby, Eric, 203–5, 212–13, 215

Atkinson, Louisa, 25–7

Atkinson, Nancy, 173–4, 206, 208–9

Australasian Association for the Advancement of Science (*also known as* Australian and New Zealand Association for the Advancement of Science), 29, 35, 37, 50, 64, 165

Australian Association of Scientific Workers, 190–3, 217–18

Australian Federation of University Women, 88, 90, 154, 163–7, 180–1

Australian National Council of Women. *See* National Council of Women

Australian and New Zealand Association for the Advancement of Science. *See* Australasian Association for the Advancement of Science

Australian Women's Weekly, 42, 161–3

Index

Bacon, Francis, 5
bacteriology (microbiology), 107, 173–5, 195–6, 207, 209
Bage, Freda, 90–1, 180–1
Barnard, Mildred, 202
Barrien, Beryl, 172
Bates, Daisy, 11, 39–43
Benham, Ellen, 79, 81, 135
Bennett, George, 29–30
Bentivoglio, Marie, 93
Best, Effie, 172, 184
biochemistry, 174, 196–8, 210–11
biology
 academic appointments, 77
 and Nancy Atkinson, 208–9
 and Freda Bage, 81
 and boys' schools, 159, 213
 and Gwynneth Buchanan, 81–2
 and Margaret Deer, 93
 disciplines (*see* bacteriology (microbiology); biochemistry; botany; physiology; zoology)
 and girls' schools, 158
 and Marion Horton, 79
 and Ada Lambert (à Beckett), 62, 76, 78, 100, 128, 145
 and Leonora Little, 82
 and Doreen McCarthy, 172, 208
 and Sibeley McLean, 207
 and New England University College, 173
 and Eileen Reed, 82
 and Georgina Sweet, 85–6, 112
 and Mavis Walker, 81
birth control. *See* contraception
Blackburn, Elizabeth, 1–2, 229–30
Blackwood, Margaret, 170, 181–2
Booth, Angela, 139, 150
botany
 academic appointments, 77, 84
 academic staff, 171
 and Louisa Atkinson, 25–7
 and Beryl Barrien, 172
 and Ellen Benham, 79, 81
 and Margaret Blackwood, 170
 and Gladys Carey, 171
 and Marjorie Collins, 81

 and Amy Crofts, 173
 and Constance Eardley, 172
 and employment, 192–3, 203–4
 and discrimination, 209–11
 and girls' schools, 158
 and Sarah Hynes, 95
 and Fanny Macleay, 21
 and Ethel McLennan, 87–8, 114–15
 and Georgiana Molloy, 17–20
 and Eileen Reed, 82
 and Bertha Rees, 101, 109
 and Ellis Rowan, 22
 and scientific illustration, 21–2
 and shortage of men, 101, 105, 212–16
 and Isobel Travers, 93
 and Jean White, 84
 and women, 5, 16, 26
 See also Ashby, Eric; Ewart, Alfred; Turner, John Stewart
boys' schools, 159, 213
Brennan, Anna, 127
Britain. *See* United Kingdom
British Association for the Advancement of Science, 16
Brown (later Browne), Ida, 171
Buchanan, Gwynneth, 81–2, 91, 111–12, 139, 145–6
Burgess, May, 79, 81
Cahn, Audrey, 197–8, 210–11
Campbell, Frances, 85
careers. *See* employment
Carey, Gladys, 171
Carroll, Alan, 37, 122–4, 133–4
Chase, Eleanor, 80
chemistry
 academic appointments, 81, 85
 and boys' schools, 67
 and May Burgess, 79, 81
 Conversations on Chemistry, 16
 and Stella Deakin, 97–8
 and employment, 96, 193–4
 and exclusion, 199–200, 208, 211, 219
 and girls' schools, 158–9
 and Rita Harradence, 175–6
 and Orme Masson, 49, 65, 96
 and David Rivett, 98–9, 104–5, 115–16

300

and Robert Robinson, 80
and Brenda Sutherland, 94
and Diana Temple, 211, 228
at University of Melbourne, 65, 208
and Norman Wilsmore, 61
children
and Alan Carroll, 122–4, 134
kindergartens, 128–9, 134
and school medical services, 129–30
Child Study Association, 123–4, 134
Clarke, Adrienne, 229
Clarke, Rev. William Branwhite, 26, 28
class, 9
and education, 7, 67–8, 157, 182
and Factory Girls' Club, 126
and kindergarten movement, 129
and settlement houses, 125–6
and scientific illustration, 21
and social reform, 152
Cleminson, Hilda, 74
College of Domestic Economy, 94
Collins, Marjorie, 81
colonialism, 13, 44, 50–1, 226–7
and amateur science, 6–7
and Indigenous Knowledge, 6
and natural history, 15, 27
and Georgina Sweet, 91–2
Commonwealth Scientific and Industrial
Research Organisation. *See* CSIR/O
contraception, 137, 144, 148–9
See also artificial insemination; sex
education; sterilisation; venereal
disease
Cookson, Isabel, 84, 111, 170
Cory, Suzanne, 229
Council of Scientific and Industrial
Research. *See* CSIR/O
Crespin, Irene, 95
Crofts, Amy, 173
CSIR/O, 189, 201–4, 218–19, 222
Curie, Marie, 3, 160
David, Edgeworth, 32–3, 60, 66
Deakin, Alfred, 97–9
Deakin, Stella, 71, 90, 97–9
decline
of women in science, 189–90, 222
Deer, Margaret, 79, 93

degrees, university science
introduction of, 6, 28, 48–9
medical, 52
at University of Melbourne, 60
See also education; graduates, university
science; scholarships; schools,
secondary; students, university
science; universities; *and names of
individual universities*
demonstrators, 84–5, 108
dietetics (nutrition), 195–9, 163, 167–8,
210
Dietrich, Amalie, 45–6
discrimination, 9, 106–12, 117
and appearance, 106–7
Australian Association of Scientific
Workers on, 190–3, 217–18
and botany, 209–16
and chemistry, 199–200
and CSIR/O, 189, 201–4
and demonstrators, 108
and dietetics, 195–9, 210
and graduates, science, 193–5
and hospital laboratory work, 196
in job advertisements, 190
marriage bar, 94, 97, 183, 191, 201–2
and masculinisation of science, 189–90
and Ethel McLennan, 109–12, 114–16
and National Herbarium, 205
and physics, 199–200
and salaries, 108–12, 206, 216–19
and Georgina Sweet, 112–13
and universities, 205–11
See also equality; exclusion
domestic science, 94, 197
Dornwell, Edith Emily, 2–3, 47, 58–9, 77
Ducker, Sophie, 170–1
Dyason, Diana, 159–61, 169, 178–9, 184
'dying race theory', 41–2
Eardley, Constance, 172
education
and class, 7, 67–8, 157, 182
and girls, 9–10, 16
in geology, 60
girls' schools, 66–7, 157–60, 183
and race, 7–8
and women, 52–3, 55, 154

Index

See also degrees, university science; graduates, university science; scholarships; schools, secondary; students, university science; universities; *and names of individual universities*

Ellery, Robert, 63–4

Elliott, Amy, 70, 95

employment, 9, 53–4, 66
 academic staff, 170–4
 CSIR/O, 189, 201–4
 Edgeworth David on, 66
 demonstrators, 84–5, 108
 discrimination (*see* discrimination)
 and equality, 177–87
 and family connections, 184
 first academic appointments, 77–88
 Ada Lambert (à Beckett), 76–9, 83
 Leonora Little, 82–3
 Ethel McLennan, 87–8
 Georgina Sweet, 85–6
 glass ceiling, 78, 112, 176, 211
 hospitals, 175, 196
 in industry, 96, 193–5
 and marriage, 78, 94, 97–100
 marriage bar, 94, 97, 183, 191, 201–2
 and masculinisation, 189–90
 media coverage
 of careers, 161–8
 and femininity, 71–3, 219–20
 professorships
 Dorothy Hill, 112, 176
 and Ethel McLennan, 114–16
 and Georgina Sweet, 112–13
 public service, 94–5
 salaries, 108–12, 206, 216–19
 and Second World War, 8, 172, 194, 201–2
 and shortage of men, 101–5, 212–16
 survey participants on, 169
 teaching, 77, 93–4, 100, 194

enrolments. *See under* students, university science

entomology, 21–2

epileptics, 140–1

equality, 177–87
 See also meritocracy

eugenics
 and Ada à Beckett, 139, 145–6
 and artificial insemination, 136
 and Angela Booth, 139, 150
 and Gwynneth Buchanan, 139, 145–6
 and Alan Carroll, 133–4
 and children, 134
 and contraception, 137, 144, 148–9
 definition of, 37, 131–2
 and epileptics, 140–1
 eugenic groups, 134–5, 138–9
 and Alice Henry, 140–1
 and Irene Longman, 132–3, 143
 and mothers, 132, 136, 144–7
 and National Council of Women
 Australian, 140
 NSW, 142
 Queensland, 143
 Victorian, 141–2
 and Marion Piddington, 136–8, 147–9
 and Racial Hygiene Association of NSW, 137–40, 148–51
 Royal Anthropological Society of Australia, 122–3, 38
 Science of Man, 37–8, 44–5, 122–3
 and segregation, 139–42
 and sex education, 137–8, 144–51
 and sterilisation, 137–40, 143–4
 and Marie Stopes, 137
 and Georgina Sweet, 139, 145–7
 and venereal disease, 138, 144, 148–51
 and White Australia policy, 120, 130, 150, 152–3
 See also anthropometry

Ewart, Alfred, 84
 and McLennan professorship, 114
 and shortage of men, 101, 105
 on women's salaries, 109–10

exclusion, 4–6
 and chemistry, 199
 and dietetics, 195–9, 210
 and historical progress, 10, 224–5, 228–31
 and Georgina King, 31, 35
 and physics, 199
 See also discrimination

family, 20, 184

302

Index

femininity, 55, 71–4, 219–20
 See also discrimination; exclusion;
 feminism; masculinity; men;
 women's groups
feminism
 and colonialism, 44–5
 maternal, 119–20
 resistance to, 182, 226
 and Georgina Sweet, 86–7
 women's groups, 89–90
 See also discrimination; exclusion;
 femininity; masculinity; men;
 women's groups
First World War, 60, 104
Fitzpatrick, Kathleen, 178, 188
Franklin, Jane, 28
Franklin, John, 28
Freeman, Joan, 175
Fuller, Mary, 202
Galton, Francis, 131
geology
 academic appointments, 79
 and Florence Armstrong, 95–6
 and Marie Bentivoglio, 93
 and Ida Brown (later Browne), 171
 and Rev. William Branwhite Clarke,
 28
 and colonialism, 44
 and Irene Crespin, 95
 and Margaret Deer, 79, 93
 and discrimination, 106, 192
 and girls, 60
 and Dorothy Hill, 176
 and Germaine Joplin, 171
 and Georgina King, 32–4
 and University of Sydney, 60, 79
 See also David, Edgeworth; Liversidge,
 Archibald
girls
 Brookside Reformatory for Girls, 121
 and education, 9–10, 16
 and geology, 60
 girls' schools, 66–7, 157–60, 183
glass ceiling, 78, 112, 176, 211
Gould, Elizabeth, 28
Gould, John, 28
government. *See* public service

graduates, university science
 and discrimination, 193–5
 first, 48, 58–63
 at University of Adelaide, 59
 at University of Melbourne, 60–1
 at University of Sydney, 3–4, 59–60
 See also degrees, university science;
 Dornwell, Edith Emily; education;
 Elliott, Amy; Guerin, Bella; Hunt,
 Fanny; Lambert (à Beckett), Ada;
 Little, Leonora Jessie; scholarships;
 schools, secondary; students,
 university science; Sweet, Georgina;
 universities; Valadian, Margaret; *and*
 names of individual universities
Graham, Barbara, 181–2, 194
Guerin, Bella, 52, 55–6, 118–19
Hamilton, Ellice, 135
Harradence (later Cornforth), Rita, 175–6
Henry, Alice, 121–2, 140–1
Herself, 132–3
Hill, Dorothy, 112, 176–7
Hindmarsh, Ellen, 80
history
 and progress, 10, 224–5, 228–31
 women's, 223
Holman, Mollie, 157–8
Holocaust, 131
Hooker, Joseph, 25
Horton, Marion, 79
hospitals, 175, 195–6
 See also dietetics
humanities, 3, 76–7
Hunt, Fanny, 48, 59
Hutchison, Nancy, 81, 103
Hynes, Sarah, 95
Indigenous people
 in anthropology, 13
 and Daisy Bates, 39–42
 and Amalie Dietrich, 46
 and education, 7–8
 Indigenous Knowledge, 6, 14
 Georgina King on, 37, 45
 massacre of Noongar people, 20
 Louisa Meredith on, 24, 38
 Georgiana Molloy on, 19–20
 and Katie Langloh Parker, 39

303

Index

Margaret Valadian, 7–8
and White Australia policy, 130
industry, 96, 193–5
Institute of Medical and Veterinary
Science, 165
Izett, Sarah, 124–5
Joplin, Germaine, 171
kindergartens, 128–9, 134
King, Georgina, 12–13
and amateur science, 13, 30, 35
and anthropology, 13, 36–8
and George Bennett, 29–30
egotism, 43
and exclusion, 31, 35
and feminism, 44–5
and Frederick McCoy, 30–1, 33,
36
friendship with Daisy Bates, 42–3
and plagiarism, 32–4
and Royal Society, 34
and Henry Russell, 30–1, 35–6
Kirby, Rev. Joseph, 59
Knowledge, Indigenous, 6, 14
Kramer, Leonie, 182
laboratories, university, 49–50
Laboratory Association, 122–3
Laby, Jean, 179
Laby, Thomas, 103, 107
Lambert (à Beckett), Ada, 60, 62
academic appointments, 76–9, 83
and eugenics, 139
and kindergarten movement, 128
and marriage, 100
and sex education, 145–6
Lang, Andrew, 38–9
Launceston, 158
Lindley, John, 18
Linnean Society of NSW, 63
literature. *See* writing
Little, Leonora Jessie, 48, 60–1, 82–3, 90
Liversidge, Archibald, 32–3, 50
Longman, Irene, 132–3, 143
Lyceum Club, 89–90
Mackerras, Josephine, 202
Macleay, Alexander, 21
Macleay, Fanny, 21, 28
Macleay, William, 21, 26

Makinson, Rachel, 203, 217–19
Mangles, Captain James, 17–20
Marcet, Jane, 16
marriage
and Daisy Bates, 40
and career, 78, 97–100, 164
Stella Deakin, 97–9
Ada Lambert (à Beckett), 100
and Second World War, 200
marriage bar, 94, 97, 183, 191, 201–2
Martin, Florence, 90
masculinisation, 189–90
masculinity, 15
See also femininity; men
Masson, Orme, 49, 65, 96
Mawson, Patricia, 172, 178–9, 182
May, Valerie, 178, 211
McCarthy, Doreen, 172, 208
McCoy, Frederick, 30–1, 33, 36
McLean, Sibely, 174, 207
McLennan, Ethel, 87–8
and Australian Federation of
University Women, 88, 166–7
and overseas research, 91
and promotion, 87–8
to associate professor, 114
application for professor, 114–16
and Rothamsted Experimental
Station, 87–8, 91
salary, 109–11
and shortage of men, 101
Syme Prize, 87
media coverage
and Elizabeth Blackburn, 2, 229–30
of careers, 161–8
and Stella Deakin, 71
and Edith Dornwell, 2–3
and femininity, 71–3, 219–20
and Ada Lambert (à Beckett), 76–7
and Brenda Sutherland, 72
and Georgina Sweet, 63, 71–3
medicine, 52, 56–7
and Josephine Mackerras, 202
See also hospitals
Melbourne
girls' schools, 157–60
Lyceum Club, 89–90

304

Index

women's groups, 89–90
 See also University of Melbourne
men
 absence of, 168, 172, 227
 and biology, 213
 and botany, 5, 212
 and masculinisation of science, 188–9
 and natural history, 15
 in science, 8, 65–6
 shortage of, 101–5, 212–16
 See also femininity
Meredith, Louisa, 23–5
meritocracy, 155, 183, 186, 205
 See also equality
microbiology. *See* bacteriology
Millis, Jean, 210
Millis, Nancy, 174
Milne, Agnes, 54
modernity, 49–50, 53–8
Molloy, Georgiana, 11, 17–20
Molloy, Captain John, 17–18, 20
mothers
 and eugenics, 132, 136
 and sex education, 144–7
 on sterilisation, 143–4
 and Sydney University Women's
 Society, 125
National Council of Women
 Australian, 140
 NSW, 142
 Queensland, 143
 Victorian, 141–2
National Herbarium, 95, 205
natural history, 14–16
 and colonialism, 15, 27
 and the family, 20
 and Fanny Macleay, 21
 and modernity, 50
naturalists. *See* natural history
Nelson, Edith, 103, 107
networking
 overseas research, 90–2
 Rothamsted Experimental Station,
 87–8, 91
 women's groups, 89–90
New England University College, 173, 209
New South Wales

girls' schools, 67, 157–8
National Council of Women, 142
newspapers. *See* media coverage
new woman, 49, 52–5, 227
 and social reform, 118–19
Nobel Prize
 and Elizabeth Blackburn, 1, 229
NSW. *See* New South Wales
Osborn, Edith, 81
Osborn, Theodore, 81, 105
Osborne, Ethel, 89
Osborne William, 89, 108
overseas research, 56, 90–2, 175
 Rothamsted Experimental Station,
 87–8, 91
Papua New Guinea, 22, 194
parasitology, 86
Parker, Katie Langloh, 38–9
The Passing of the Aborigines, 41
Paxton, Joseph, 18
pay. *See* salaries
Payne-Scott, Ruby, 192, 202
physics
 and boys' schools, 67
 and Frances Campbell, 85
 and discrimination, 107, 192,
 199–200
 and equality, 179
 and Joan Freeman, 175
 and girls' schools, 158–9, 200
 and Nancy Hutchison, 81, 103
 and Jean Laby, 179
 and Thomas Laby, 103, 107
 and Edith Nelson, 103, 107
 and Ruby Payne-Scott, 202
 and Edna Sayce, 80, 93
 and shortage of men, 103
physiology
 and academic staff, 174
 and dietetics, 94, 197
 and Edith Dornwell, 59–60
 and equality, 179
 in girls' schools, 158
 and Ellen Hindmarsh, 80
 and sex education, 145
 Sir Thomas Elder's Prize, 58–9
 and Edward Stirling, 59

305

Index

Piddington, Marion, 136–8, 147–9
Pittman, Edward, 32, 34
plagiarism, 32–4
presence of women in science, 3, 8–11, 155, 223–5
 and absence of men, 168, 172, 227
 and academic appointments, 85
 and Elizabeth Blackburn, 229–30
 and decline, 189–90, 222
 and scholarships, 84
 in universities, 56, 65, 69–70
 and 'Women in Science' symposium, 227–8
 See also discrimination; exclusion; equality
press. *See* media coverage
Preston, Elizabeth, 96
Princess Ida Club, 68
professorships
 Dorothy Hill, 112, 176
 and Ethel McLennan, 114–16
 and Georgina Sweet, 112–13
progress
 historical, 10, 224–5, 228–31
 and modernity, 53–8
 social, 51, 164
public service, 94–5
 and shortage of men, 103–5
 marriage bar, 94, 191, 201–2
Queensland
 National Council of Women, 143
 prickly pear experimental station, 84, 95
 See also University of Queensland
race
 and education, 7–8
 and Georgina King, 45
 White Australia policy, 120, 130, 150, 152–3
 See also anthropology; colonialism; eugenics
Racial Hygiene Association of NSW, 138–9, 148–51
Reed, Eileen, 82
Rees, Bertha, 101, 109
reform. *See* social reform
religion, 15, 119, 144

research
 overseas, 56, 90–2, 175
 Rothamsted Experimental Station, 87–8, 91
The Responsibility of the Community towards Sex Education, 146
Rivett, David, 98–9, 104–5, 115–16
Robinson, Gertrude, 80
Robinson, Robert, 80
Rothamsted Experimental Station, 87–8, 91
Rowan, Ellis, 22
Royal Anthropological Society of Australia, 122–3, 38
 Science of Man, 37–8, 44–5, 122–3
Royal Institution (Britain), 16
Royal Society of NSW, 32–4
Royal Society of Victoria, 63–4
Russell, Henry, 30–1, 35–6
Sackett, Penny, 229
salaries, 108–12, 206, 216–19
Sayce, Edna, 80, 93
scholarships, 84–5
 See also education; degrees, university science; graduates, university science; schools, secondary; students, university science; universities; *and names of individual universities*
schools, secondary
 completion rates, 157
 girls' schools, 66–7, 157–60, 183
 medical services, 129–30
 science in, 66–7
 See also education; degrees, university science; graduates, university science; scholarships; students, university science; universities; *and names of individual universities*
science
 domestic, 94
 expansion, 83–4
 modern, 7
 unpopular, 65
 See also amateur science; anthropology; biochemistry; botany; chemistry; entomology; eugenics; geology; physics; scientific societies; physiology; zoology

306

Index

Science of Man, 37–8, 44–5, 122–3
scientific illustration, 21–2, 28
scientific societies, 16, 28, 50, 63–4
Scott, Alexander, 21–2
Scott, Harriet, 21–2
Scott, Helena, 21–2
Second World War
 and CSIR/O, 201–2
 and employment, 8, 172, 194
 and marriage, 200
 and science, 160, 188
 and student numbers, 3, 168, 220
segregation, 139–42
settlement houses, 125–6
sex education, 137–8, 144–51
 and Ada à Beckett, 145–6
 artificial insemination, 136
 and Gwynneth Buchanan, 145–6
 contraception, 137, 144, 148–9
 and mothers, 144–7
 and Marion Piddington, 147–9
 and Racial Hygiene Association of
 NSW, 148–51
 sterilisation, 137–40, 143–4
 and Georgina Sweet, 145–7
 venereal disease, 138, 144, 148–51
 and White Australia policy, 150,
 152–3
sexual discrimination. *See* discrimination
Sherrard, Kathleen, 190–3, 217–18
social reform
 Factory Girls' Club, 126
 and Bella Guerin, 118–19
 and Alice Henry, 121–2
 and Sarah Izett, 124–5
 kindergarten movement, 128–9
 Laboratory Association, 122–3
 and modernity, 53
 school medical services, 129–30
 and science, 119
 settlement houses, 125–6
 and White Australia policy, 120, 130,
 150, 152–3
 and women, 119–20
 university educated, 125–7, 152
 unmarried, 128
 See also eugenics

South Australia
 and Edith Dornwell graduation, 58
 girls' schools, 158
 See also University of Adelaide
Spencer, Baldwin, 61
 female appointments, 83–4
 and Ada Lambert (à Beckett), 78–9, 83
 and Leonora Little, 82–3
 and Sweet professorship, 113
sterilisation, 137–40, 143–4
 See also artificial insemination;
 contraception; sex education;
 venereal disease
Stirling, Edward, 59
Stopes, Marie, 137
students, university science
 enrolments, 65, 168, 220
 See also education; degrees, university
 science; graduates, university science;
 scholarships; schools, secondary;
 students, university science;
 universities; *and names of individual*
 universities
Sugden, Ruth, 96
survey participants, 155–6
 and employment, 169
 on student numbers, 168–9
Sutherland, Brenda, 72, 91, 94
Sweet, Georgina, 11, 60, 62–3, 71–3
 academic appointment, 85–6
 and eugenics, 139
 and feminism, 86–7
 and Lyceum Club, 90
 and overseas research, 91–2
 and professorship, 112–13
 and sex education, 145–7
 and social reform
 on Factory Girls' Club, 126
 on unmarried women, 128
 and Syme Prize, 86
 on women's salaries, 111–12
Sydney
 girls' schools, 158
 Sydney Teachers' College, 93
 See also University of Sydney
Sydney Quarterly Magazine
 on employment, 53–4

307

Index

on the modern woman, 55–6
Sydney Teachers' College, 93
Sydney University Women's Society, 125–6
Syme Prize, 86–7
Tasmania
 girls' schools, 158
 and Louisa Meredith, 24
 See also University of Tasmania
teaching, 77, 93–4, 100, 194
Temple, Diana, 211, 228
Thorn, Frances, 127, 154
Travers, Isobel, 93
Turner, Helen Newton, 201
Turner, John Stewart, 204–5, 213–16
United Kingdom, 51, 175
United States, 126, 131, 141
universities
 academic staff, 170–4
 and amateur science, 48
 demonstrators, 84–5, 108
 and discrimination, 205–11
 in botany, 209–16
 and salaries, 108–12, 206, 216–19
 equality in, 177–87
 expansion of science in, 83–4
 fees, 67–8, 182
 first academic appointments, 77–88
 Ada Lambert (à Beckett), 76–9, 83
 Leonora Little, 82–3
 Ethel McLennan, 87–8
 Georgina Sweet, 85–6
 and glass ceiling, 78, 112, 176, 211
 and marriage bar, 97, 183
 professorships
 Dorothy Hill, 112, 176
 and Ethel McLennan, 114–16
 and Georgina Sweet, 112–13
 and salaries, 108–12, 206, 216–19
 scholarships, 84–5
 and shortage of men, 101–3, 212–16
 women students, 51, 56–7, 68–74
 See also Australian Federation of University Women; degrees, university science; education; graduates, university science;

scholarships; schools, secondary; students, university science; *and names of individual universities*
University of Adelaide
 academic appointments, 79–81
 academic staff, 172, 174
 and chemistry, 199
 and discrimination, 208–9
 Edith Dornwell graduation, 2–3, 47, 58–9
 and equality, 178
 and shortage of men, 102, 105
 women science students, 59
University of Melbourne
 academic appointments, 79, 85
 in botany, 84
 Ada Lambert (à Beckett), 76–9, 83
 Leonora Little, 82–3
 Ethel McLennan, 87–8
 Georgina Sweet, 85–6
 academic staff, 170, 173–4, 188
 chemistry at, 65
 degrees, science, 60
 and discrimination, 106–12
 and equality, 177–8
 Princess Ida Club, 68
 and shortage of men, 101–3
 women science students, 48, 57, 60–1, 68–70, 193
 See also Guerin, Bella; Little, Leonora Jessie; Spencer, Baldwin
University of Queensland
 academic appointments, 81
 and Margaret Valadian, 8
 women science students, 48, 70
University of Sydney
 academic appointments, 79–80
 academic staff, 171
 and equality, 178
 geology at, 60, 79
 and Georgina King, 29
 and shortage of men, 102
 Sydney University Women's Society, 125–6
 women science students, 3–4, 48, 51, 65, 70–1, 193

308

Index

University of Tasmania
 academic appointments, 81
 and discrimination, 206
 Amy Elliott, 70, 95
 women science students, 70
University of Western Australia
 academic appointments, 81–2
 and discrimination, 206–7
 and shortage of men, 103
 and Georgina Sweet, 112
 women science students, 182
Valadian, Margaret, 7–8
venereal disease, 138, 144, 148–51
 See also artificial insemination;
 contraception; sex education;
 sterilisation
Victoria
 boys' schools, 213
 girls' schools, 66–7, 157–60
 National Council of Women, 141–2
von Frauenfeld, Georg Ritter, 21–2
von Mueller, Ferdinand, 15, 26, 29
Waite Institute, 165, 172, 214–15
Walker, Mavis, 81
Weste, Gretna, 182–3, 210
Western Australia
 Daisy Bates in, 40–1
 Georgiana Molloy in, 11, 17–20
 See also University of Western
 Australia
White Australia policy, 120, 130, 150,
 152–3
White, Jean, 84, 95
Wilsmore, Norman, 61
'Women in Science' symposium, 227–8
women's groups, 89–90
 See also Australian Federation of
 University Women; feminism,
 National Council of Women
women's history, 223
women's rights. *See* feminism
Woodroofe, Gwen, 174, 208
Woolls, William, 25–6, 28
Workers' Educational Association of
 NSW, 135
World War I. *See* First World War
World War II. *See* Second World War

writing
 nature writing, 22–3
 and Louisa Atkinson, 25–7
 and Louisa Meredith, 23–5
zoology
 academic appointments, 77
 and Effie Best, 173
 and Eleanor Chase, 80
 and shortage of men, 101–4
 and Georgina Sweet, 86, 113
 and University of Melbourne, 170
 See also Agar, Wilfred; Buchanan,
 Gwynneth

About the Author

Jane Carey teaches history at the University of Wollongong, where she was a founding co-director of the Centre for Colonial and Settler Studies. She has published widely on Australian history, British colonial history, Indigenous history and women's history. The editor of numerous collections, including *Indigenous Networks* (2014) and *Colonial Formations* (2021), she has held a Monash Fellowship at Monash University and an Australian Research Council Postdoctoral Fellowship at the University of Melbourne.

Milton Keynes UK
Ingram Content Group UK Ltd.
UKHW010610070923
428212UK00002B/73